CLASSIC
BY
DESIGN

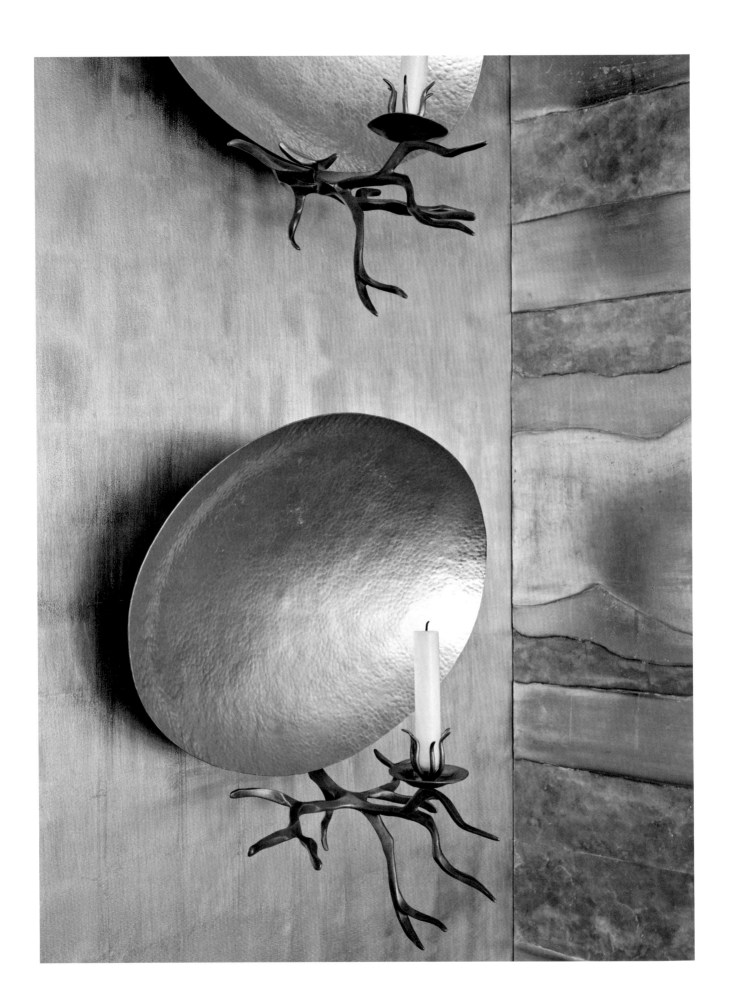

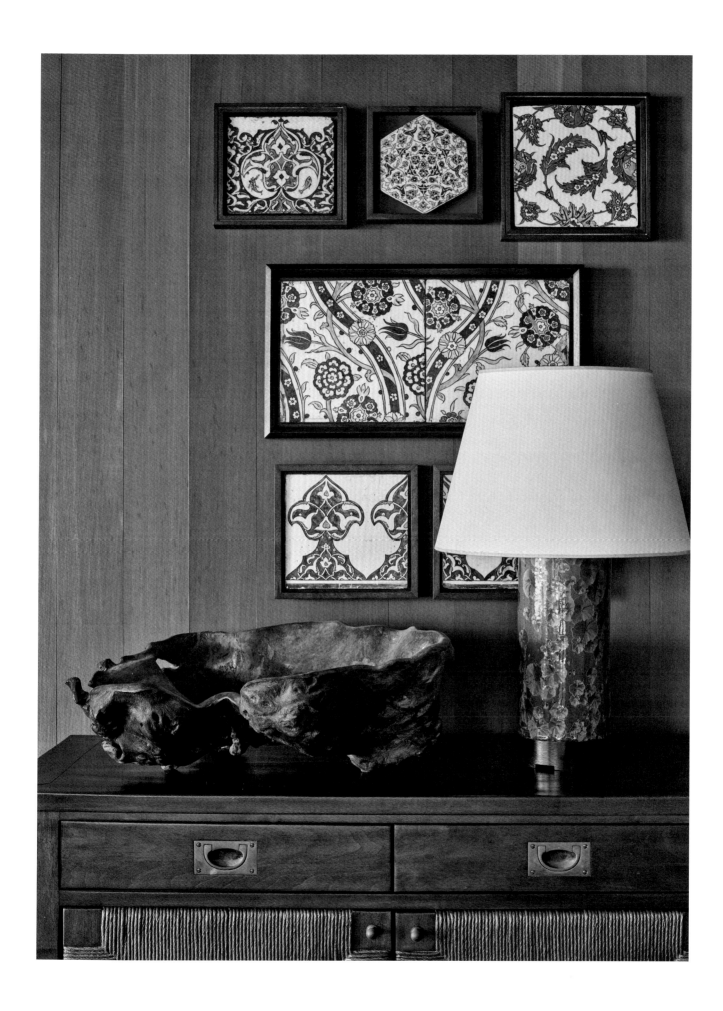

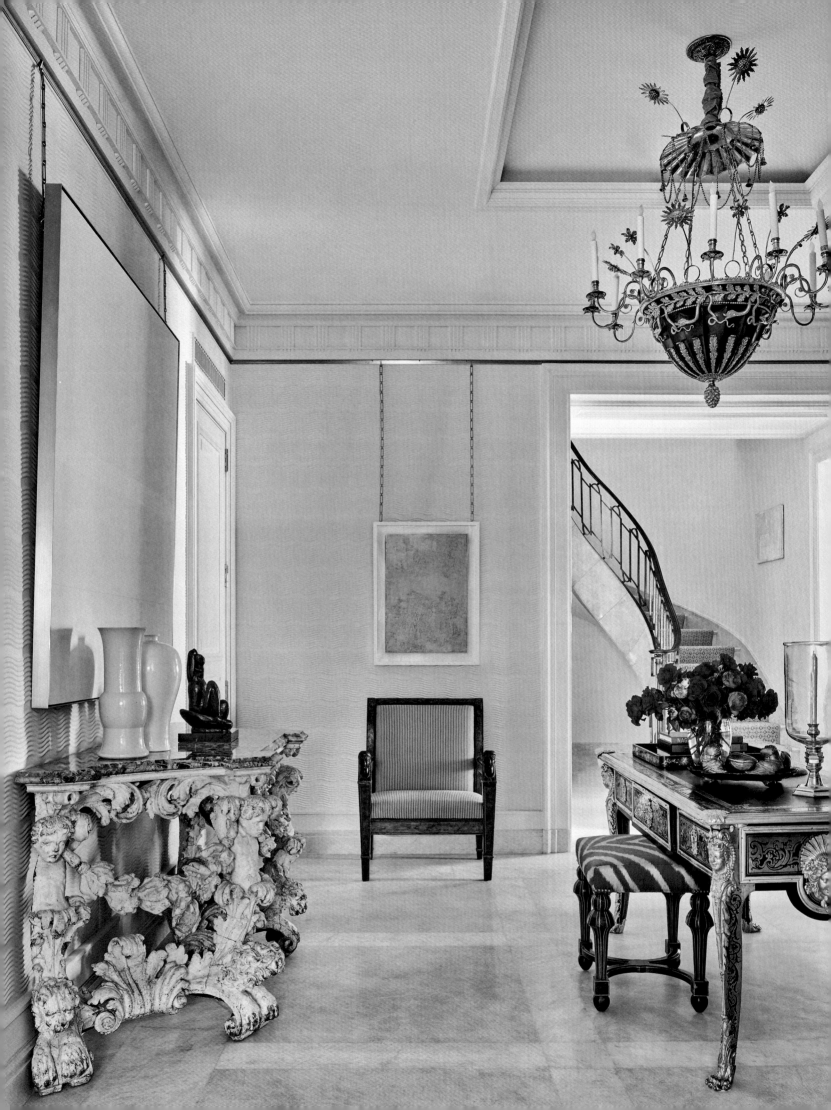

Michael S. Smith

CLASSIC BY DESIGN

WITH
Andrew Ferren

FOREWORD BY
Shonda Rhimes

RIZZOLI
NEW YORK

New York Paris London Milan

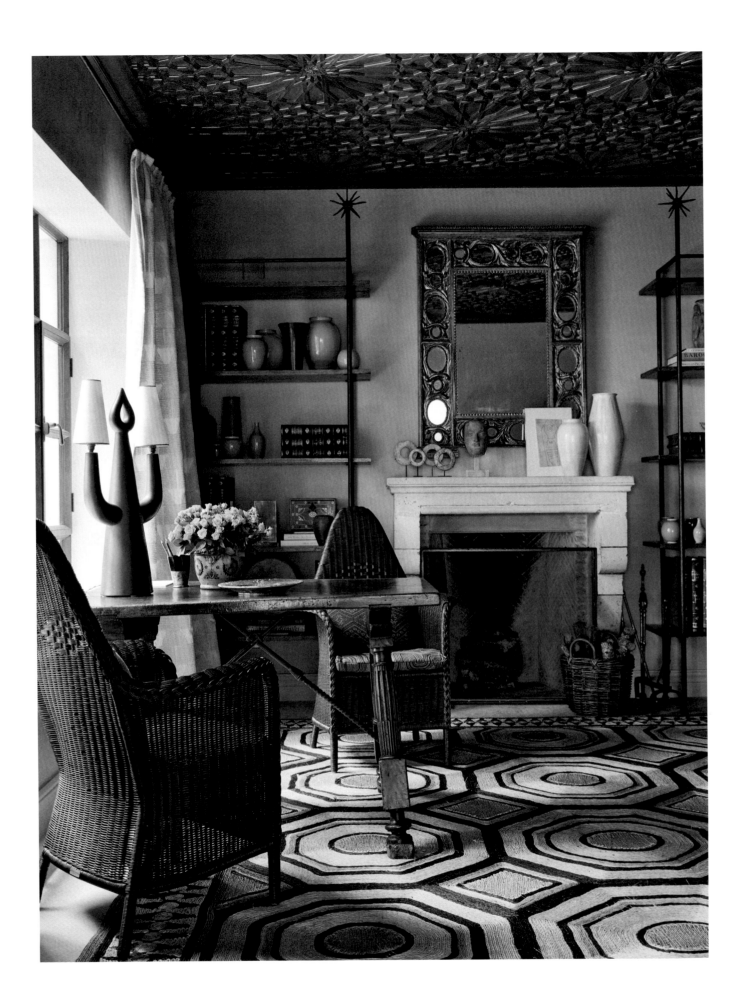

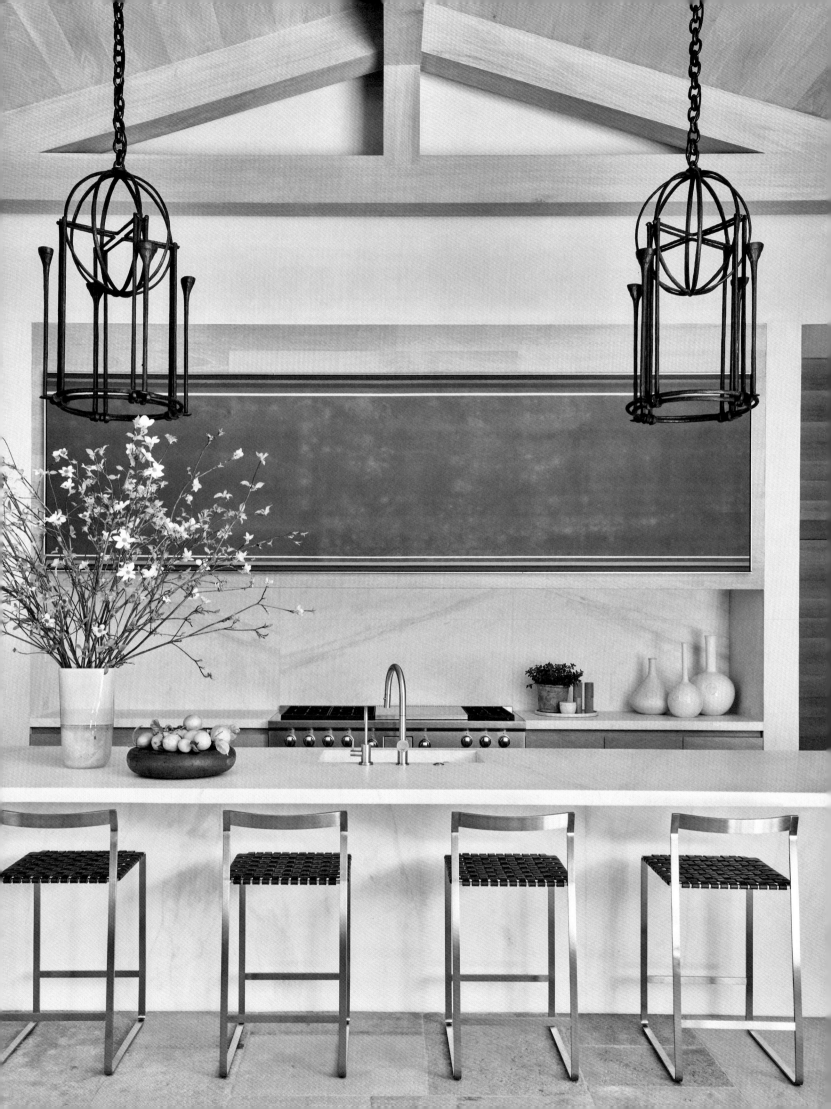

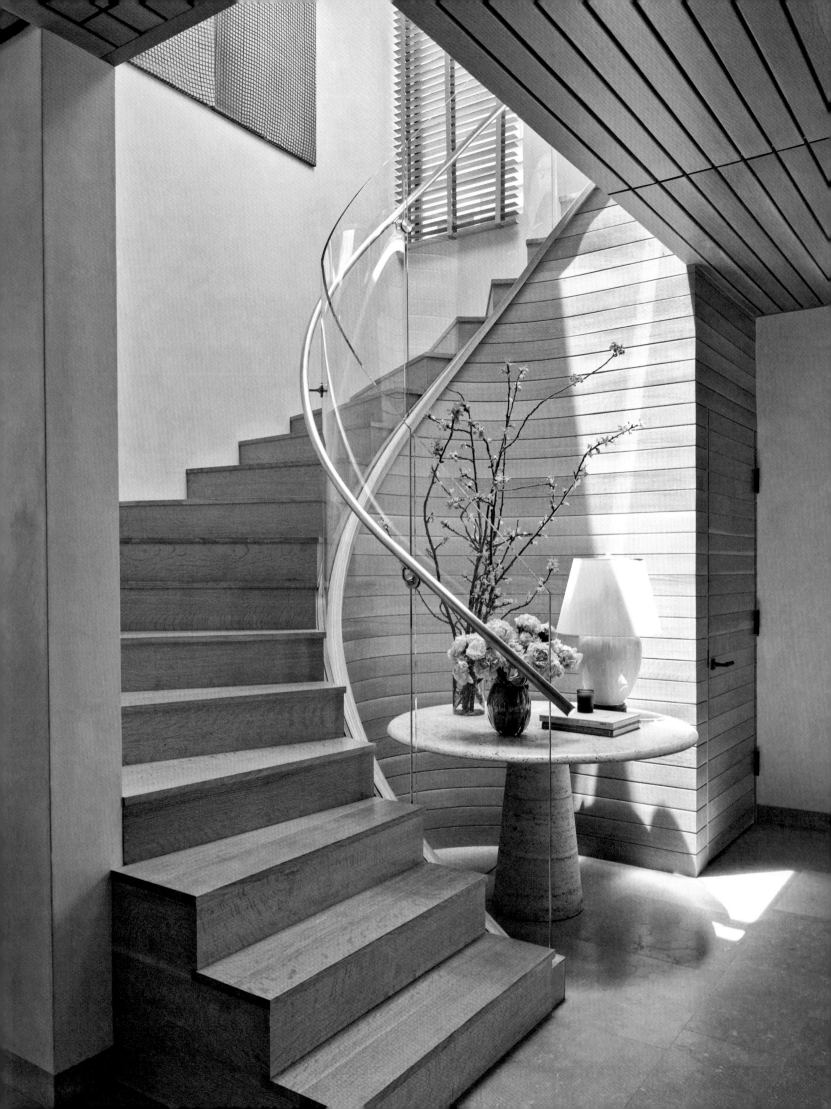

CONTENTS

Foreword
12

Introduction
14

THE HOUSES

Holmby Hills Pavilion 16

East River Penthouse 52

Mountain Retreat 72

Cliffside Villa 94

Prewar Duplex 116

Eighteenth-Century Château 138

Upper East Side Penthouse 148

1930s Spanish Revival 162

Pied-à-Terre 184

Saltbox Reimagined 198

Garden House 220

Modern Beachfront 240

Island Compound 254

Acknowledgments
268

Credits
270

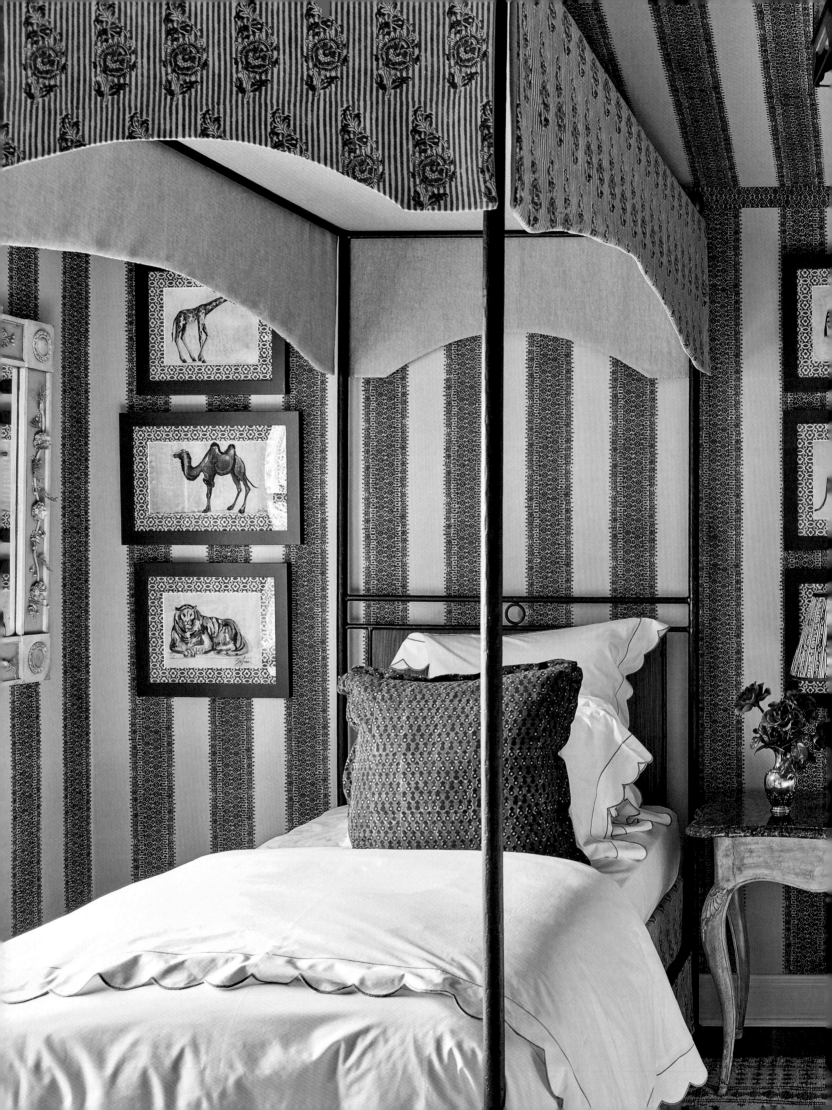

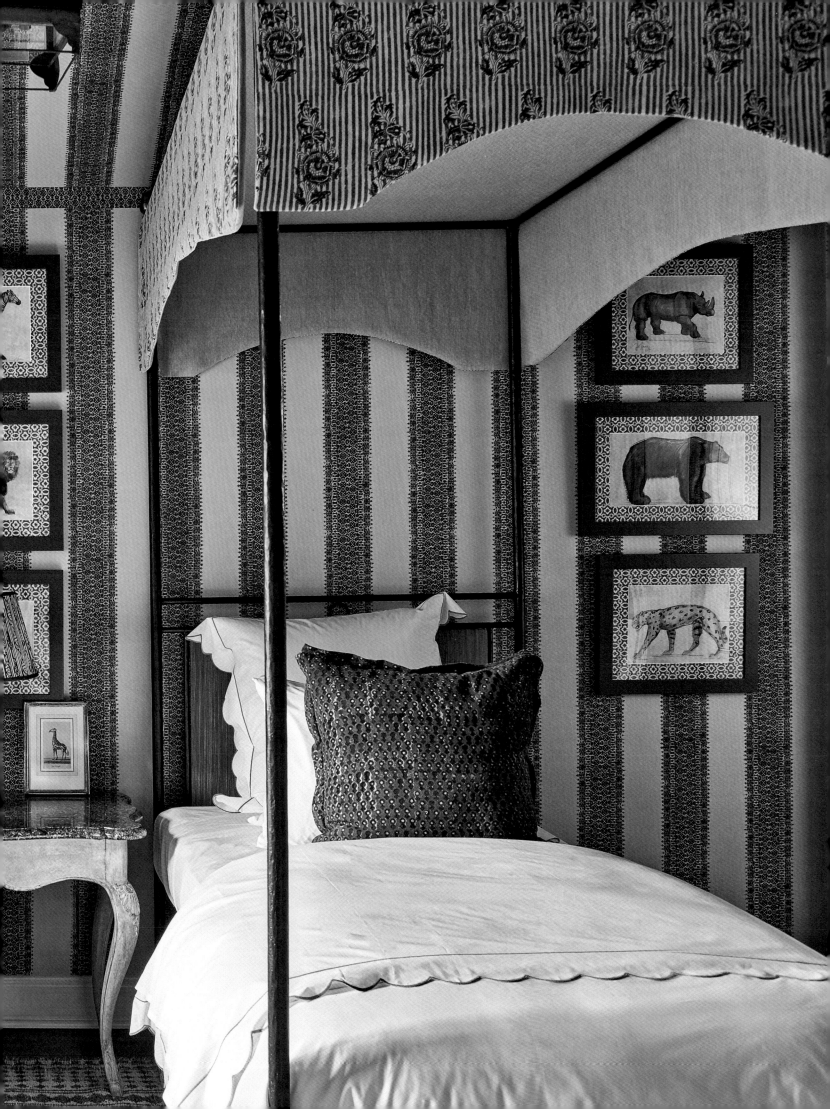

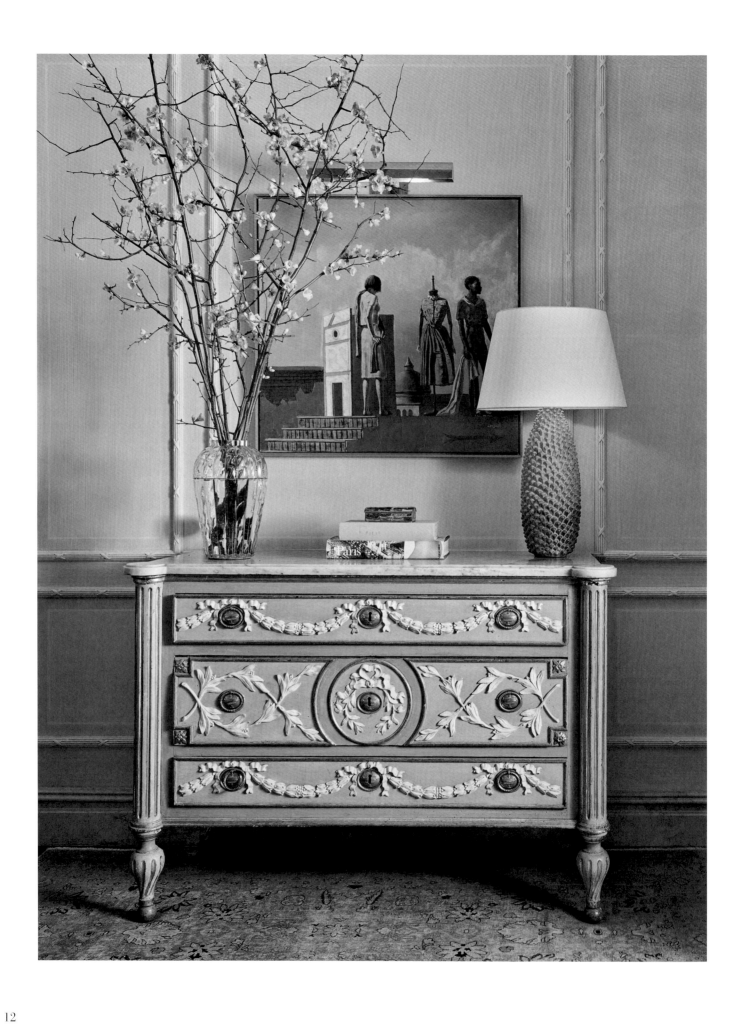

FOREWORD
By Shonda Rhimes

Michael Smith is many things to many people—a vibrant talent, a visual genius, an unrelenting perfectionist, a part-time therapist, a force of nature. I concede that he is all of those things. But to me, Michael Smith is most of all a purveyor of joy.

My first meeting with Michael felt more like a first date. It was clear that he was deciding whether to choose me as a client as much as I was deciding whether to choose him as a designer. Michael vetted me. He poked and probed and asked careful questions, working to uncover the secrets to my personality. This was not a breezy chat. He seemed to be making clear that his was not frivolous work—this was serious business. Answering every question, I was unnerved but also strangely delighted. Michael wanted really to know me. At the time, I did not understand why. Now, I understand why he will not work any other way.

As the design process unfolded, I saw that all of those probing questions had a purpose. I am an introverted and reserved person, and I am still unsure how Michael pulled so many personal details out of me about the home of my dreams. I only know that I felt completely comfortable with his knowing me on this intimate level. That intimacy shows up in the spaces he designs. He translated the essence of me into a physical home. He worked to understand me. When he learned that as a writer I like to wander from room to room as I imagine a story, Michael created inviting nooks and havens in every space so that wherever I happened to be, there was a place to sit and invent. Once he discovered that I'm not a visual thinker in any way, he gave up on design images. We talked, and then he turned my words into a vivid palette of comfort that matched my imagination. I shared with him how my family spends time, how we sleep, what I keep in my closets. Michael wove a beautifully authentic home, turning my quirks and passions—my addiction to books, a ragged old chair holding ancient family memories, the many teapots I have overcollected, my need for impromptu dance parties—into magical qualities that are both visually stunning and supremely comfortable. His work left my homes feeling optimistic. It is an optimism that emanates from every drape, each stretch of wallpaper, every chair, every sink. My homes invite my family to be themselves and feel happy inside their walls. My homes reflect me in ways I never considered. And spending time in these Michael Smith-created spaces, I feel joyful. He delved into my soul, and then he handed my soul back to me in the form of joyful living.

Michael's standards are purposeful. He probes and pokes for a reason. His creativity requires finding a collaborative client, someone who will give of themselves, someone willing to open up their dreams. He wants to know more than where you live. He wants to learn how you live. He wants to find the true essence inside of you; he wants to discover what defines who you are. Once that work happens, he fiercely protects that part of you through design. I've had a front-row seat to this magic, and I am better for it. I have learned that Michael creatively thrives with this process. It is his air. It is his superpower. Michael will never deign to design a generically beautiful home. He is happiest and his work is at its finest when a home matches its occupants.

That is how he makes a home. That is how he purveys joy.

INTRODUCTION

Interior designer Michael S. Smith is widely celebrated for his encyclopedic knowledge of period furnishings, art movements, and architectural and design styles past. For example, asked about the difference between French Régence and English Regency furniture, the interior designer handily weaves a tale of two cities separated by a century and the English Channel, expertly teasing out the delicately nuanced differences in carving and gilding. While Smith's own tastes tilt toward traditional design, he's also astonishingly up-to-the-minute in the realms of contemporary art and design, and very aware of the design moment in which we find ourselves today.

"It's in my interest to be aware of the references," the Los Angeles-based Smith says, noting that the internet and social media have turned the once rarefied realm of interior design into a global spectator sport. "But I need to filter them and give my clients their own world, a piece of unique territory for them and their prized possessions, wherever they choose to live." Whether he's designing a Manhattan apartment, a Montana mountain resort, or a retreat on Mallorca overlooking the Mediterranean, the goal is to create an environment that reflects the rich traditions and tastes of each locale. Even more importantly, the homes highlight the distinctive personalities, interests, and passions of the clients—who are typically wildly accomplished professionals well-versed in world cultures. And almost all are dear friends he's gotten to know intimately through shared travels, shopping trips, and, of course, home renovations.

"As we work together on successive homes, for me the bar is always being raised," Smith says, referring not only to his clients' ongoing accrual of knowledge and refinement in their taste and collecting, but also to his own expanding understanding of both contemporary culture and historic design. For beloved clients with whom Smith has worked on more than a dozen residences, and who were committed to building a bold, modernist house in the dunes of East Hampton, Smith conjured a stunningly spare, stripped-down classic saltbox that perfectly suits both its site and its owners' needs for a seaside family retreat. "It has the sense and organization of a contemporary house, but the warmth and patina of a historic home," he says.

Time and again, Smith delivers the classical ideal of the connoisseur's most cherished space, where one can be alone and at ease with the people and possessions that inspire them most, in an atmosphere that was conceived just for them. "If a home doesn't reflect the personality of its owner, then the environment that we worked so hard to create won't feel authentic or fully achieved," he declares.

And even in the most modern of houses, such as his own home in Los Angeles or a stunning surfside teak pavilion in Hawaii, Smith evokes an aura of richness and sophistication by layering in texture and visual interest through his command of classical design elements, textiles, art and antiques that convey a sense of refinement and intentionality. "My job," Smith says, "is to make sure it all comes together in an immersive way that celebrates my clients' own style."

That collaborative sensibility, the desire to harness his talents to the aim of highlighting his clients' taste, is classic Michael Smith.

15

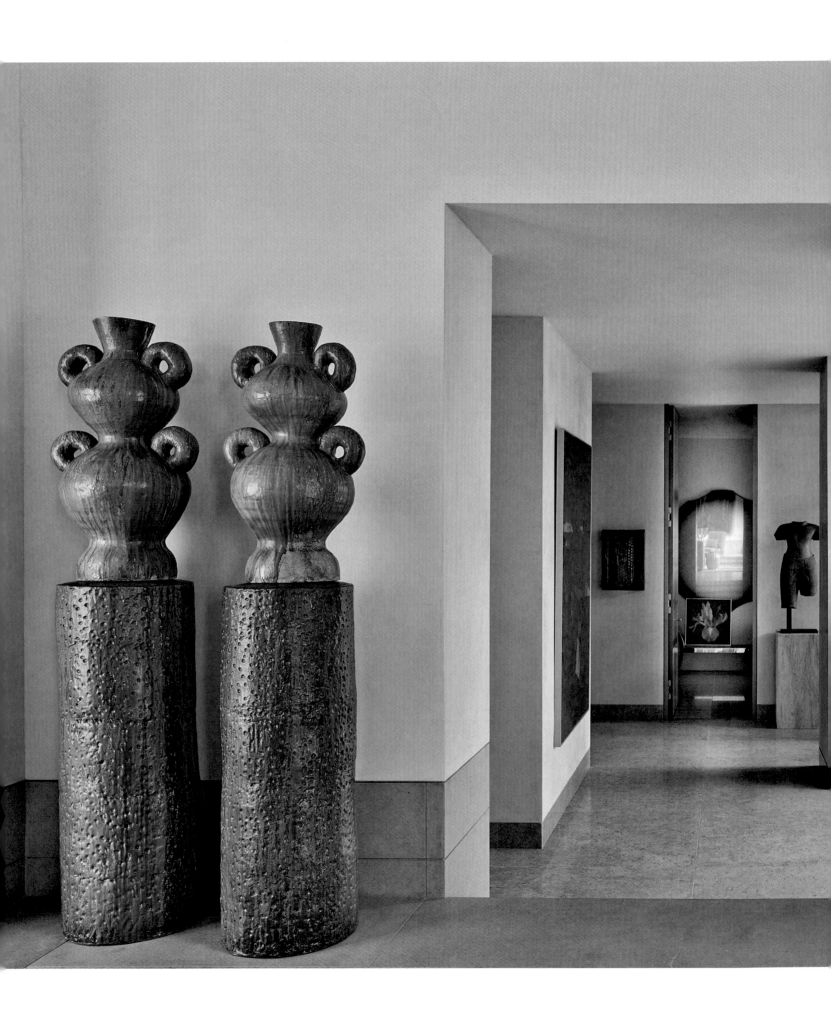

HOLMBY HILLS
PAVILION
LOS ANGELES

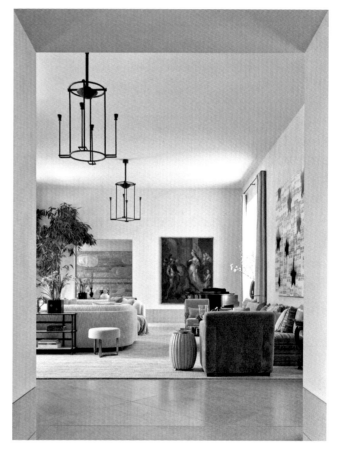

UNSURPRISINGLY, NO HOUSE ILLUSTRATES the scope of Michael Smith's imagination better than his own. And of all the designer's various residences, present and past, this standout modernist pavilion in the Holmby Hills neighborhood of Los Angeles is the definitive one. Not only is it the primary residence of Smith and his partner, James Costos, but it's also the place they've lived the longest.

Designed by Santa Barbara–based architect Timothy Morgan Steele in collaboration with Shuvin-Donaldson, the imposing 11,000-square-foot concrete and glass structure was built in the 1990s as a home for art collec-

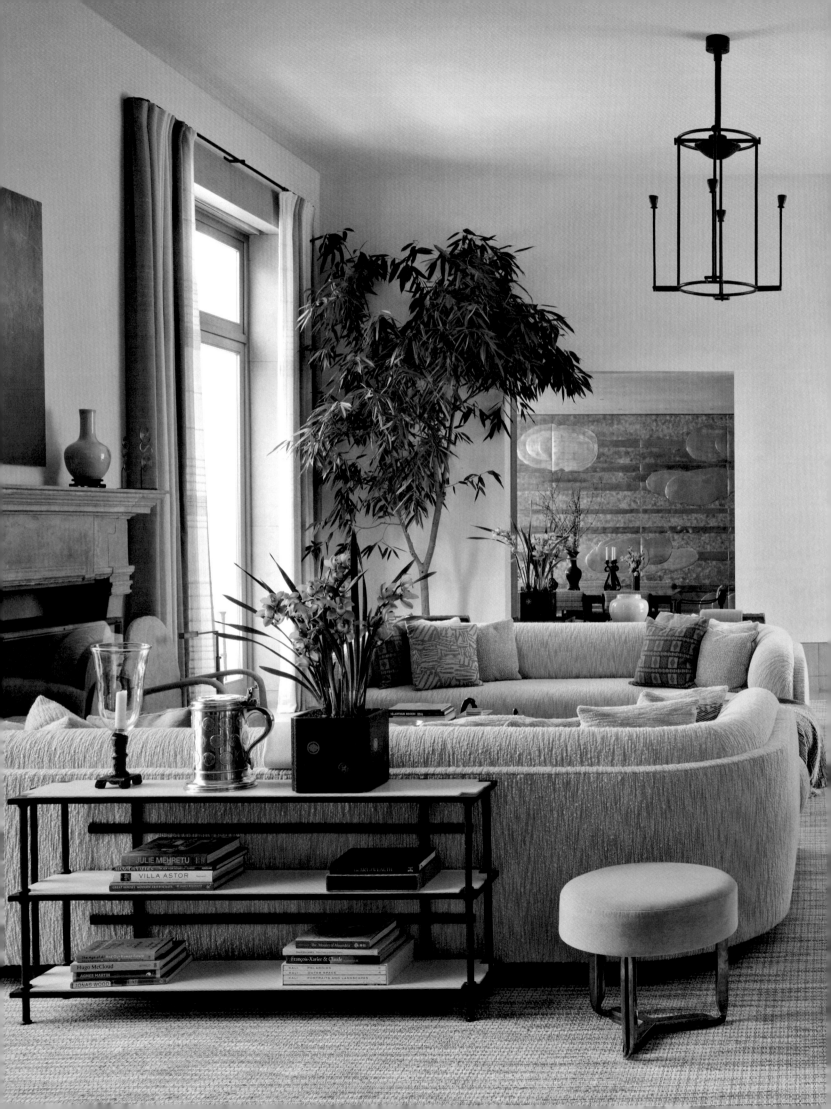

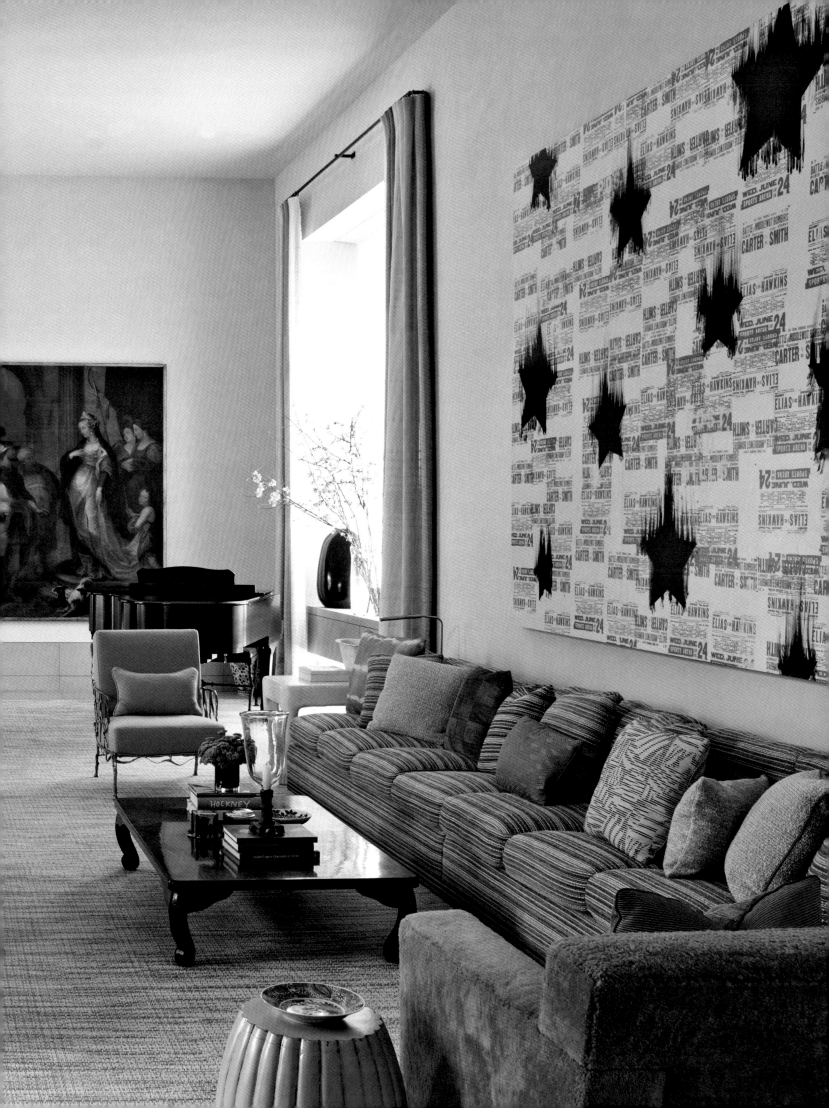

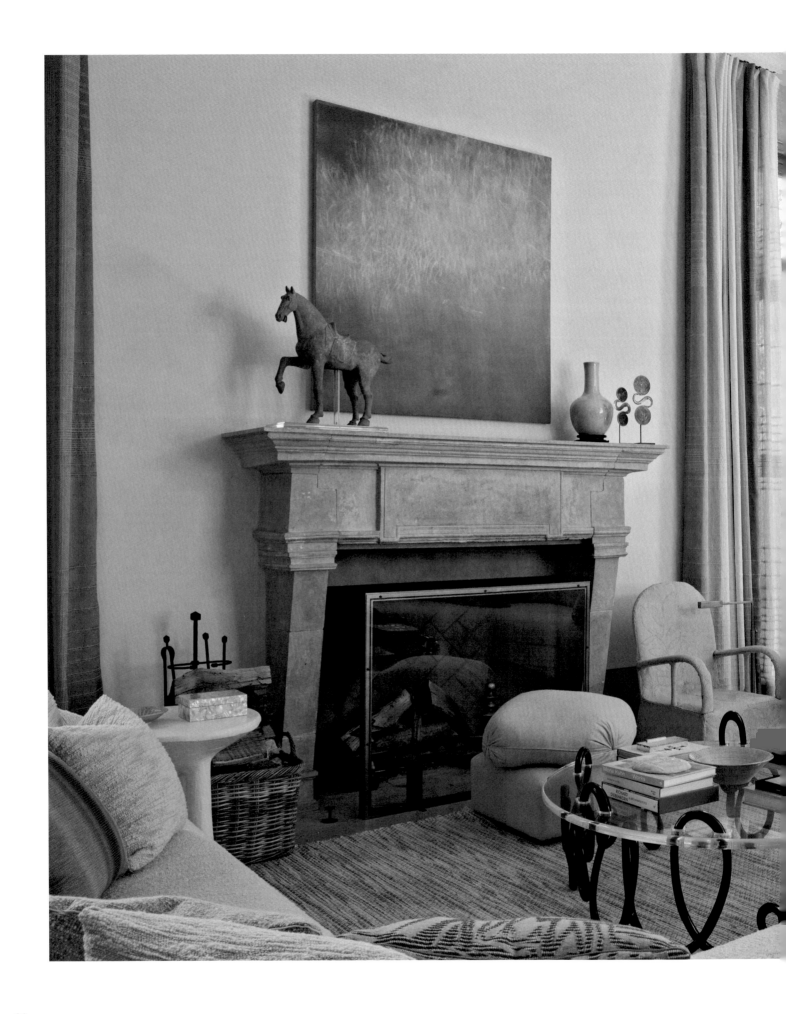

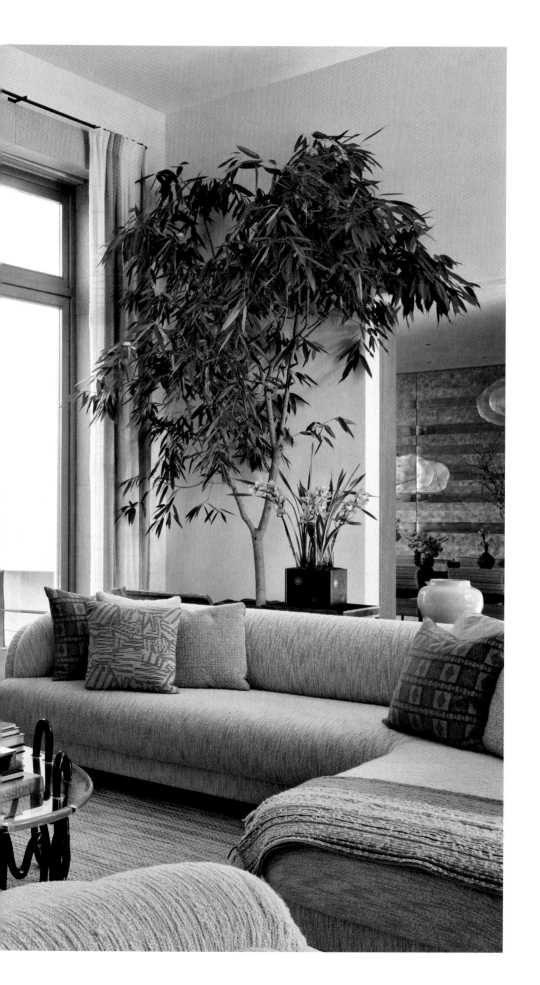

PAGES 16-17: Two stoneware sculptures by Peter Schlesinger stand to the left of the hall leading toward the primary bedroom. The mixed-media artwork at right is *Choir* by Philip Taaffe. The sculpture at the end of the hallway is a thirteenth-century male deity from Cambodia. PAGE 17: A view from the same vantage point but looking in the opposite direction into the living room. The large black lanterns were custommade by Philippe Anthonioz. PREVIOUS PAGES: At the far end of the Jasper custom Argyle sofa at right are a John Dickinson plaster table and a Mattia Bonetti bronze Thread armchair. Gary Simmons's *Hurricane* hangs above the sofa at right and a school of Rubens painting that Smith acquired early in his career is above the piano. LEFT: A painting by Christine Taber hangs above the mantel. Smith designed the sofas in front of the fireplace, inspired by the work of Vladimir Kagan.

tors and philanthropists Audrey and Sydney Irmas. Smith calls it "an engaging composition of interlocking volumes." Some of those interlocking volumes (i.e., rooms) were scaled large enough to display specific standout pieces from the previous owners' collection of contemporary art, including paintings by Roy Lichtenstein, Cy Twombly, and Andy Warhol. The striking exterior hints at the form and function of the interior.

Smith purchased the home in 2009, after he sold his picture-perfect Georgian-style English cottage in Bel Air—considered one of the prettiest houses in Los Angeles by Hollywood and design cognoscenti. Indeed, Smith's design references are typically informed more by the 1790s than by the 1990s. But he saw lots of potential in the new property, especially in its rambling yet quirkily monumental constructivist form. It managed to hold its own in a neighborhood where grand mansard roofs of faux châteaux and turrets of towering Tudors peek discreetly over imposing hedges.

"This propagandistic series of gallerylike volumes was nothing I would have ever built or designed for myself, so I was eager to embrace the challenge of dealing with space that was so much more modern," Smith recalls.

Following the same advice Smith regularly gives to his clients, he and Costos moved in without doing any major renovation to get a feel for the sprawling, one-story home. An architectural rara avis, the home is defiantly original inside and out and far from the classically inspired Mediterranean villas he's done for clients in Mallorca and elsewhere. Smith wanted time to decide how to make it his own, and that time lasted nearly a decade.

With its vast interiors and expansive terraces, the house worked brilliantly for entertaining—the couple are acclaimed Hollywood hosts, as well as major Democratic Party fundraisers. But when it came to quieter moments, Smith was increasingly noticing the drawbacks—principally that it had only one proper bedroom, plus some awkwardly placed service quarters. "When Michelle Obama was coming to stay for the first time, James and I offered her our bedroom rather than a little room off the kitchen," the designer recalls. So, just before the pandemic, he undertook a top-to-bottom overhaul that included adding a second floor with guest rooms.

"I'd become acutely aware that my work over the last decade has been about a new level of treasure hunting—starting, as was the case here, with the search for a truly unique property. At the same time, there has been a doubling down on customization—site-specific commis-

sions from artists and craftspeople—as the best way, if not the only way, to create homes for friends and clients that feel like unique expressions of their tastes, needs, and aesthetics," says the designer. "After nearly a decade of living in a home designed to suit someone else's lifestyle, I was ready to give James and me that same level of bespoke personalized detail and comfort. Architect Michael Kovac helped me execute the changes I'd had ample time to mull over."

Smith wanted to preserve the home's cool and crisply modern gallerylike entrance hall, where two large-scale Peter Schlesinger stoneware sculptures now stand guard. Smith acquired the works from the Los Angeles–based artist to display at the White House, which he decorated for the Obama family in 2008. On the wall nearby hangs a swirling psychedelic canvas by Philip Taaffe, who, like Schlesinger, is a personal friend of the designer.

In the spacious living room, Smith artfully suggested a passage to the dining room by putting seating areas on either side of the long, wide, and tall space. Near the fireplace wall, adorned with a stately French limestone chimneypiece inherited from the previous owners, he placed two custom curvy Vladimir Kagan–inspired sofas facing each other across a Mattia Bonetti Meander cocktail table with a cursive-style base. "I was definitely interested in the futuristic look of Kagan's era, but I wanted sofas that were deeper, plusher, and more comfortable to create an inglenook—a cozy place to sit with a friend in that large space," says the designer. "I don't like rooms that people merely pass through or that only get used for parties or special occasions, so I aim to create more intimate enclosures within larger rooms that encourage people to stop and sit down."

Overhead, Smith hung a pair of striking Philippe Anthonioz bronze lanterns. With their matte black patina they have a sculptural effect in the luminous room and visually lower the ceiling, enhancing the sense of intimacy. Above the piano in the corner hangs a totem from the beginning of Smith's career, a school of Rubens

OPPOSITE: Jack Roth's *Thesis IV* hangs near the front door. FOLLOWING PAGES: The dining room is clad in gold- and silver-leafed gesso panels made by artist Nancy Lorenz evoking Japanese screens. Smith says, "From the living room, people think it's just one panel or perhaps one wall, so as they get closer they're amazed to see that it covers the entire room. When it's lit with candles at night, the room glows."

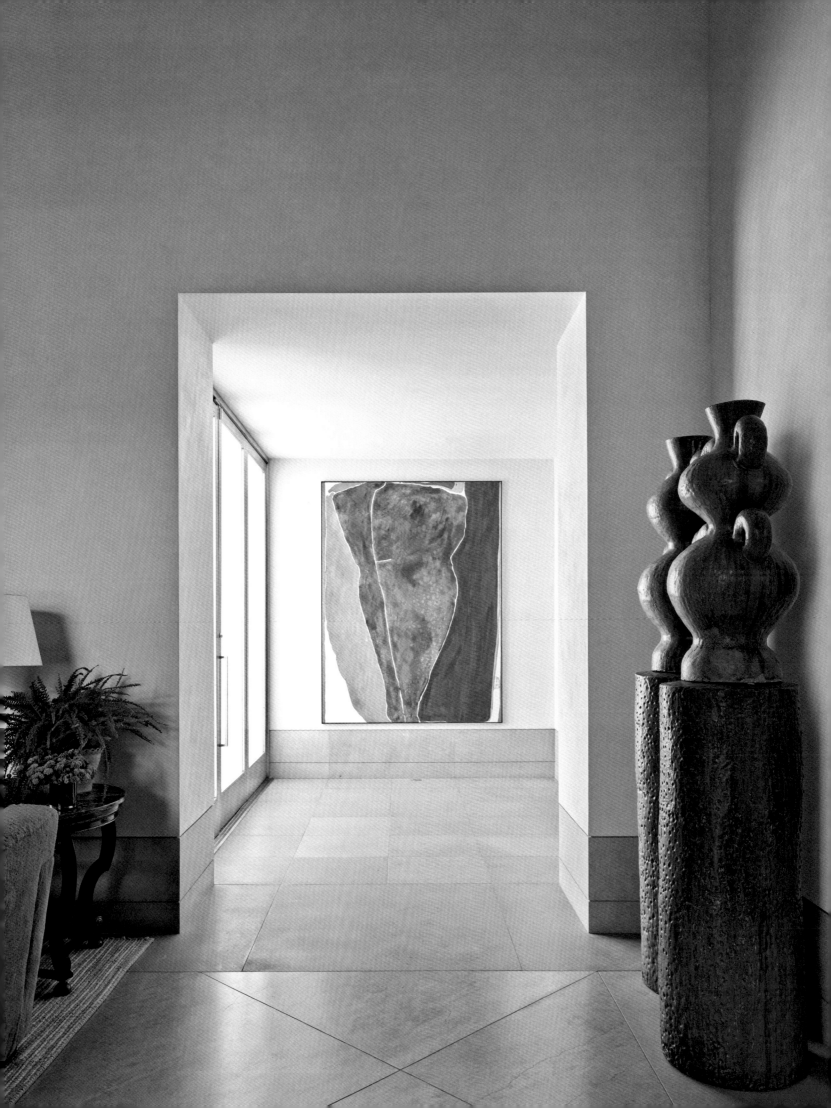

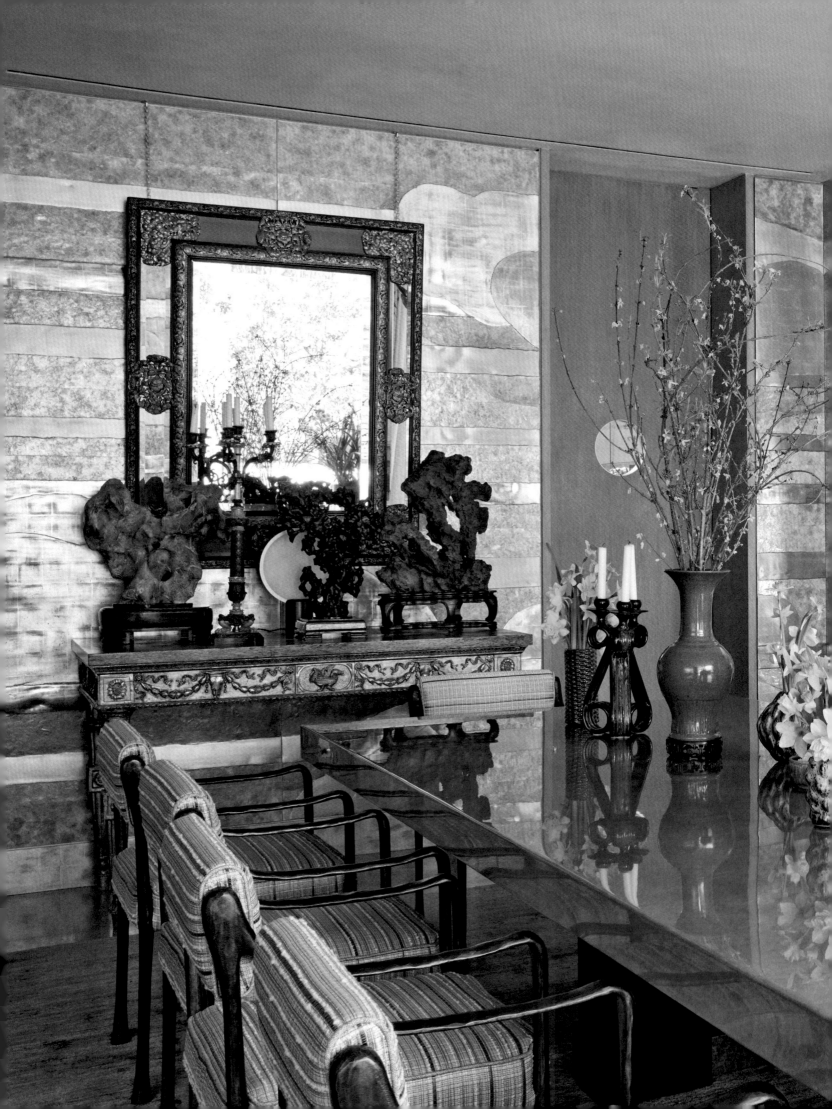

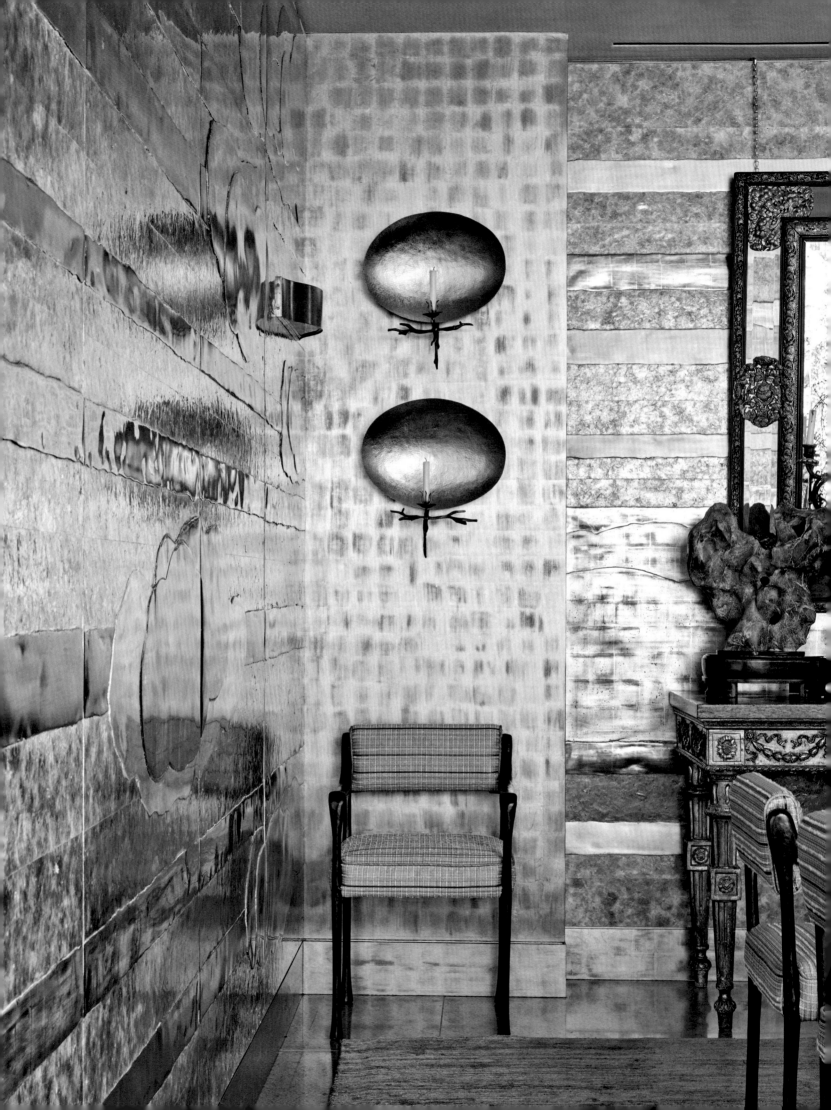

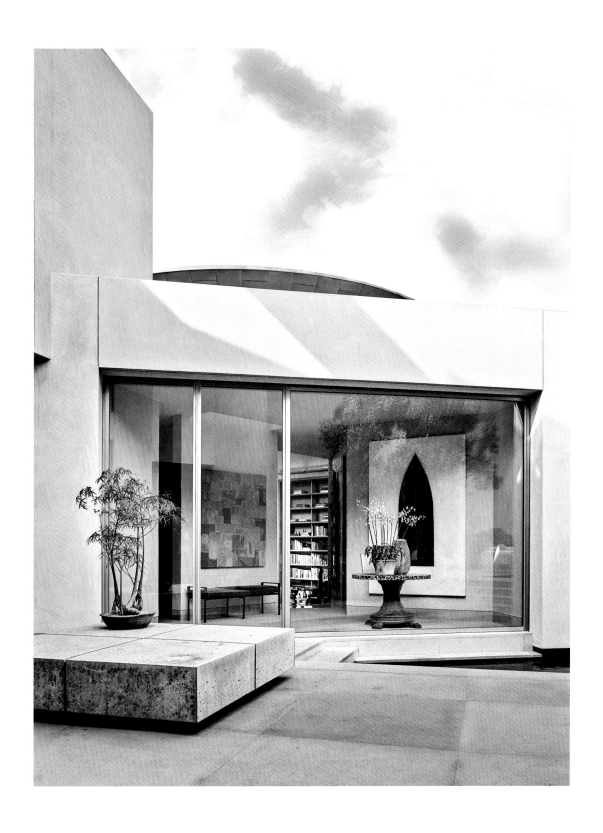

OPPOSITE: A corner of the dining room. Smith deployed his collection of Chinese scholar's rocks on an eighteenth-century Italian console, one of a pair. Sconces by Hervé Van der Straeten. ABOVE: The entrance to the screening room with artworks by Robert Therrien, right, and, above the bench at left, Samuel Levi Jones. FOLLOWING PAGES: The den is paneled in squares of Oregon Douglas fir and the upholstery, like the woven Senegalese fabric on the Jonas Chatham swivel chair seen here, was selected to enhance the warming wood tones. Photographs by Jack Pierson.

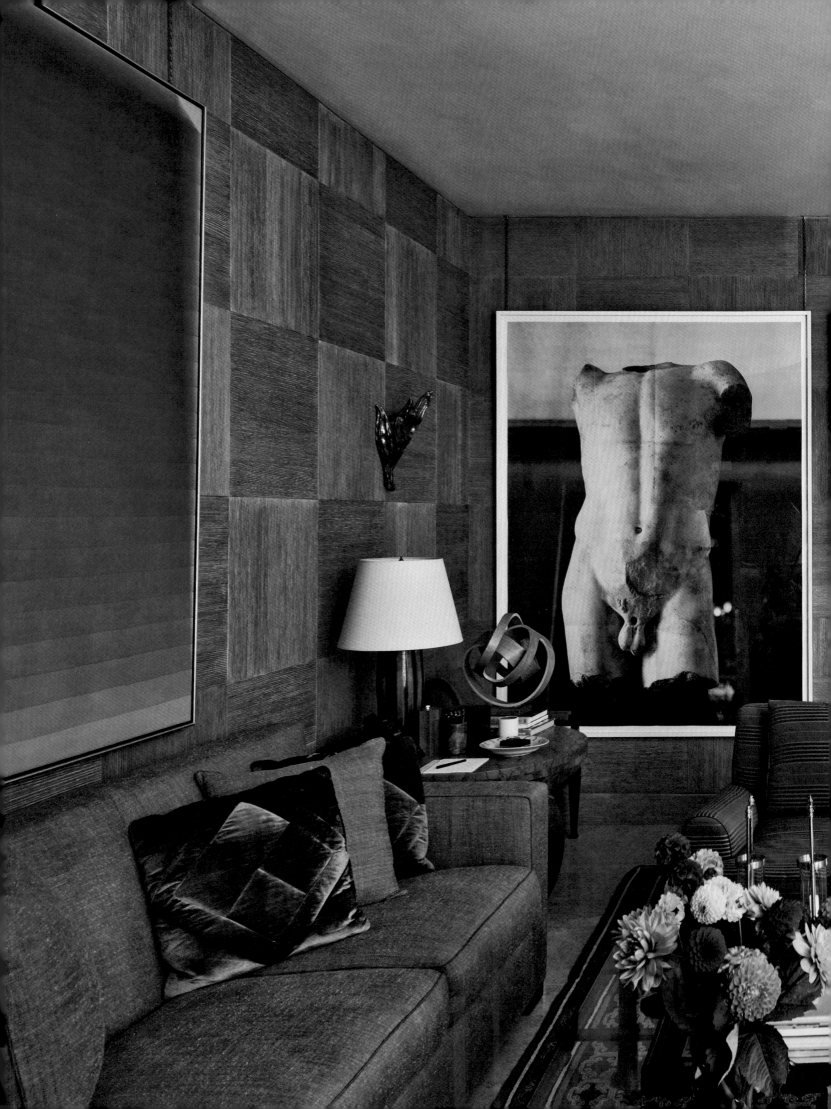

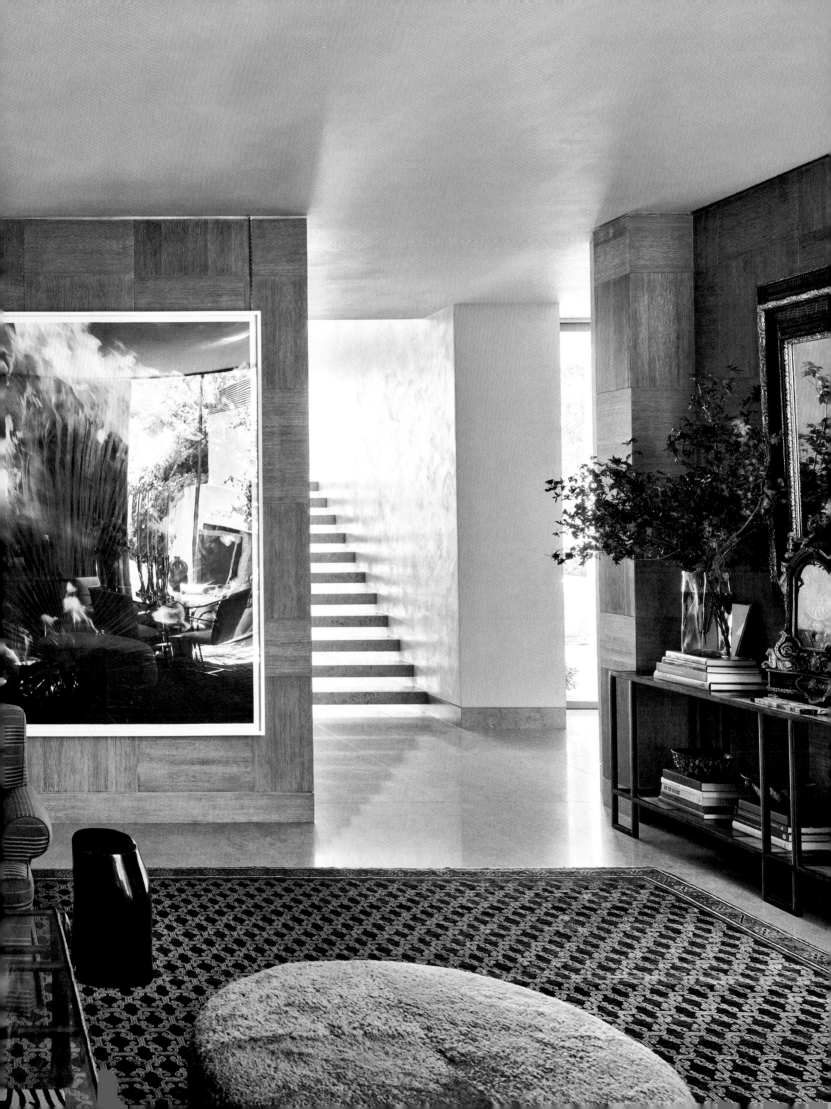

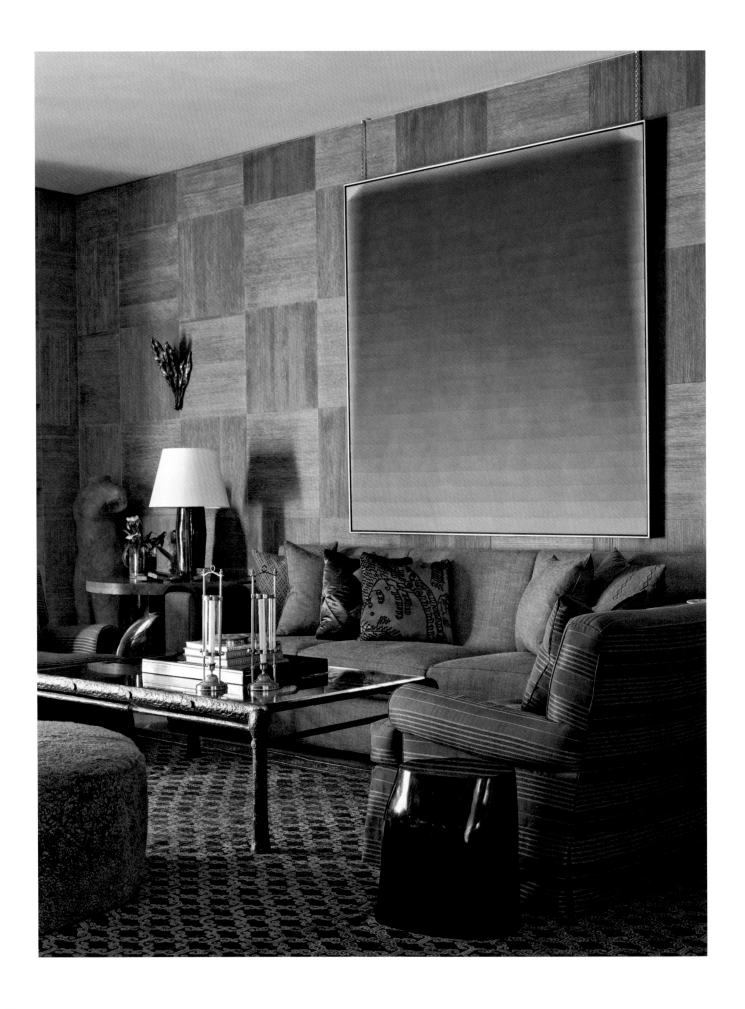

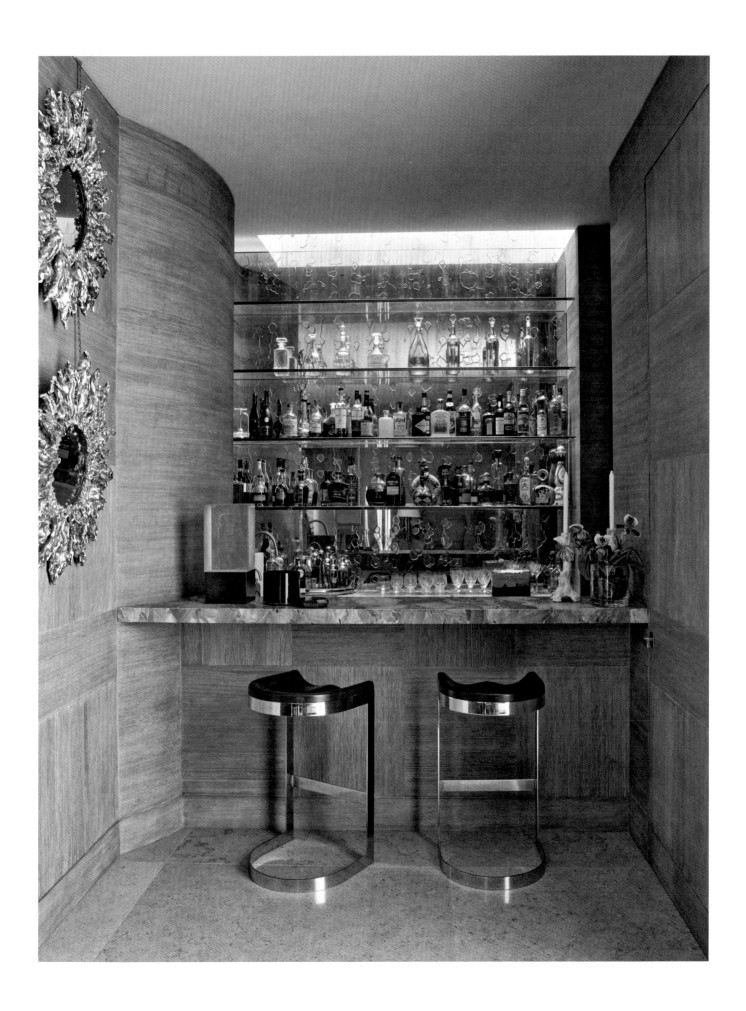

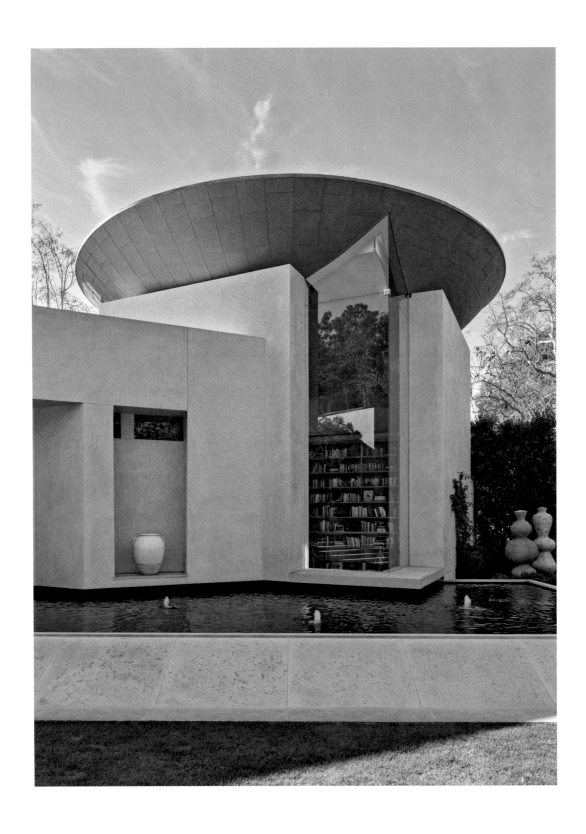

PAGE 30: In the den a custom bronze Philippe Anthonioz coffee table and *Blue, Green, and Red*, a painting by Power Boothe, bring subtle nuance. PAGE 31: Smith continued the den's paneling into the adjacent bar. ABOVE: The combination library-screening room is topped with an inverted zinc-clad dome. OPPOSITE: The custom bookshelves in the library-screening room were inspired by the library of Charles Beistegui at Château de Groussay. For luxe film-watching comfort, Smith chose Paul Dupré Lafon tub chairs with matching ottomans in Holly Hunt silk mohair velvet.

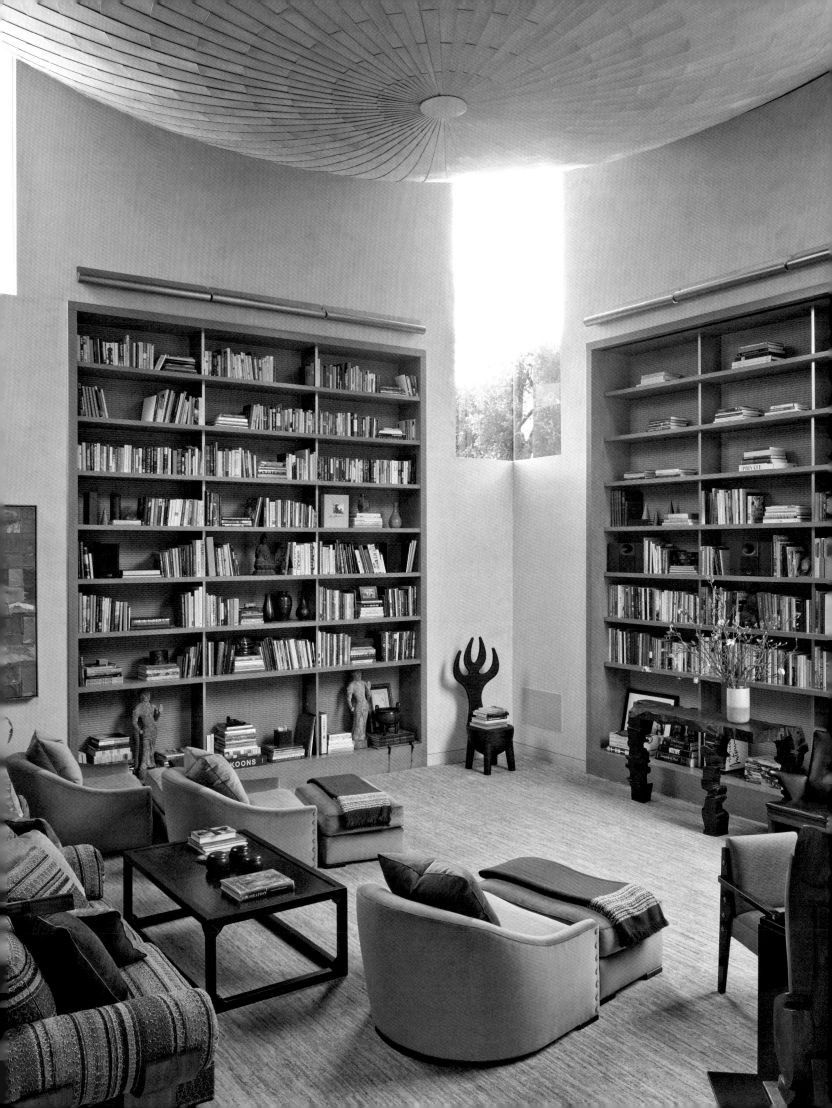

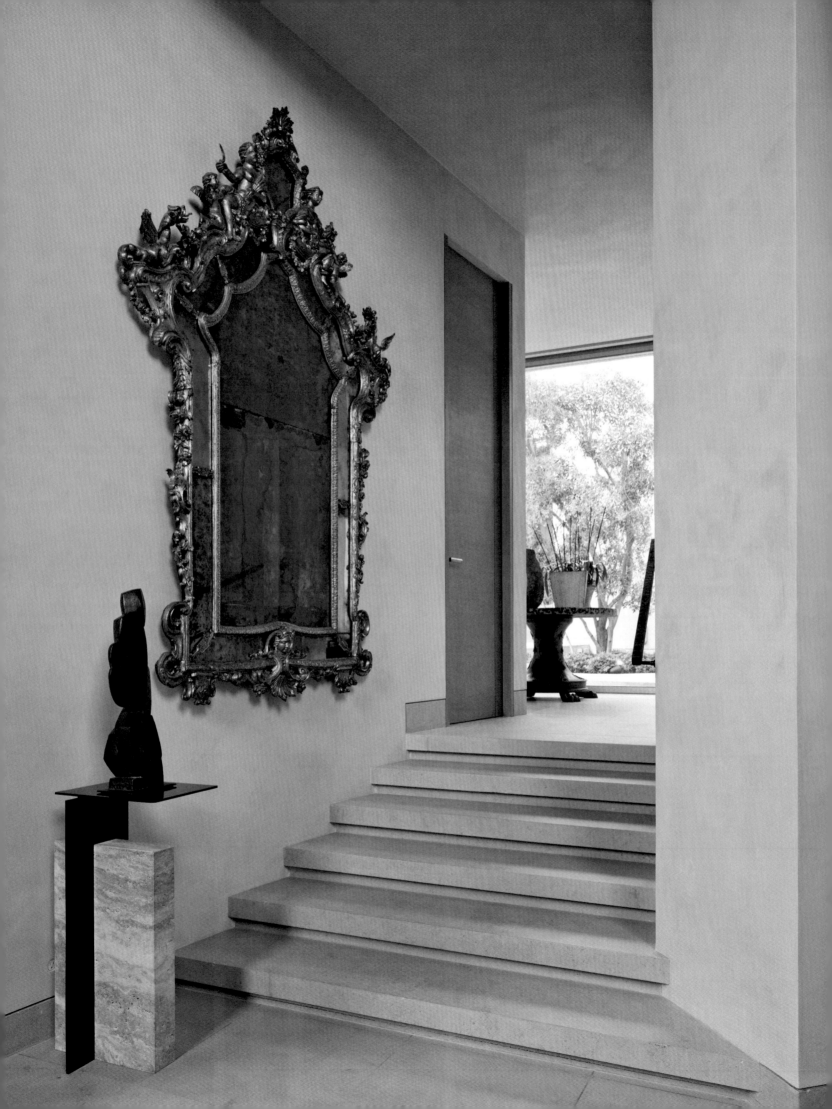

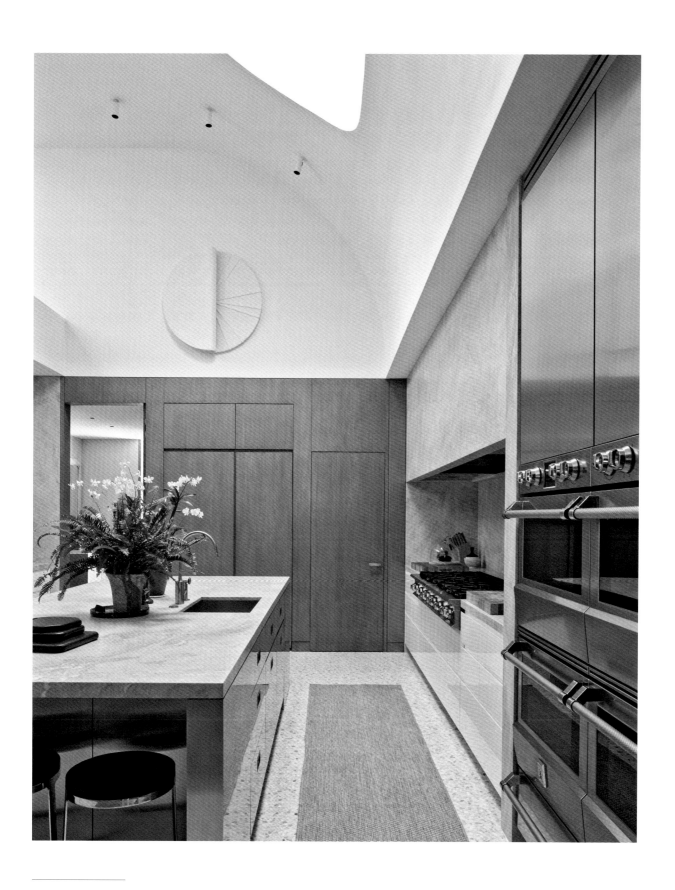

OPPOSITE: A grandly scaled gilt-framed eighteenth-century Italian mirror marks the entrance to the library-screening room. ABOVE: Though Smith shortened the kitchen by seven feet to create a larger dining room, it maintains a spacious feel due to its vaulted ceiling. To highlight that volume, he kept the look spare, almost monastic, with flush surfaces and custom terrazzo floors by Concrete Collaborative. The island is brushed stainless steel topped with Perla Venata quartzite and the plaster sconce (one of a pair) is by Stephen Antonson.

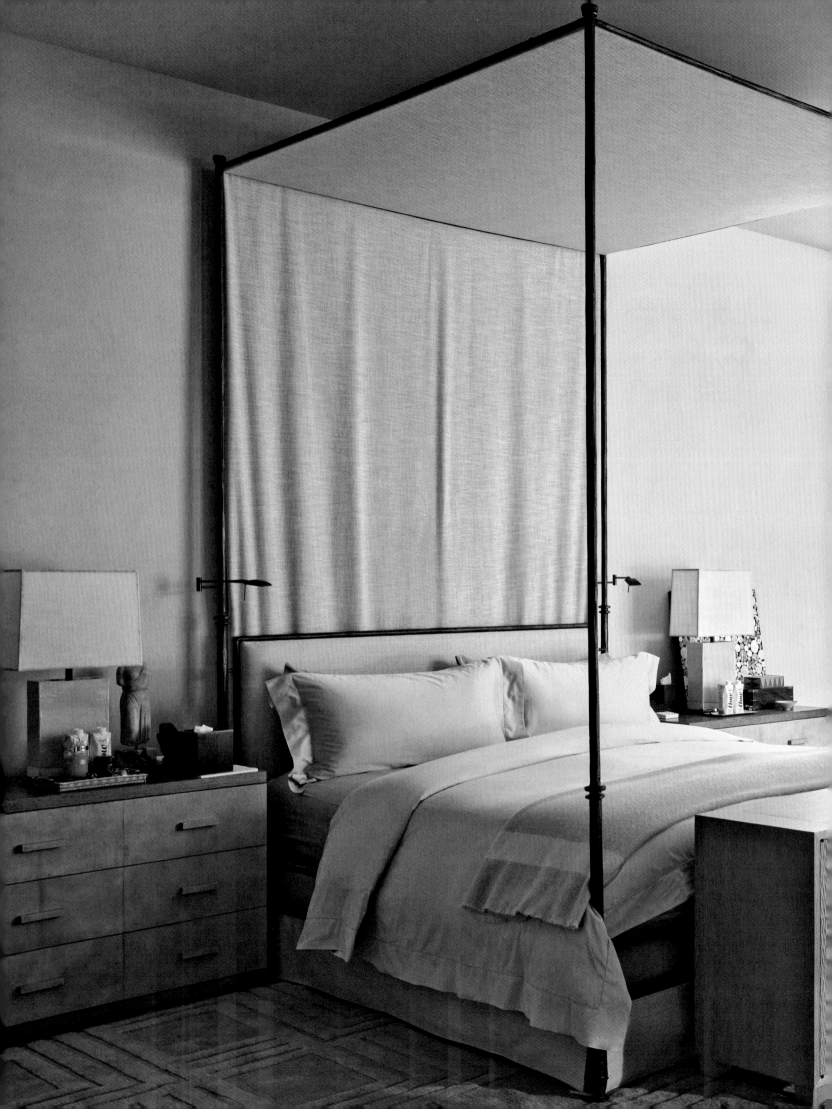

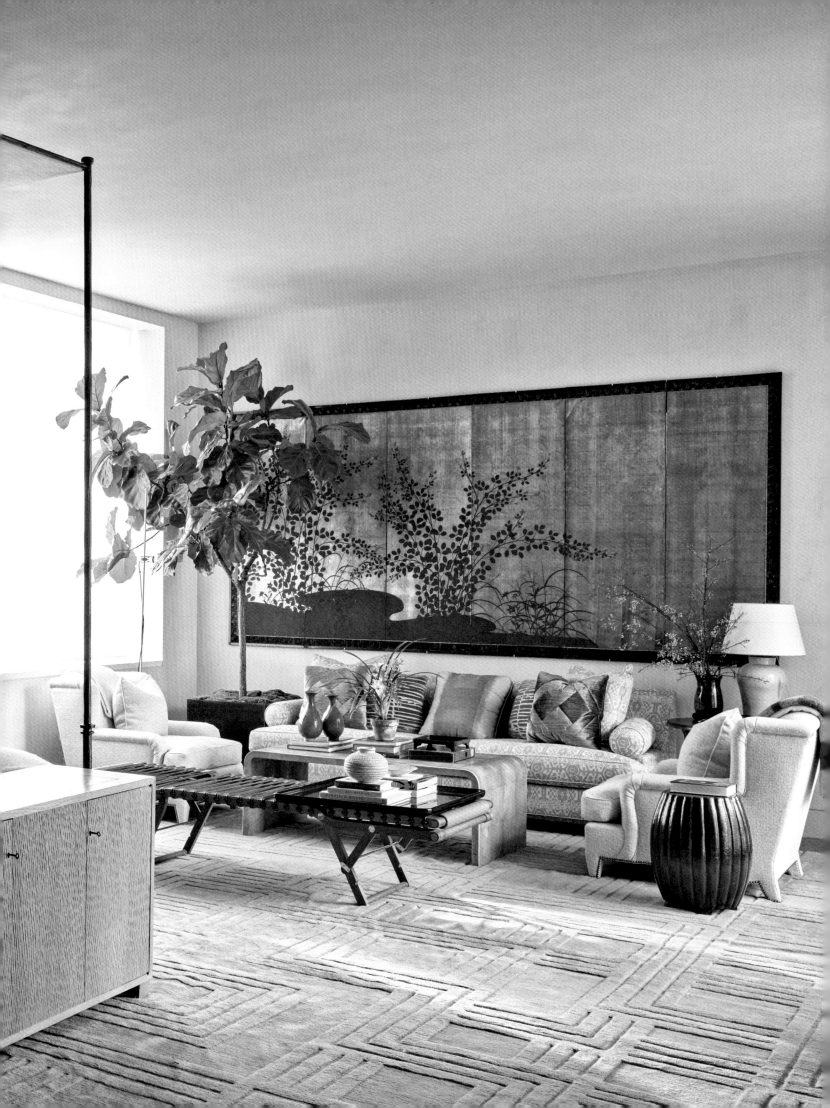

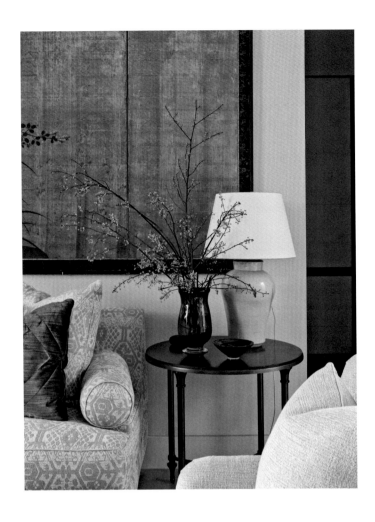

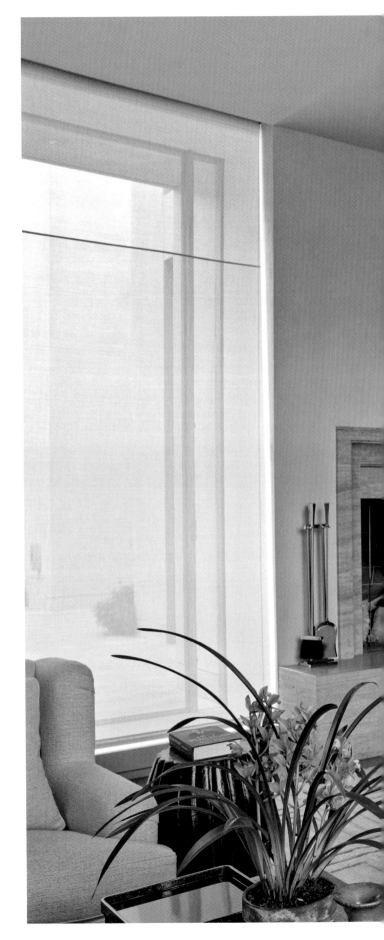

PREVIOUS PAGES: A fan of sleeping in cozy spaces, Smith created several discrete areas within the overscale primary bedroom. One enclosure is the custom Jasper bronze canopy bed upholstered in Rose Tarlow fabric and a bed hanging from Henry Calvin. Across the room, a Mattaliano sofa holds court amid a six-fold Japanese screen and a shagreen Jean-Michel Frank coffee table. ABOVE: A corner of the bedroom sitting area. RIGHT: A fireplace warms the wall opposite the bed; in the foreground is a brass and leather Hermès lounge chair.

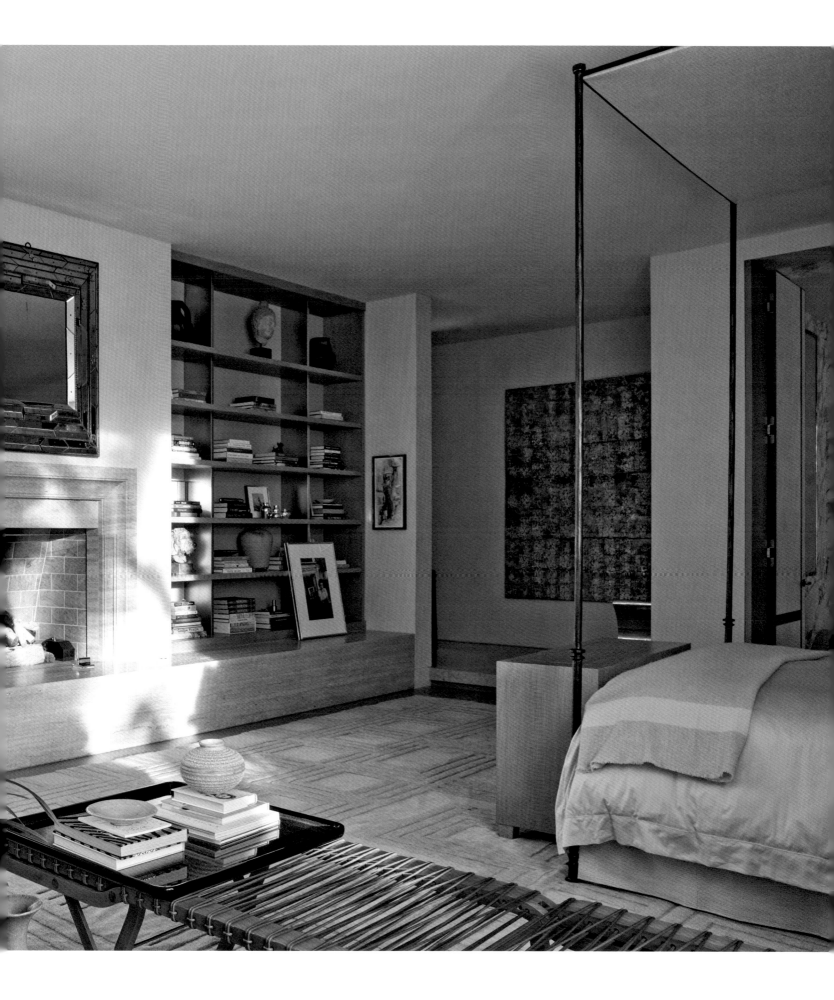

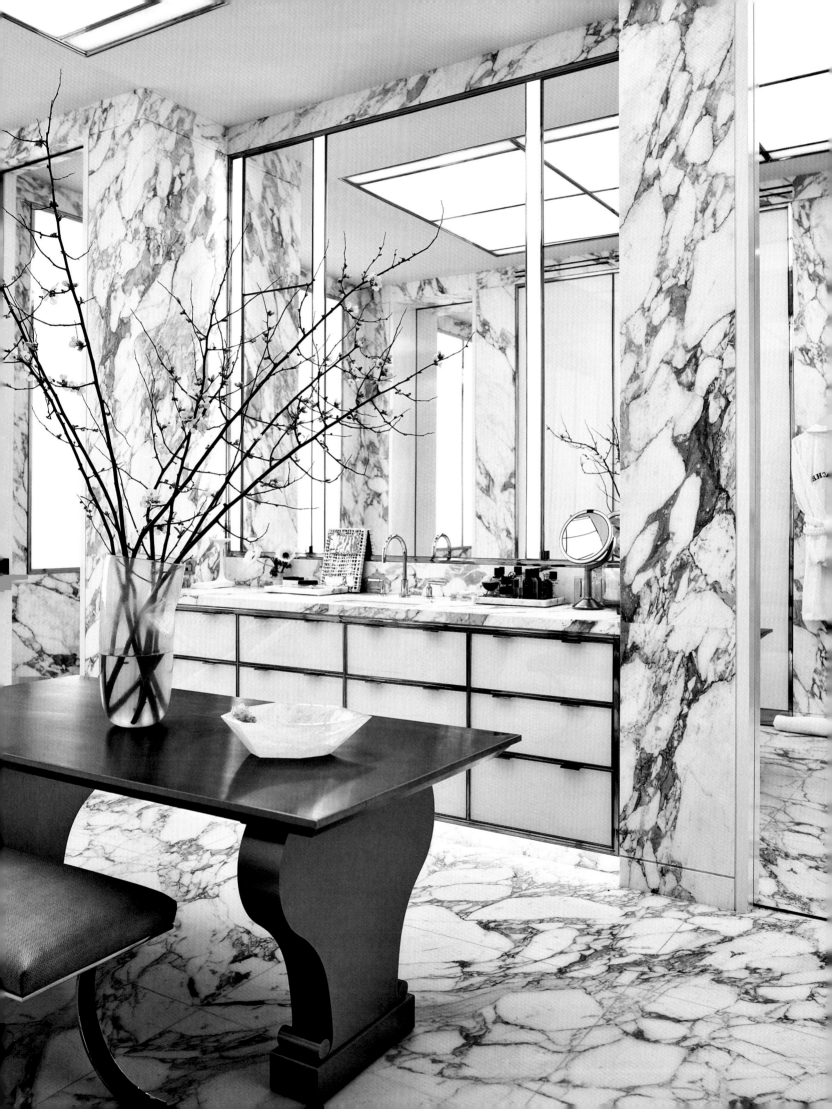

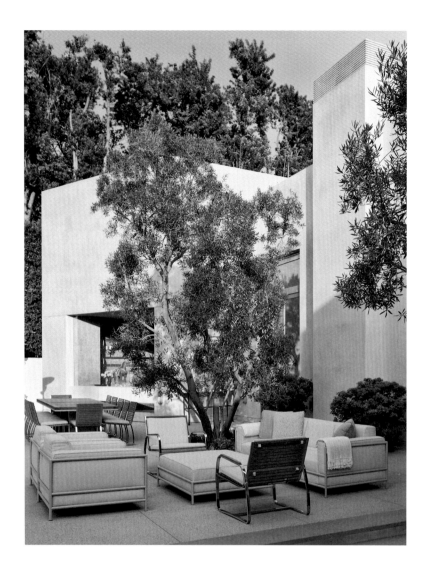

painting given to him when he was just nineteen years old that has followed him from home to home ever since.

A signature Smith element is found in the dining room, where he entrusted New York–based artist Nancy Lorenz, a friend and frequent collaborator, to create luminous sculpted gold and silver panels accented by muted gold-leafed walls. He says, "I dislike any surface that is too plain, especially in a dining room. Guests may sit for hours with the same view, so the walls need a sense of depth and movement. Nancy's work, a contemporary interpretation of traditional Japanese screens, brilliantly creates a view, while keeping your attention in the room."

Adding to the Asian ambience is the luxuriously hefty lacquer-topped dining table by Hervé Van der Straeten in Paris. A selection of Chinese scholar's rocks—another of Smith's long-running collections—is proudly displayed at the far end of the room.

Rounding out the home's public areas are a cozy den with a bar, both paneled in cognac-colored squares of Oregon Douglas fir, and a one-of-a-kind library and screening room beneath a striking inverted zinc-clad dome that was original to the house.

Like the living room, the primary bedroom was large enough for Smith to satisfy his penchant for multiple areas in a single space. The impressively large tester bed is from Smith's own brand, Jasper, which was named after a beloved pet. It provides a soothing enclosure for sleeping. The large living area in the bedroom features a fireplace and library in front of the bed, and seating nestled beneath the understated luxury of a silver-leafed folding screen.

While Smith delights in saying that a decorator's own home should never in any way boil down to a sort of highlights tour or mélange of his past work, his Holmby Hills home does offer a subtly refined distillation of the designer's oeuvre at this moment in time. One thing is certain, however: this house—and this designer—will continue to evolve.

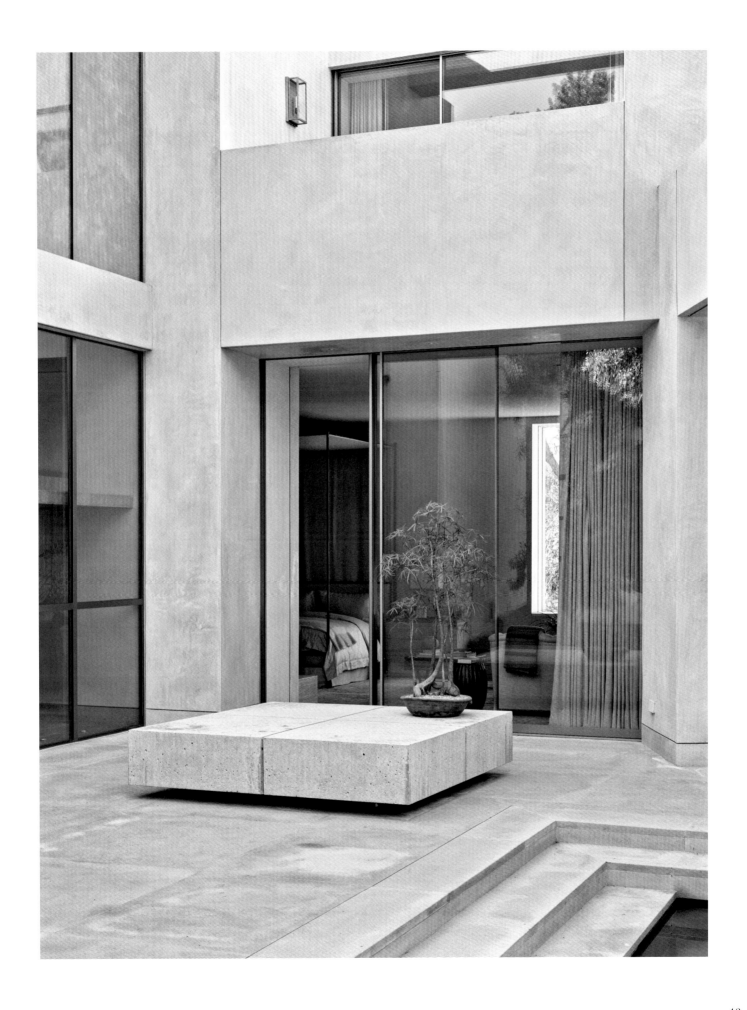

ABOVE: The stair landing in the new guest wing features the Andy Woll painting *Mt. Wilson* and a custom bronze lantern that was a gift from artist and longtime collaborator Patrice Dangel. At right is a limited-edition Richard Meier lacquer chair. OPPOSITE: In a guest room an André Sornay desk sits beneath a Louise Nevelson textile composition.

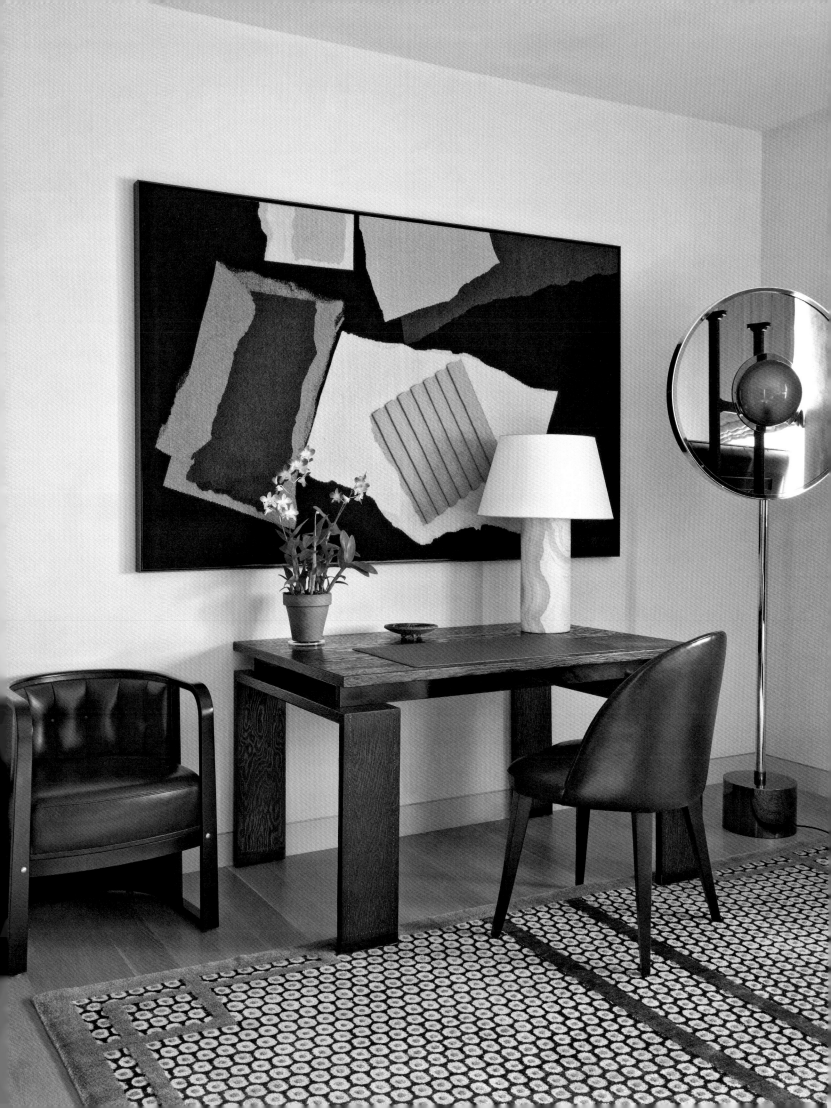

ABOVE: A suite of boldly graphic prints by celebrated abstract
Spanish sculptor Eduardo Chillida hangs above a custom bed
in a guest room. OPPOSITE TOP AND BOTTOM: Two views
of a Dessin Gerard Holmen desk in the principal guest suite
beneath a mirror by Paul Mattieu through Ralph Pucci.

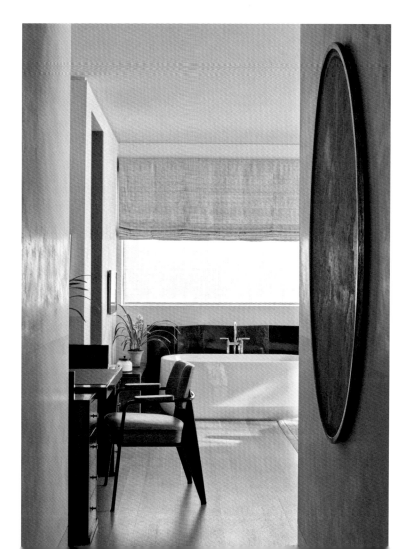

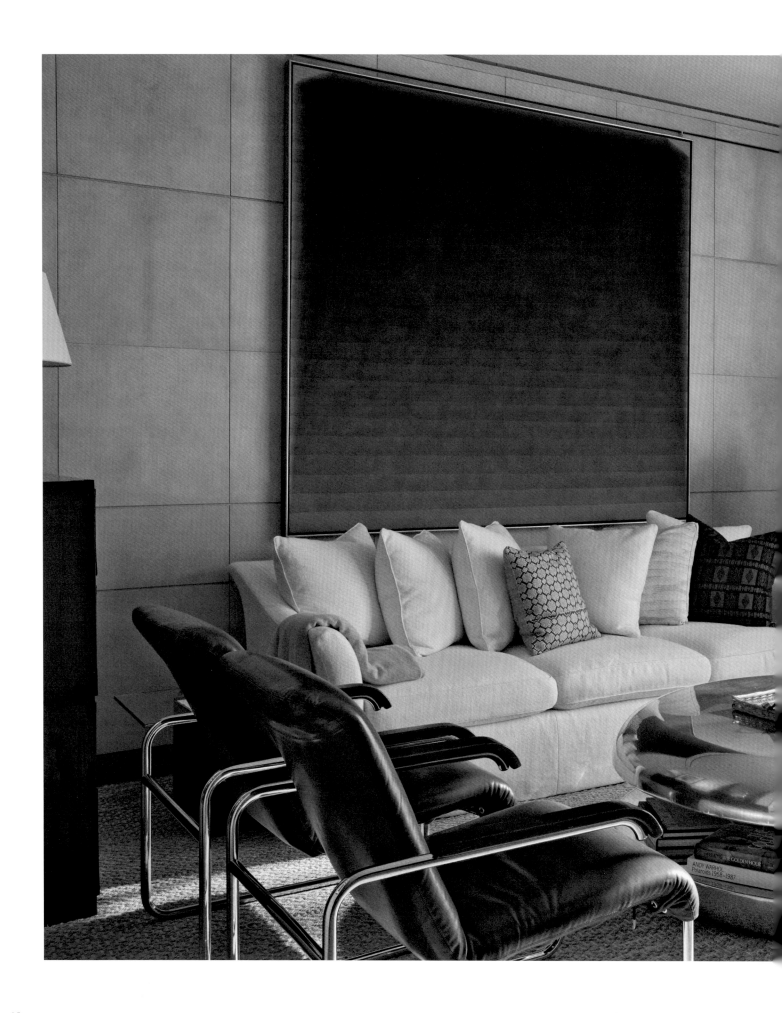

LEFT: A guest wing sitting area has
parchment walls and a Mattia Bonetti
steel Yo-Yo table. A richly hued Power
Boothe canvas and a photograph
by Irving Penn hang on the walls.
FOLLOWING PAGES: A view of the rear
façade of the house from the new pool.

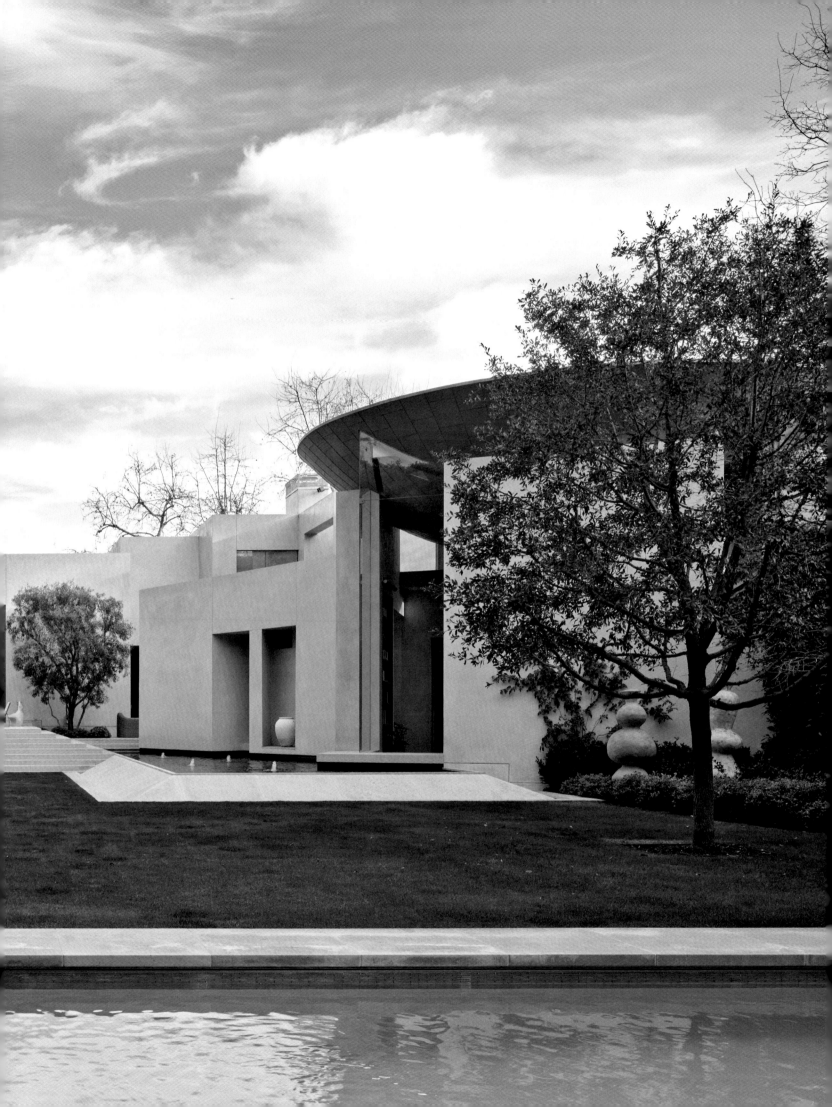

EAST RIVER PENTHOUSE
NEW YORK CITY

"SOMETIMES, MY WORK STARTS long before the decorating begins, by helping my clients choose the right home," Smith says. That was certainly the case with this spectacular apartment overlooking the East River on the Upper East Side of Manhattan. "My clients were determined to have an apartment with views of Central Park, but I knew that once they saw these sweeping views downriver, across to Long Island, and upriver toward Gracie Mansion, they'd understand the uniqueness and value of this property, even if it was a bit off the beaten path."

There's also the fact that the apartment provides the ultimate twenty-first-century luxury—privacy. The home is accessed through a separate elevator rather

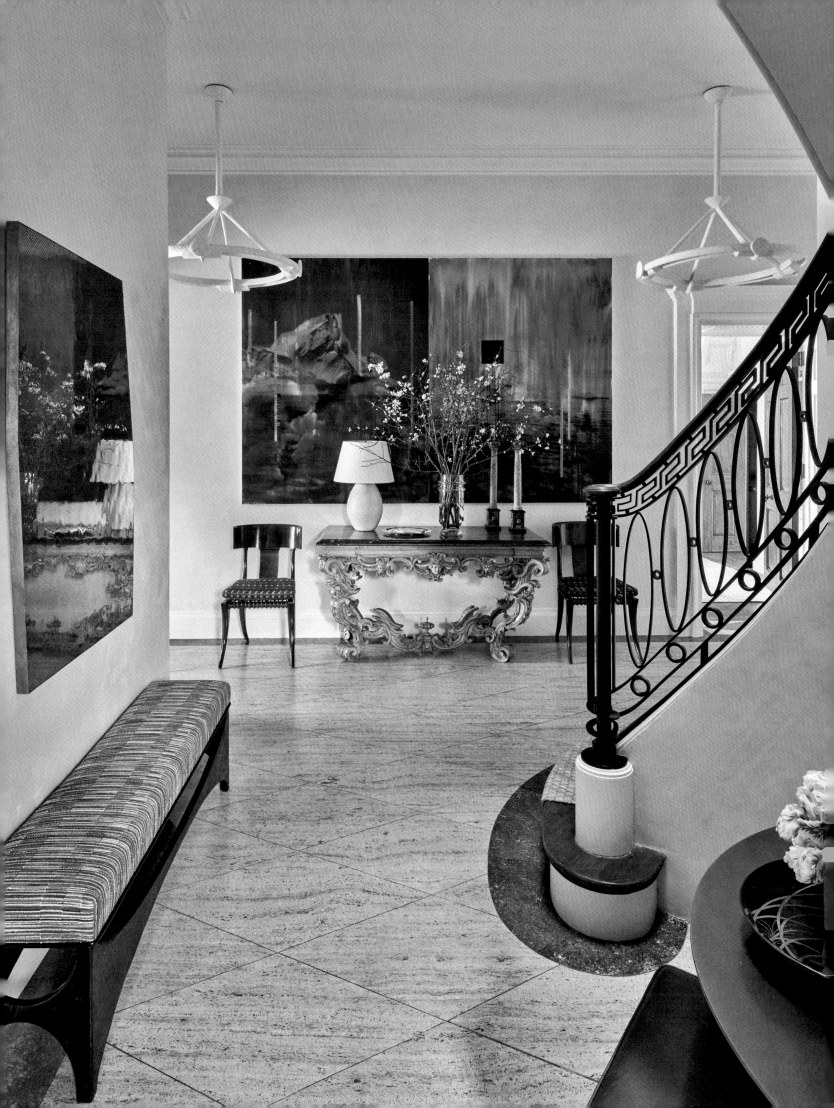

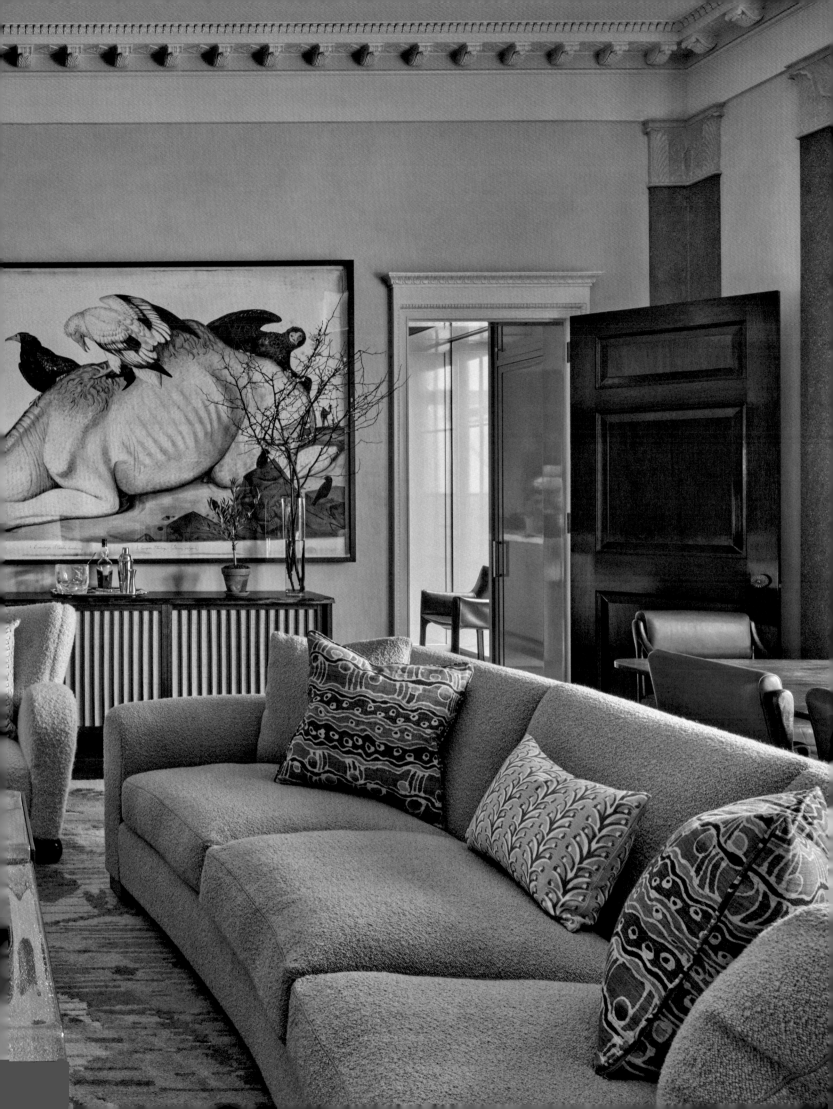

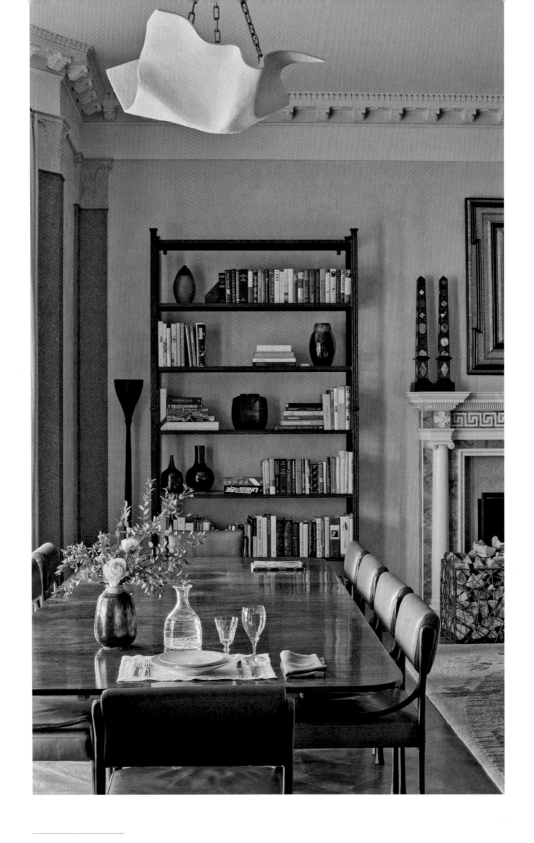

PAGE 52: The entry foyer with its original inset marble floor. PAGE 53: The apartment's gracious stair hall. Smith and the architectural firm Ferguson & Shamamian designed a new iron balustrade with motifs drawn from original metalwork in the building. The mirror at left is by Sébastien Reese and the painting above the nineteenth-century console is by Lorna Simpson. PREVIOUS PAGES: The vast dining room does double duty as a family room. A Walton Ford painting of a camel hangs above a George Nakashima cabinet. The antique French club chairs sport a snuggly Dedar fabric and the deep-seated sofa was inspired by Jean Royère; the carpet is by Doris Leslie Blau. ABOVE: Beneath a Patrice Dangel light fixture, a nineteenth-century mahogany dining table is flanked by DLV Designs chairs in Jasper leather. OPPOSITE: Smith and his clients loved the pronounced scale of the original moldings in the principal reception rooms. Above the chimneypiece from Jamb is a Louis XIII giltwood and ebony mirror. The fireplace is flanked by Meridian Iron Works bookshelves.

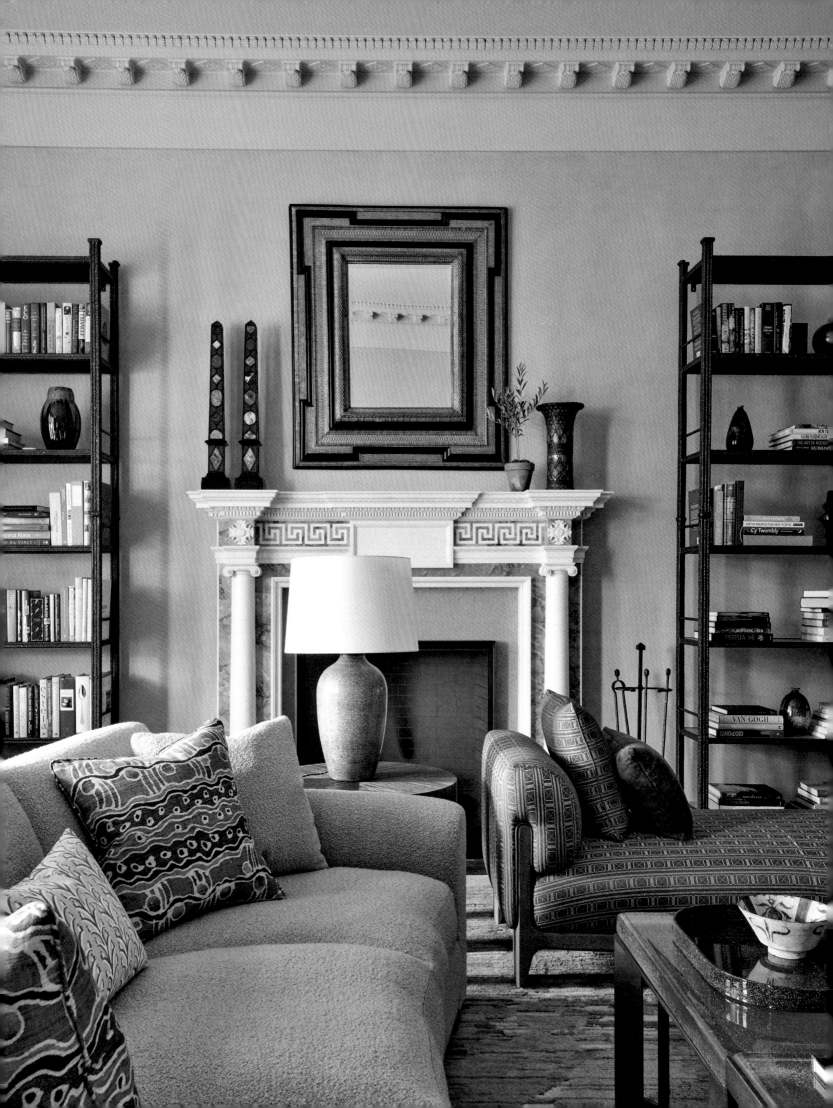

than a shared lobby, and miraculously those panoramic views include nary another building. Down at ground level, a parklike esplanade shields the building from the noise and traffic of the ever-bustling FDR Drive. Smith notes, "It's like being on a promontory over the water—you basically feel like you have this astonishing view all to yourself."

Located in a legendary 1930s art deco building where former residents have included Brooke Astor, Gloria Vanderbilt, and Madame Chiang Kai-shek, the 5,000-square-foot, five-bedroom duplex had long ago been carved out of a larger triplex apartment. In the process of subdividing the space, this apartment got many of the grandest rooms with the most fabulous moldings and architectural details. Another huge plus is that there's an almost equal ratio of terrace to interior space.

Once Smith had his clients in the right apartment, he set out to make the apartment right for his clients. "We all really loved the original details and definitely wanted to bring the place back to its former glory, but it also had to be modern and work for them," Smith says. "The living room and dining room are huge spaces compared to the bedrooms—almost ballroom scale—but the family doesn't host a lot of balls. They wanted more flexible spaces that could handle a book party for 150 guests or a family dinner for three."

Cue Smith's talent for creating multifunctional rooms that can do double or even triple duty, with areas for dining, receiving guests, working, or just lounging, all within the same four walls. The apartment is full of such spaces, but for Smith, the combination dining room-family room is the best example of that multifunctionality in action.

As now configured, the room features a huge Walton Ford painting of a camel above an impressively wide George Nakashima cabinet. Placed off-center near the windows, the dining table reads almost as a library table or workspace, but it seats ten to twelve and easily dresses up for dinners and celebrations. "Really, almost everything in the room—from the Jean Royère–inspired custom sofa to the tall bronze bookshelves—is overscale, but it doesn't feel in any way imposing or claustrophobic."

Smith's trick for expanding the kitchen, which was designed with architectural firm Ferguson & Shamamian, was to hang a large Renaissance master-piece—a Fra Angelico fresco filtered through the lens of contemporary photographer Robert Polidori—over the breakfast area. Smith feels that many homeowners make

RIGHT: A Robert Polidori photograph taken in a Renaissance monastery adds, in Smith's parlance, "another window" to the kitchen. Leather chairs by Mario Bellini and a Robert Marinelli bench in Dedar fabric surround a custom table by Collier Webb. The cabinetry at left is painted in Benjamin Moore's Seapearl.

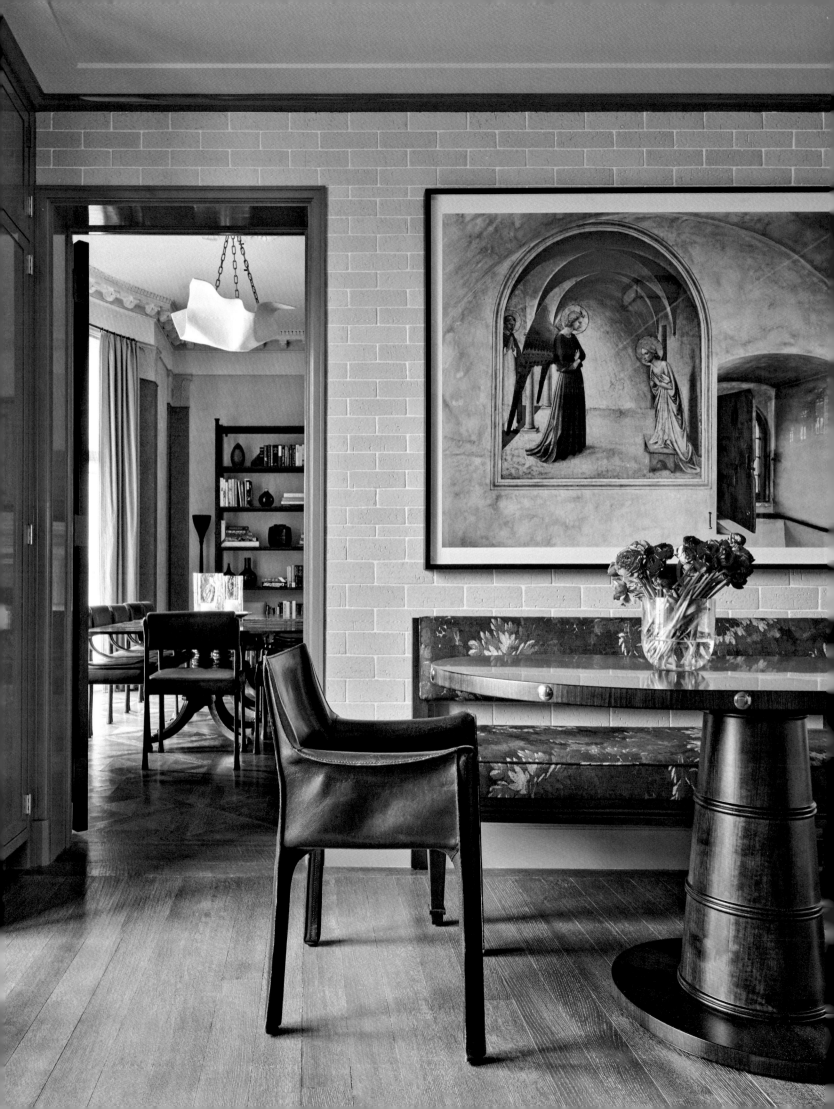

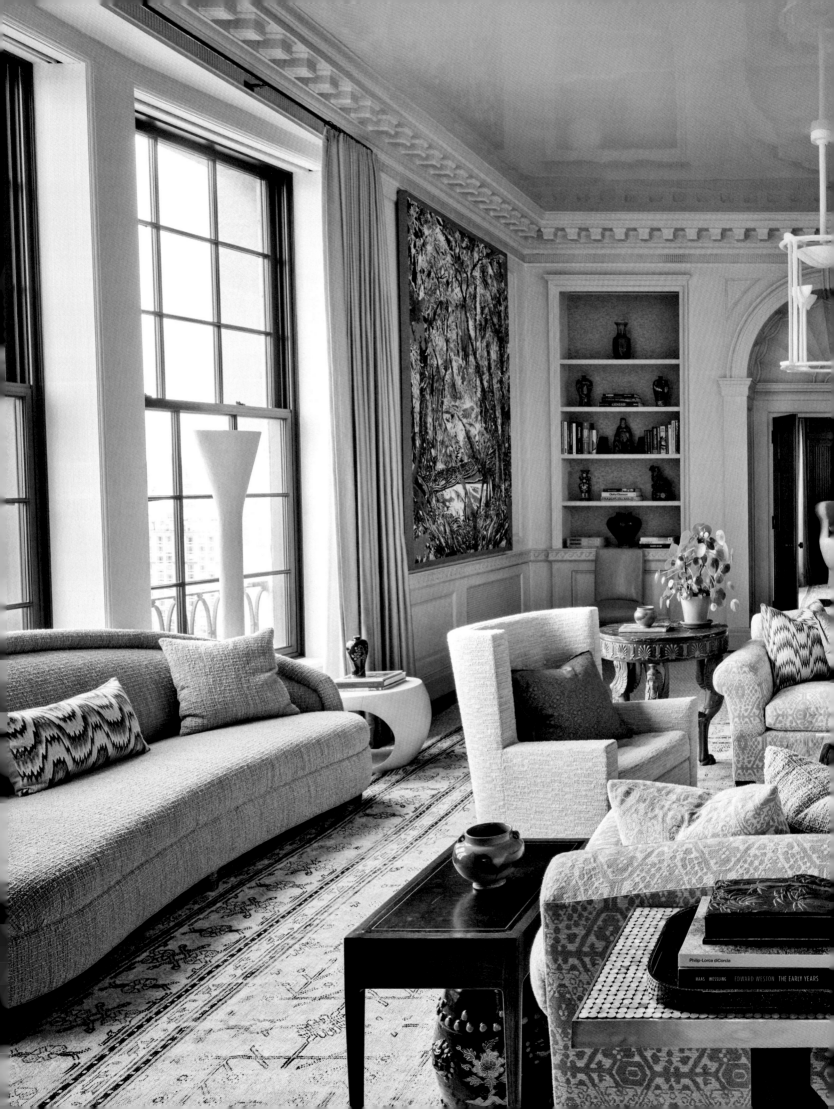

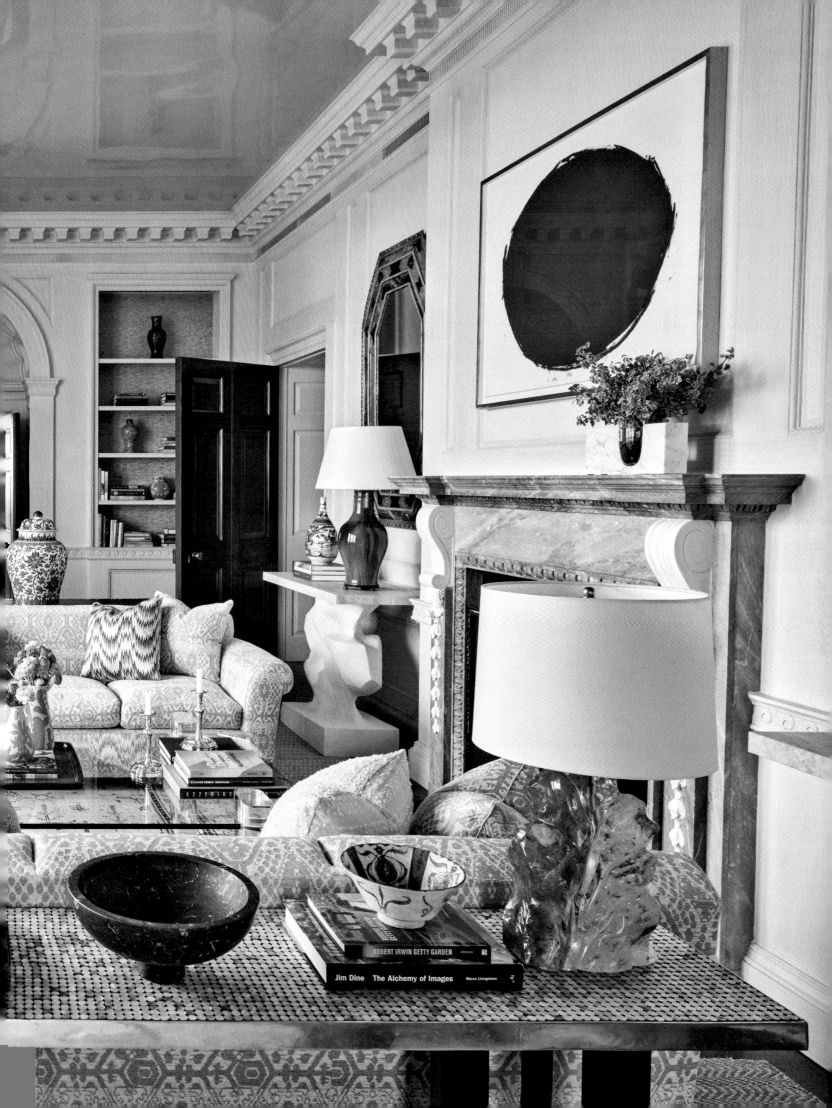

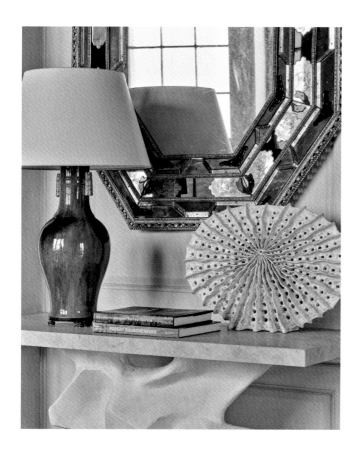

the mistake of hanging their least interesting objects in the kitchen. "But today, families pretty much live in their kitchens, so why not put great art in there instead of leaving them to look at blank tile walls with clocks, plates, pots, and pans."

Smith and the architects from Ferguson & Shamamian finessed other details of the home, like a new loopy ironwork banister added to the dramatic floating staircase in the entrance. With a muscularly carved and gilded nineteenth-century console, an ethereal canvas by Lorna Simpson, and a custom mirror by Sébastien Reese, the entrance provides a tantalizing hint of the sophisticated mix of furnishings, art, periods, and styles to be found throughout the home.

While the paneled living room's architecture tilts traditional with arched doorways, built-in bookcases, and an exuberant dentil cornice, Smith designed a curvy modernist Jasper settee to go in front of the huge riverfront windows. The settee has artfully hammered bronze legs for an extra layer of modernity and texture. Nearby, a bold canvas by Spanish artist Santiago Giralda echoes the steely blue tones that punctuate the room, from the custom Jamb fireplace to pillows, porcelain lamps, and the Tabriz carpet on the floor. A shimmery blue corner sofa with a small marble table marks off an area of the room that can be used for intimate dinners.

In the compact and cozily paneled study, an eye-catching Christian Astuguevieille rope chair prototype, which Smith found at auction, nestles like a cuddly teddy bear next the fireplace. The architects and designer also rejiggered some of the paneling in this room for symmetry and redid the plaster tracery on the barrel-vaulted ceiling to simplify the design while maintaining an echo of the Jacobean vibe. A convex mirror in a beautifully aged giltwood frame hangs above the fireplace and further ratchets up the almost hermetic old-world charm of the room.

The primary bedroom in the family's private quarters is among the most indulgent Smith has ever created. With its fireplace and private terrace, it feels like a standalone home within the home. The designer calls it "a refuge." A vine- and flower-strewn Jasper wall covering envelops the space, at the center of which is a canopy bed based on the one created for Pauline de Rothschild at Château Mouton Rothschild. A sumptuously plush grassy-green Cogolin carpet underpins the gardenlike atmosphere, enhanced by a deftly placed wicker armchair and a vividly colored abstract painting by

PREVIOUS PAGES: In the living room a pair of Jonas sofas in Jennifer Shorto fabric face off in front of the Jamb fireplace beneath a bold Richard Serra print. The large abstract painting at rear left is by Santiago Giralda. OPPOSITE: Sweeping East River views beckon behind a custom Michael Smith-designed sofa. ABOVE: A tablescape combines sinuous curves, straight lines, and natural forms atop a custom Patrice Dangel console. The Italian gilt-framed mirror was bought at Christie's.

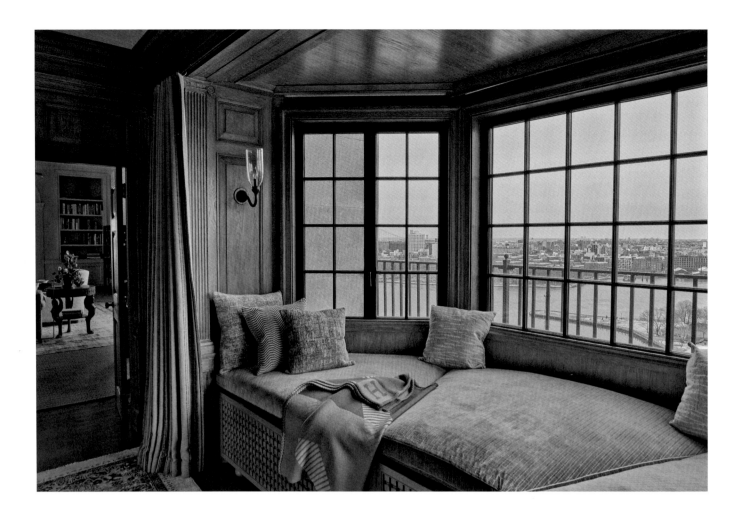

Antonio Corpora. When there's work to be done, a striking blue-lacquered Italian secretaire with gilded adornment and a bright cinnabar interior stands at the ready.

Another of Smith's multitasking rooms, the library, is on the upper floor and similarly feels like the world's best hotel suite. It's outfitted with a chic and stately Jasper iron bed to one side and a comfy reading area on the other. With a wallpaper of verdant country hills almost as lively as the urban river scene through the ample windows, the room has the feel of a grand English country house.

When Smith first saw the apartment while scouting for his clients, it reminded him of the early Truman Capote short story "Mojave" about a couple who live in an equally cinematic apartment on the East River. "It's like having your own private paradise in the sky," Smith says. He says that as far as his clients are concerned, the East River offers a much more interesting and dynamic view than Central Park—the rhythm and movement of the water and the boats, from sleek yachts to barges and tugboats, provide endless visual diversion.

ABOVE: A comfy daybed upholstered in a plush Scalamandré velvet Mogador has been built into the study's broad bay window overlooking the East River, giving the impression of a ship's cabin. OPPOSITE: Smith streamlined the design of the cozy paneled study's plaster ceiling to create an airier, more art deco design. A Christian Astuguevieille rope chair sits next to the Edwardian Jamb fireplace. The sconces are by Rose Uniacke. FOLLOWING PAGES: With its custom Jasper bronze bed, the upstairs library also serves as a guest room (with its own wraparound terrace). A scenic Gracie wall covering gives the room a full panoramic vista.

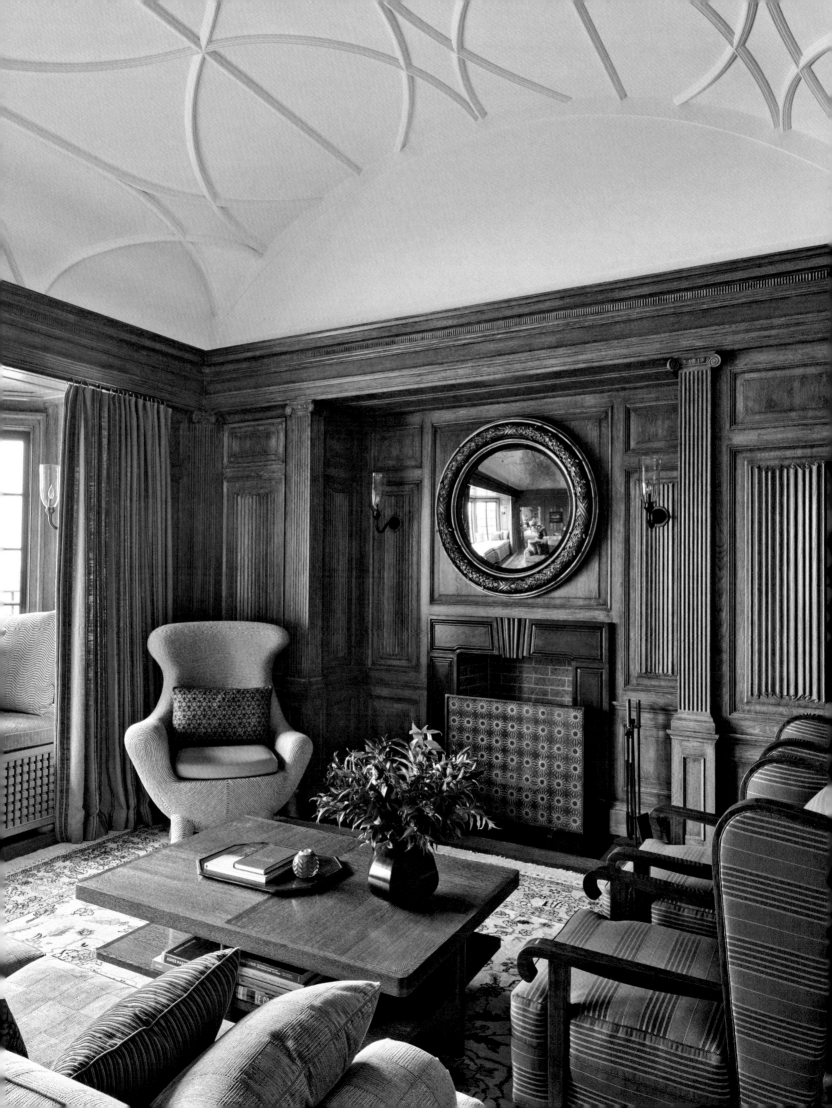

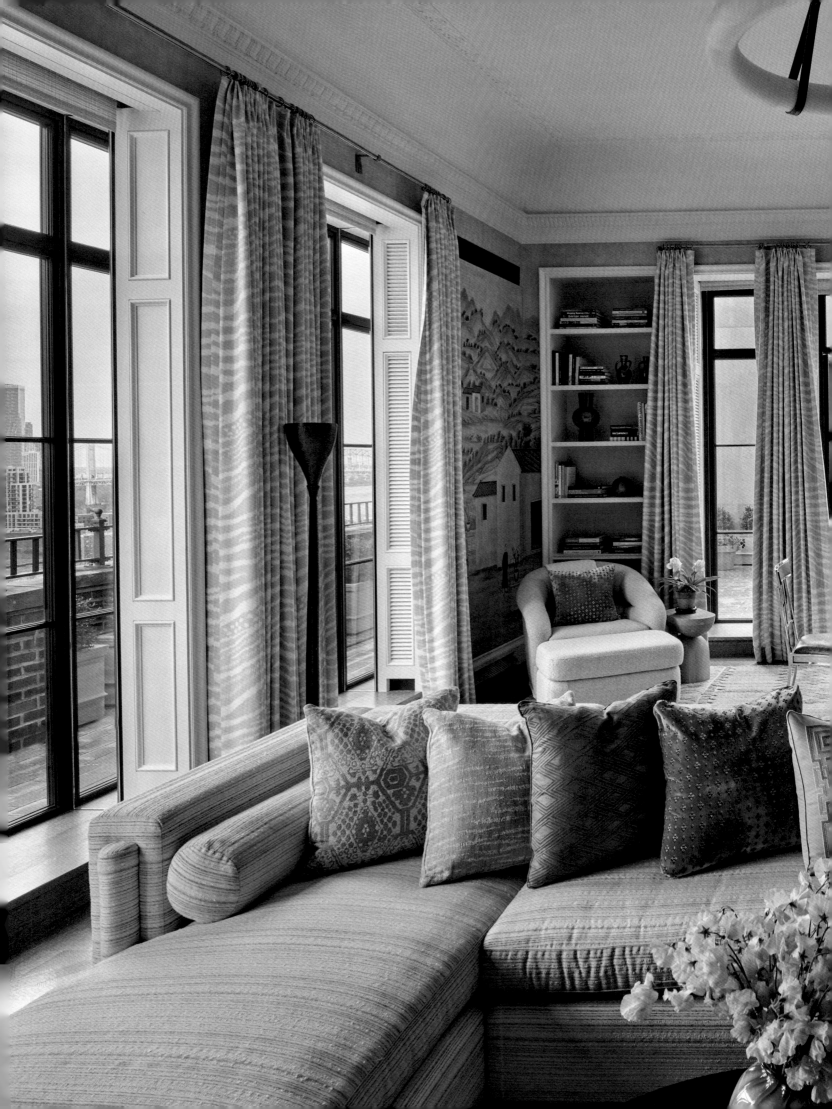

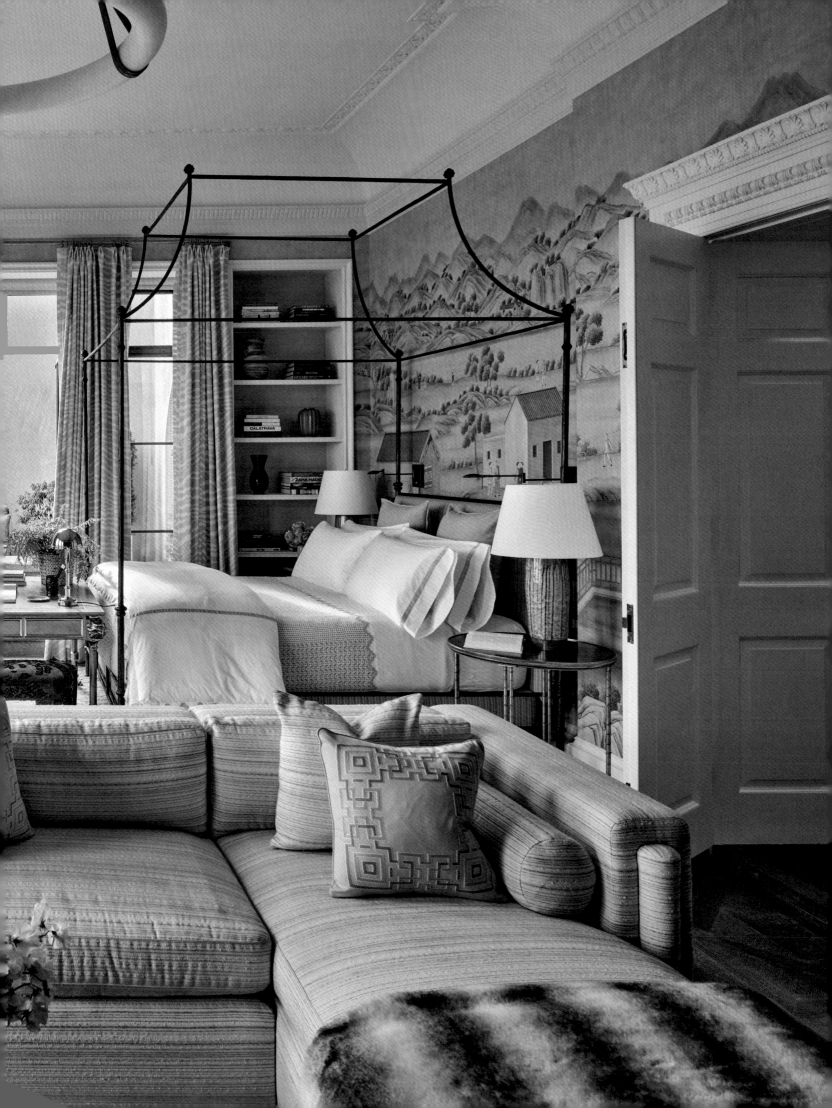

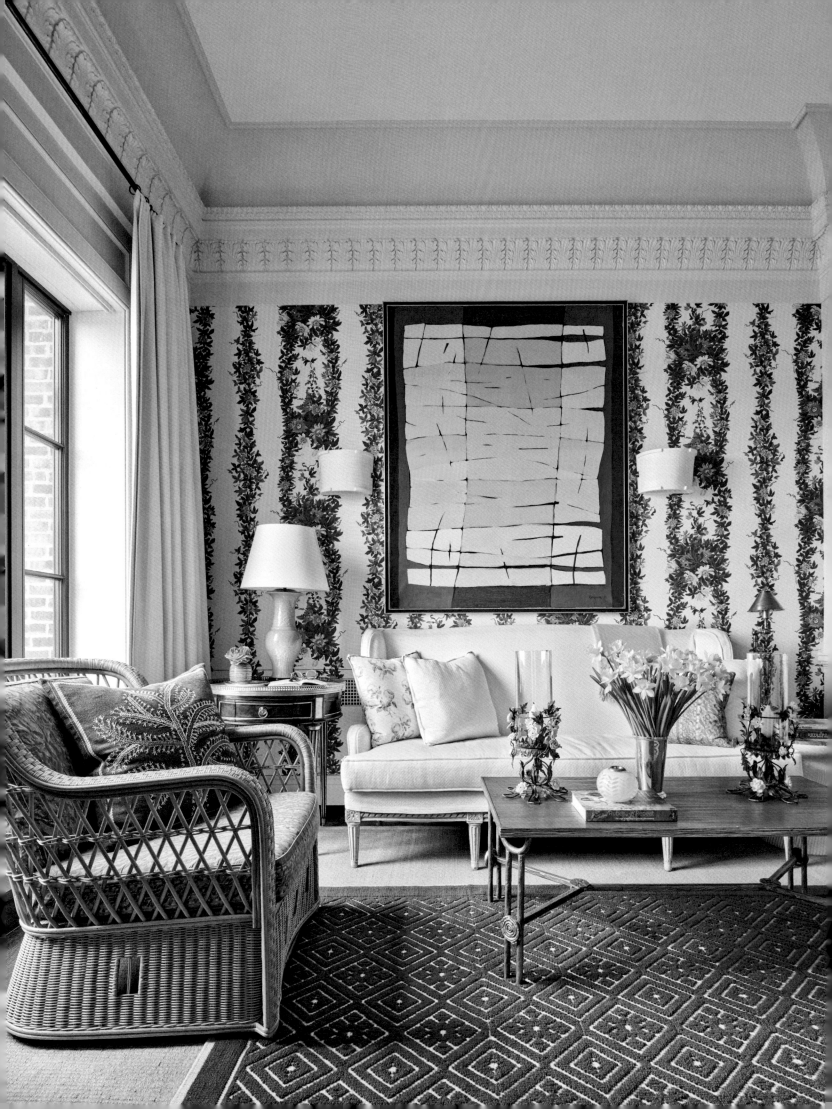

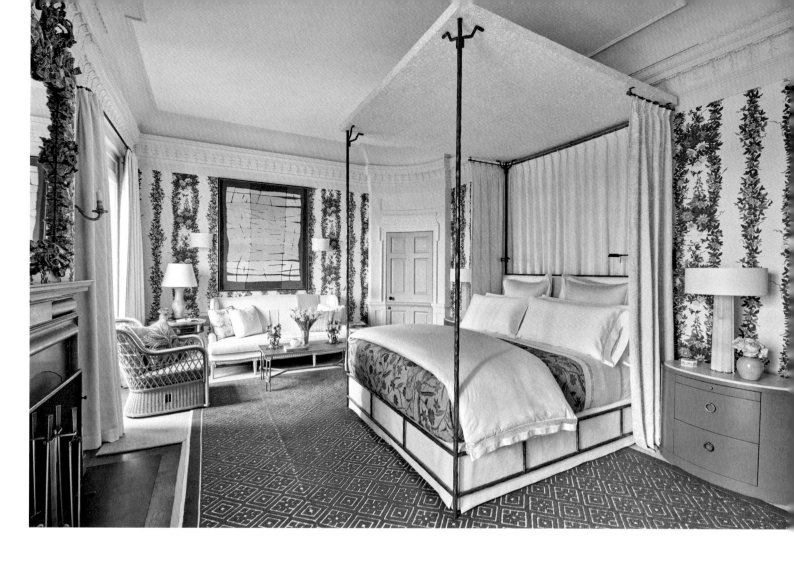

OPPOSITE AND ABOVE: The primary bedroom evokes an
indoor garden—complete with Bonacina wicker seating—
and the Jasper Malmaison-Fontaine wall covering strewn
with vines and flowers. The canopy bed was modeled on
Pauline de Rothschild's at Château Mouton Rothschild,
while the Hervé Van der Straeten bedside lamps add a
modern note. The bedroom seating area is presided over
by a vibrant work by Antonio Corpora. The grassy green
carpet is by La Manufacture Cogolin. RIGHT: A striking
indigo-blue lacquered Italian secretaire with gilded
decoration stands next to the closet. FOLLOWING PAGES:
The cheerful green dressing room features a painting by
Joanna Choumali. The walls and built-in furnishings are
painted in Benjamin Moore custom finishes.

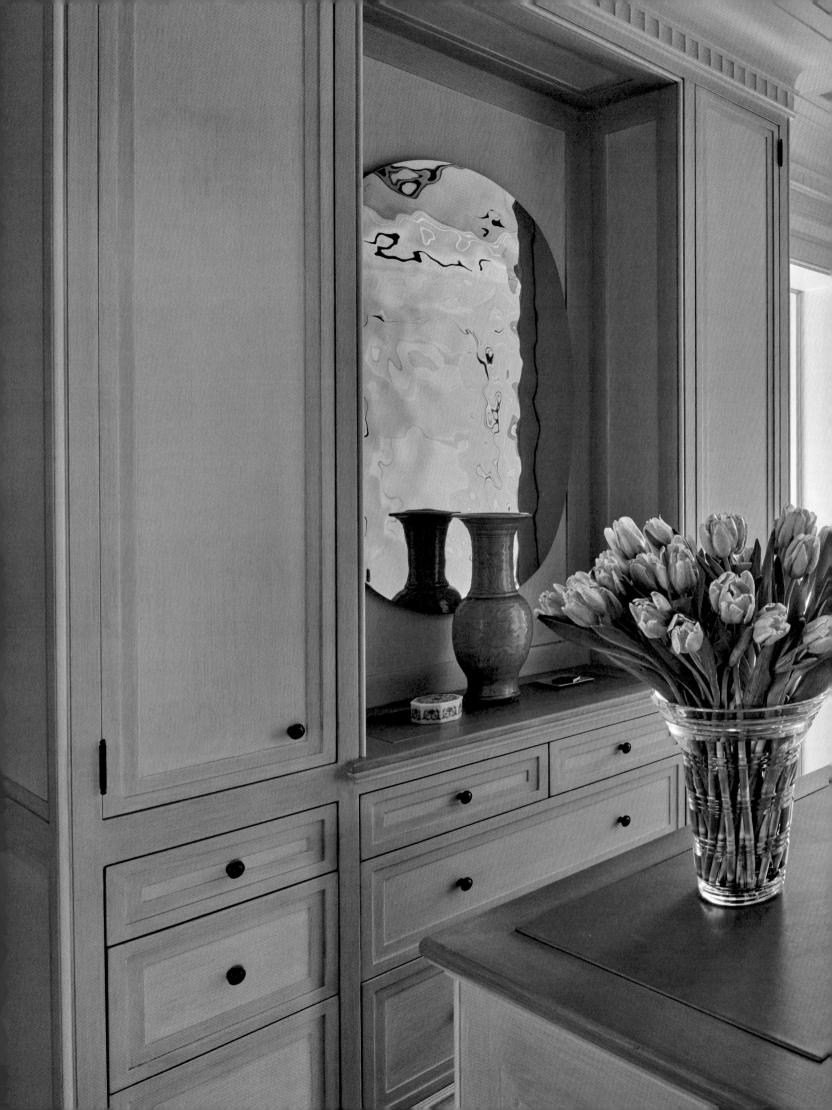

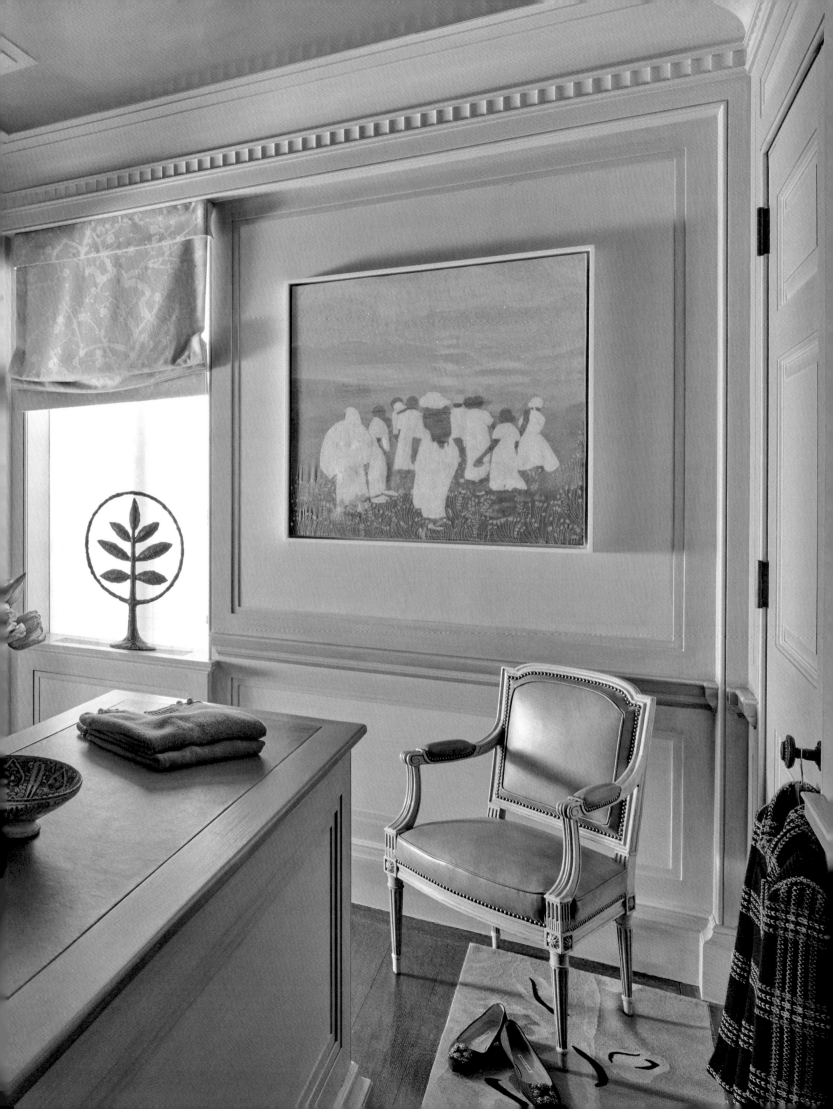

MOUNTAIN RETREAT

MONTANA

"HOLIDAY HOMES IN RESORT LOCATIONS can often be a little too 'on the nose,'" Smith says. "Think whales in Nantucket." Far be it from this designer to go overboard with such literal references.

In the exclusive Yellowstone Club in northern Montana, Smith had already helped the same clients, a prominent Los Angeles couple, with a house they purchased when it was still under construction. While Smith was able to intervene somewhat in the layout and design of that house in a way that went beyond decoration, within a few years, the clients wanted to start from scratch with the designer and create their ideal mountain getaway.

"This was a ground-up new build," Smith says. Working with Pearson Design Group, the designer and the couple created what he describes as "a small compound of seemingly vernacular structures with an organic mixture of shapes and volumes, and exterior cladding that adds interest to the overall look of the home in a very discreet way so that it seems part of the landscape."

Inside, Smith went for rooms that are distinctly more eye-catching. The home is customized in every aspect using a harmonious blend of natural, elemental materials—wood, stone, iron, bronze, concrete, glass, wool, and leather. For a Michael Smith house, it has precious little gilding, but that doesn't leave it feeling homespun or diminish the level of luxury and sophistication. In place of a grand Louis XIV mirror, there's a screen of beautifully honed and joined slabs of knotty golden burled maple root by Mira Nakashima, daughter of the acclaimed Pennsylvania cabinetmaker.

New York–based artist Nancy Lorenz studied in Japan and often provides Smith with modern adaptations of the tautly controlled compositions typical of Japanese screens. But near the Mira Nakashima screen in the stair hall,

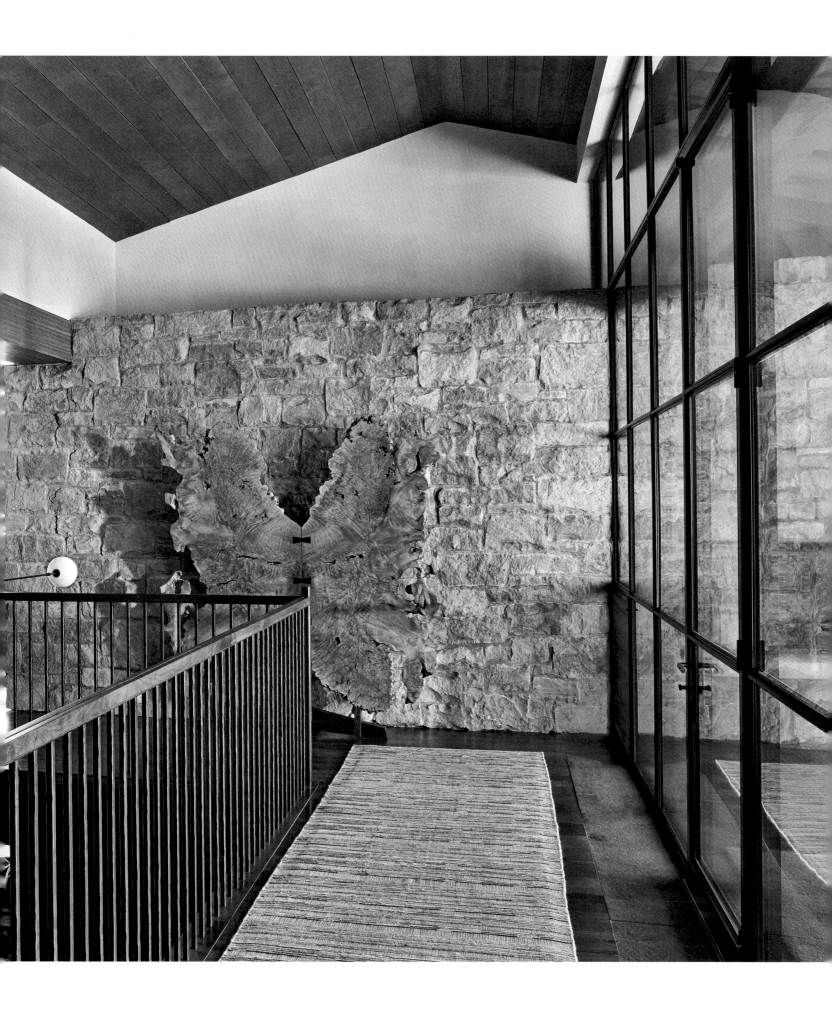

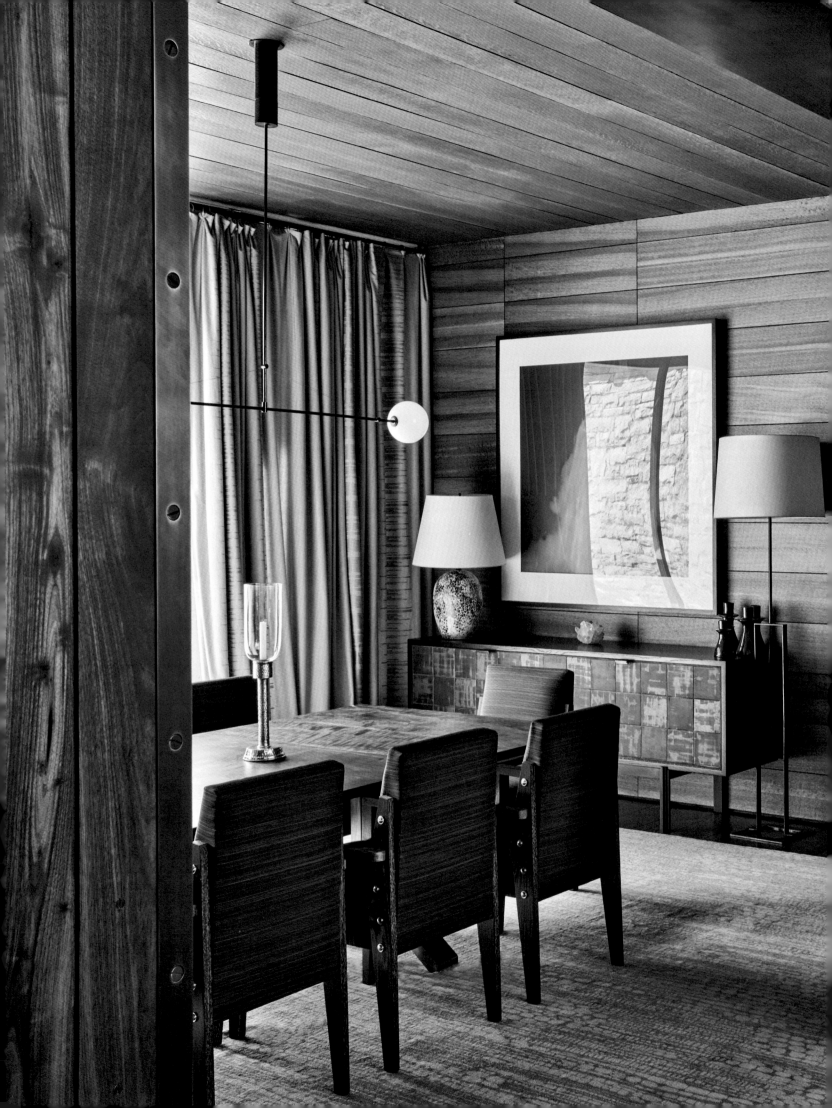

PREVIOUS PAGES: A stair landing reveals the home's restrained, modern aesthetic of
elemental materials—stone, wood, steel, glass, and concrete—as an elegantly spare backdrop
for a rich display of art, including a shimmering wall relief by Nancy Lorenz to the left
and a tree-root screen by Mira Nakashima that together express the dynamism of nature.
LEFT: Encased in beautifully honed walnut planks, the dining room glows in the afternoon
sunlight. ABOVE Smith brightened up the dining room with pale-cranberry horsehair fabric
by John Boyd Textiles on chairs inspired by legendary art deco designer Paul Dupré-Lafon.

RIGHT: The plush hall runners were handwoven in Nepal. The lanterns are by Studio Van Den Akker. FOLLOWING PAGES: So as not to compete with the spectacular view outside, the living room features a cozy range of textiles in warm neutral tones, though with lots of texture. The black walnut sofa at right is vintage George Nakashima, and the ceiling light fixture was custom-made for the space by David Wiseman.

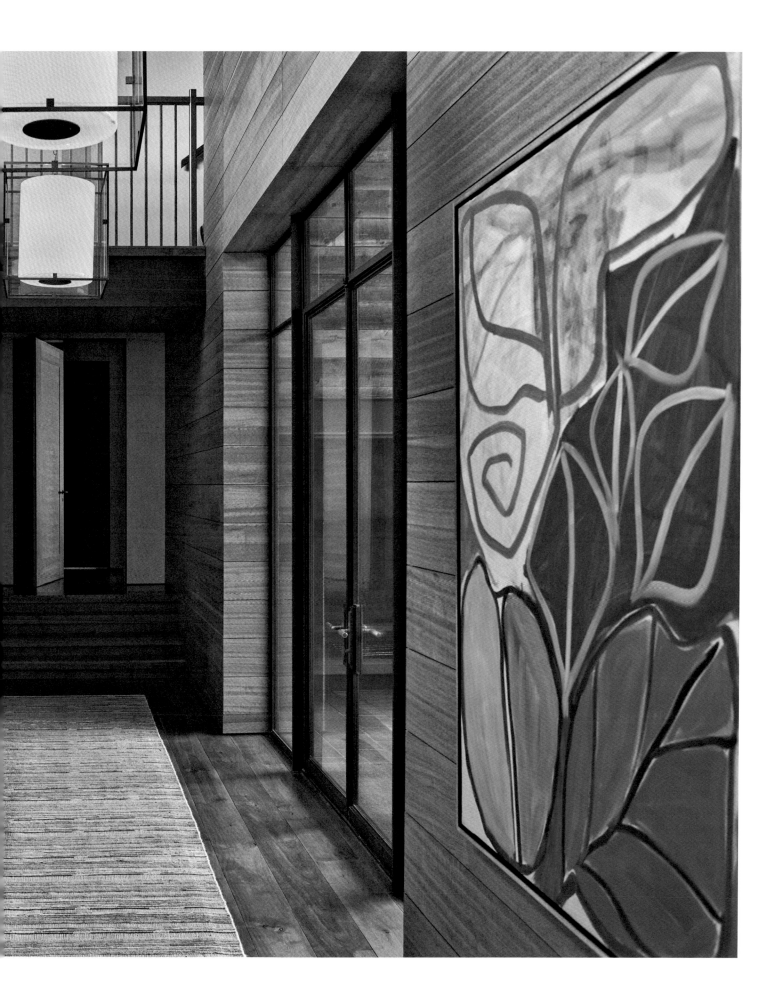

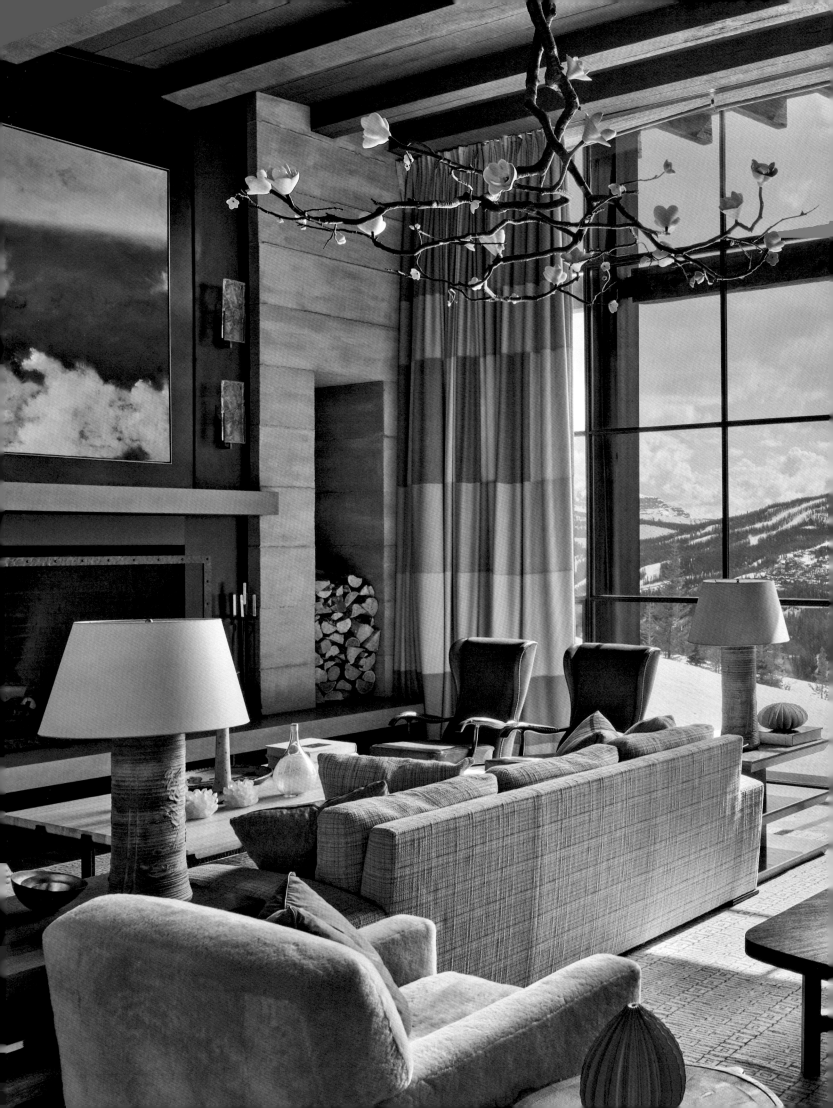

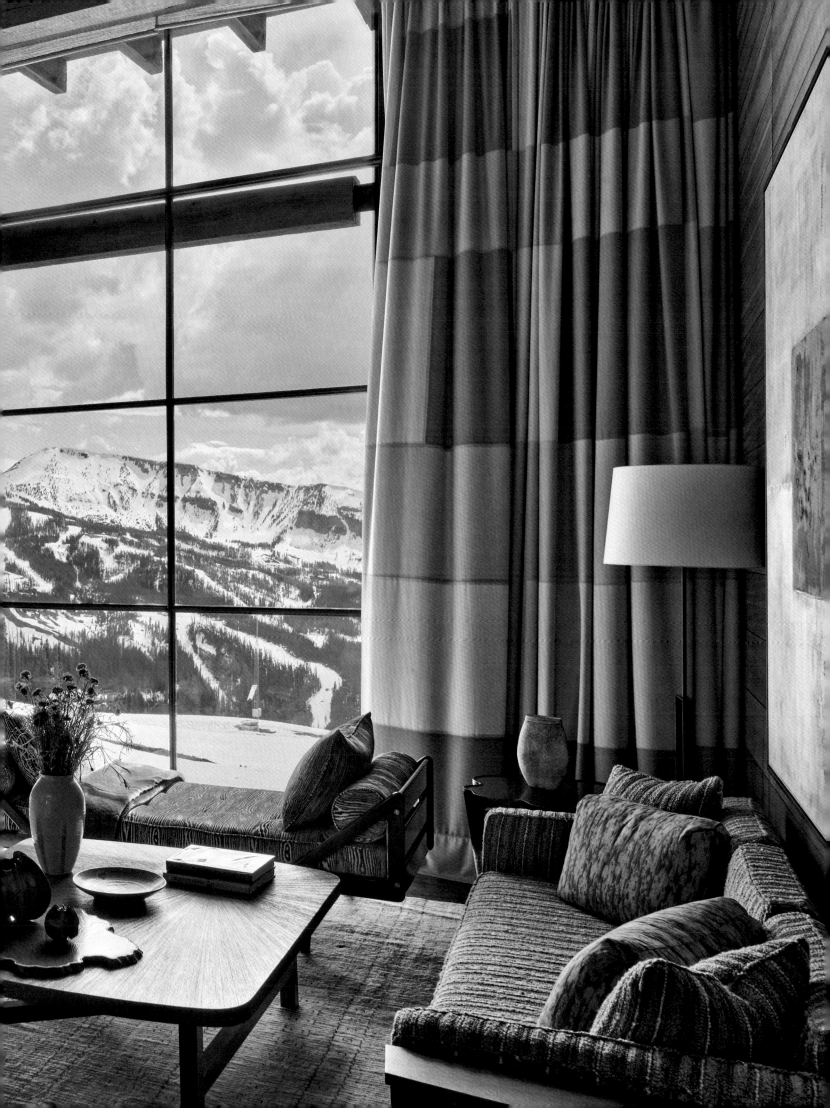

ABOVE: A collection of textural Claude Conover ceramics nestles next to the living room fireplace. OPPOSITE: Separating the living room from the central hall is a ceramic screen by Madrid-based Italian artist Clara Graziolino. The bench with leather cushion is by George Nakashima.

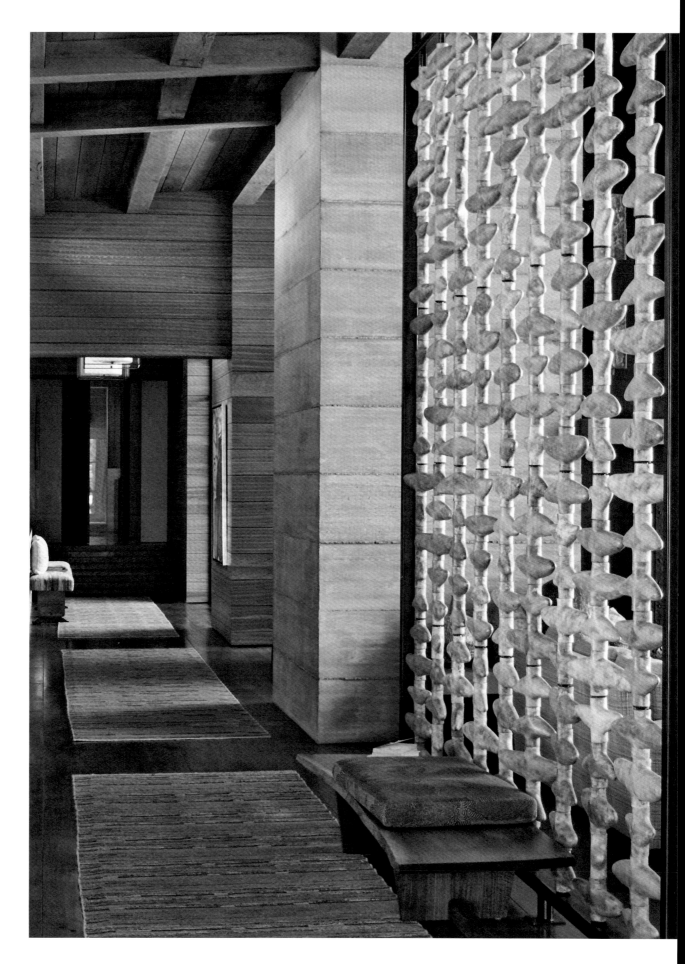

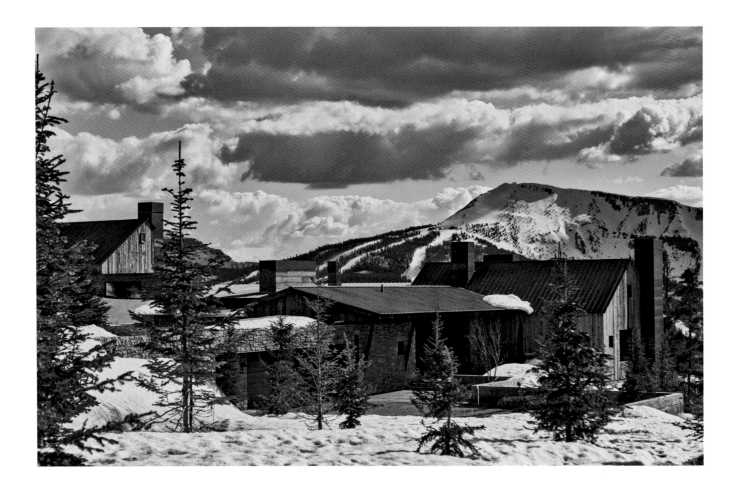

Lorenz went in a different direction and created a large, swirling silvered gesso wall relief that conveys a dramatic primordial or glacial effect. The super-simple, Calder-like Michael Anastassiades hanging lamp of black rods and white lights suspended in front of Lorenz's composition strikes a contrasting note of crisp modernity.

Throughout the house, there's a similar urbane-rustic dialogue. In a resort where the view outside the windows might be enough for some homeowners to look at, there are also blue-chip art, Japanese antiques, and room after room full of custom-made furniture and objects designed for the very spots they occupy. On walls and ceilings, the repetition of short, richly grained walnut planks elegantly imparts the warmth of wood in a far chicer manner than the standard log walls of many a mountain house.

In the 1930s, when legendary American architect Frank Lloyd Wright's clients Edgar and Liliane Kaufmann expressed surprise at his decision to build their weekend house in western Pennsylvania—the residence now famously known as Fallingwater—atop a waterfall rather than on the facing riverbank from which the Kaufmanns could enjoy the view of the cascad-

ing water, Wright replied that if they were to look at the waterfall every day, in time they would stop seeing it.

Smith possesses a similar understanding of view management, and in the living room he employed multiple elements to frame, filter, and focus the view of the Rockies, from the overscale mullion windows to the hefty patchwork curtains in shades ranging from beige to butterscotch with varying degrees of translucence. Separating the living room from the passageway behind it is a striking built-in ceramic screen by Madrid-based Italian artist Clara Graziolino. It looks like a totemic accumulation of paleolithic vertebrae and serves the dual purpose of enclosing the living room and animating the view for anyone passing by.

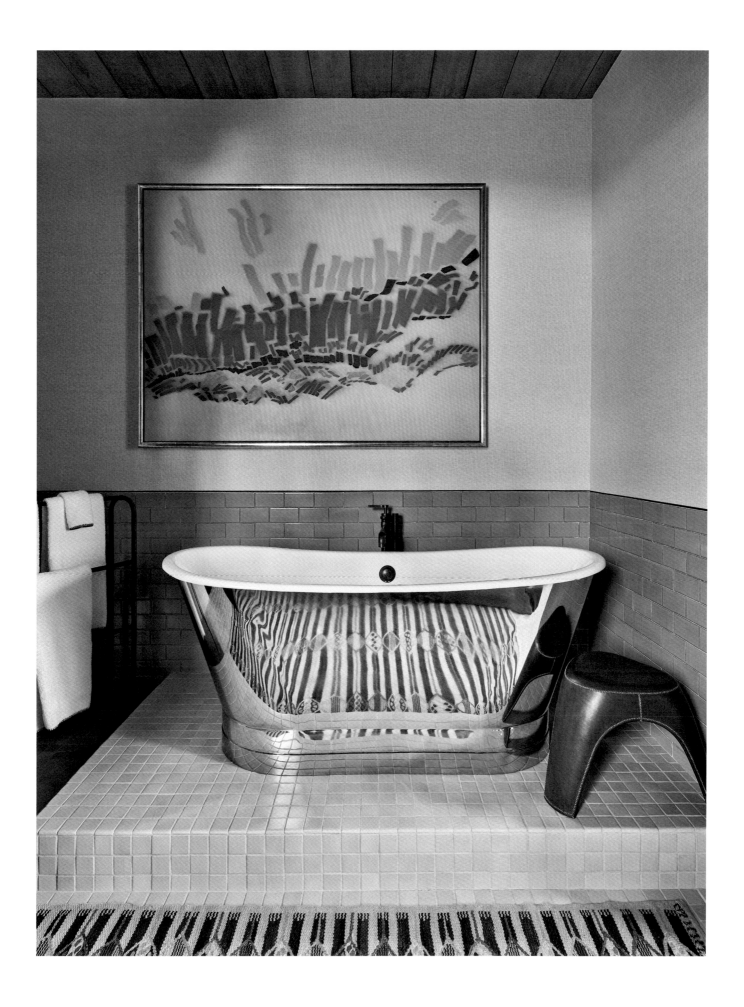

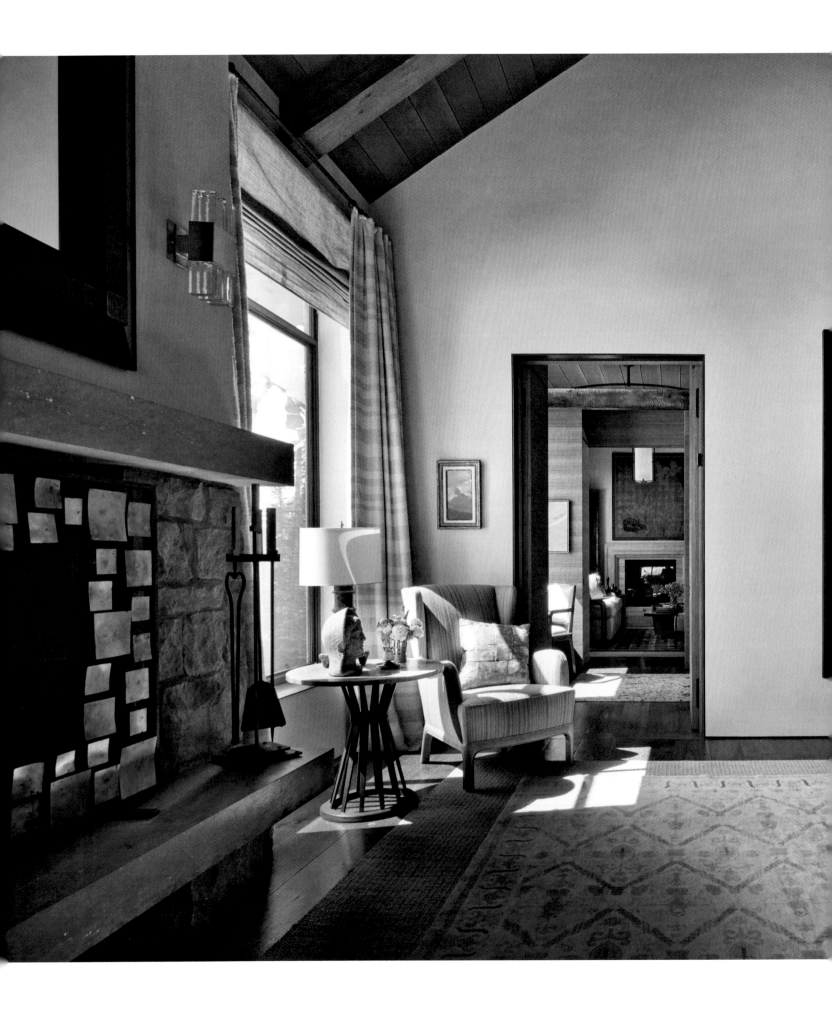

LEFT: The primary suite was designed as a refuge for the homeowners and includes a large bedroom with a fireplace set between windows with sweeping vistas of the mountains. A Jack Pierson photograph of sunset over the Adriatic provides another tranquil view. ABOVE: California lighting designer Lianne Gold's cast glass-and-bronze light fixture, aptly named Little Sky, floats above the primary bedroom.

"Much of the time when the owners are using the house, the view outside—as stunning as it may be—is a range of whites and grays, so it's fairly monochromatic," says the designer, who enlivened the living room with an engaging mix of warmer tones, textures, and finishes. Overhead, a very large bespoke David Wiseman blossoming branch chandelier brings nature and the promise of springtime right into the living room. "There's a wonderful meditative stillness to such awe-inspiring mountain vistas, but the rooms need to be energizing and have a bit of movement, or else the whole thing can get a little too quiet," Smith notes.

The dining room is anchored at one end by a baronial-sized fireplace wrought modern with more than sixty bronze panels, each subtly polished and hued to a unique finish by the craftsmen at Moorland Studios in New Jersey—the same metal fabricators and conservation experts entrusted with maintaining the massive

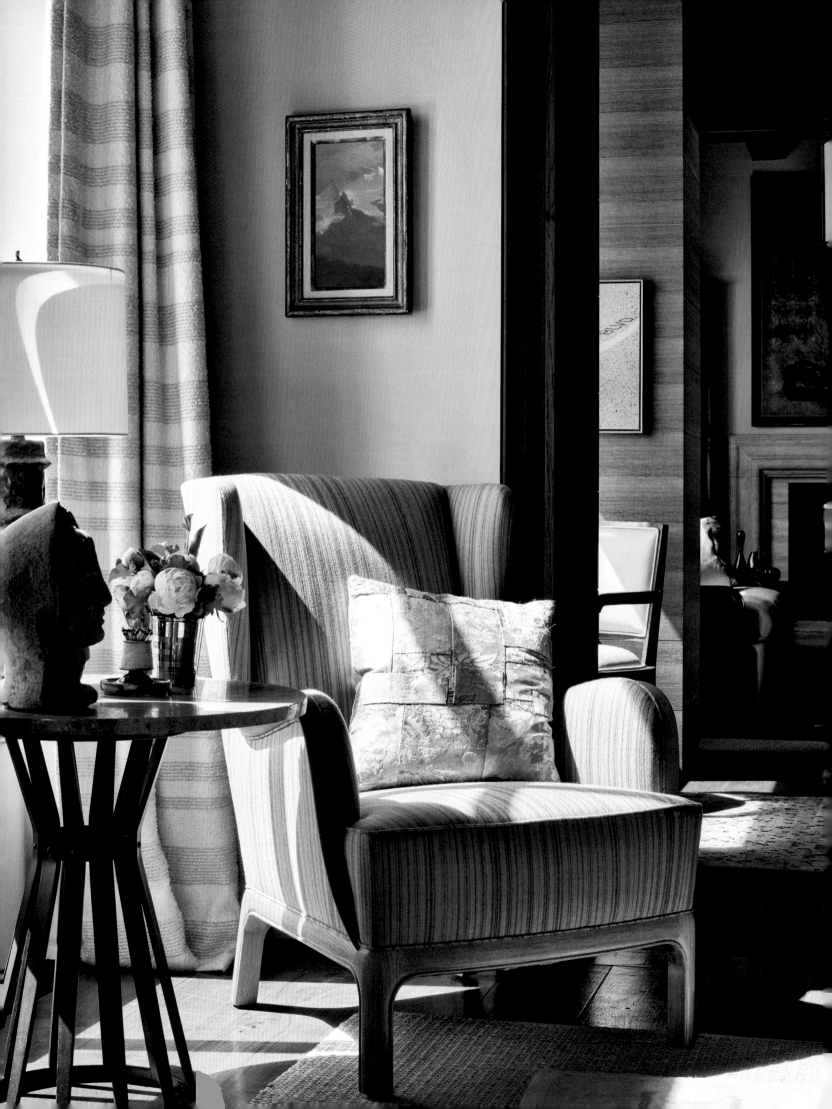

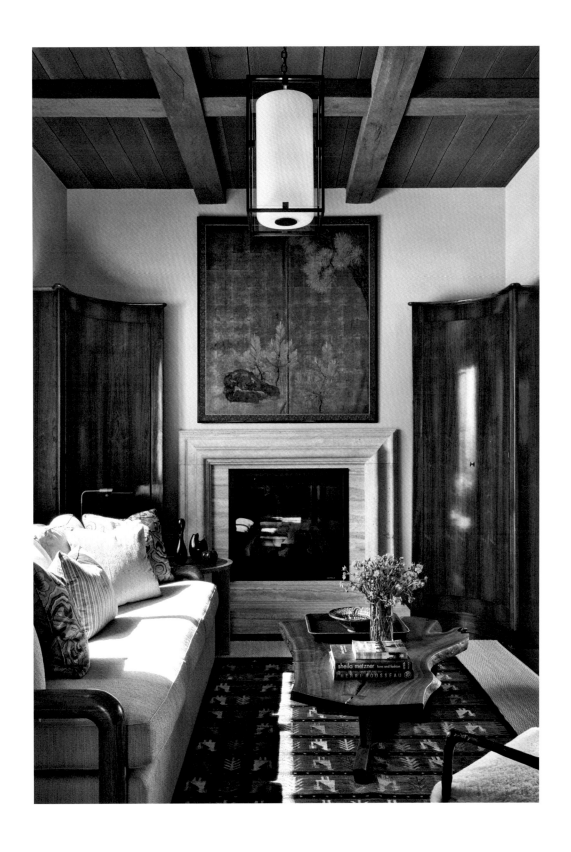

OPPOSITE: A Frits Henningsen wingback chair is upholstered in a golden striped wool. A detail of an Ed Ruscha painting can be spied on the wall behind it. ABOVE: The primary suite's intimate sitting room has its own fireplace, above which hangs a nineteenth-century Japanese screen. In front of it, a deep blue Swedish folk rug lies under a small walnut Nakashima table and a 1930s Italian sofa.
FOLLOWING PAGES: The primary bathroom mirrors and sconces are among the few places in the home where Smith deployed gold-leaf accents. The two small canvases are by Spanish artist Santiago Giralda.

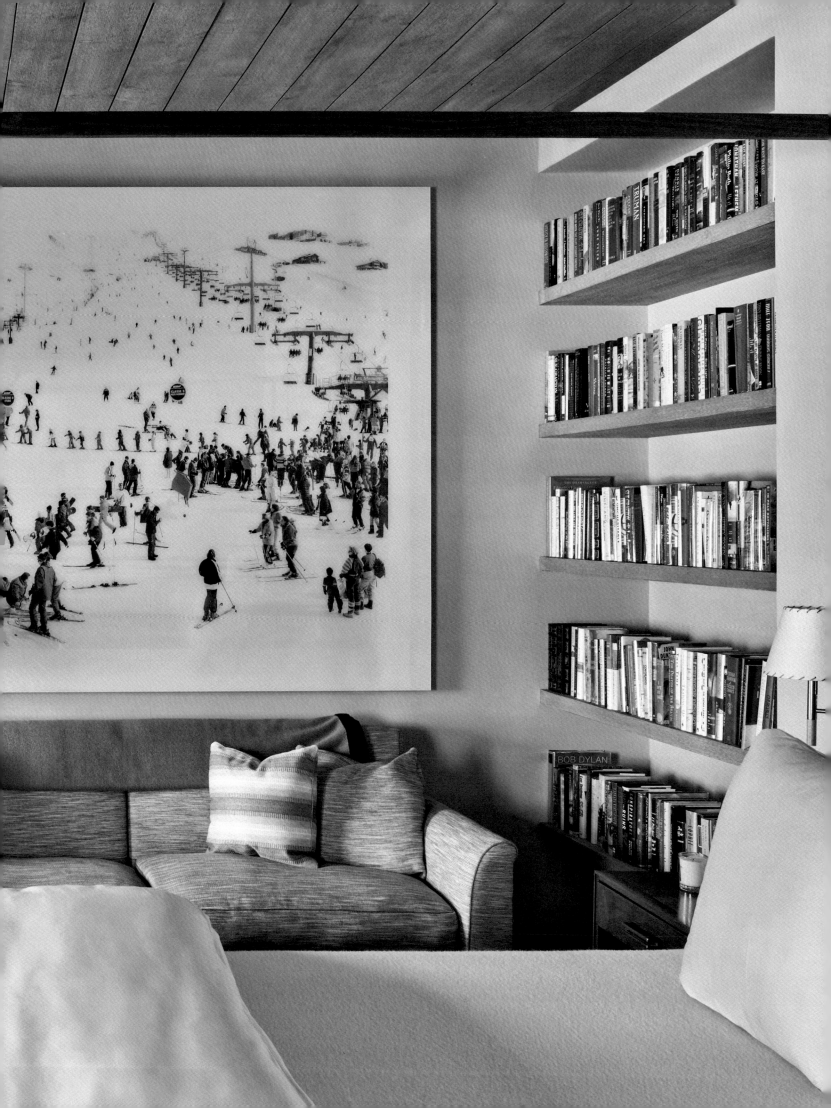

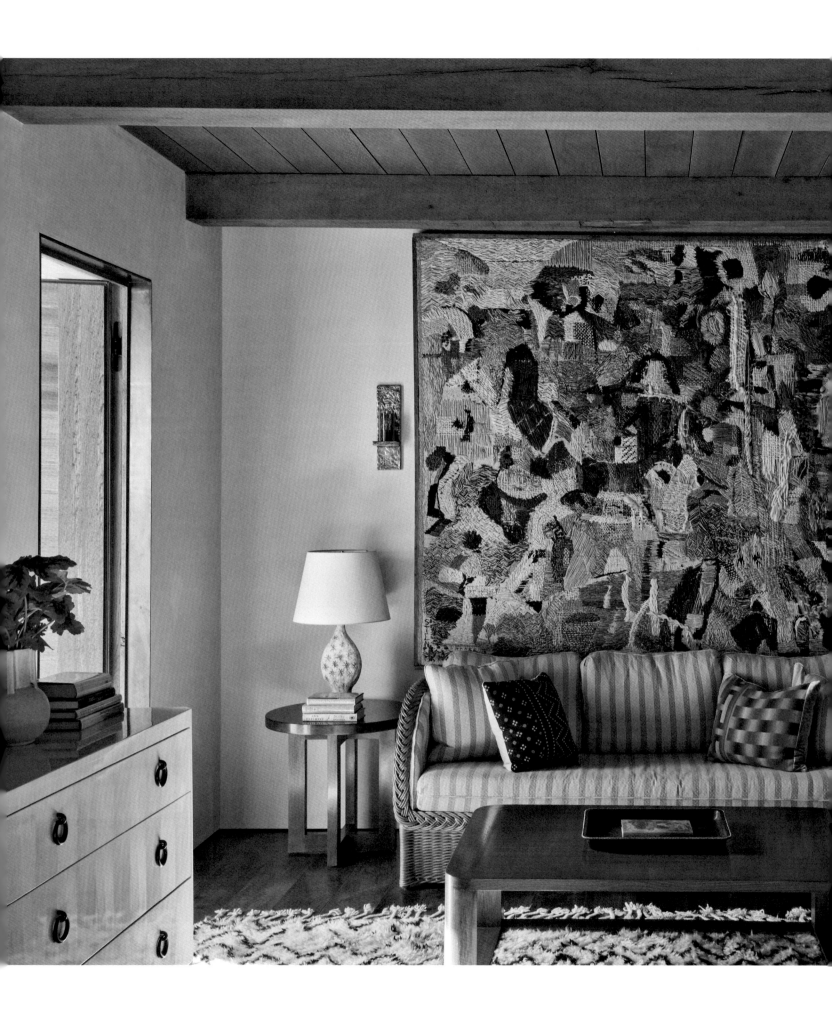

bronze statue of William Penn that stands atop Philadelphia's City Hall and other monuments. Not surprisingly, the fireplace wall seems as site-specific as an art installation. Against that crisp geometry, the room is enlivened by a large format Lynn Davis photograph of geysers, as well as the standout cerused-oak dining chairs with pale cranberry horsehair upholstery that were inspired by famed art deco designer Paul Dupré-Lafon and made by Mattaliano.

In the primary bedroom, where a vaulted ceiling cedes space to a tall Holly Hunt tester bed, Smith created a private retreat with two fireplaces. The fireplace facing the bed is covered by one of the few flashes of gold in the house—a gilt-metal fire screen by Del Williams Studios that radiates warmth even when there's no fire burning behind it. Overhead, a cast glass-and-bronze ceiling fixture adds an icy touch, until it's illuminated and glows a gentle amber.

A vintage Frits Henningsen wingback chair—a subtle combination of smooth wood and textured wool upholstery—guards the hall to the bedroom's dressing room, bathroom, and cozy sitting room: "a combo the clients liked from the earlier home," Smith says. The sitting room has its own fireplace beneath panels from an antique Japanese screen. In front of the sofa, on a vivid lapis-blue Swedish rug, sits a curvy George Nakashima coffee table in walnut, just one of several beautifully honed, vintage pieces of furniture by the artist in the house.

Downstairs, tucked into in a comfy guest room, we find one of the decorator's few obvious nods to the home's Rocky Mountain location, a large Massimo Vitali photograph of a ski slope.

"In time, the first house came to feel too mountainy," says Smith. "This one is less thematic and uses more luxurious textures, finishes, fabrics, and art to create a natural and comfortable atmosphere for the family, who have very sophisticated tastes and enjoy a deep connection to the art and objects that surround them."

PREVIOUS PAGES: The colors of a large and aptly ski-themed Massimo Vitali photograph and abundantly stocked bookshelves in this bedroom stand out amid Smith's otherwise muted palette of earthy neutral tones, reminders this is a place for fun. LEFT: The seating area of an auxiliary bedroom features a range of simple elemental materials— wool, leather, wicker, and bronze—transformed into standout pieces of art and design. Wool and linen tapestry by Sten Kauppi.

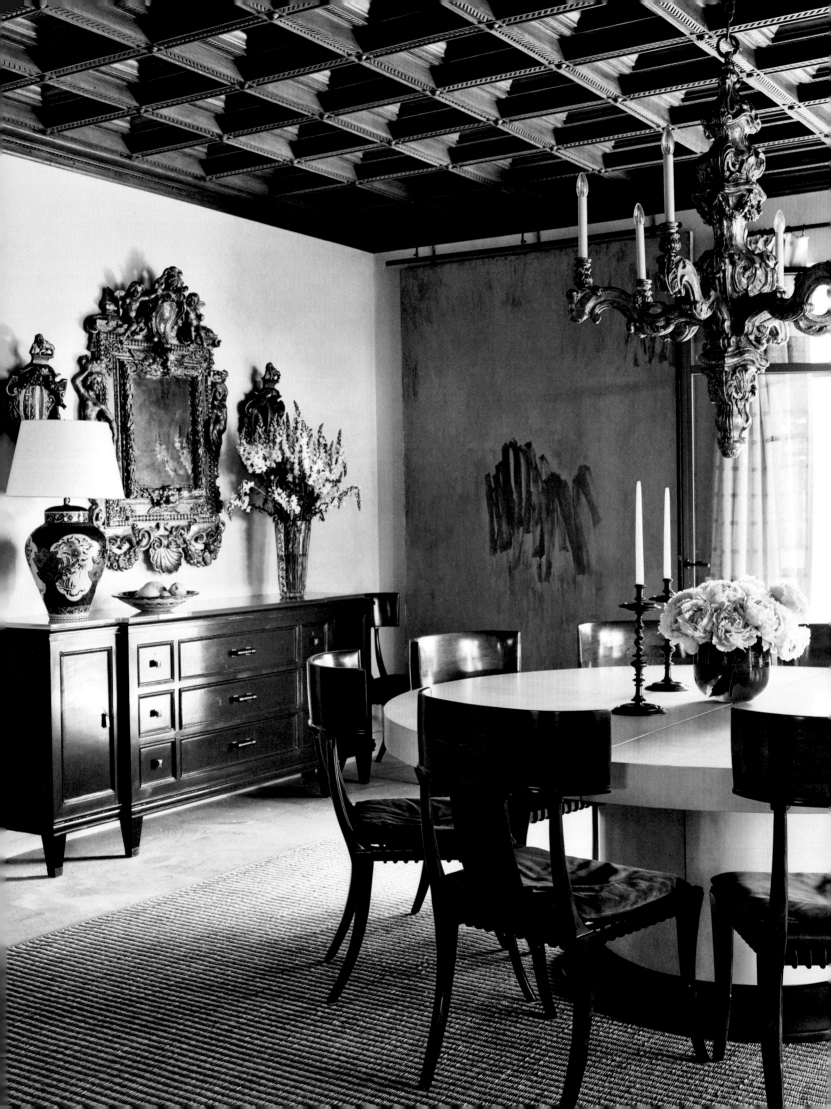

CLIFFSIDE VILLA
MALLORCA

"**STARTING IN THE LATE AUGHTS,** James and I began visiting Mallorca practically every summer with another couple. Eventually, they purchased a house near Deià on the island's rugged northern coast, and I then decorated it," recounts Smith. "Thus, they were not in the market for property a few years later when—based on a chance meeting—they saw this home stunningly perched over the sea."

The house was not officially on the market, but it languished unused. Smith recalls, "The previous owners had several other homes and turned their attention away from this one, so it never got the use and love it needed to feel resolved and finished." A deal was struck, and soon Smith and his team were conjuring ideas about how to revive the home.

The possibilities of the property were immediately apparent, starting with breathtaking views of Alcúdia Bay and no fewer than four private access points to the sea. However, the house needed to be brought up to par—there was an obvious disconnect between the siting, the landscape, the views, and the structure sitting in the midst of them.

Smith says, "Working with the local architectural firm Bastidas, we invented a narrative that the original (imaginary) structure had been a Moorish fortress overlooking the sea. And from there we spun a fantasy involving all the influences that had washed over the island—Roman, Byzantine, Venetian, Moorish, Aragonese, and Spanish—each leaving their imprint on the home we see today."

On the exterior they accentuated the home's main vertical block, reinforcing the idea of a fortified tower guarding the coastline, and raised the garden terraces to make them appear as parapets protecting the tower itself. On the upper floors small lookouts—terraces and balconies—were created for several of the bedrooms.

For the interior of the house, Smith and his clients ran headlong with the inspiration of Mediterranean cross-pollination. Together they had toured many iconic homes, such as Hubert de Givenchy's house in Saint-Jean-Cap-Ferrat and others in places like Capri and Marrakech. The clients had already owned a house on Mallorca and knew how diverse the interiors could be. "They loved the idea of a pan-Mediterranean mix, collecting the diverse objects and distinctively textured fabrics that are so well-suited to Mallorca," the designer says of the homeowners.

Hence the dining room has a hefty baroque Venetian chandelier hanging from a deeply coffered wooden ceiling made in Morocco. There's also a suite of vintage klismos chairs from Greece and a gracefully sleek Jacques Adnet cabinet, adding a French accent. In the adjacent living room, Smith stenciled the walls with a delicate veil of lacy white patterns derived from Indian *jali* screens, the intricate, privacy-enhancing latticework widely used throughout the Islamic world, including North Africa and Spain's Andalusia region. The Spanish steel-and-glass pendant lamp reflects a similar feel in its faceted panels, as do the bold geometric African textiles that punctuate the room.

A love of exoticism, color, fantasy, and bold pattern took root throughout the home and is especially apparent in the winter garden, with its bright floral upholstery, jewel-toned Moroccan tile wainscoting, and a towering Maison Jansen-ish metal palm tree—a wink at Mallorca's reputation as a sun-splashed paradise. The room has large glass doors that open onto various terraces in warm weather but also allow it to be sunny

PAGE 94: Smith's design plan was to focus on Mallorca's pan-Mediterranean influences across the centuries. Hence the dining room features a twentieth-century French cabinet, classical-style Greek klismos chairs, and a baroque Venetian chandelier suspended from a handmade Moroccan coffered ceiling. The painting, *Wild Vine*, is by Chrisopher Le Brun. ABOVE: Working with local architectural firm Bastidas, Smith and his clients added retaining walls to level the garden and create a fortresslike aesthetic. OPPOSITE: They also enhanced the verticality of the home's exterior, adding height and balconies to the central tower.

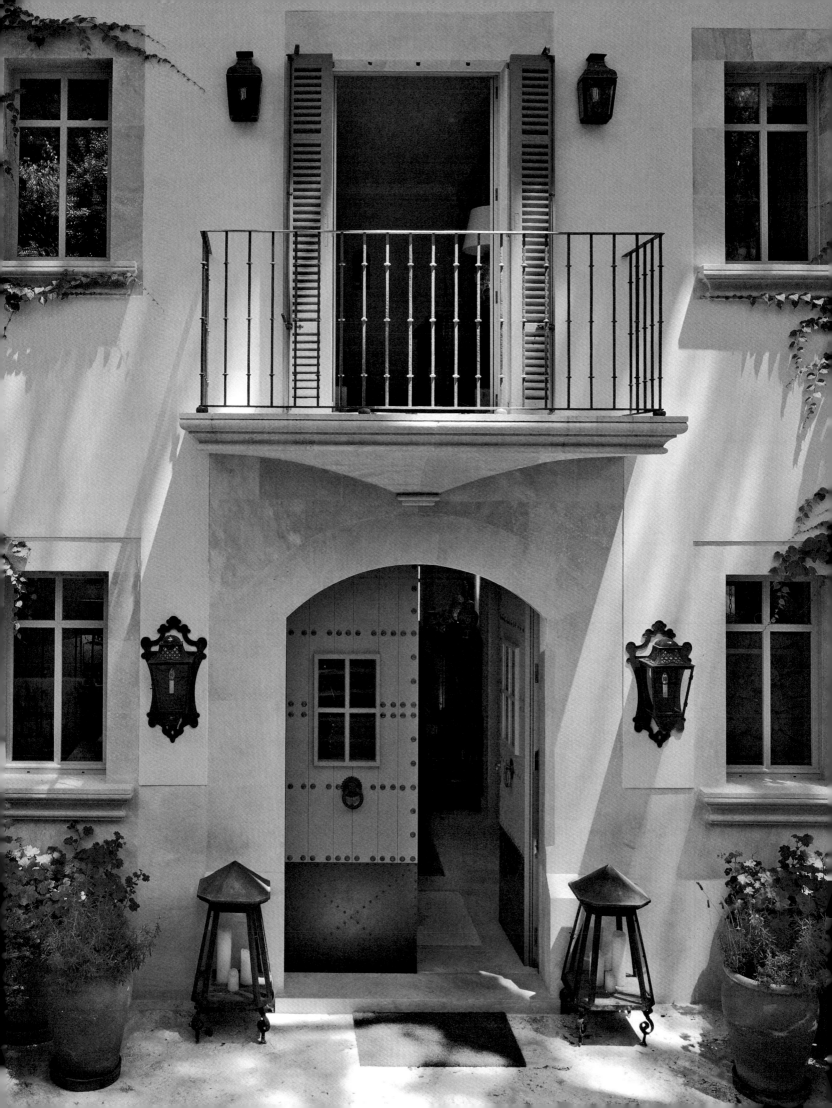

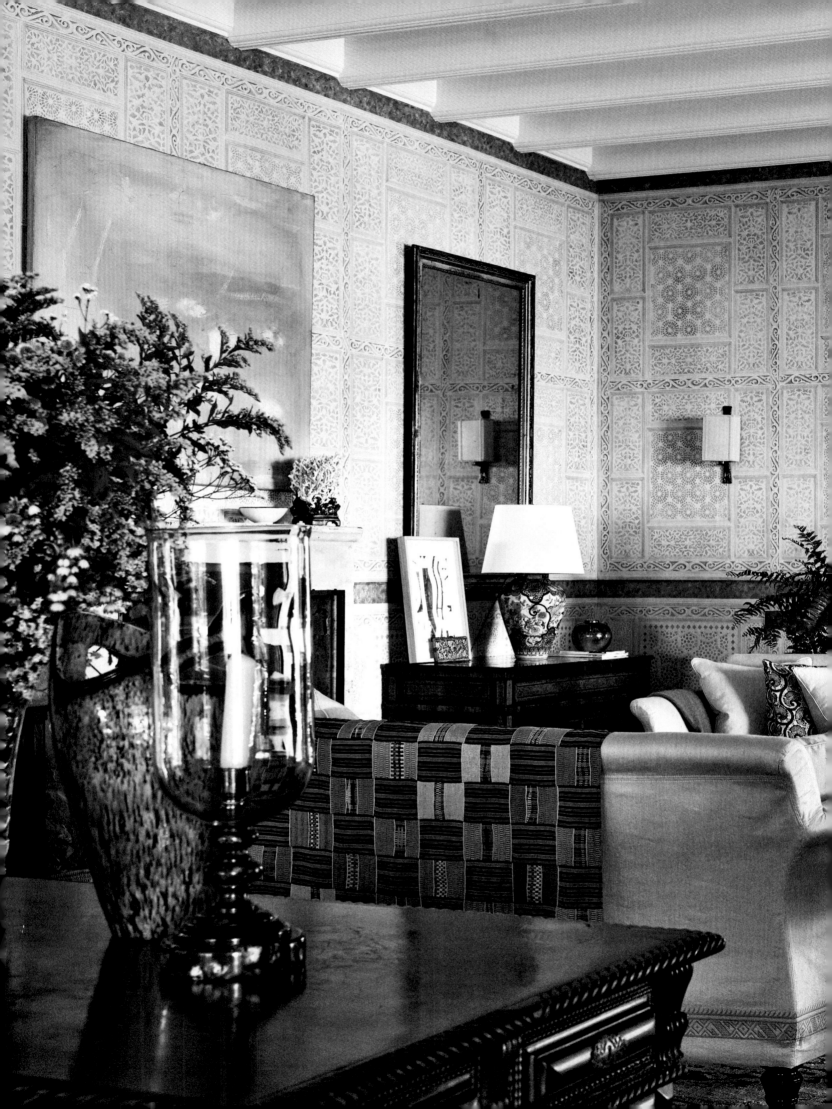

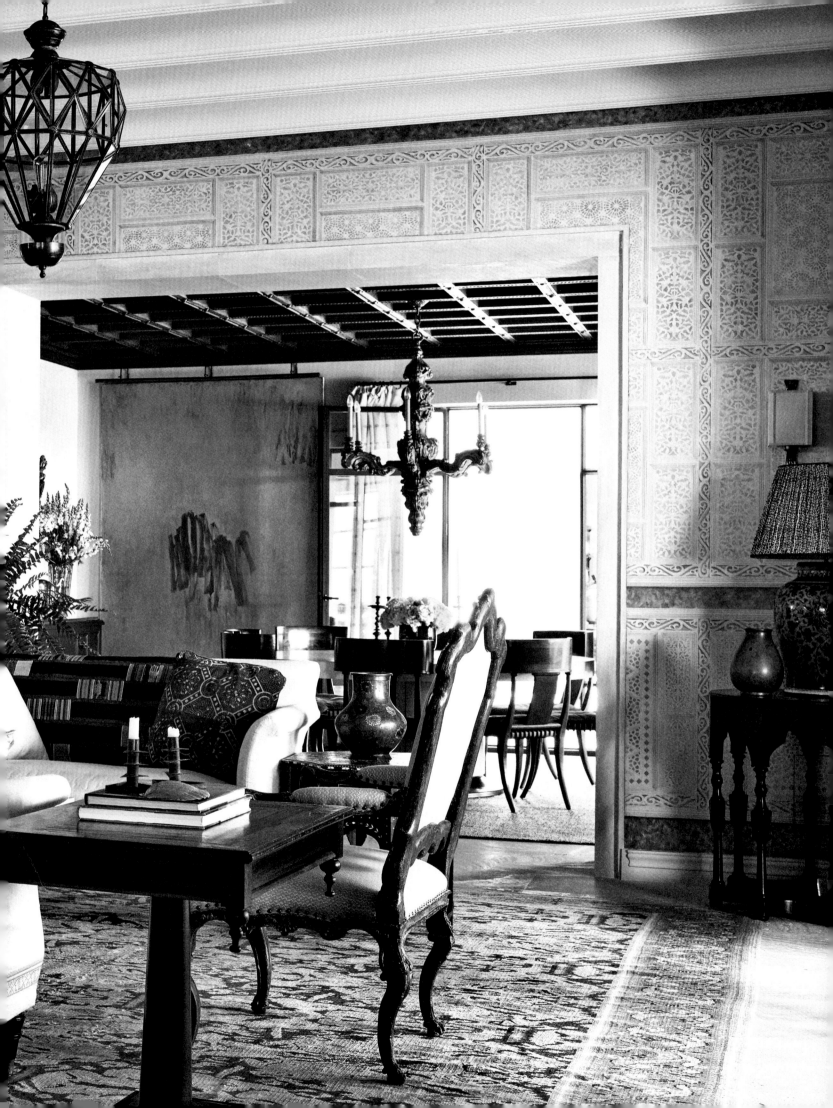

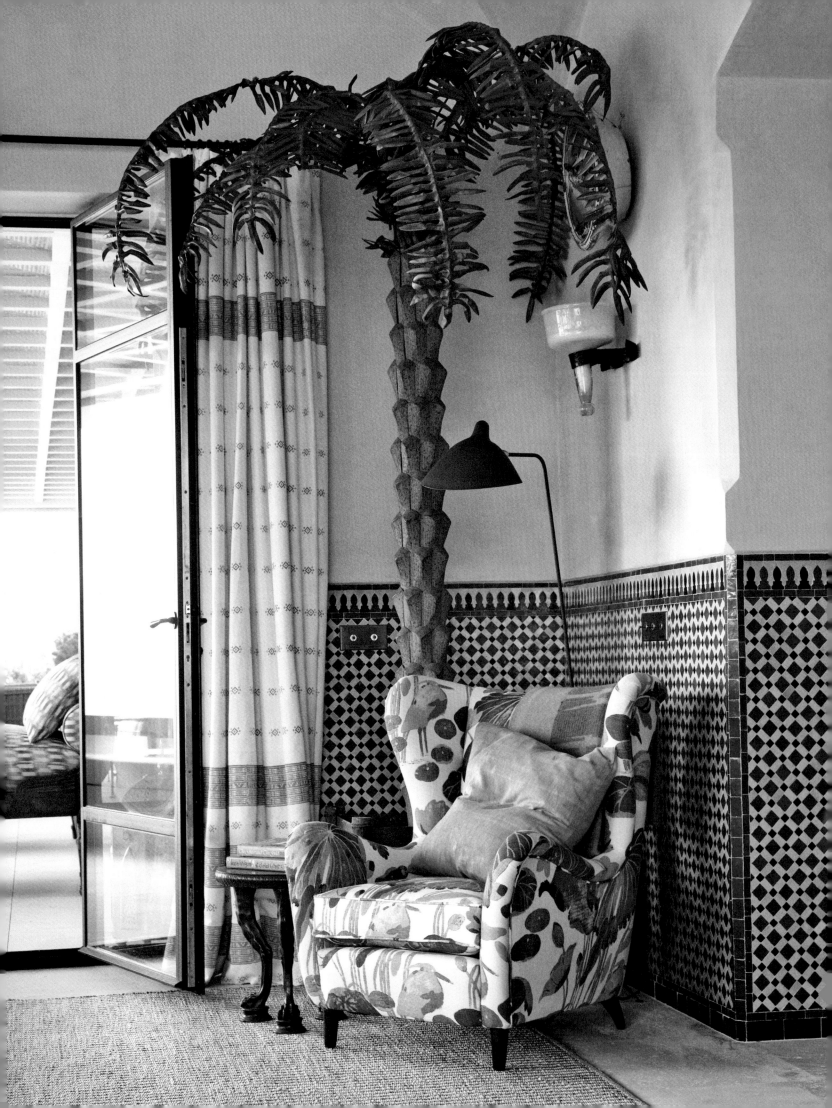

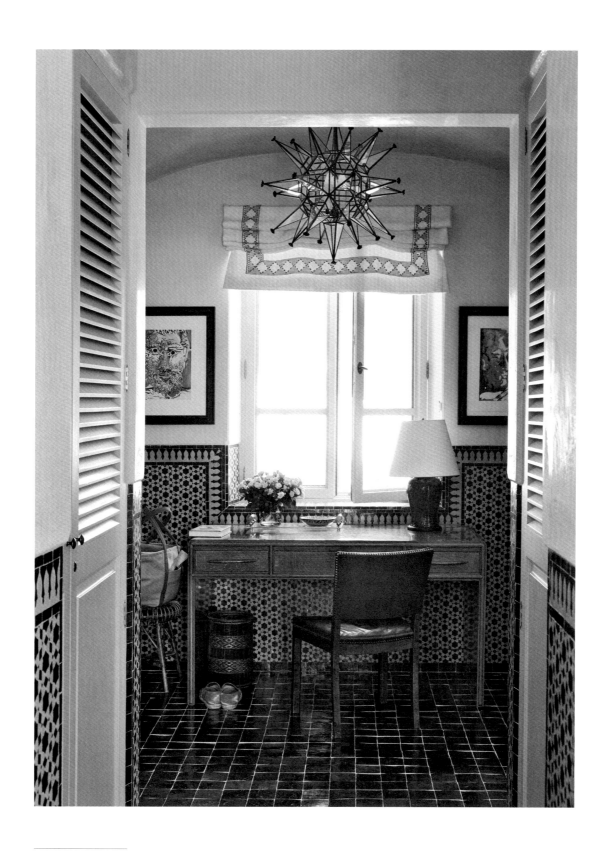

PREVIOUS PAGES: The living room also showcases the Mediterranean's artistic crosscurrents with a bold selection of African textiles and Mallorcan and Moroccan antiques. The multifaceted pendant light is Spanish, and Smith had the walls stenciled with a pattern that echoes the fretwork screens widely used in Islamic architecture from India to Andalusia. OPPOSITE: A chic vintage metal palm stands tall in the winter garden. ABOVE: Easily cleaned and impervious to humidity, this Hispano-Moroccan tile mosaic is as practical as it is beautiful. Two Picasso lithographs flank the window.

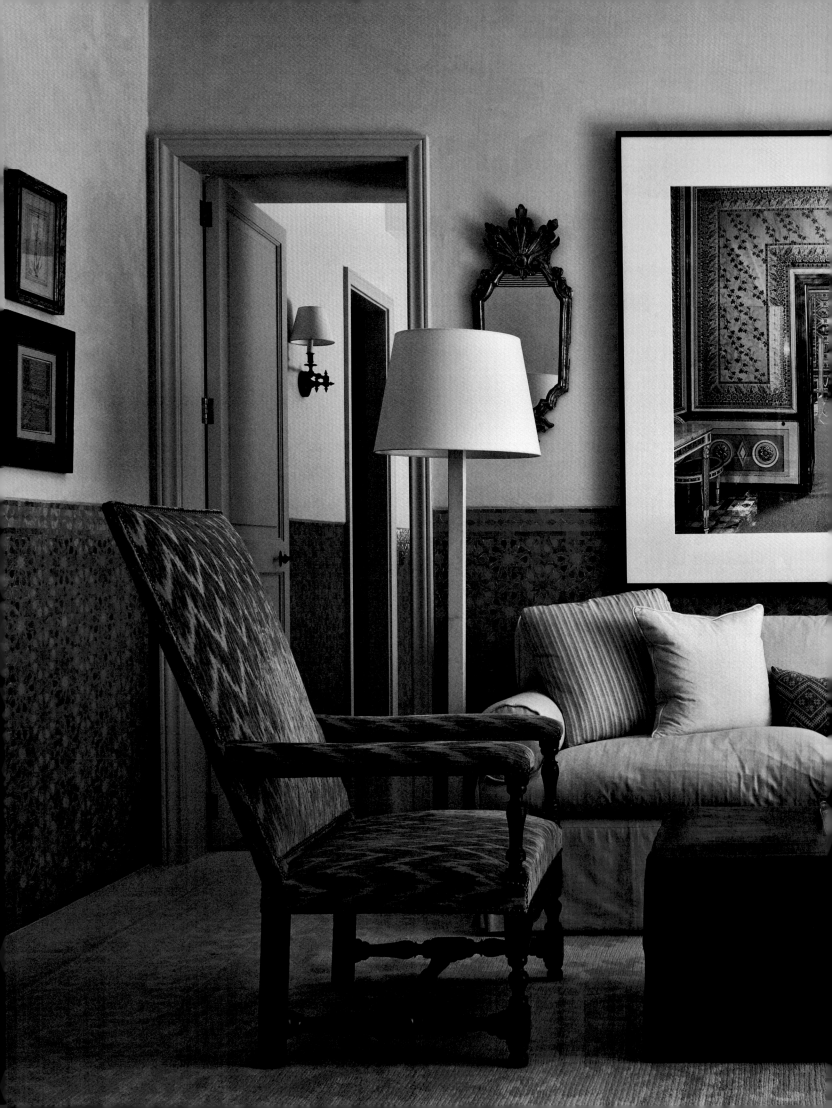

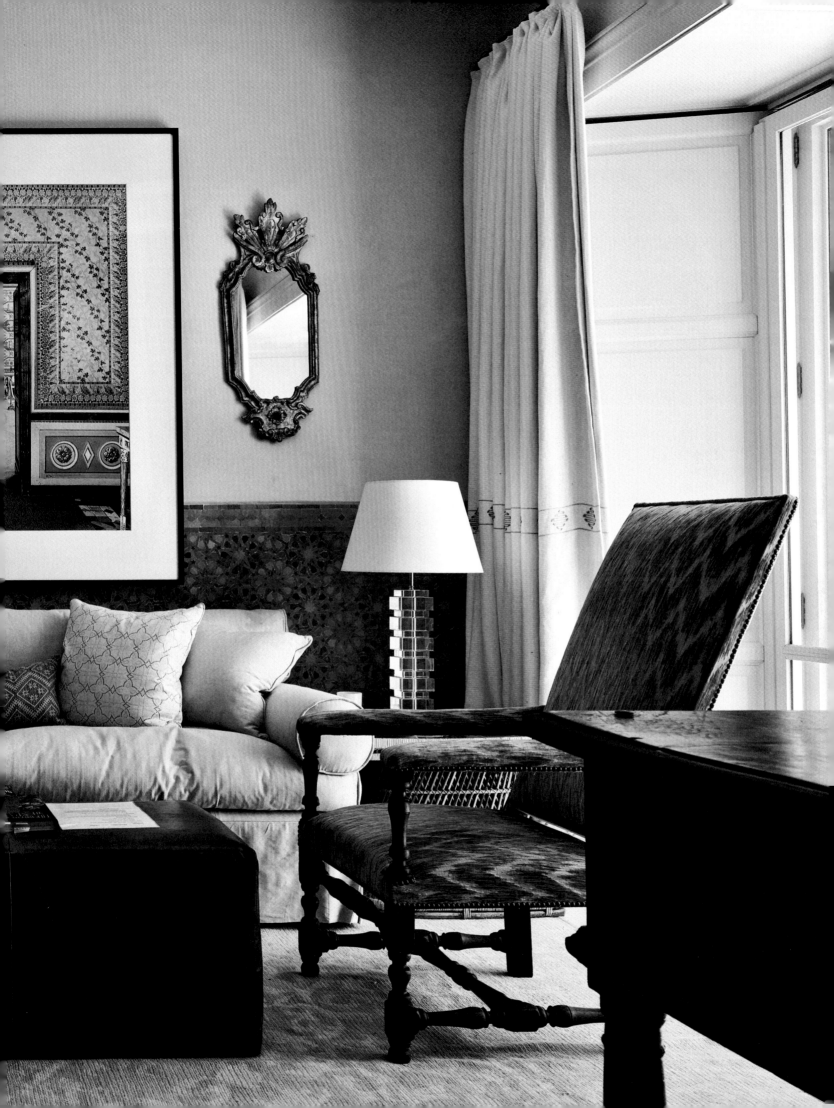

yet snug in cooler seasons, which do occur. In the chilly and wet winter of 1838 to 1839, George Sand and Frédéric Chopin nearly froze on the island, where they had come to try to escape the cold of Paris. In short, they discovered what all Mallorcans know—that the island enjoys all four seasons, and the best houses are prepared for them.

One of the coziest guest rooms has shaggy Berber carpets, a traditional spindle-turned Mallorcan four-poster bed, and a 1950s Italian sofa covered in Mallorcan fabric, all surrounded by wainscoting of a beautifully hand-colored, handwoven Moroccan wall covering. Says Smith, "I loved this wall covering since I first saw it in Morocco. Years later I began to visit historic houses on Mallorca and discovered it had been used there as well."

When Smith positioned the cushioned daybed he'd ordered in another guest room, he immediately lit on 1940s images of a bedridden Henri Matisse in the South of France working on his now famous cut-outs. In an homage to Matisse, the designer had similar forms stenciled onto the natural raffia wall covering. "Matisse was a great portrayer of Mediterranean life," notes Smith. "His paintings of Provence, Algeria, and Morocco have deeply informed our image of those regions."

The Matisse room is one of several bedrooms with carpets Smith made in collaboration with Madrid's centuries-old Royal Tapestry Factory. The royal workshops maintain stores of every thread or yarn ever used to be able to repair damage or wear on any carpets or tapestries they ever produced. In a complete about-face for them, Smith specifically commissioned old-looking carpets that appear faded and worn. "As soon as James was named U.S. ambassador to Spain, I wanted to showcase these legendary workshops any way I could," the designer says. "It took some doing to convince the weavers not to create a perfect product, but my clients appreciate a patina of age and use in the things they collect."

PREVIOUS PAGES: Throughout the primary suite—including this symmetrical sitting area—Smith used a more muted tile wainscoting of his own design so as not to compete with the glorious blues of the sea outside. RIGHT: In a guest room, the bed is a classic Mallorcan spindle-turned four-poster. Smith first encountered the type of vivid handwoven and dyed-grass wall covering used for the wainscoting years ago in Morocco.

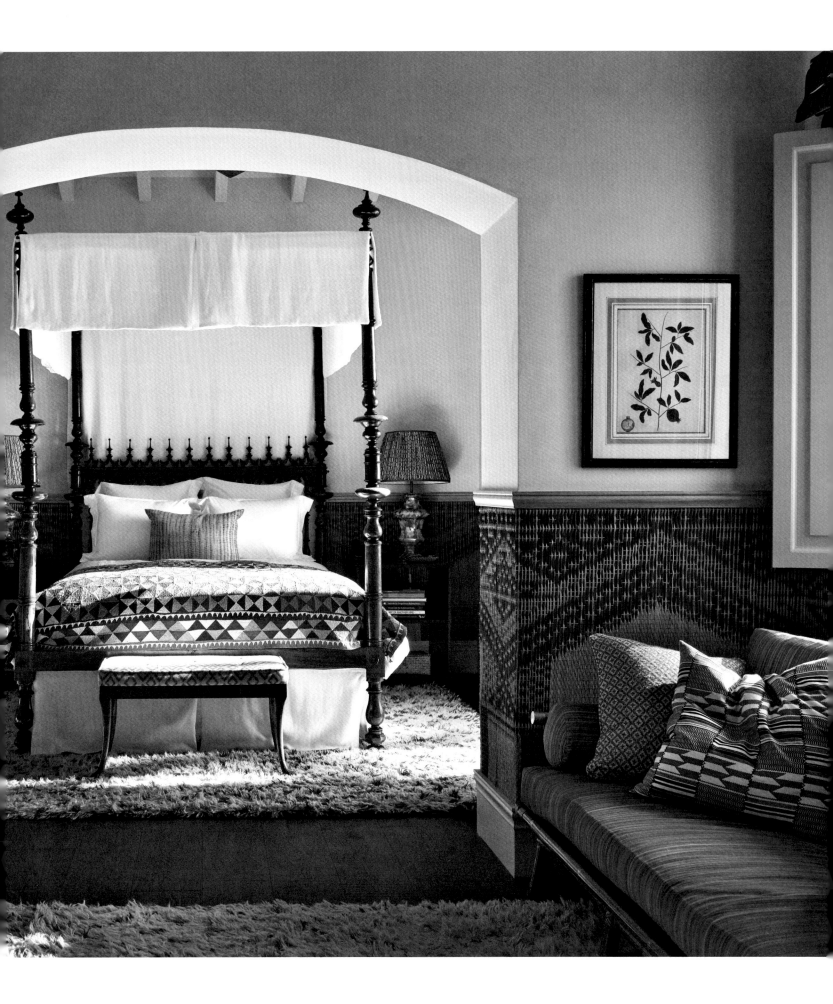

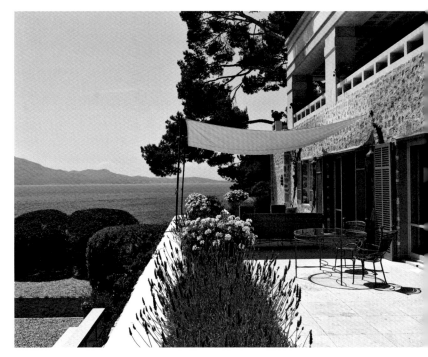

LEFT: For this room, with its stenciled raffia wall covering, Smith was inspired by thoughts of the bedridden and ailing Matisse joyfully creating his famous cut-outs and painting on the walls of his hotel near Nice. Smith designed the rug, which was woven at Spain's 300-year-old Royal Tapestry Factory in Madrid. ABOVE: The home has multiple sea-view terraces.

In the serene primary bedroom, a crisp white canopy bed floats amid a sea of muted blue, gray, and taupe tile mosaic that Smith designed for the room's floor and wainscoting. The colors reflect—but do not compete with—the views of the sea outside, creating a tranquil and meditative atmosphere. The sleek twentieth-century chrome-plated bench at the foot of the bed is just another part of what the designer describes as the home's "mashup of styles, periods, and places of origin so it's not heavy and ponderous—it's still a summer house."

With summer in mind, the eye is drawn down to the seaside, where a winding staircase leads to a small stone platform with several fabulous lounge chairs from Hervé Baume, a manufacturer of outdoor furniture in Avignon. "Whenever we see those stripey chairs billowing in the breeze we remember how much we love Mallorca," Smith says. It's easy to see why.

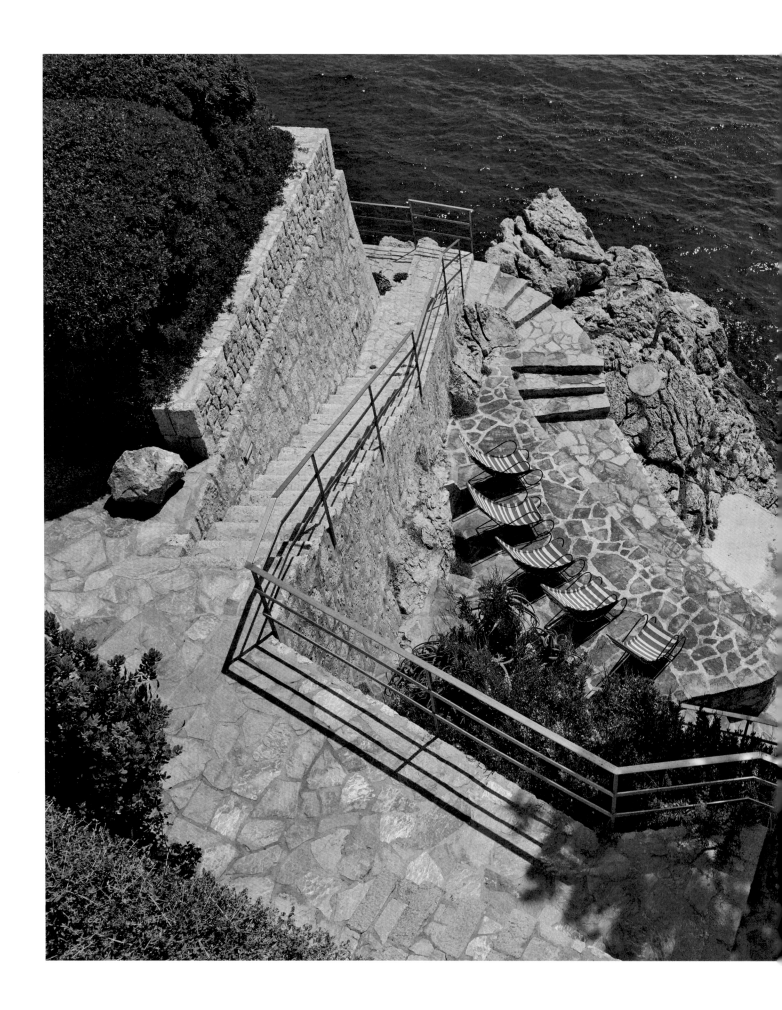

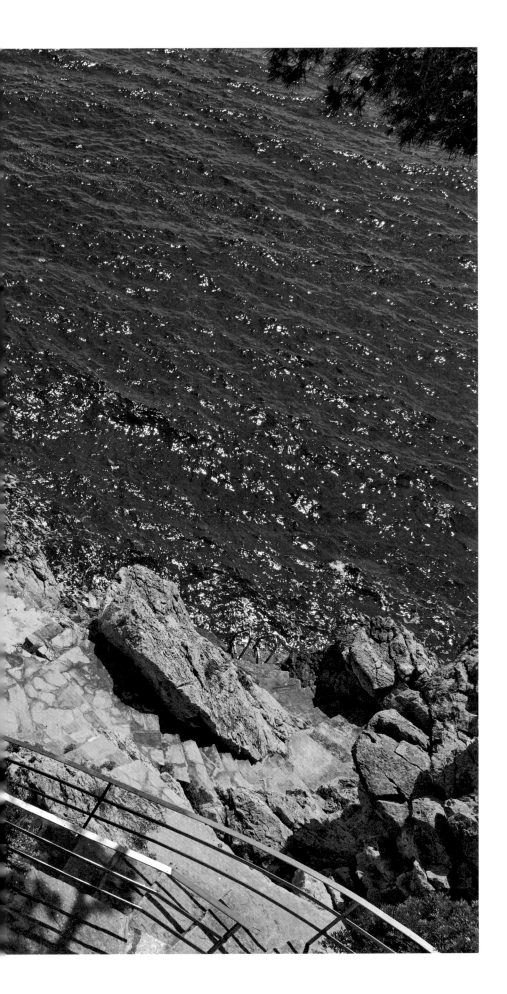

LEFT: One of the home's four access routes down to the sea. Chairs from Hervé Baume. FOLLOWING PAGES: Two views of the passageway in the primary suite: looking into the dressing area and bathroom from the bedroom (left) and looking into the sleeping area with the sitting room beyond (right). Smith drew from his clients' collection of seventeenth-century Iznik and Middle Eastern ceramics to highlight the arch.

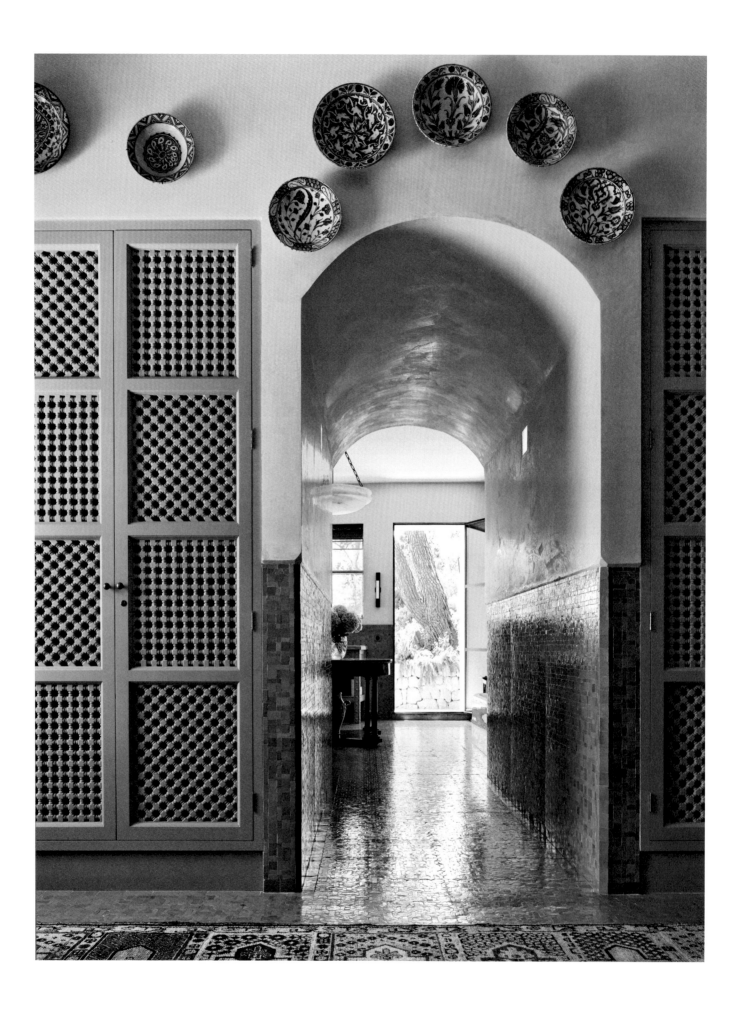

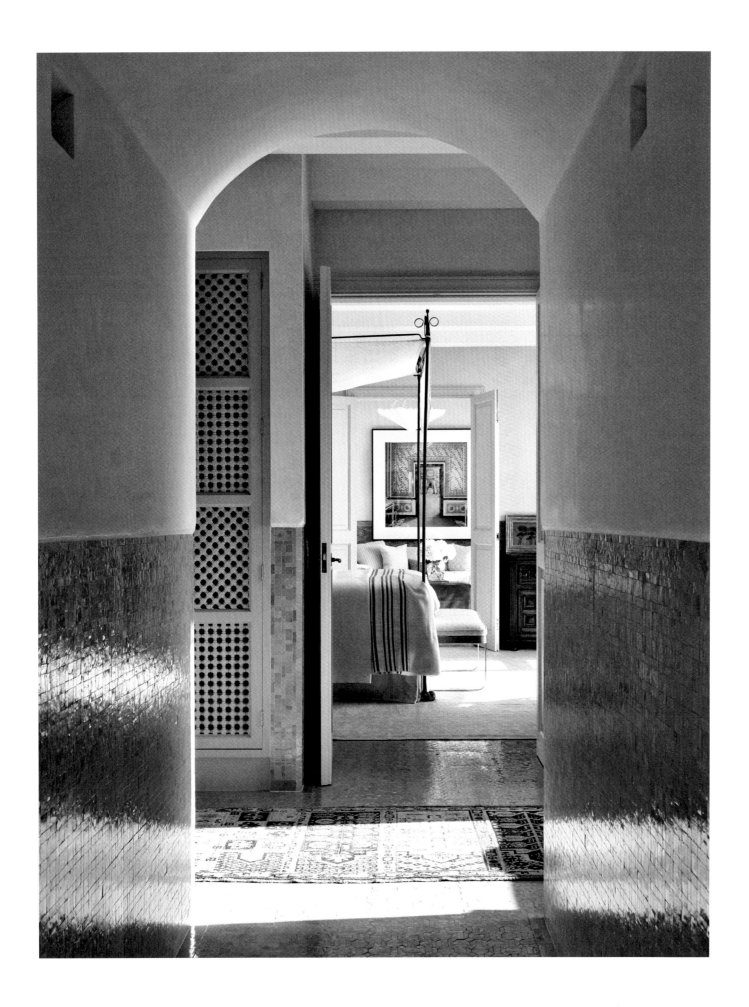

ABOVE: A window in the primary suite offers a glorious view of Alcúdia Bay. OPPOSITE: With its range of whites and woven textures, the primary bedroom has a breezy ephemeral quality. The bedding and hangings are a mix of Ralph Lauren fabrics and local Mallorcan weavings. FOLLOWING PAGES: When the custom sink consoles were first installed in the turret-like primary bath, Smith found they lacked interest, so he ordered some large French nailheads and had them hammered into the legs and painted to simulate carving and give the cabinets patina.

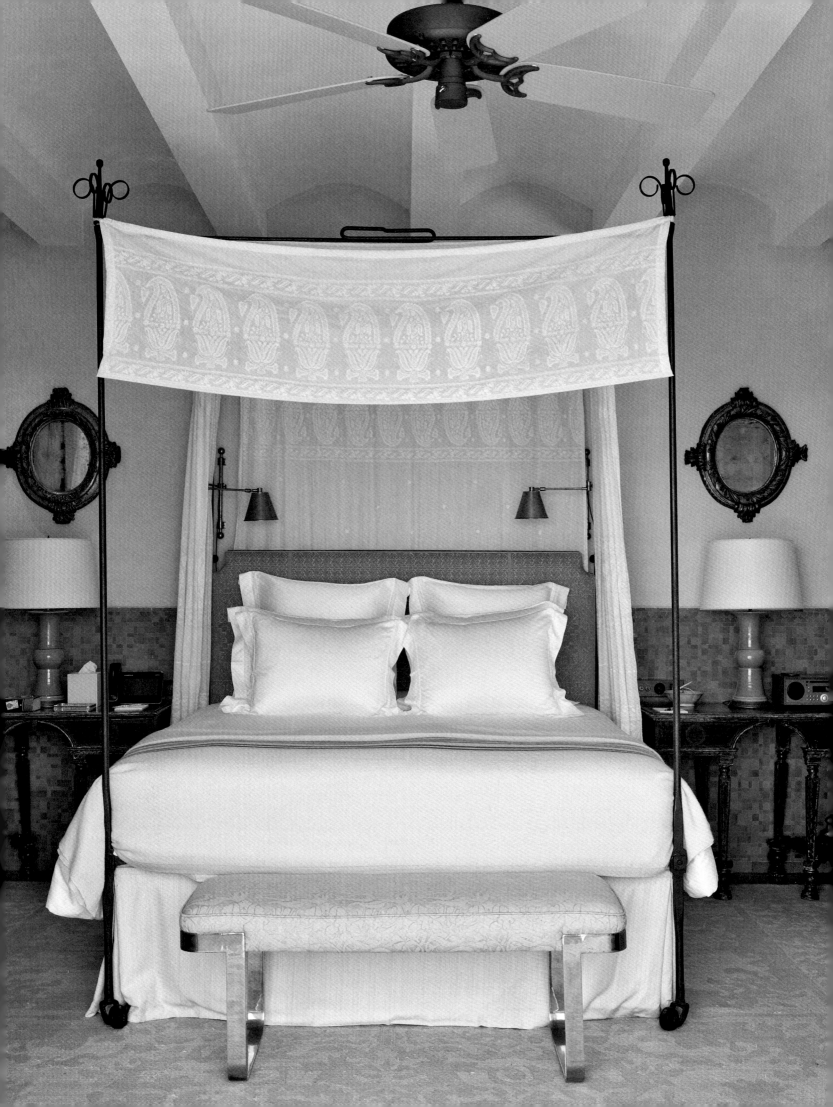

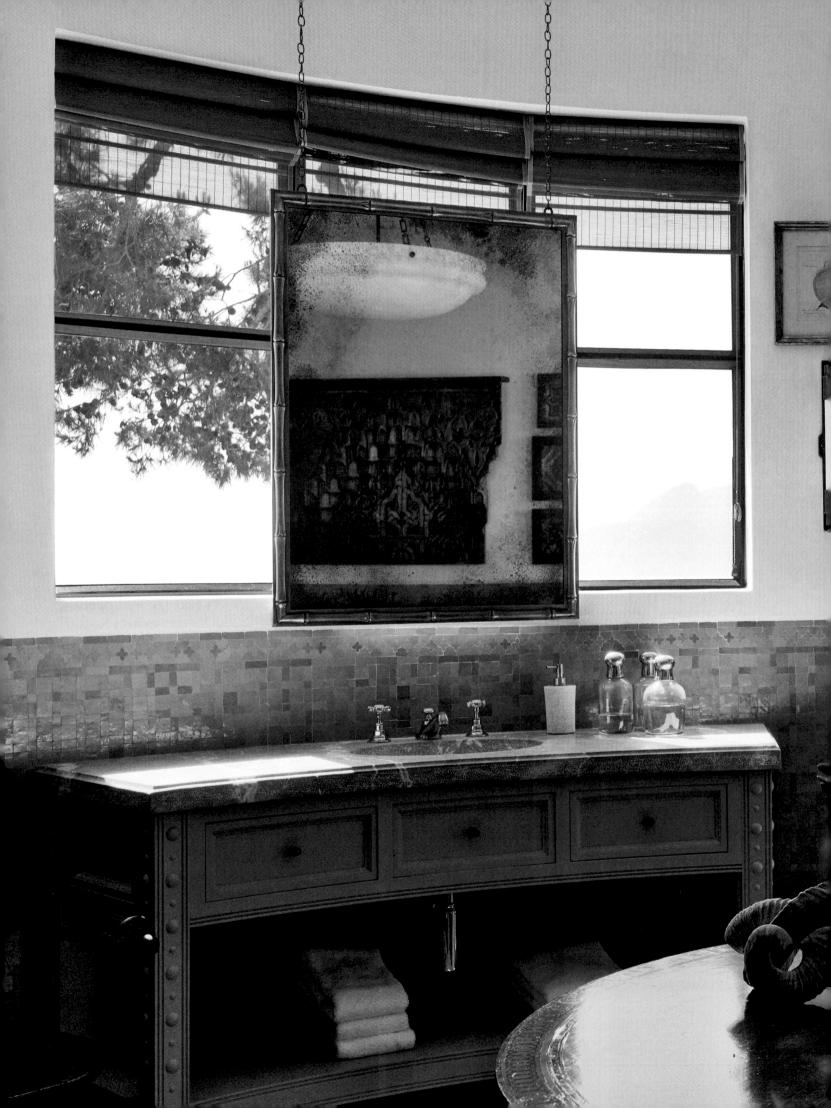

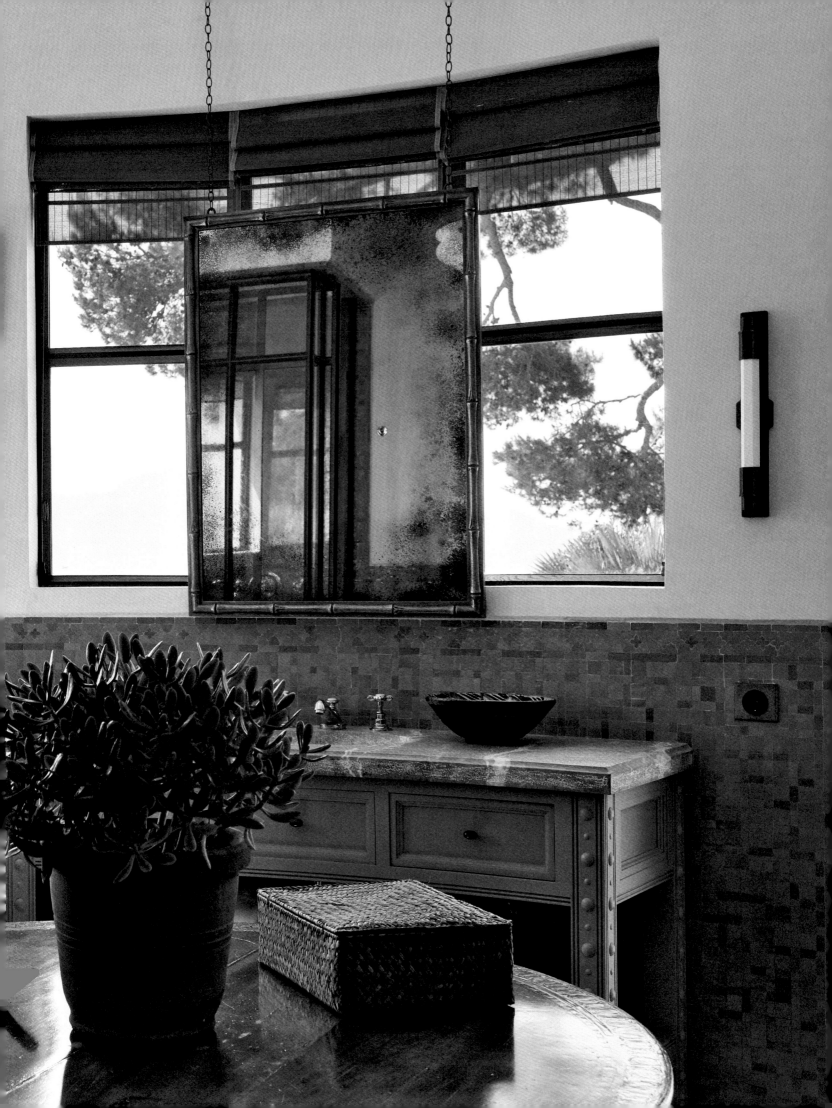

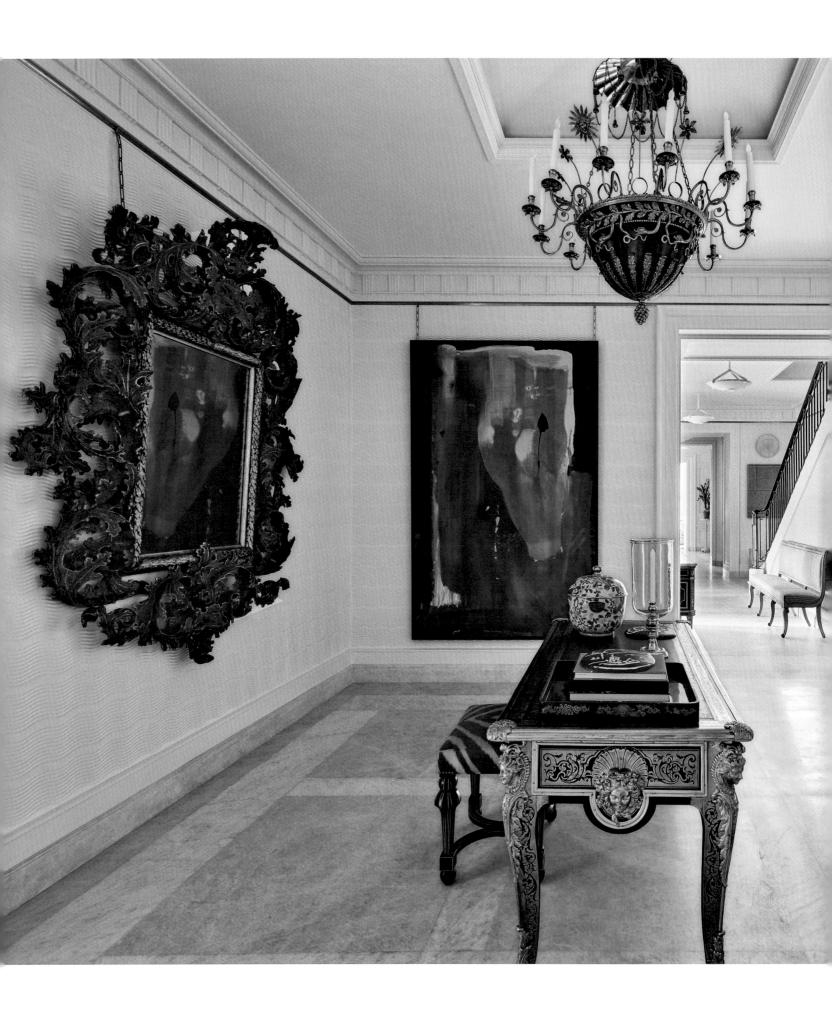

PREWAR
DUPLEX
NEW YORK CITY

THIS IS THE STORY OF THE FANTASTICALLY grand uptown Manhattan apartment that almost wasn't. Since the 1980s, two adjacent duplexes, each with its own grand curving staircase, in a coveted 1920s Rosario Candela–designed building had been awkwardly linked together. Their former owners, a media mogul and his wife, had connected the two but had never fully integrated them into one home. When the husband passed away, his widow listed the property at a jaw-dropping, head-line-grabbing price befitting a prime chunk of Manhattan real estate that had been off the market for decades.

Smith says the two apartments were "connected by two little doors—one upstairs and one down." The experience was one of living in a private house, but also having keys to the neighbors' place. Unsurprisingly, it lingered on the market.

"Everyone—including some of the smartest, most successful people in New York—saw the apartment," Smith recalls. "But no one bid because it seemed perpetually destined to remain two side-by-side apartments, largely due to the placement of the second staircase at the center of the combined units. When my clients bought it, they actually received a note from a very high-profile person saying, 'Congratulations on the purchase of your new apartments; too bad you'll never be able to connect them.' But architect Oscar Shamamian and I asked, 'Can't we just move that staircase?'"

The answer was yes, they could, and when they did, the designer says, the floor plan clicked into place. "Because of the reverence people have for a Candela-designed building, I think prospective buyers felt it was sacrosanct and unalterable—no one had hit on the solution in nearly forty years. Once we moved the staircase—which, admittedly, required a massive renovation—the

domino effect on the layout was tremendous, and the result is very much in line with the essence of a great Candela design."

It took four years to renovate and decorate. With the two units now graciously integrated into one sensible layout, the vast eight-bedroom duplex is a visual feast of luxurious and ingenious wall coverings, textiles, ceiling treatments, and art from the Roman and Byzantine eras through today. Since the clients had sold their previous Manhattan home, a glamorous apartment on Central Park South, as well as another house they'd owned for years, Smith had access to lots of beautiful things from earlier homes he'd designed with them. He says, "All the jewels acquired over the previous twenty years migrated to this apartment. Though we've introduced lots of newly acquired pieces and the clients have become much more significant collectors of contemporary art, it's still sort of a 'greatest hits' house from decades of design collaboration and shopping forays."

When the new staircase opened up the center of the apartment, Smith became obsessed with what to do with the vast expanse of walls in the entry hall, which had more than doubled in length to about seventy feet long. "I'd seen images in *The World of Interiors* of this wavy sculpted plaster at a coffeehouse in Padua from the Napoleonic era—it was a random connection, but there's a commonality between the wave pattern and the subtle art deco details of Candela's façade for the building."

The wavy sculpted wall treatment ties the hallways and other spaces of the home together. Smith adds, "That plaster detailing on the walls is a testament to the bond I share with the team at Ferguson & Shamamian, both personally and professionally after so many years and projects, because they're always enthusiastic about trying new things and allowing me to explore novel concepts."

The impressively grand and intricately carved Italian mirror and gesso console in the entry contrast with the smooth, polished surface of the French Boulle desk in the center of the room, not to mention the lyrical abstract paintings by Americans Helen Frankenthaler and Agnes Martin. "I love playing with modernity and formality where these disparate objects are treated more like sculpture—as individual objects, not just elements of decor," the designer says.

The living room is equally heterogeneous—a treasure trove of items placed together, like the back-to-back custom sofas that anchor the room and a large Franz Kline painting that has followed the clients from home to home. Standout pieces from world cultures include a Russian neoclassical table, a Chinese Tang Dynasty horse, a richly hued nineteenth-century Savonnerie rug, and a small Alexander Calder sculpture. The buttery yellow Josef Albers painting *Homage to the Square*, previously in the collection of Swiss actor Maximilian Schell, was bought specifically to hang in its prime perch over the fireplace, which is flanked by two stunningly tall Boulle cabinets from Galerie Kugel in Paris. All of it is wrapped in chalky white paneling created by Féau Boiseries, a storied French firm with which Smith works frequently.

As one of the apartment's previous owners worked in media, they had combined a dining room and a library into a screening room. That vast space is now the family room. Smith clad it in a deep cognac-colored rattan wall covering, painstakingly stenciled in a dense pattern based on an antique textile panel from Borneo. It makes a strikingly exotic backdrop for artworks by Pablo Picasso and Louise Nevelson and a lushly painted canvas from Richard Diebenkorn's *Berkeley* series that hangs above the fireplace.

Other rooms also sport sumptuously elaborate wall treatments: the snug and silvery bar has a chic Emilio Terry chimneypiece and walls covered in a delicate veneer of mica, giving the room an ethereal glow. The dining room's bleached oak paneling is based on a room in the Guerlain family home outside Paris. Smith has taken it down a notch by hanging a large 1960s Frank Stella painting almost the same color as the wood across the better part of one wall. "It's a very tonal room," he says, in reference to the range of tobacco browns, including the hue of the bronze Claude Lalanne candelabra.

And the designer brought nature into the master bedroom with a verdant Zuber wallpaper of arcadian scenes and a custom bronze Carole Gratale bed that appears to be made of slender, carefully pruned tree

PREVIOUS PAGES: By relocating a staircase, Smith and architects Ferguson & Shamamian created a palatial entry hall measuring nearly seventy feet long. The painting next to the doorway is by Helen Frankenthaler, and an Agnes Martin painting hangs over a small Matisse sculpture atop a console. The 1820s gilt-bronze light fixture is from Galerie Perrin. OPPOSITE: Lessons on precision and perfection in craftsmanship: A large-format *Homage to the Square* by Josef Albers hangs above the fireplace and beside an exquisite Boulle cabinet from Galerie Kugel in Paris, one of a pair.

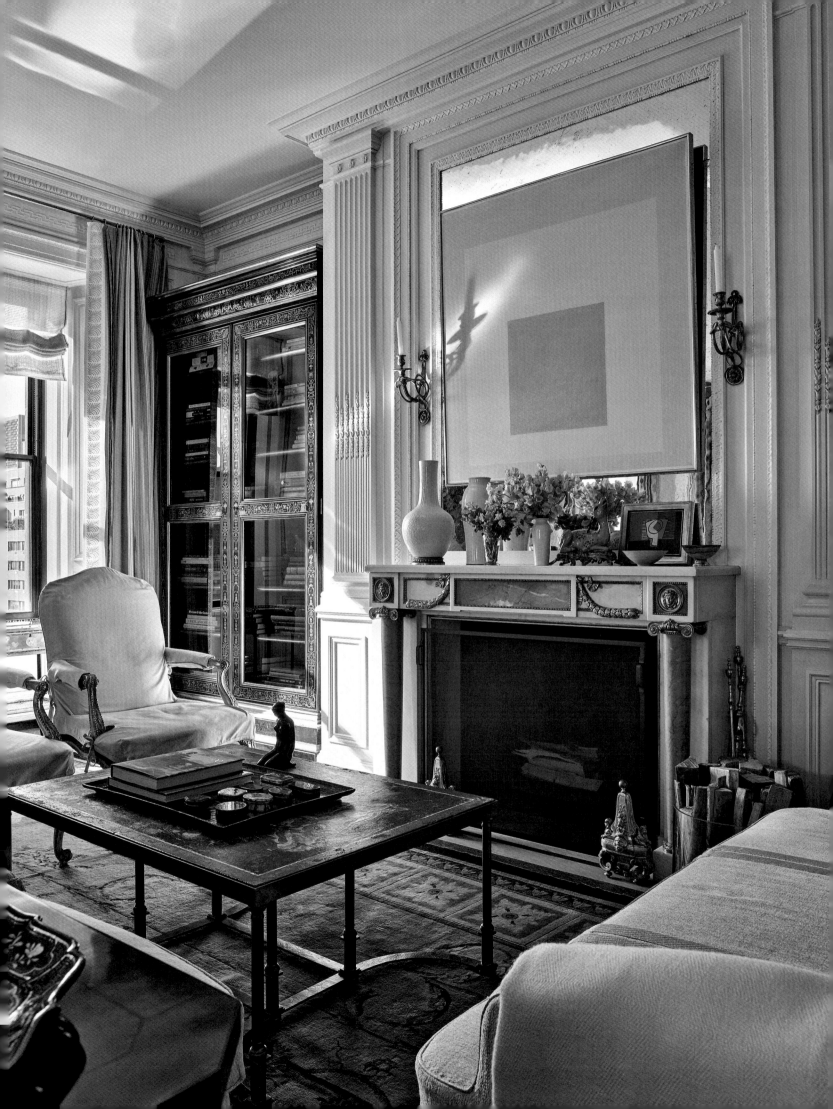

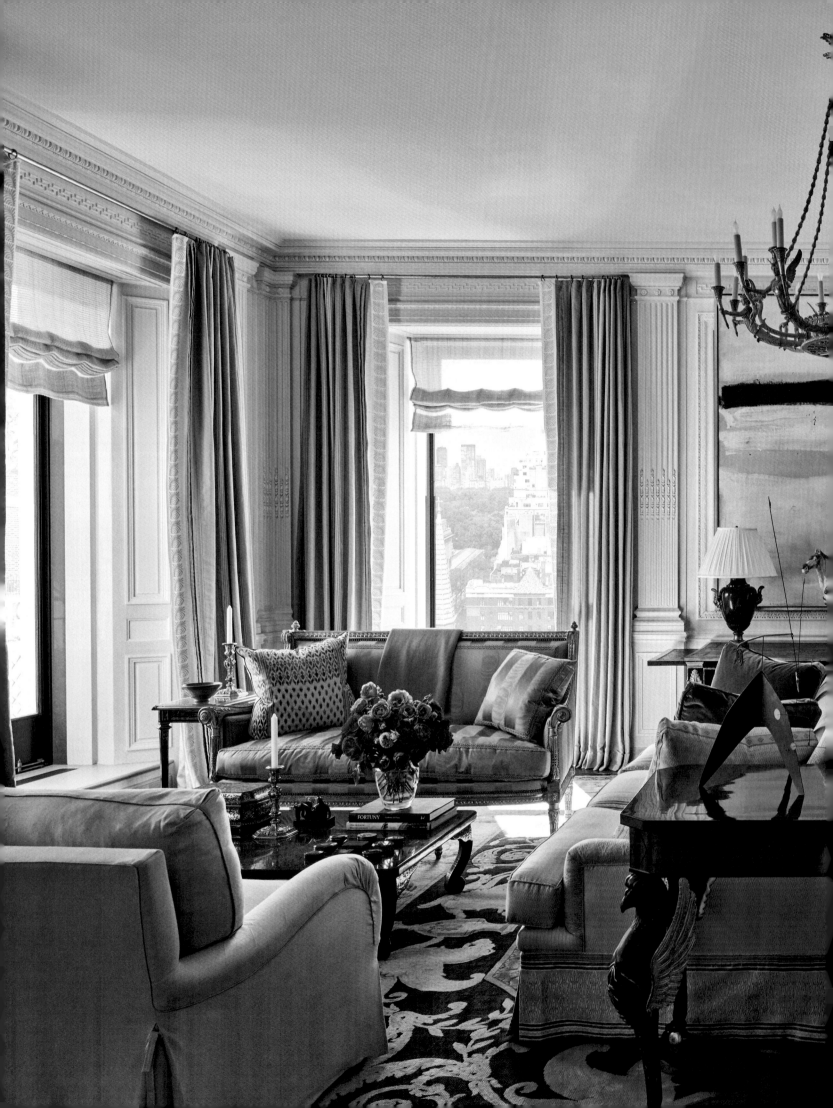

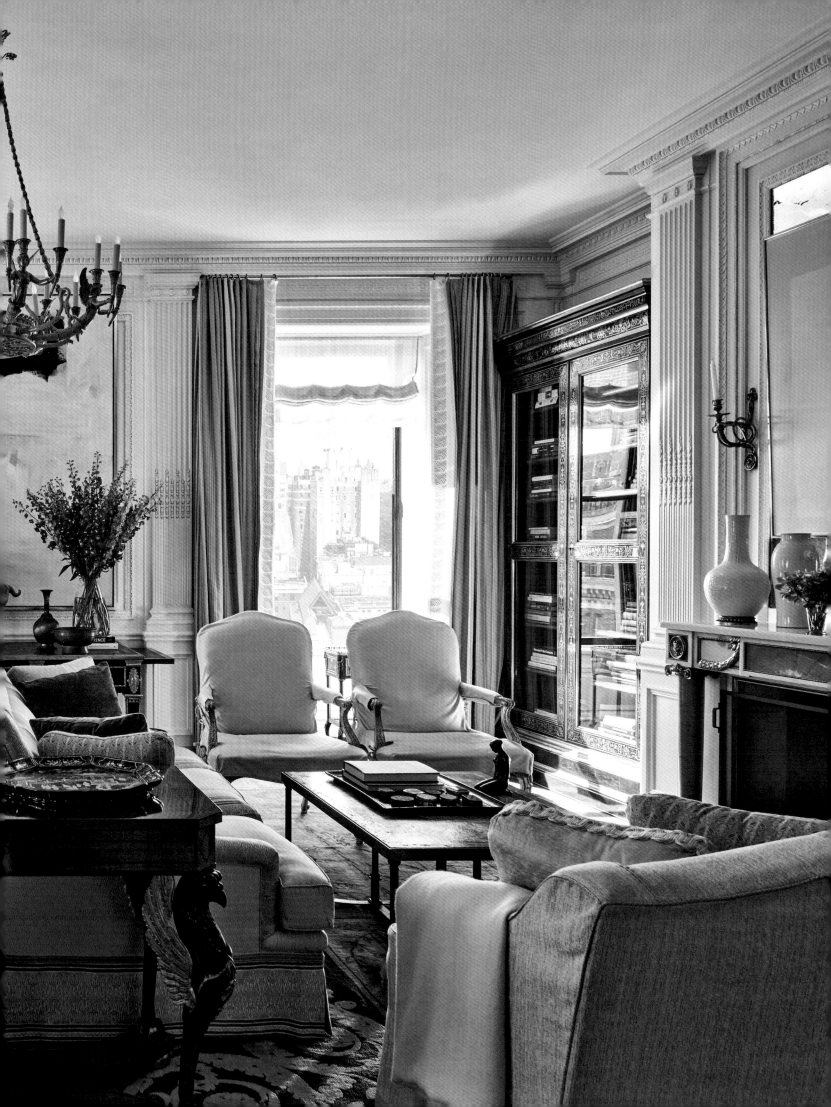

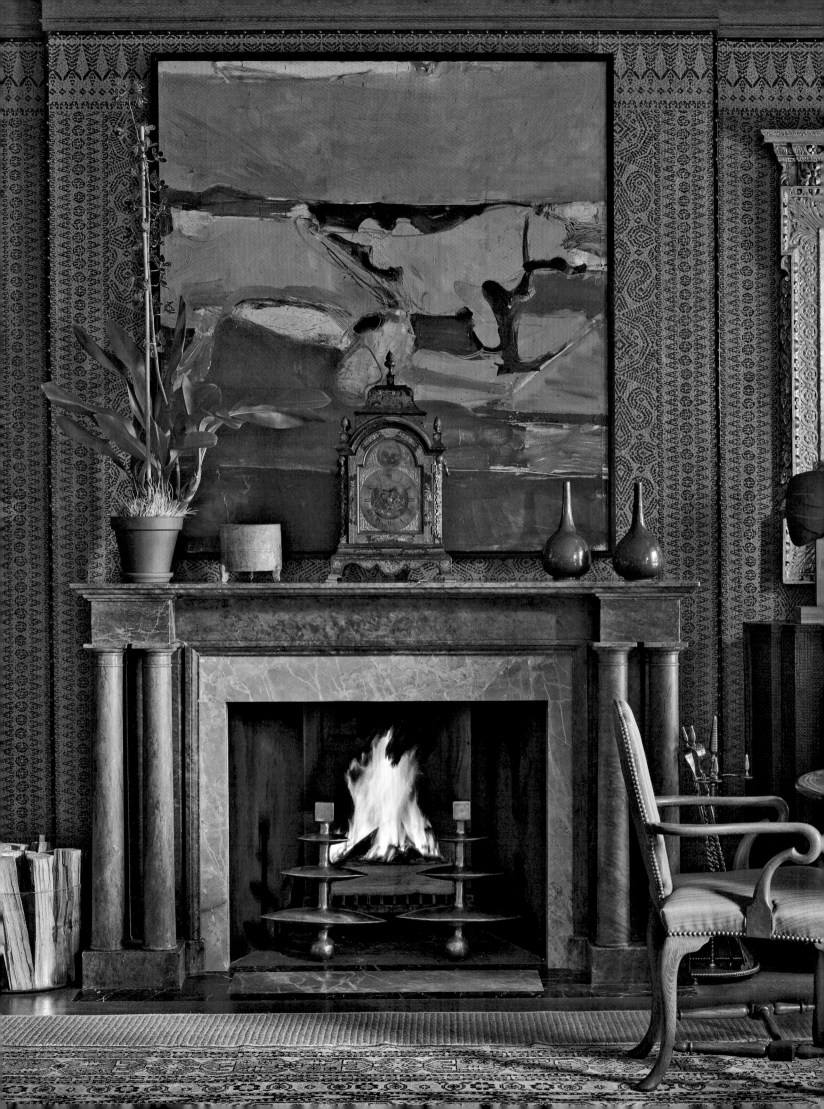

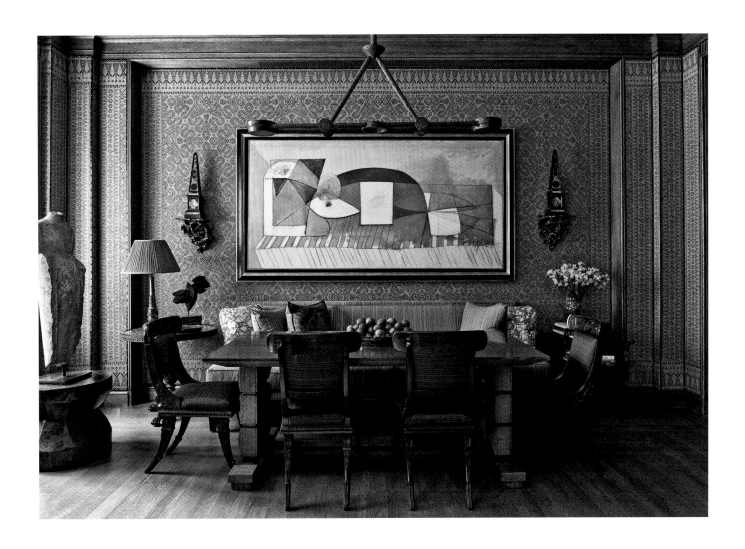

PREVIOUS PAGES: The main living room hosts multiple seating areas and is wrapped in chalky white paneling by Féau Boiseries in Paris. Between the cabinets, a gilt bronze chandelier, and a Russian neoclassical table—as well as an oxblood Savonnerie carpet—the room whispers regal elegance. A painting by Franz Kline and a small Alexander Calder sculpture add a touch of twentieth-century modernism to the room. OPPOSITE: A stunning canvas from Richard Diebenkorn's *Berkeley* series hangs above the neoclassical fireplace. The Samuel Marx andirons were bought from Wright Auctions. ABOVE: Smith encased the large family room in a rattan wall covering in a warm cognac color that he had hand-stenciled with an intricate pattern. It is the perfect foil for Picasso's crisply linear reclining figure, which hangs above a custom sofa in Fortuny cotton.

trunks. The wife's sparsely furnished dressing room has a shimmery silver-leaf ceiling, mirrored closet doors, and a Paul Frankl daybed. By contrast, the husband's dressing room—which has its own fireplace—suggests a nineteenth-century cabinet of curiosities. Smith had his client's collection of Indian miniatures mounted behind glass on silk backing and inset on the closet doors. An incredibly distinctive marble he says "none of us will ever see anywhere again" tops the dresser, and the assemblage of rarefied objects suggests that it's the husband who has the passion for collecting.

"What's so wonderful about this apartment is that it feels like a house," enthuses Smith. "The bedrooms are upstairs and the kitchen, dining and living rooms, and that huge family room are downstairs. It's like you picked up a house and put it on top of a building." Whatever you call it, it's an only-in-New-York story.

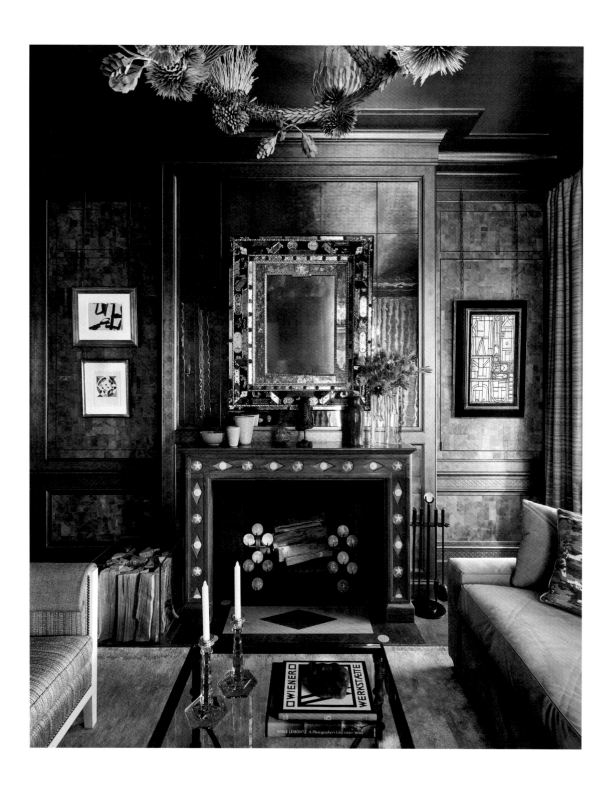

ABOVE: This cozy room is almost a perfect square, and Smith played off its clubby feel and made it a bar. The extraordinary mica-veneered wall covering gives it a smoky atmosphere, and the rare Emilio Terry chimneypiece makes it feel like someplace special, as does the intimate Joaquín Torres-Garcia painting at right. OPPOSITE: The bar's dramatic uptown views are almost as striking as the masterpieces contained within, such as the eighteenth-century Venetian marble panel with a rhythmic pattern located between the windows. The custom forged-steel chandelier by Junko Mori came from Adrian Sassoon Gallery. FOLLOWING PAGES: The sunroom serves as an alternate dining room and was among the new spaces created by integrating the two duplexes into one home. The ceiling, from which hangs a Philippe Anthonioz lantern in a plaster finish, is both silver-leafed and mirrored. The table is by Hervé Van der Straeten, and at right is a work by Brice Marden.

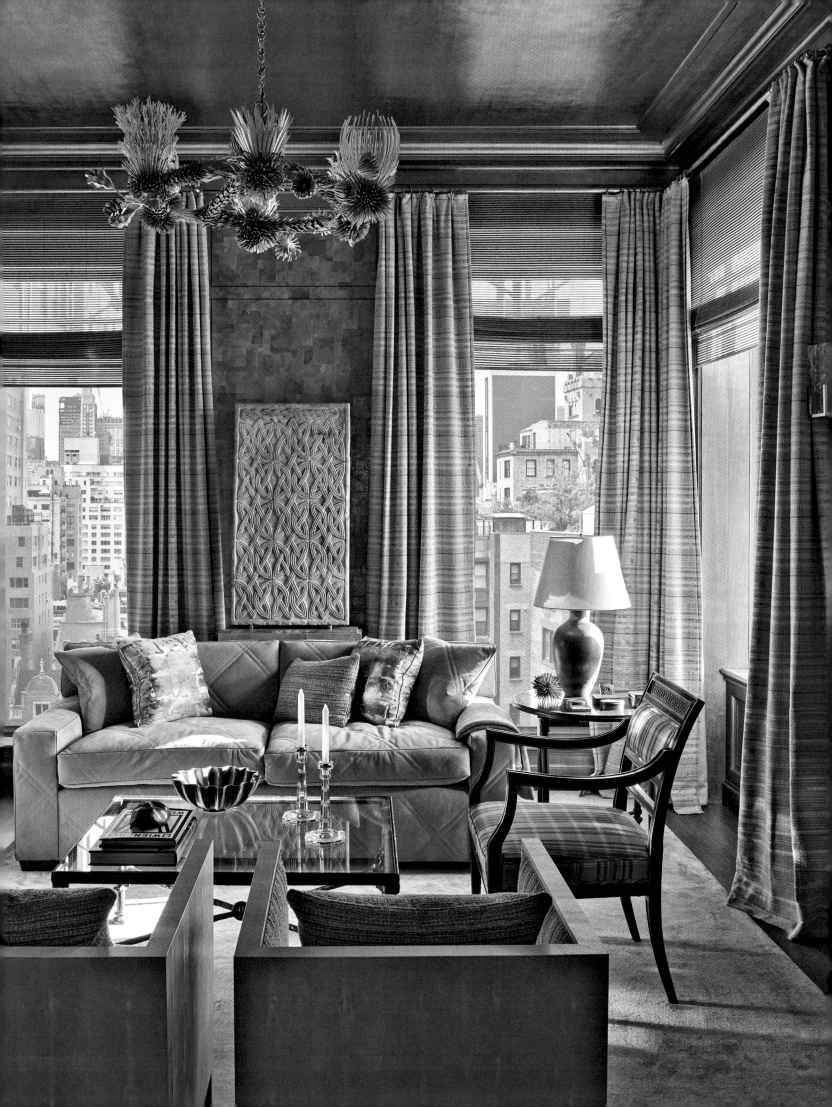

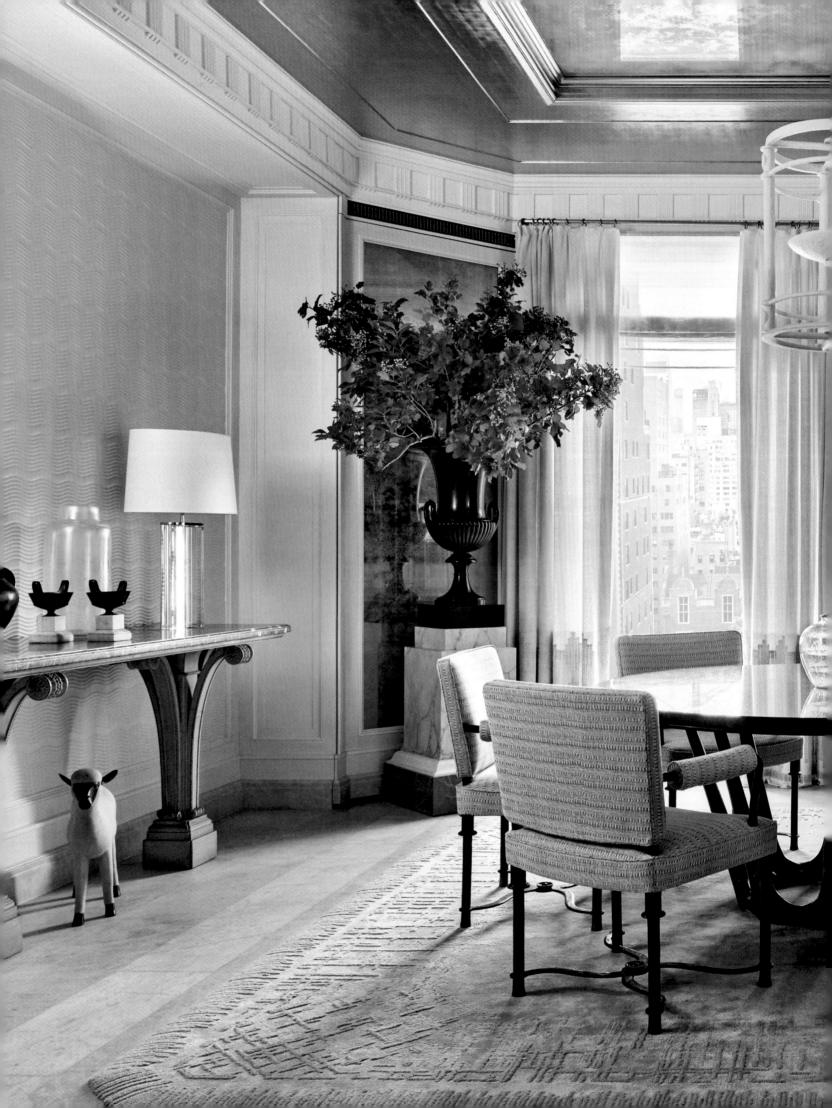

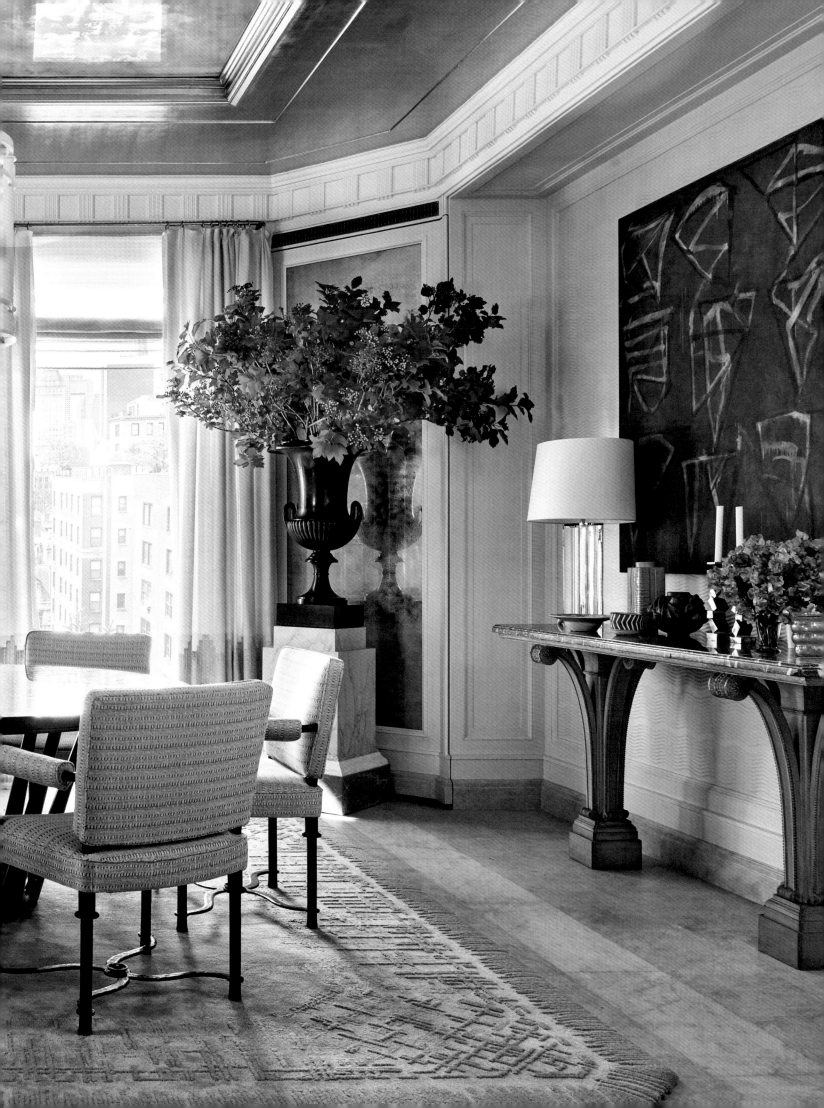

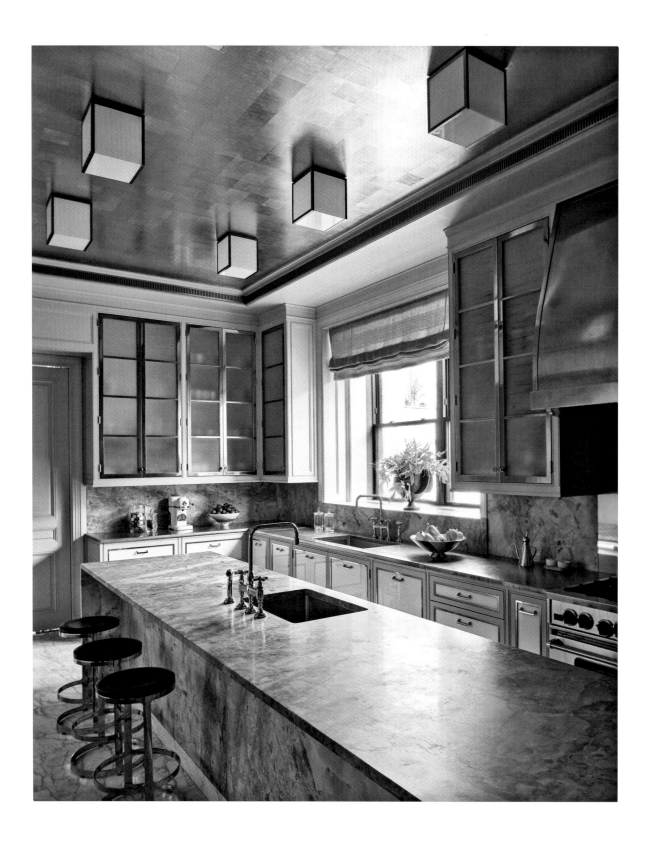

ABOVE: Smith firmly believes a kitchen should be as beautiful as any other room in the house. Here he gave the ceiling pewter-leaf shimmer to reflect the striking Jean Perzel cube lights. OPPOSITE: The breakfast room provides a spot for more intimate gatherings. Artist Nancy Lorenz created the stunning opalescent gesso and metallic-lacquered panels behind the nineteenth-century Italian settee.

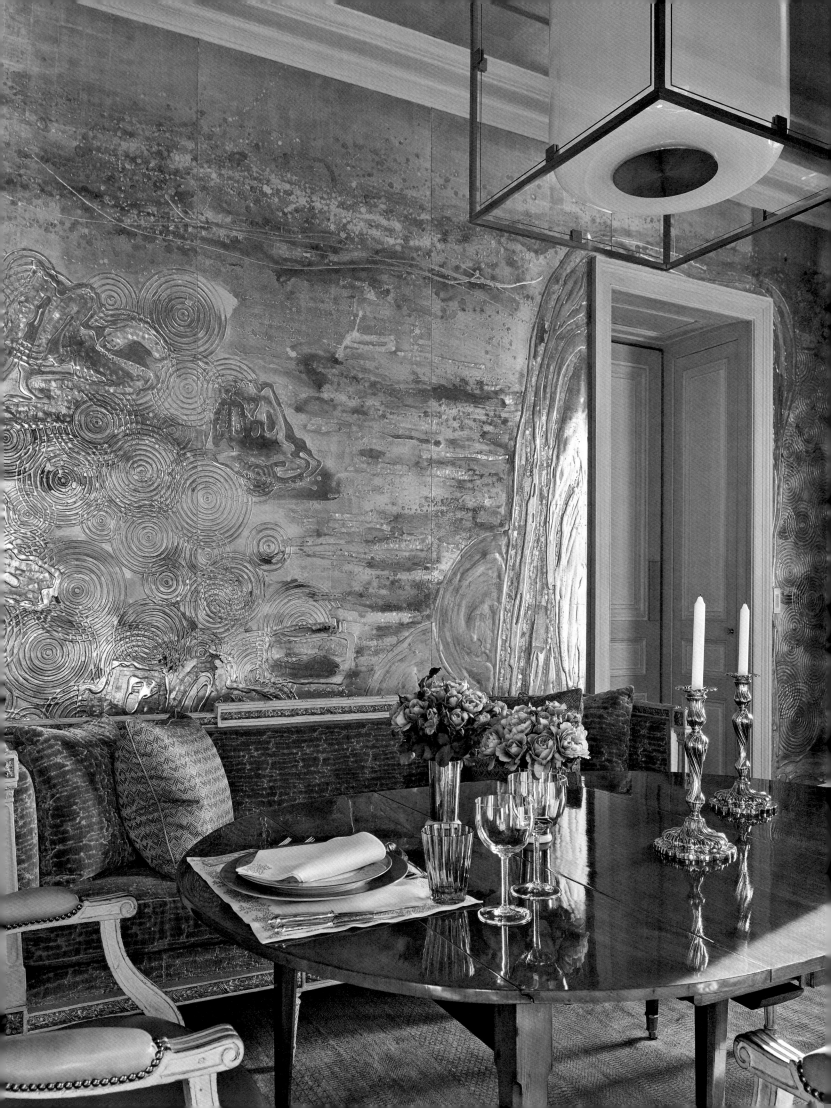

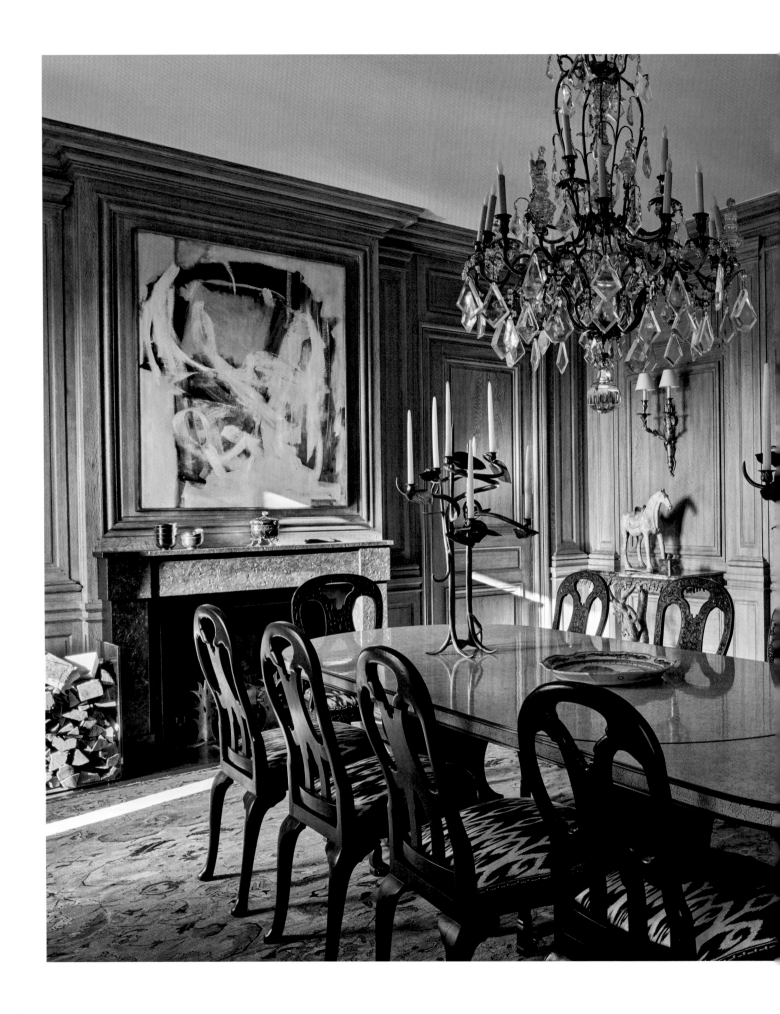

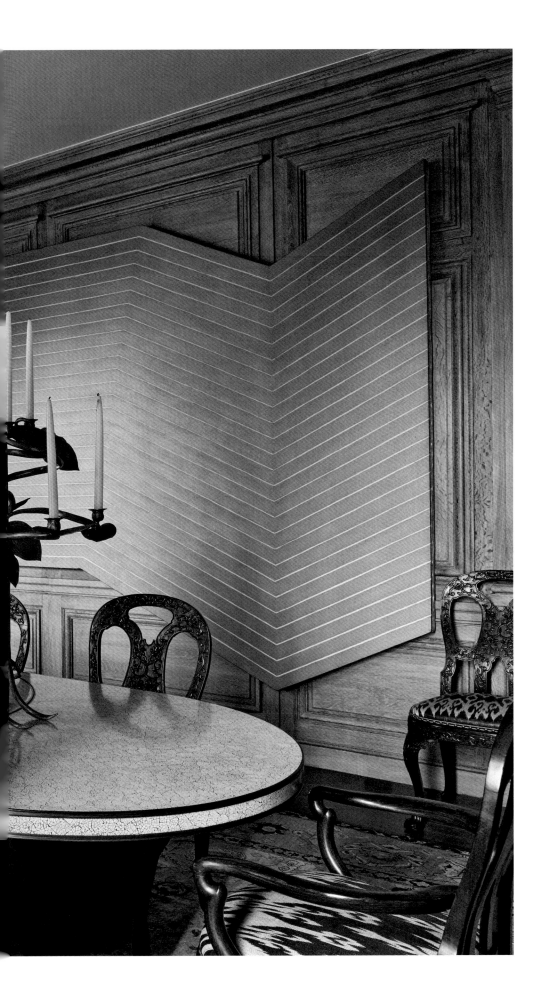

LEFT: Bronze Claude Lalanne candelabra stand atop Smith's custom-designed eggshell lacquer-topped table, which can cleverly be converted to two smaller tables. The Queen Anne–style chairs were made in China for export; Smith and his clients collected them over time and eventually amassed sixteen. The large monochromatic painting at right is by Frank Stella and the work above the fireplace is by Peter Lanyon. PAGE 132: In the library, a portrait by Joseph Wright of Derby hangs proudly over the fireplace between two towering bronze bookshelves teeming with volumes and collectibles. PAGE 133: The husband's dressing room is a *Wunderkammer* of exquisite objects.

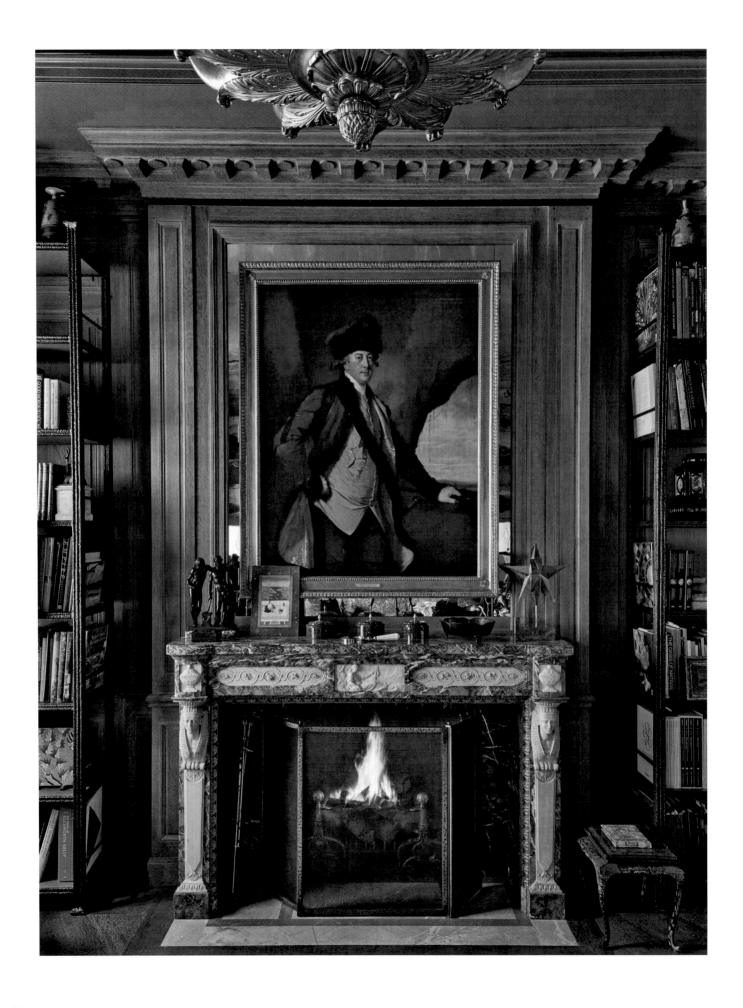

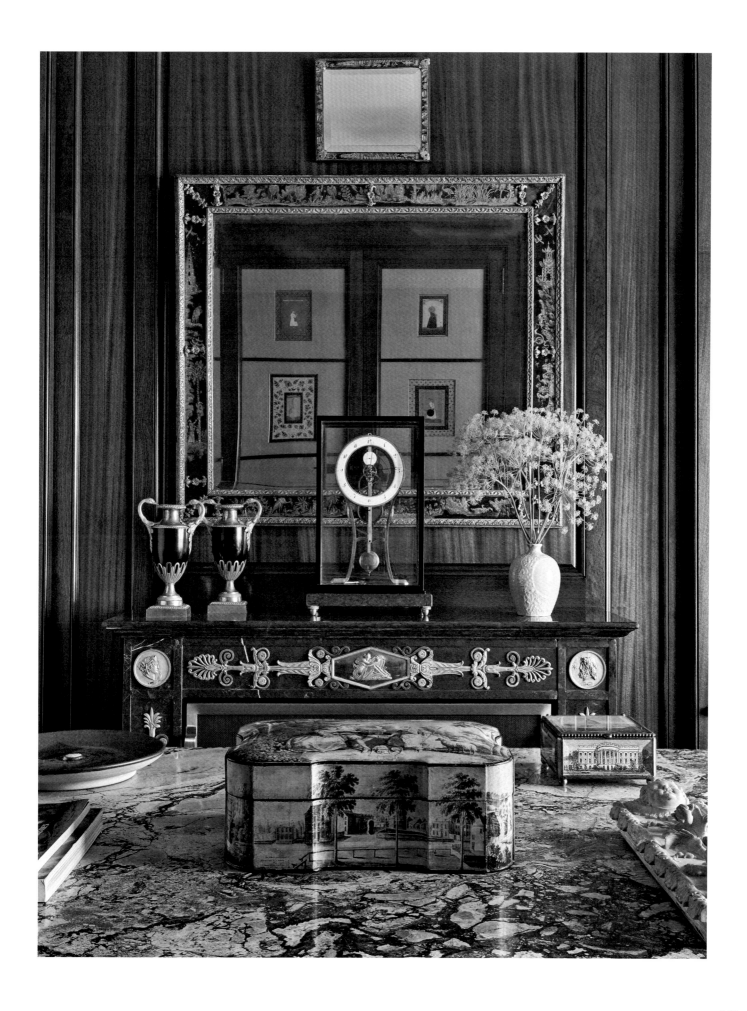

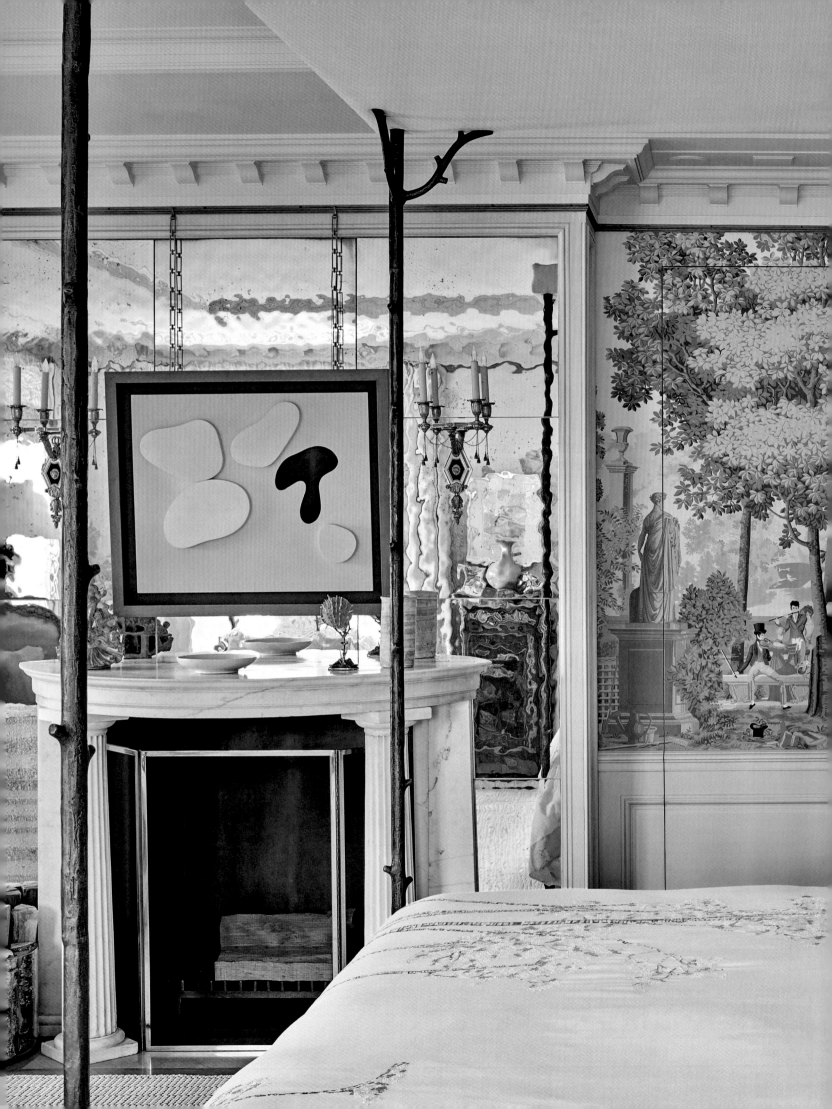

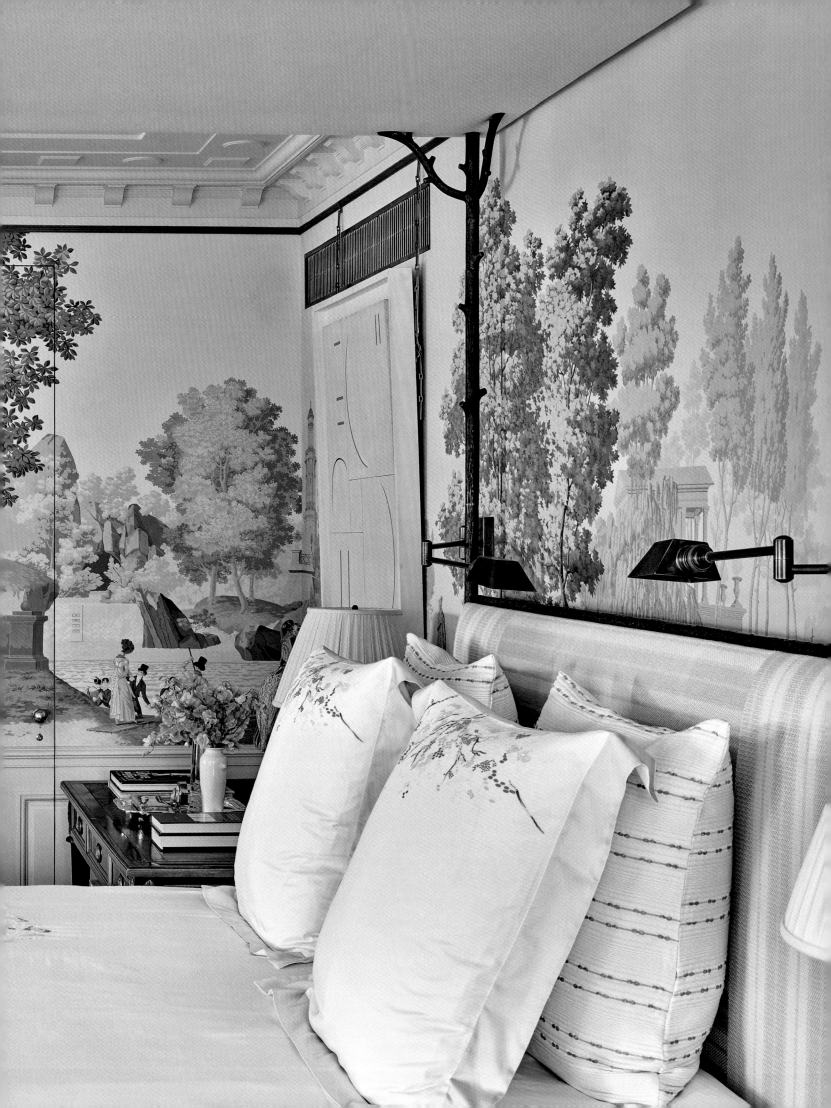

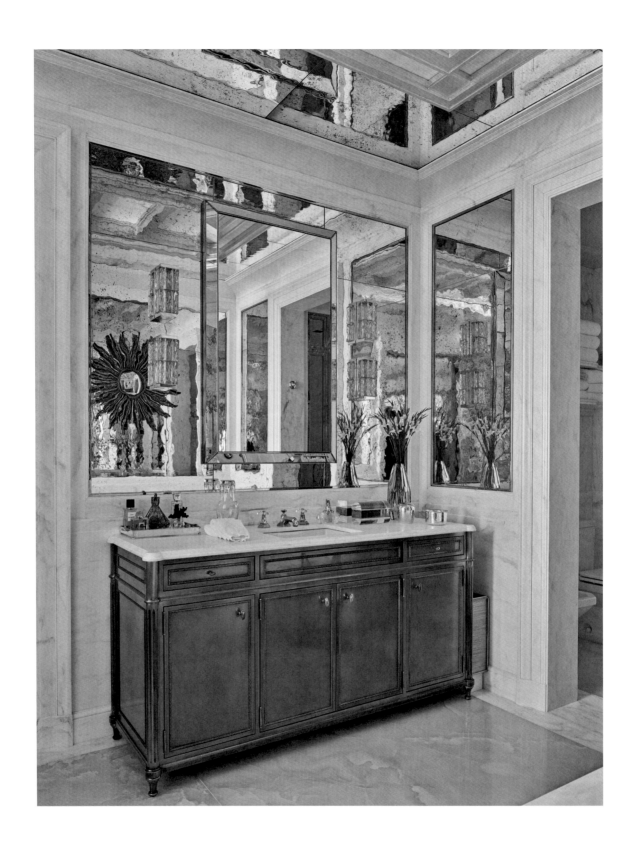

PREVIOUS PAGES: In the primary bedroom, Smith brought the countryside
into a Park Avenue penthouse with a pastoral Zuber wallpaper and a custom
bronze bed by Carole Gratale, whose vertical elements resemble slender
tree trunks. The work over the fireplace is by Jean Arp. ABOVE: In a corner
of the wife's bathroom, mirrors are layered on both the walls and ceiling.
OPPOSITE: A Paul Frankl daybed anchors the wife's dressing room.

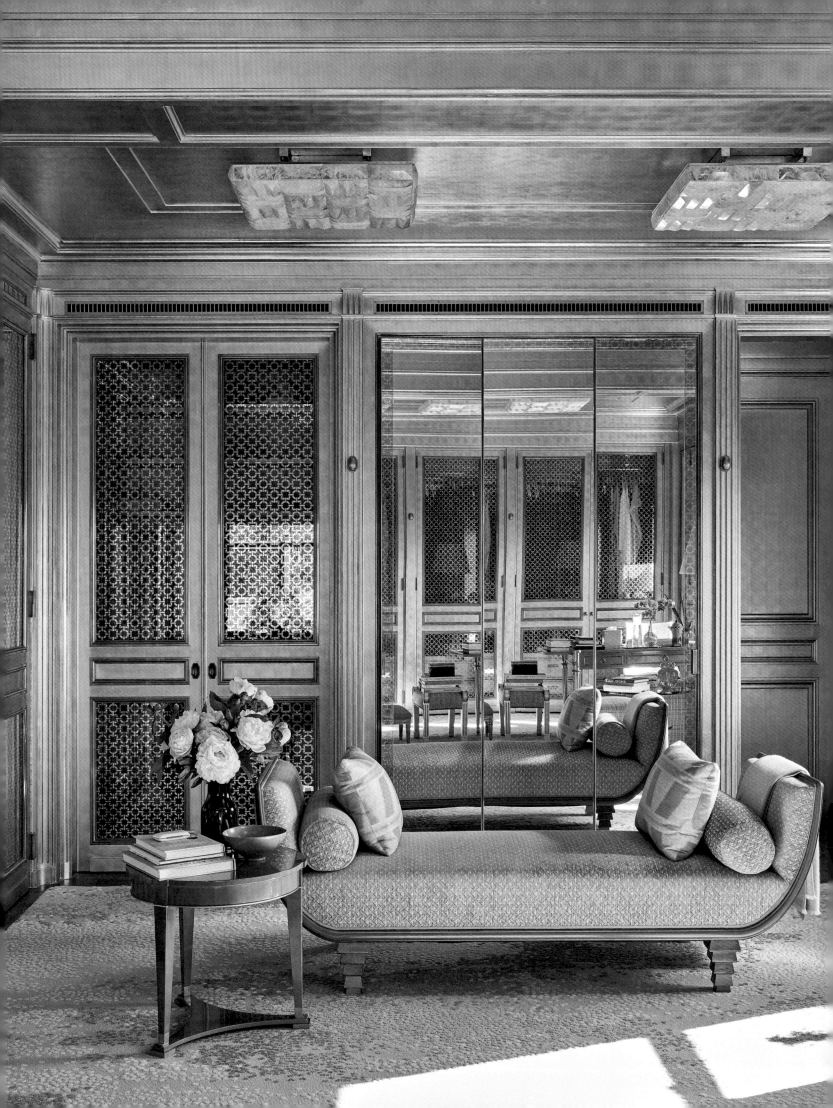

EIGHTEENTH-CENTURY CHÂTEAU
PROVENCE

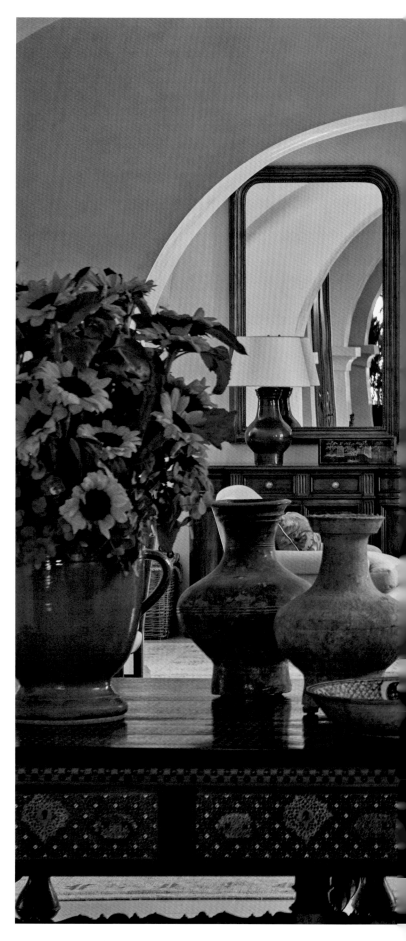

A SELF-PROFESSED FRANCOPHILE with encyclopedic knowledge of all things Louis XIII through XVI, Smith relishes any opportunity to practice his craft in the mother country. But while he has furnished many a pied-à-terre with choices from the antiquaries and galleries of the Rive Gauche, this project enticed him with an intriguing twist. The clients—Smith's longtime friends George Lucas and Mellody Hobson—wanted comfortable scale, practicality, and ease of living for their restored eighteenth-century château.

Located in the heart of Provence, Château Margüi is set amid ancient forests and rolling hills, and the estate's

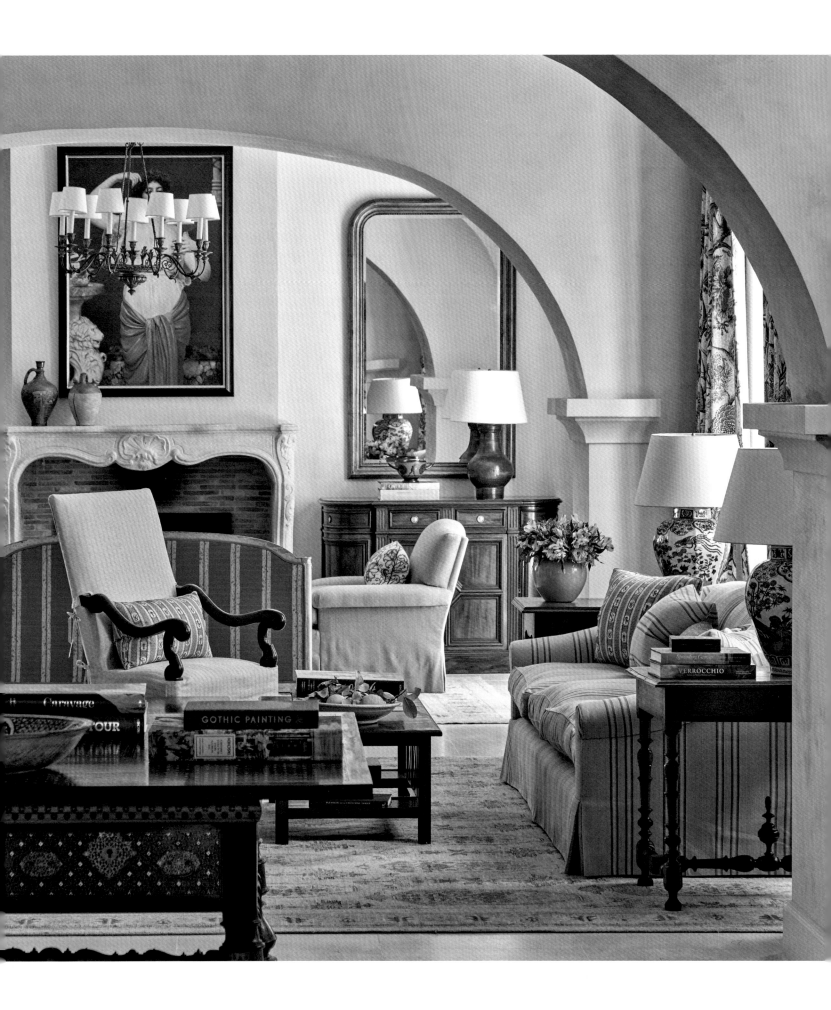

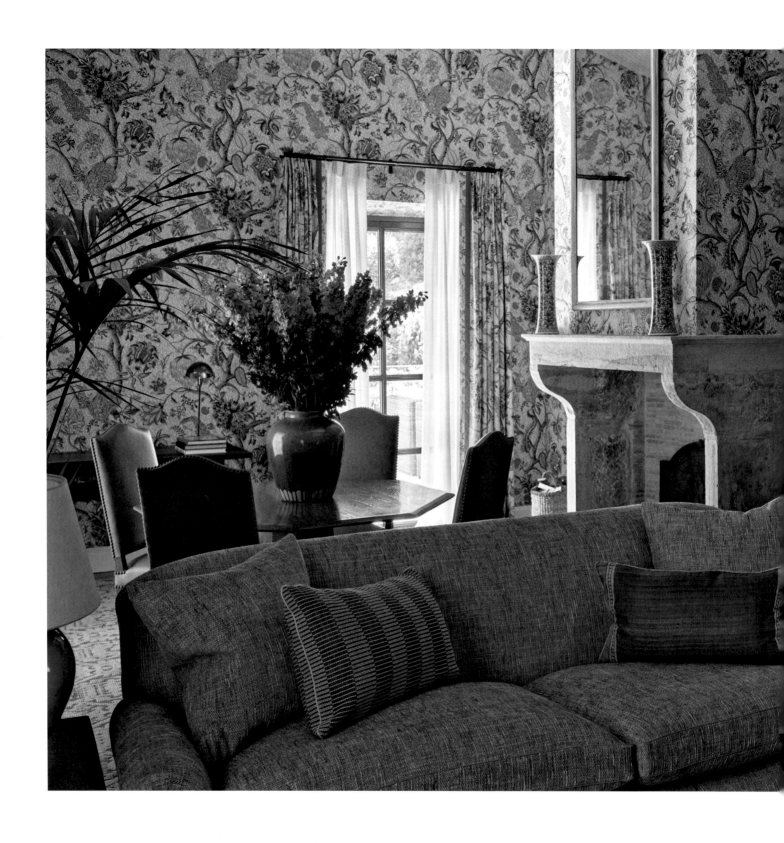

PAGE 138: A corner of a guest-suite sitting room with a deep marigold custom Carolina Irving Patmos Stripe fabric on the walls. PAGES 138–139: In the grand reception hall of the main house, or *bastide*, an intricate Portuguese-Goanese table stands in the foreground. ABOVE: The sitting room of one spacious guest suite is a symphony of blue-and-white fabrics. OPPOSITE ABOVE: Even the grand reception hall has cozy corners. The curtains are Pierre Frey. OPPOSITE BOTTOM: In the vestibule, Smith covered the walls with his own Jasper Mercury fabric in a deep aubergine color. FOLLOWING PAGES: In the primary suite, Smith commissioned Maria Trimbell to paint a delicate sepia forest on the walls. He deftly snuck in another layer of texture with tone-on-tone brocade curtains by Jasper.

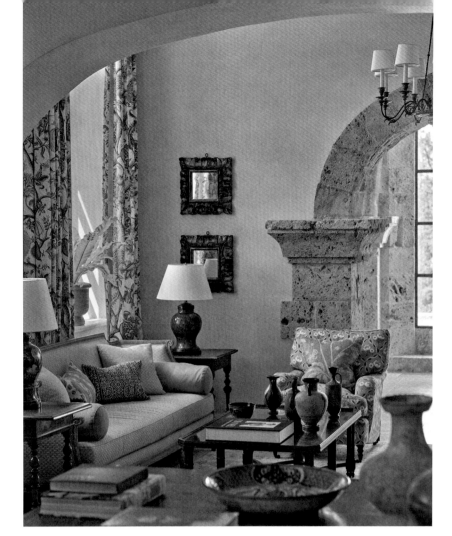

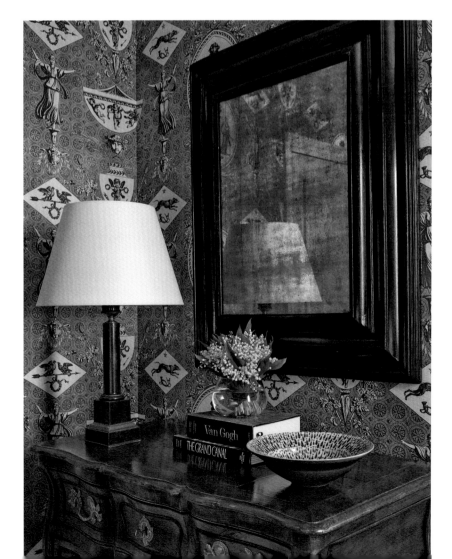

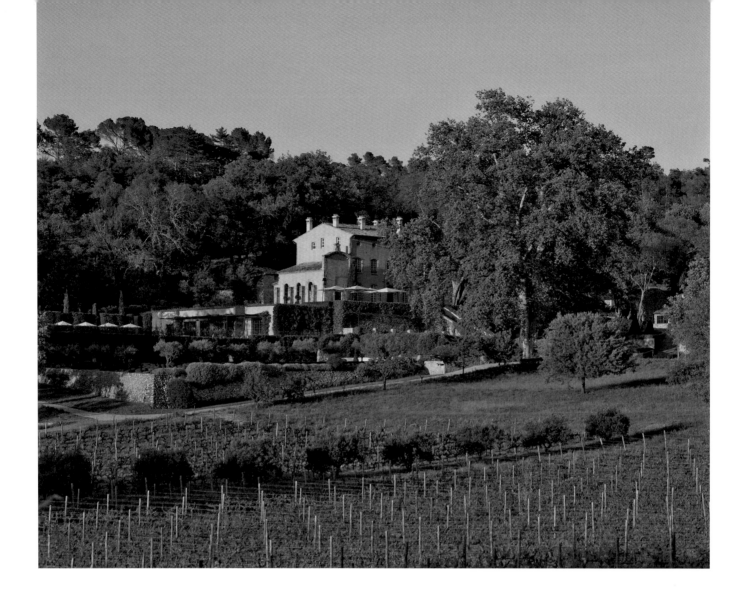

vineyards and farmland have been cultivated at least since Roman times. The fertile soil and abundant natural springs that traverse the land were of paramount interest to the clients.

"While George and Mellody definitely saw the appeal of summering in a gorgeous Provençal château, they are really driven by the shared desire to produce the world's best wines," Smith says, referencing the legendary filmmaker's thirty-year career as a vintner. Lucas started with just five acres of vines in California's Marin County that have grown into the famous—and multinational—Skywalker Vineyards. In addition to the California winery and Château Margüi, the Skywalker enterprise includes Convento Viandante del Cielo, a sixteenth-century monastery in Umbria.

When Château Margüi was purchased in 2017, there was much work to be done. Although Smith is often intimately involved in modernizing the layout of a historic property, his role here began when the renovation was complete. The multiyear project created a state-of-the-art winery and included installing all new systems,

commercial kitchens, and laundry facilities in the house. Once all the infrastructure was done, Smith stepped in to finish the interiors. The designer says, "My job was pure decoration, which is an exercise I love because you really get to see how seemingly simple elements like fabrics, wall coverings, and lighting can transform a space, and in this case restore the sense of Provençal charm by adding history, color, and warmth." In the large reception hall just off the entrance, Smith softened the room's muscular architecture and hefty arches with a range of Indian- and Asian-inspired French prints. "It's the first time we've used such patterns for these clients," Smith recounts. "But in the main house, which is an architectural form known as a *bastide* in French and meant to evoke a fortress, the masculine

ABOVE: A view across the vineyards toward the *bastide*.
OPPOSITE: A corner of the primary bedroom sitting area emanates Provençal charm—from the chevron flooring to the paint-stripped but still elegant cabinet and the collection of curvy chairs.

vibe benefited from having some florals and comfy seating thrown in without tilting too far in the other direction. It's a balance."

Smith says, "Mellody likes things romantic but understated." He knew he had to tread lightly in the primary bedroom. So instead of filling it with antiques, he hired painter Maria Trimbell to paint a pale sepia forest on the walls, adding a sense of romance that subtly connects the interiors to the outdoors. The aesthetic is even more effective in the primary suite's sitting room, where the seating arrangement and Trimbell's curvy tree trunks gently lead one's gaze to the balcony and the verdant views beyond.

Since the dining room is quite formal, with elegant blue-painted boiserie, Smith took the breakfast room (which needed to feel embracing whether set for six guests or twenty-five) in the opposite direction, with jumbo yellow checked curtains and French café chairs. He says, "The overscale check on the curtains and Trimbell's bucolic scenes painted on the walls create a sense of being in an arcadian forest. People hang out there at all times of day—it's very welcoming."

The couple use the home often in summer and throughout the year for film and wine events, but it's also available to rent. "From the beginning, George and Mellody knew that such a large estate ought to be shared," Smith says. "The main house alone has nine bedroom suites, and nine others are spread among several outbuildings, so it's like a small inn."

Since the house doesn't get shuttered when the owners are not in residence, it has a palpable vibrancy. In Smith's words, "It's a very together house—not crumbling or fey in any way." Indeed, unlike many grand historic homes, it has no dark corners or cast-off hallways where a distant relative's taxidermy bear or vintage doll collection has been tucked under the stairs. "George and Mellody are warm and embracing, and they're always looking to meet and know new people, and their personality has seeped into the culture of Margüi, giving it the great extended-family feeling you want when convening friends."

LEFT: An antique draper's table from Galerie Quattro anchors the breakfast room, which also features café chairs by Maison Louis Drucker. Boldly checked curtains in Namay Samay's Gamcha fabric make a striking contrast to the fluid lines of artist Maria Trimbell's painted forest on the walls.

UPPER
EAST SIDE
PENTHOUSE
NEW YORK CITY

SMITH HAS A LONG ROSTER OF REPEAT CLIENTS who either started out as good friends or became good friends during their first projects with him, leading to enduring personal and professional relationships. Just as these clients' homes and family needs have evolved over the years, so too have the tastes and affinities of both clients and designer, as they influence and inform each other over the course of multiple projects. Among those close friends is powerhouse television writer and producer Shonda Rhimes, for whom Smith designed this Park Avenue aerie as an urban retreat when she's working in New York.

"I'd done several homes with Shonda, but this was the first one outside of California," Smith notes. "She had often stayed in our Manhattan apartment just across the street, so I understood exactly what she wanted—one-half "*Green Acres*" and the other half pure urban sophistication."

Smith continues, "My goal was to create for her a cinematic version of Upper East Side penthouse living that offered a nexus of soothing, contemplative spaces—almost like sets for living." Knowing how his friend works—constantly, whenever and wherever inspiration strikes—he made sure that each of those spaces had a place for her to write. She even has her choice of seats at a double-sided Regency desk that is tucked discreetly into the living room. Each of the other rooms contains either an actual desk, or a broad expanse of tabletop with a comfortable chair nearby. Most of these workspaces are located in front of windows, so Rhimes can sit and allow her eye to wander the outdoors in search of inspiration.

Indeed, an abundance of windows was a big part of the apartment's appeal for Rhimes. It sits on a high floor and has four exposures and a wraparound terrace, so every room is flooded with natural light, no matter how gray the day. Smith says, "Coming from Los Angeles, this

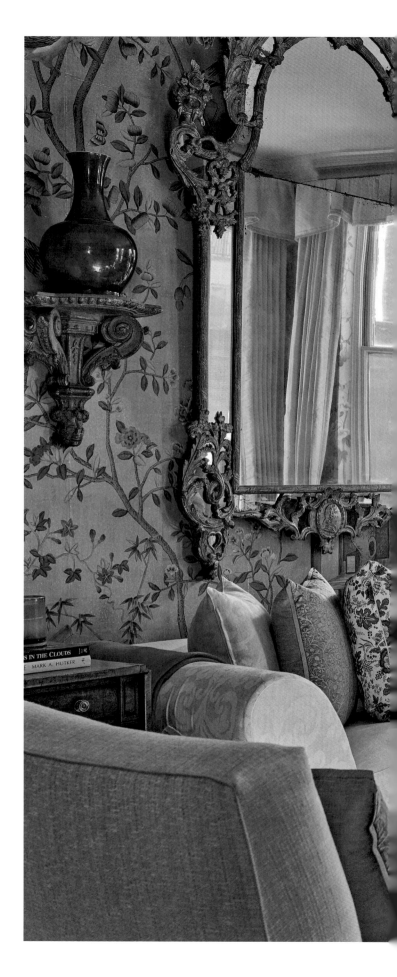

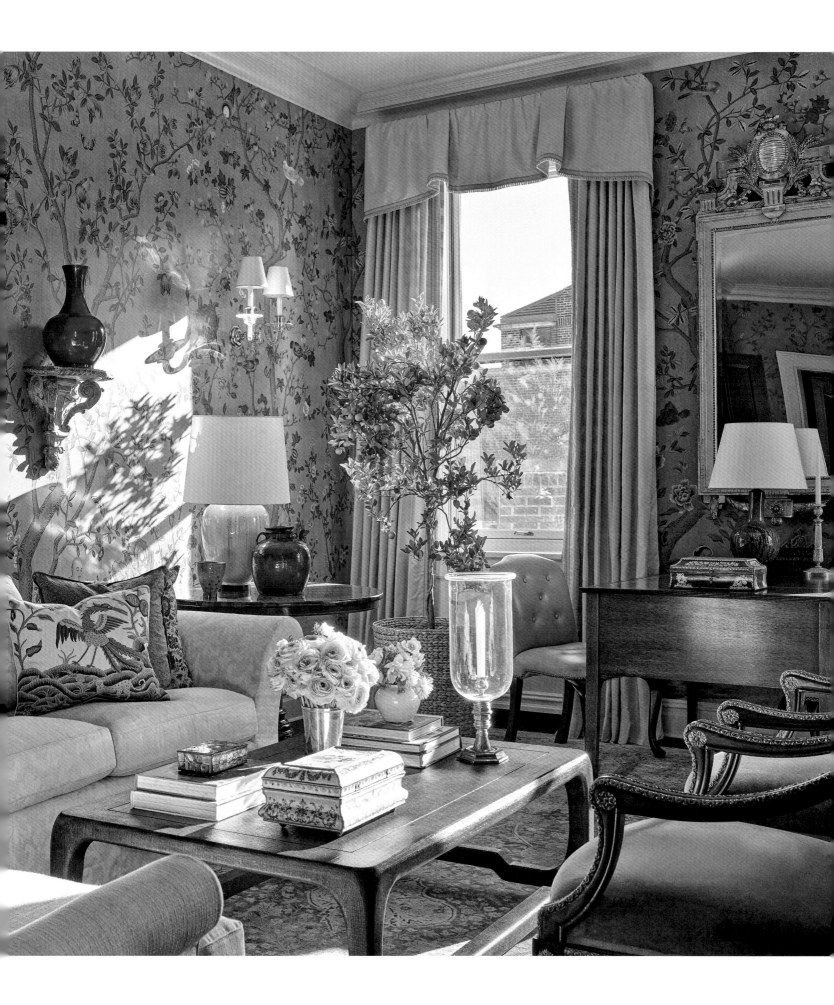

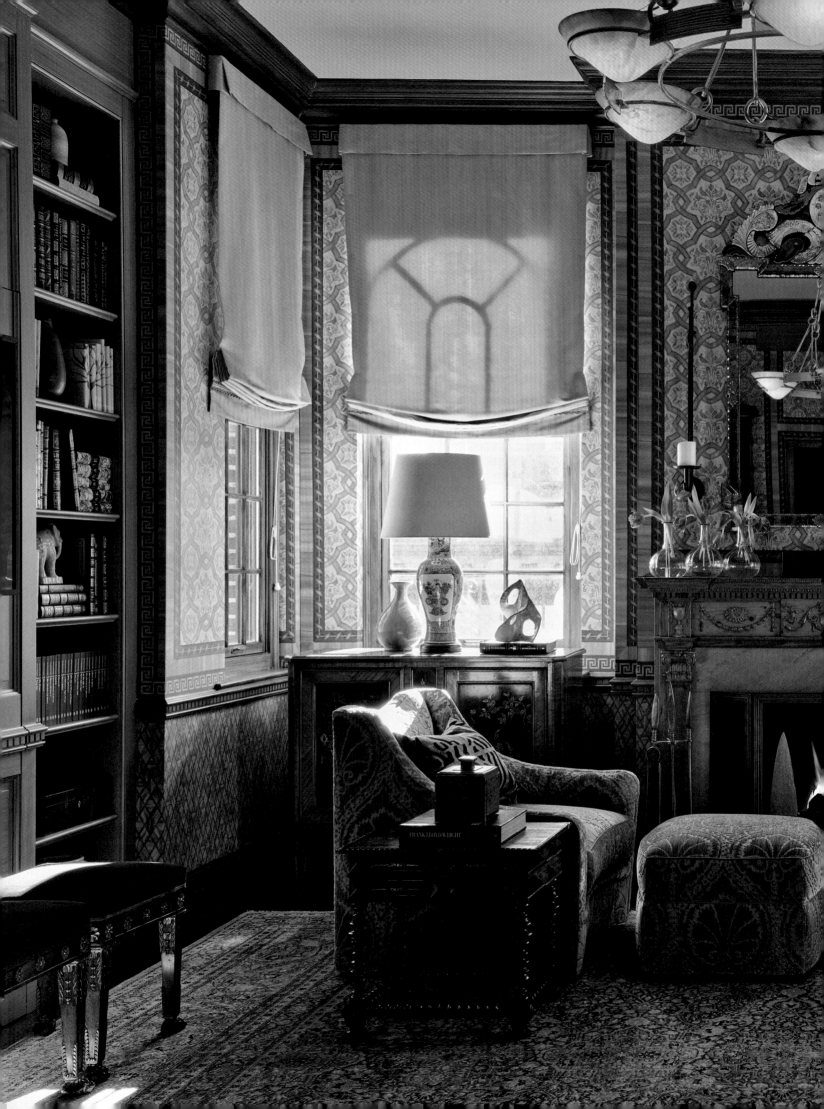

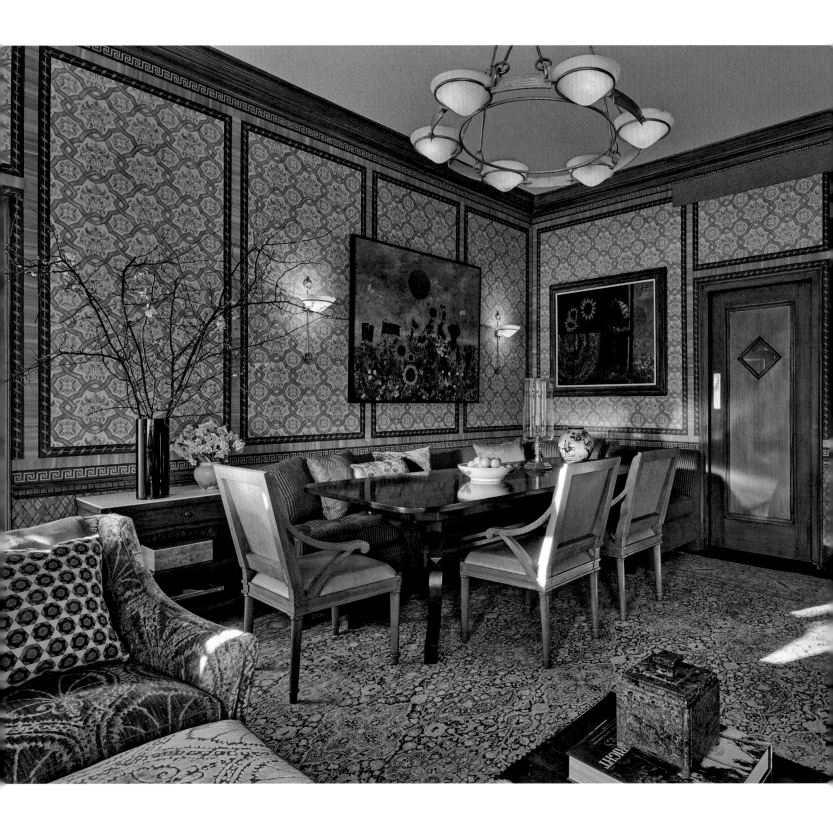

PAGES 148–149: Smith had the living room's de Gournay wallpaper custom colored in more intense shades to hold up to all the color, textures, and gilding he wanted to include in the room, like the stunning Régence mirror that hangs above the custom Jasper sofa. At right is a double-sided Regency desk, one of the many places in the apartment where Rhimes, the creator of *Bridgerton* and other series, can write. PREVIOUS PAGES: Since Rhimes is typically in New York City for work, Smith had the dining room cede space to a library and sitting room. To give it a literary feel, he clad the space in custom hand-painted wallpaper by San Patrignano Design Lab. The chairs and ottoman are by Liz O'Brien, and the Venetian mirror is eighteenth-century. ABOVE: Rhimes is an avid collector of African-American art. The two paintings are by Walter Henry Williams Jr. The classically inspired brazier ceiling fixture and sconces are by Patrice Dangel, and the Khorasan rug is antique. RIGHT: A detail of the intricate marquetry wallpaper.

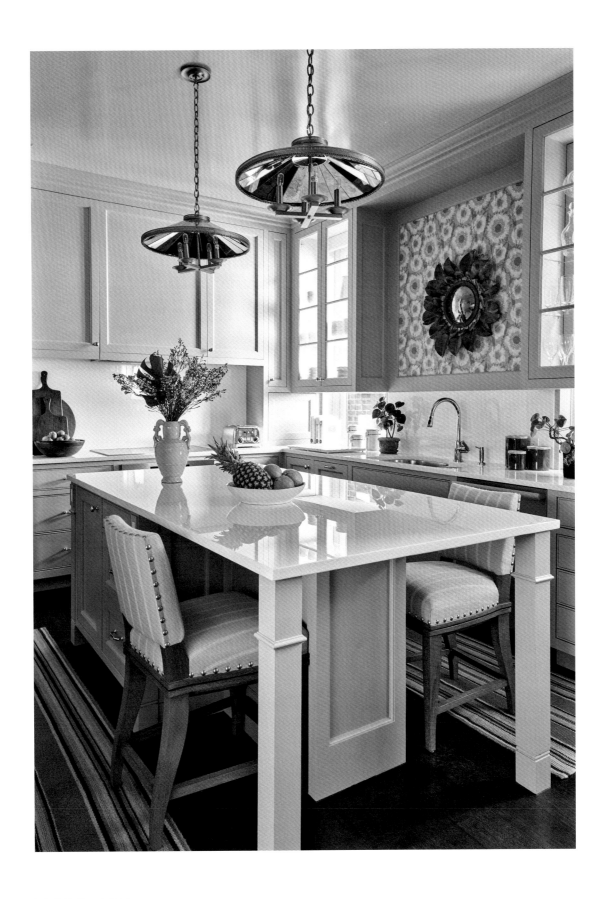

OPPOSITE: A little workspace just off the dining room–
library, one of many Smith created for his client.
ABOVE: The cheerful kitchen has a sunny yellow ceiling
and Sunflowers wallpaper by Adelphi Paper Hangings.

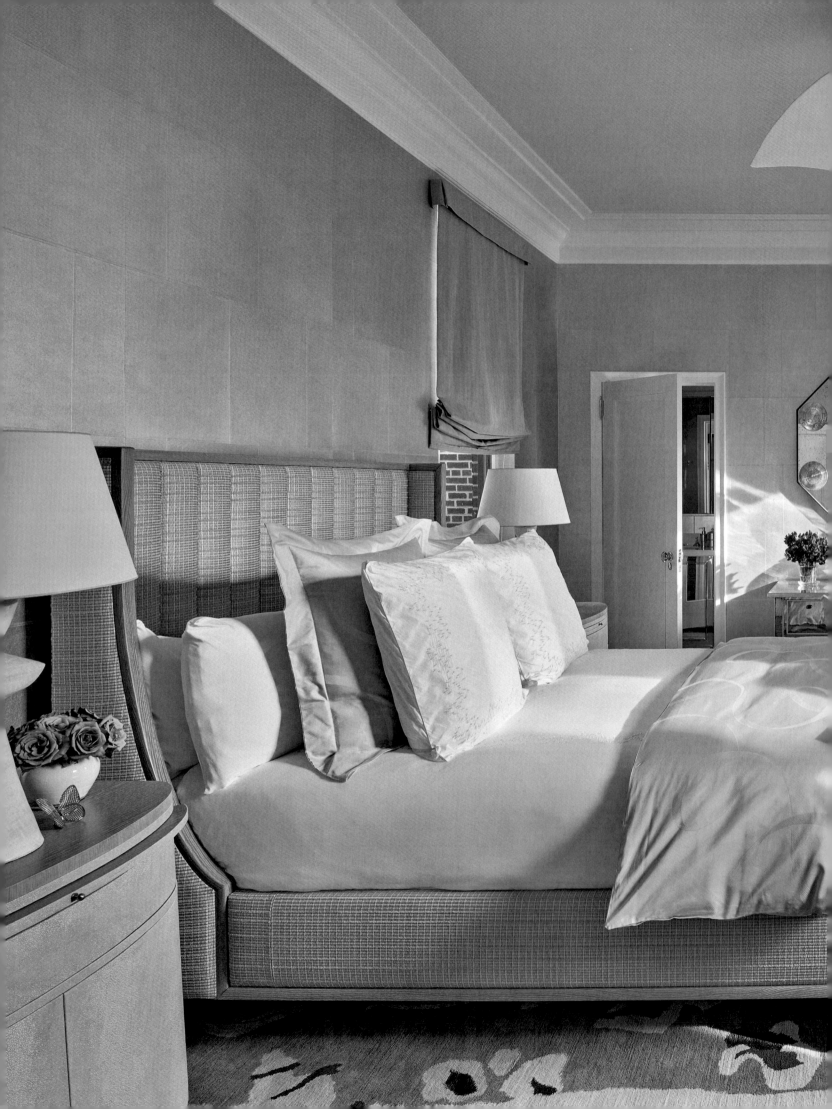

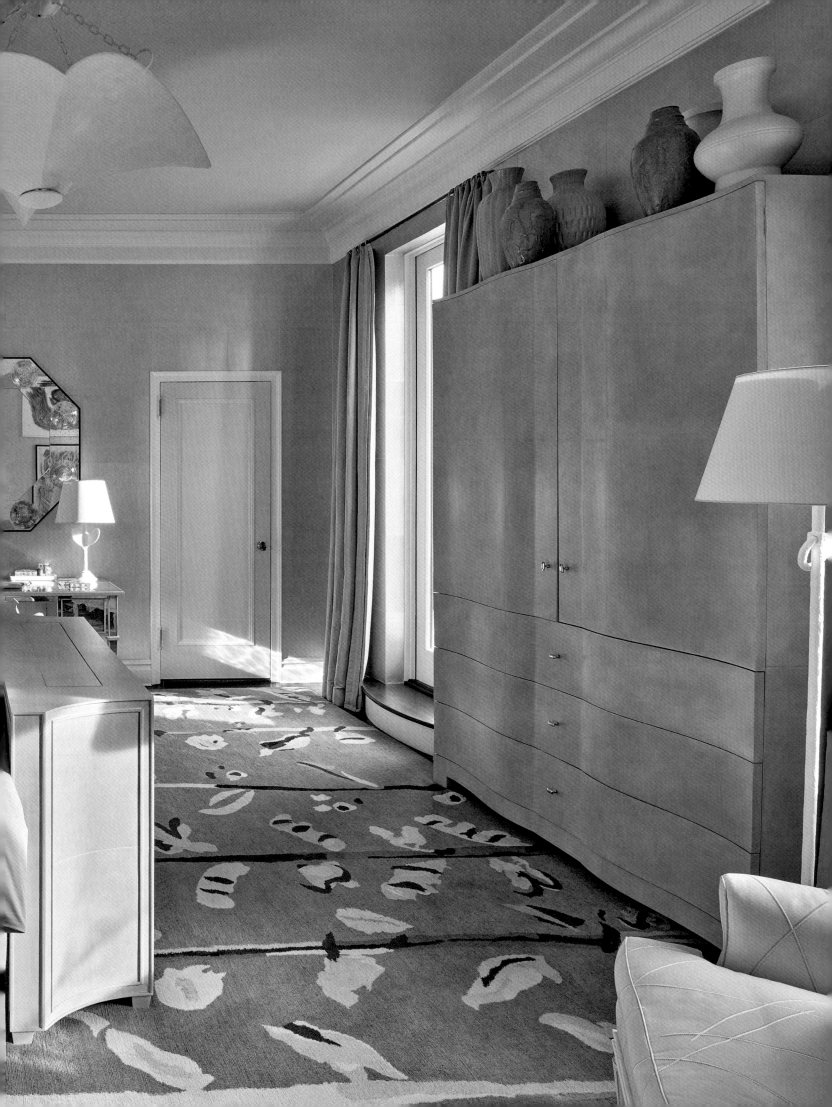

PREVIOUS PAGES: The inspiration for the primary bedroom was Golden Age Hollywood glamour, so Smith used a wall covering that imitates the luxury of parchment and restricted the palette to shimmery shades of seashells and sea glass. The carpet from La Manufacture Cogolin was designed by Christian Bérard, and the light fixture is by Stephen Antonson. ABOVE: A comfy corner of the bedroom featuring two works by Thornton Dial. OPPOSITE: The dressing table and art deco mirror amply convey Hollywood glamour. The sculptural chair is from Liz O'Brien.

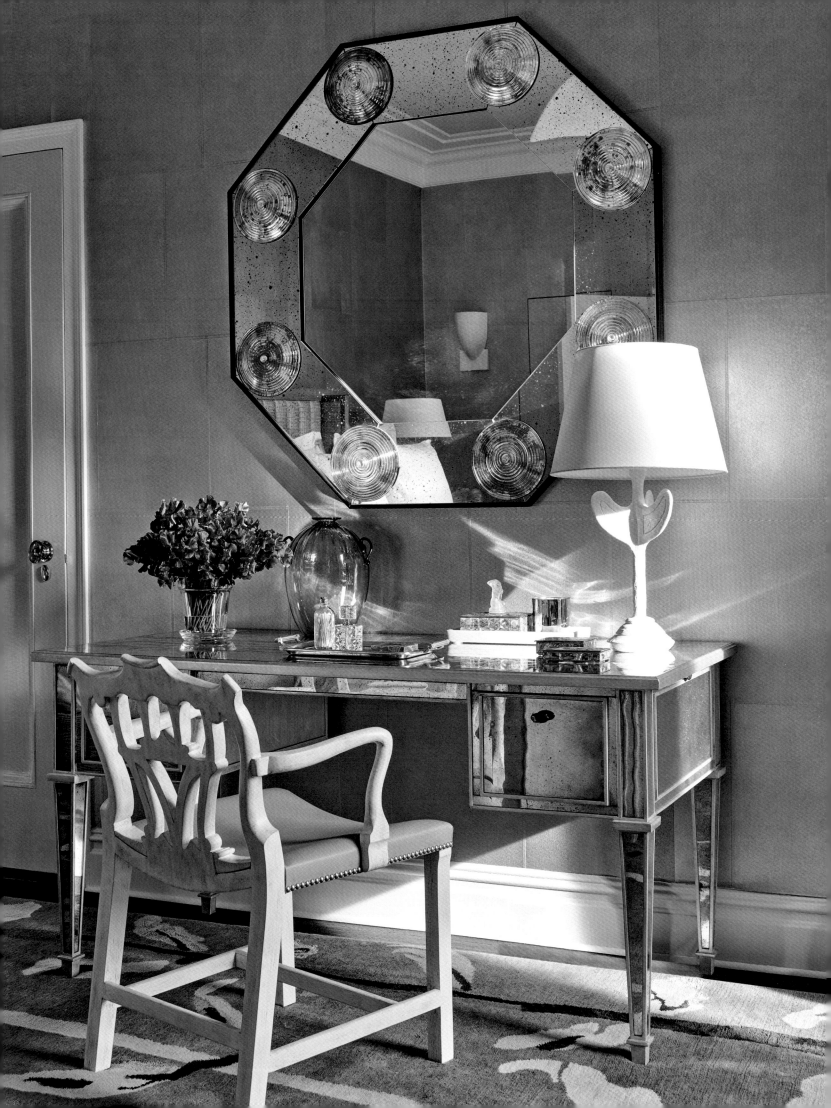

was really something to celebrate in New York, where even the grandest apartments usually have at least a few windows that open onto airshafts or are blocked by a neighboring building."

Given the ample light, Smith decided to create a vibrant living room that felt like an indoor garden, deploying a custom-made Chinese-inspired de Gournay floral wallpaper as a backdrop for an eclectic mix of furnishings. Smith says, "I had the paper done in more intensely saturated colors than it would normally be made so that it would hold its own against the vivid Chinese imperial yellow silk taffeta curtains I had in mind for the windows."

Besides the energizing mix of colors, the room features a generous dose of luscious gilding on armchairs, wall-mounted brackets displaying Chinese vases, and all manner of candlesticks and other objects on the tables. The standout among all those gold-tinged furnishings is the large Régence mirror behind the sofa, which the designer describes as "a nod to iconic Park Avenue apartments of decades past."

"I always try to make Shonda's homes colorful and welcoming—she has such a warm personality—but I had no idea when we did the living room that it would feel like such a *Bridgerton* space," Smith says, referring to Rhimes's popular television series set in early nineteenth-century England. "I chose the Regency period because it felt right for her and the proportions of her New York home, but then—when you look at the interiors on her show and this room—clearly there was a confluence of her work and mine at play."

Creating the sense of hominess that Smith wanted for his client was handily accomplished in the cozy caramel-colored library, which can do double duty as a dining room or small sitting room. "My goal was to create a clubby, bookish environment, set against this amazing custom hand-painted San Patrignano Design Lab wallpaper," says the designer.

With details that echo the patterns of both intricate wood marquetry and Spanish embossed leather, the wall covering is a symphony of earthy brown, taupe, and tobacco hues that glow in the daylight. That radiance is even more pronounced after dark, when light emanates from the classically inspired alabaster and gilt-bronze light fixture and sconces by French sculptor and designer Patrice Dangel. A vintage Venetian mirror with appliqués of silver, gold, and black mirrored glass hangs above an antique Adamesque English chimneypiece,

and the plush Khorasan rug underpinning it all adds another subtle layer of pattern.

The kitchen is the one room in the apartment that exudes a decidedly twenty-first-century ambience. Designed with the architecture firm Ferguson & Shamamian, longtime Smith collaborators, it features cheerful yellow accents, elegant but simple cabinetry, state-of-the art European appliances, and rather mod Sunflowers wallpaper by Adelphi Paper Hangings.

For the primary bedroom, which has two exposures and its own terrace, Smith wanted to create as cosseting an environment as possible, so he designed the room with an eye toward what he calls "a 1930s Hollywood golden-age version of New York glamour." He says that covering the walls in simple yet elegant tea-stained rectangular sheets of paper added "a wink at parchment-covered walls of that era."

The bedroom's restrained palette of pearly grays and ecru is anchored by a moodier deep gray Christian Bérard rug from La Manufacture Cogolin with painterly splashes of pale pink and teal. Overhead, the chalky white hanging lamp appears as if it's about to take flight against the silvery ceiling, enhancing the sense that the apartment is floating above the city. There's more shimmer on the very Hollywood mirror-clad dressing table with its sculptural low-backed chair beneath an art deco-inspired octagonal mirror.

In the largely blue and white bedroom where her daughters stay when visiting, the look is decidedly less sleek and more eclectic and exotic, with striped cotton that looks handwoven on the walls and a Smith-designed Jasper bed upholstered with an overscale Komal Paisley in navy and white by Brunschwig & Fils. A boldly graphic sculpture hangs over the bed's headboard, while the floor is covered with a custom carpet in dense variegated gray stripes that echo Turkey's distinctive Marmara marble. Add the ceiling's cobalt-blue Murano chandelier and the oval mirrors in gilded frames above the nightstands, and the room touches upon almost as many distinctive worlds as Rhimes's television universe.

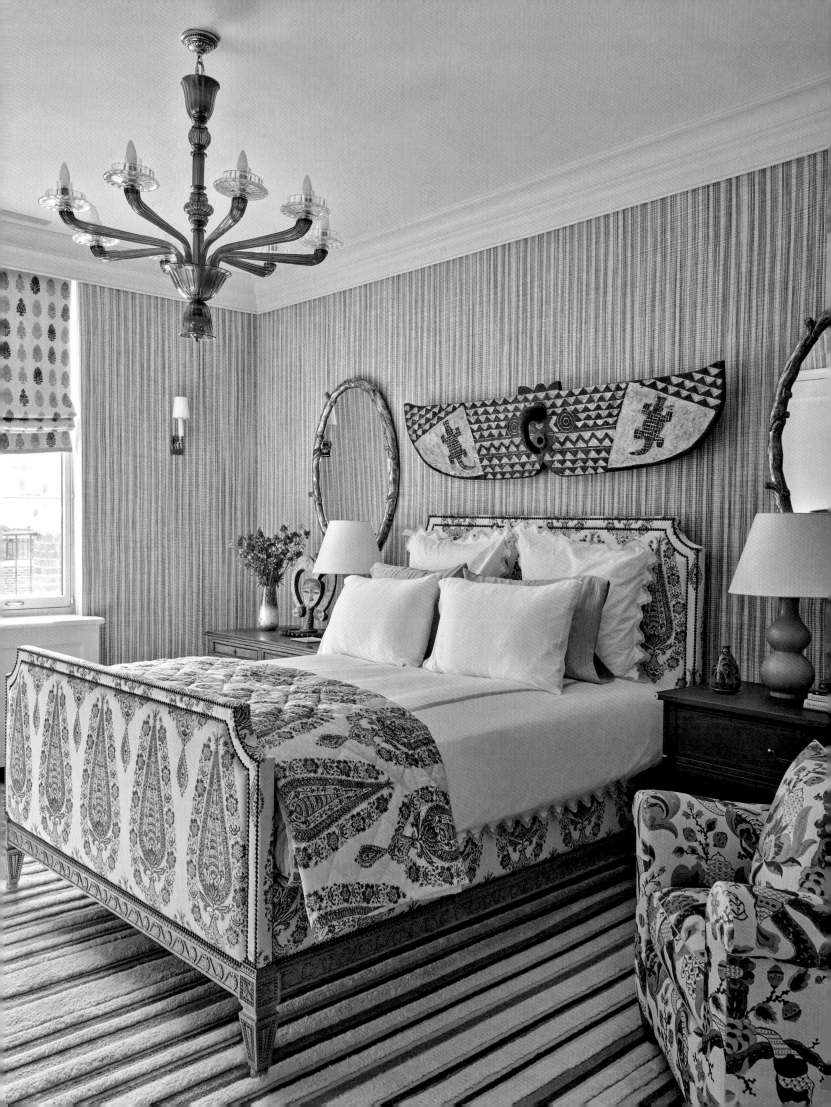

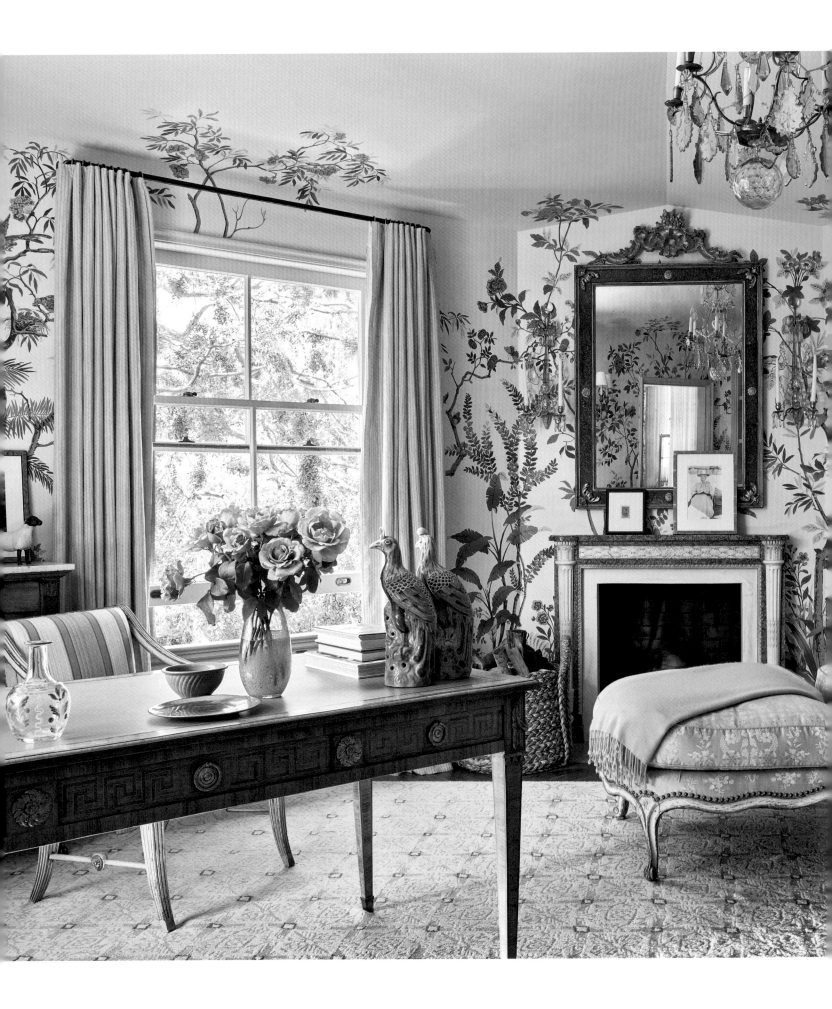

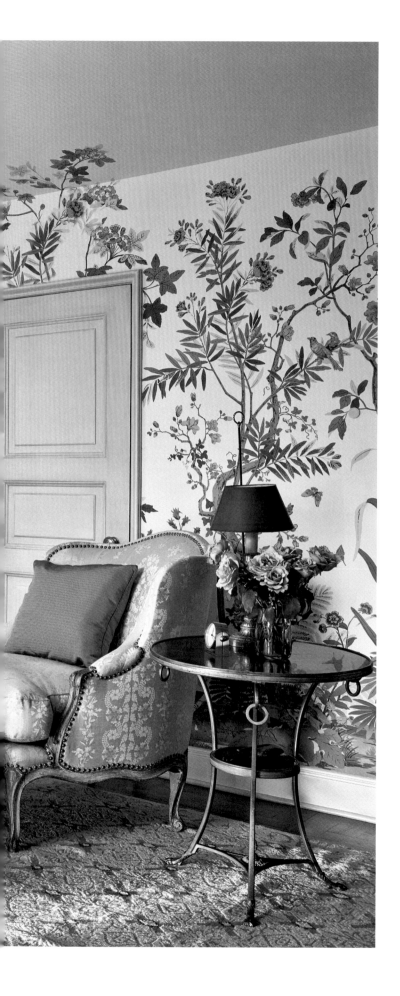

1930s SPANISH REVIVAL
BEVERLY HILLS

THE OWNERS OF THIS LOVELY Spanish Revival from the 1930s in Beverly Hills have been such close friends, clients, and frequent traveling companions of Smith's over the last thirty years that he describes them as family. Along the way, they've collaborated on more than a dozen residences, the aesthetics of which have always been informed and enhanced by their travels. The allure of Spain draws them back repeatedly to the country, especially the island of Mallorca, where both Smith and his clients now have second homes.

Even though far from the Mediterranean, this house, with its distinct Spanish accent, is also essentially a vacation home. After starting their careers and raising their family in California, Smith's clients now spend much of the year in New York. "Essentially, it's a weekend place in their former hometown," Smith muses. "The couple comes to see family and relax, and the house reflects that paradigm shift from a high-functioning family abode to the peaceful oasis of a grandparents' house."

A Mediterranean atmosphere pervades this gracious house, whose entrance is guarded by a centuries-old olive tree and adorned with the kind of curlicue ironwork door typical of Andalusian patio houses.

Once inside the stair hall, the Iberian ambience hardly fades, though it starts to get more cosmopolitan. Instead of the standard black-and-white checkerboard marble floor, Smith created an artfully random arrangement of gray and white marble tiles reclaimed from a defunct convent in Galicia in northwestern Spain. Upon it rests an elaborately carved and curvy eighteenth-century northern Italian walnut console with a floridly striated marble top supporting an array of classical and classically inspired carved stone objects, from Michelangelo-esque male nudes to obelisks and marble

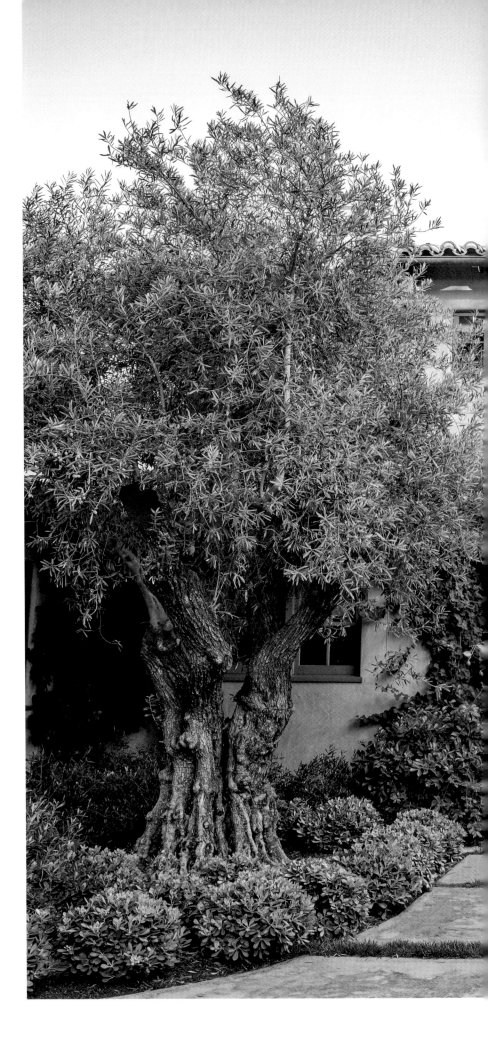

PREVIOUS PAGES: Located just off the primary bedroom and wrapped in a florid Zuber wallpaper of sinuous vines and colorful flowers, the wife's study brings the garden indoors. Smith had an artist continue boughs, blossoms, and tendrils onto the ceiling to make the effect even more embracing.
RIGHT: The home's principal façade welcomes visitors with a detectable Spanish accent—from the red tile roof and the vine-entwined balcony to the arched entrance with a curlicue ironwork grille, common in many Andalusian patio homes to keep out strangers but let in breezes. A centuries-old olive tree stands a few steps away.

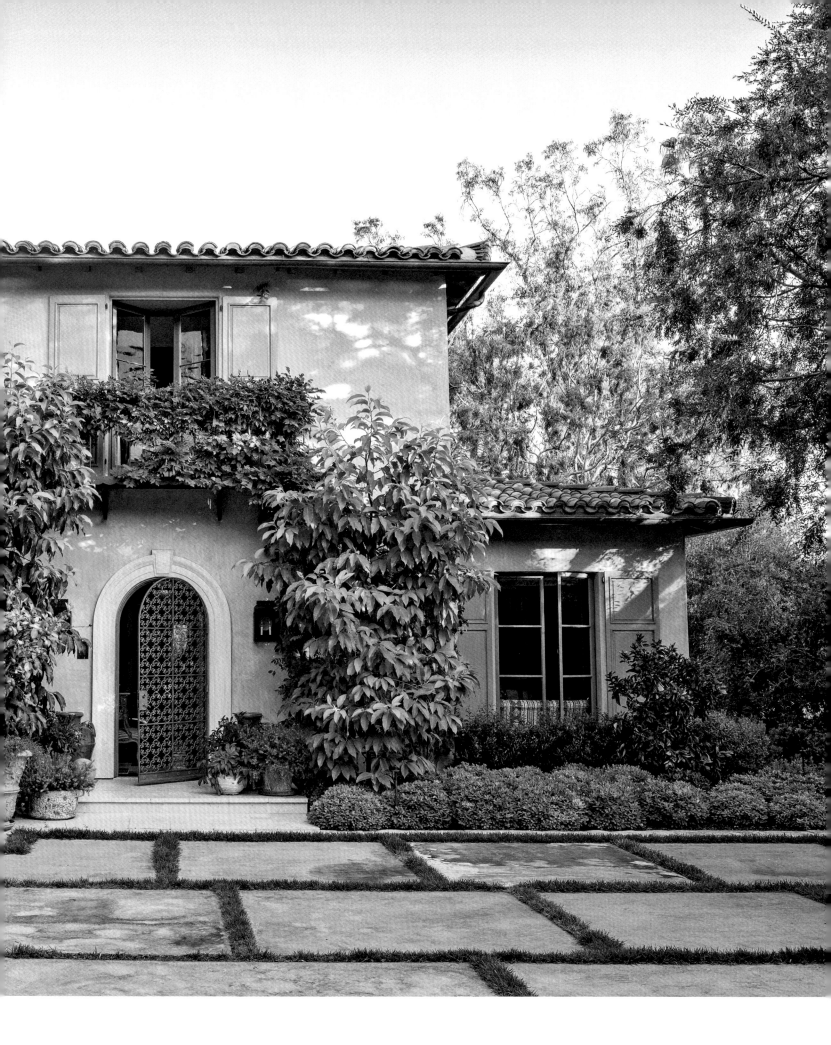

ABOVE: Visitors arrive through this romantic vaulted hall sheathed in Venetian plaster. Smith randomly arranged reclaimed gray and white marble floor tiles from a defunct convent in Spain for the flooring. The sconces are from Rose Uniacke, and the lanterns are bespoke. OPPOSITE: The arched passageway opens to a dramatic two-story, skylit stair hall that suggests the open courtyards of Spanish manor houses. The elaborately carved console is eighteenth-century northern Italian.

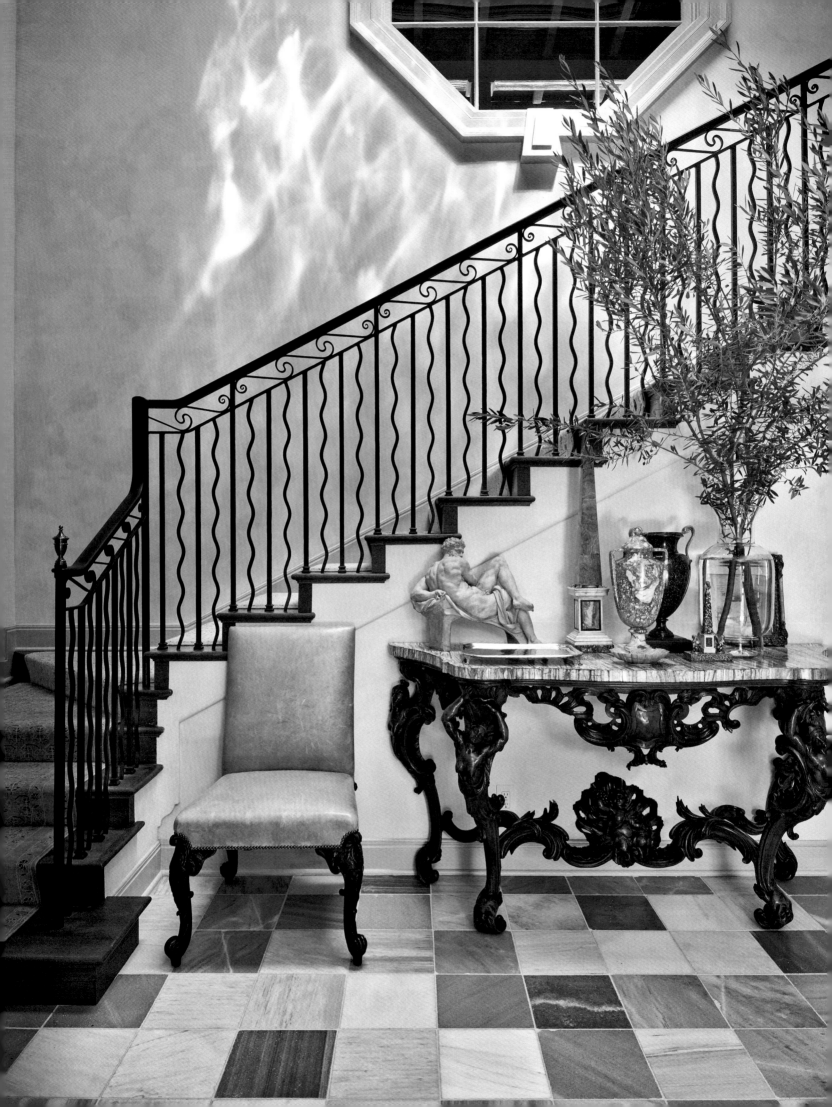

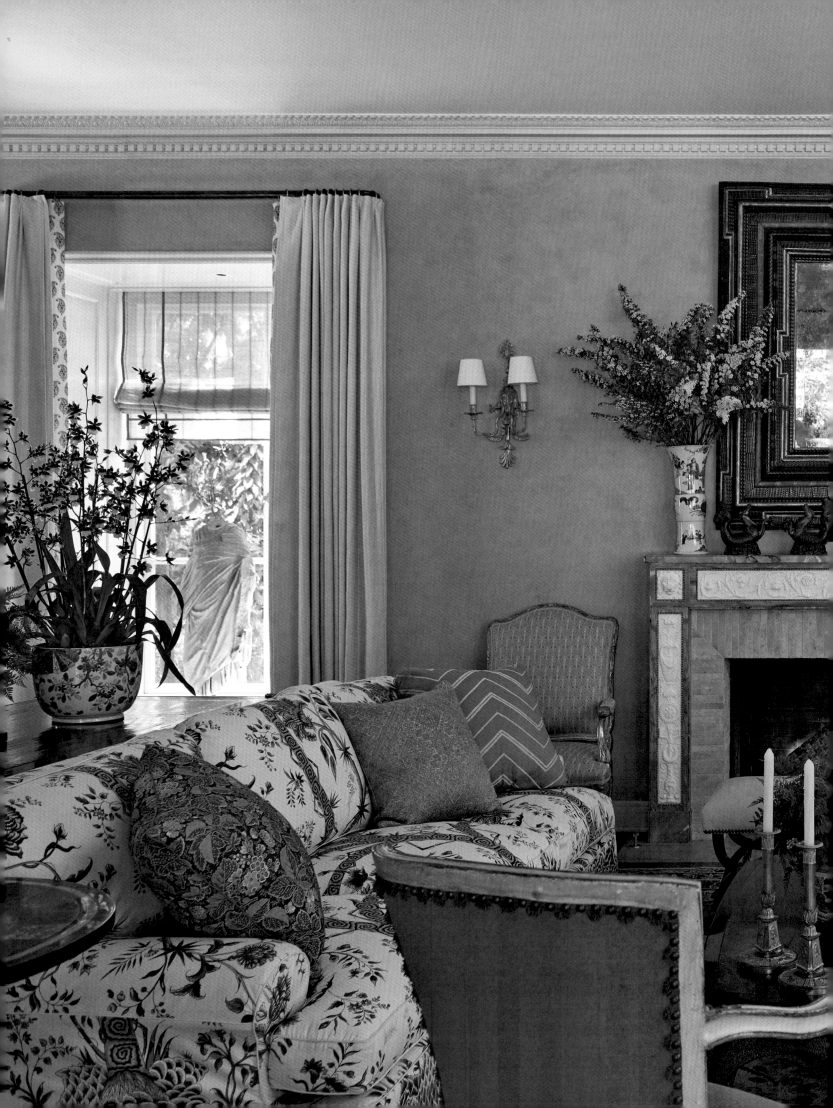

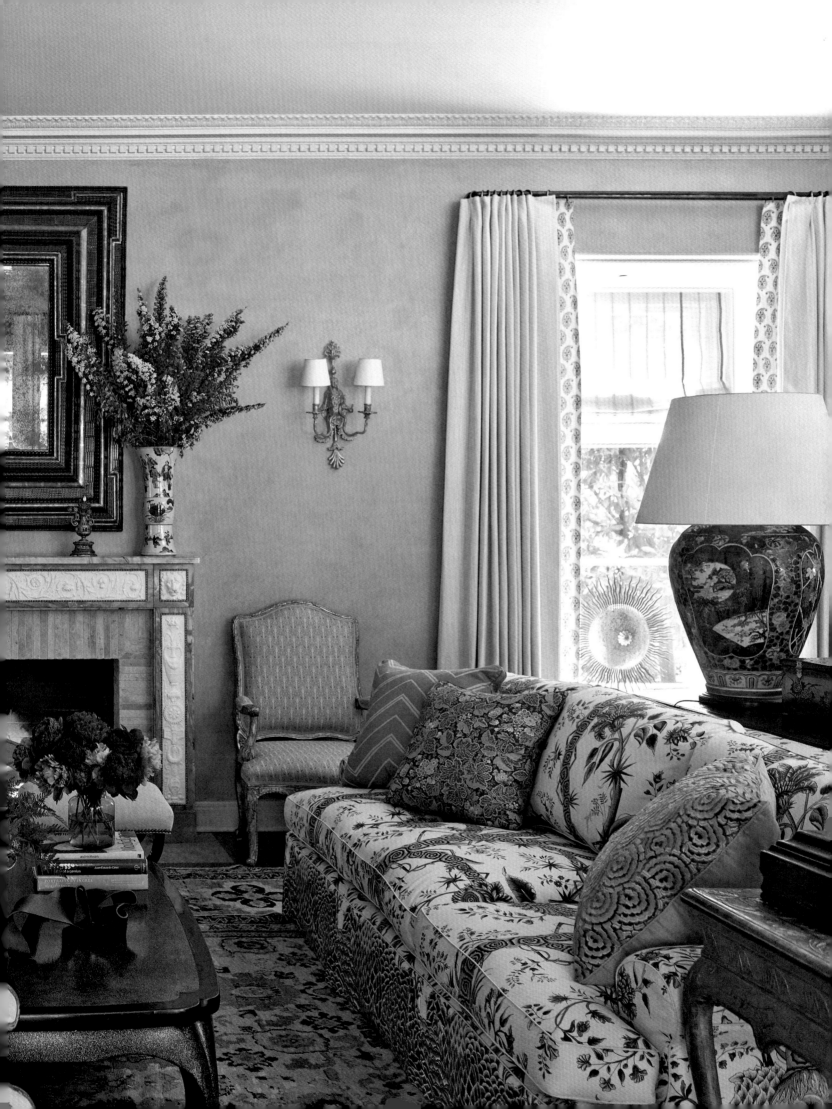

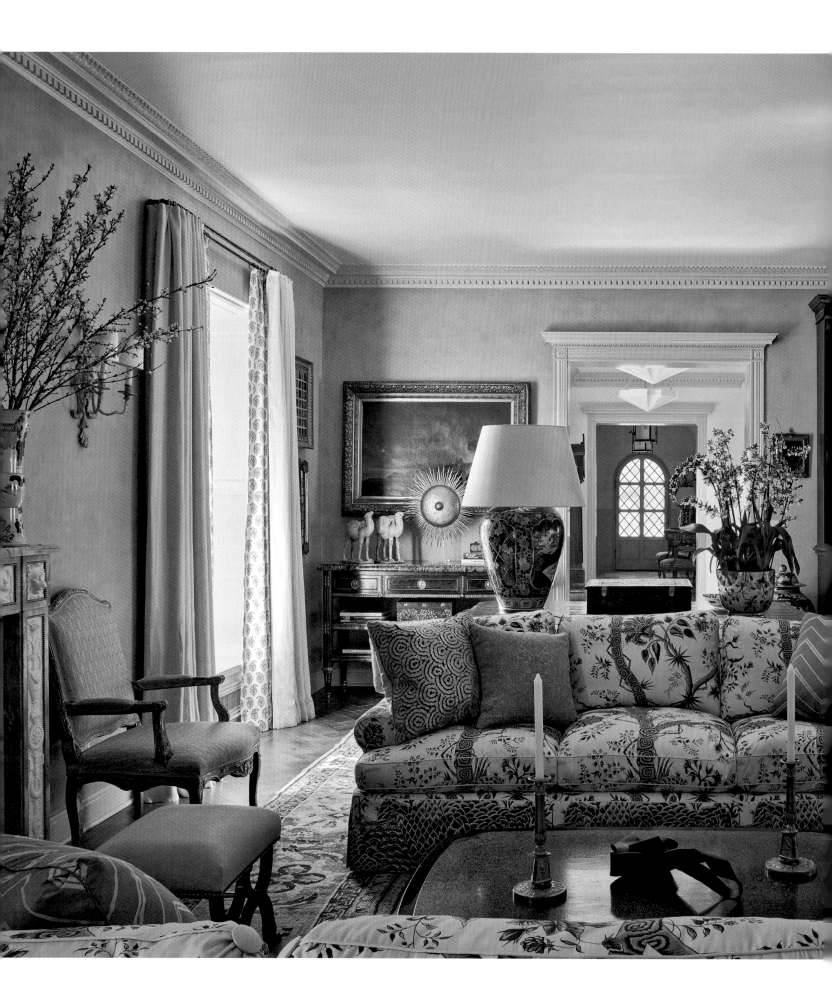

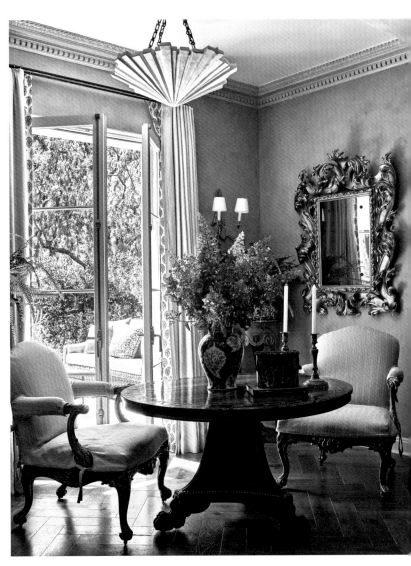

PREVIOUS PAGES: The living room is a celebration of pink in its full range of hues, from the rosy blush of the Venetian plaster walls and the Louis XVI–style marble chimneypiece to the flashes of coral, vermilion, and pomegranate woven into the Pierre Frey upholstered sofas and pillows. The curtain fabric is by Namay Samay. LEFT: The idea of having a pink living room had been previously raised by the clients in past projects but never realized until this home. Smith added references to the couple's shared passion for travel with an international mix of objects—Chinese ceramics and Japanese lacquerware, European Grand Tour–era painting, and a handsome neoclassical library case. ABOVE: A quiet corner of the living room reveals how wonderfully the home is integrated with the garden. FOLLOWING PAGES: The dining room, which opens onto a spacious loggia, is wrapped in sumptuous hand-painted leather by Atelier Mériguet-Carrère, and the wainscoting and overdoor panels have been marbleized. The chairs around the eighteenth-century mahogany table are slipcovered in a Le Manach checked fabric.

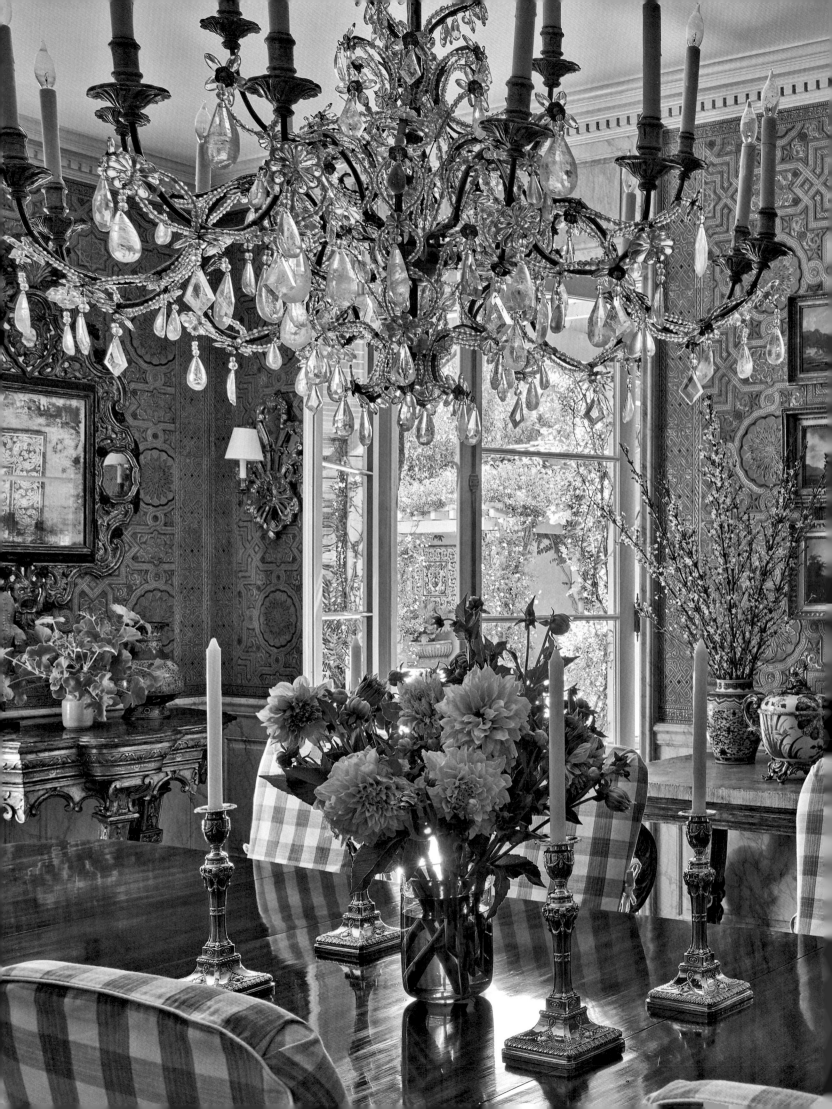

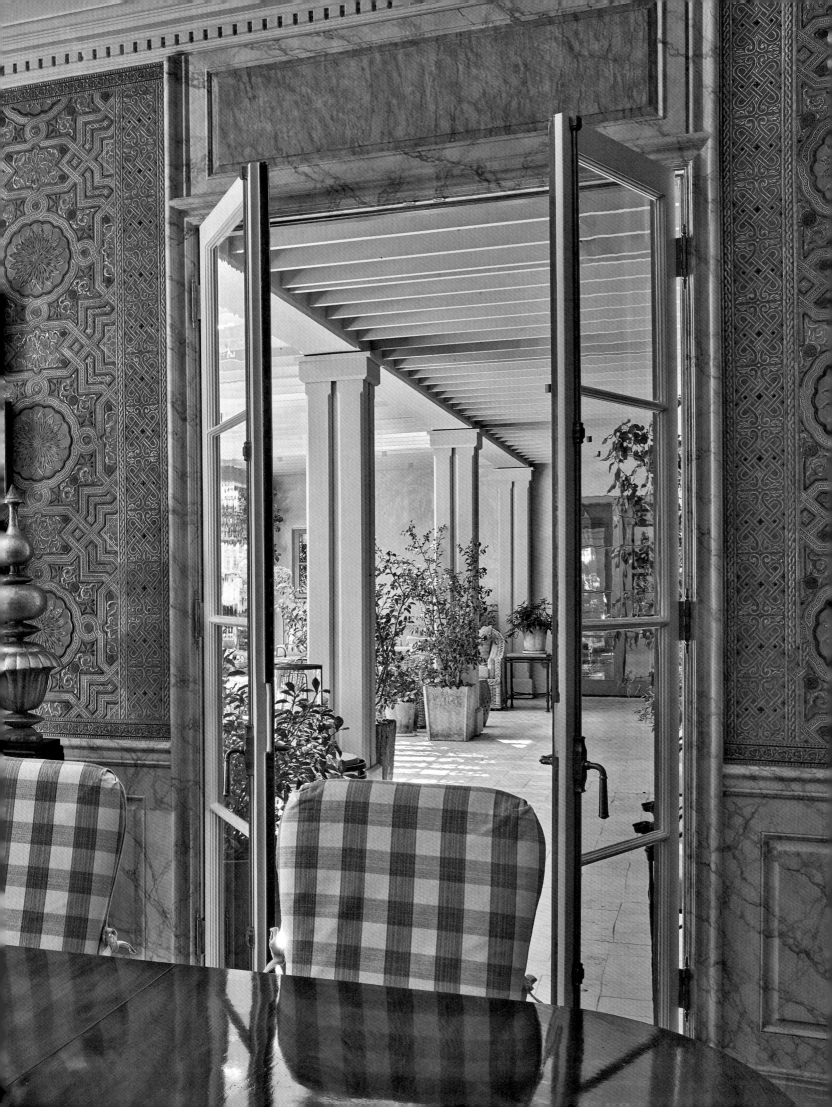

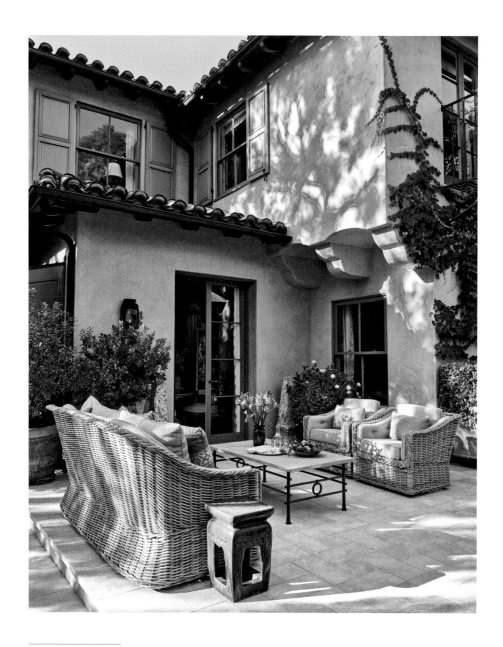

ABOVE: Smith designed this house for clients whose now-adult children have left the nest, so the home is just for the couple's enjoyment—"like having a vacation home in your hometown." Hence the small seating areas in charming timeless materials like wicker. OPPOSITE: Nothing is more Spanish than colorful plates adorning the walls around the breakfast table. These, however, were made by French ceramist André Metthey. The lantern is by Jamb.

amphorae—a veritable Grand Tour in miniature. Warming rays of sun enter through a skylight above the stairs and shimmer across the pale plaster walls.

"This was a case of taking a house to the next level of customization, making it a portrait of the clients' tastes and way of living," says the designer. "It's a distillation of the things they most loved about their previous homes."

With their children grown, the clients chose this 12,000-square-foot Spanish-style home for their next chapter. They had lots of furniture and art they'd accumulated over time. Smith concentrated on using their most treasured pieces, deploying them in a refreshed, sophisticated way—a process he refers to as a "reshuffle" that brought to light new facets of objects they'd lived with and loved for years.

A holdover concept that had never been realized from earlier homes was a pink living room. Smith had, however, held onto the idea and finally implemented

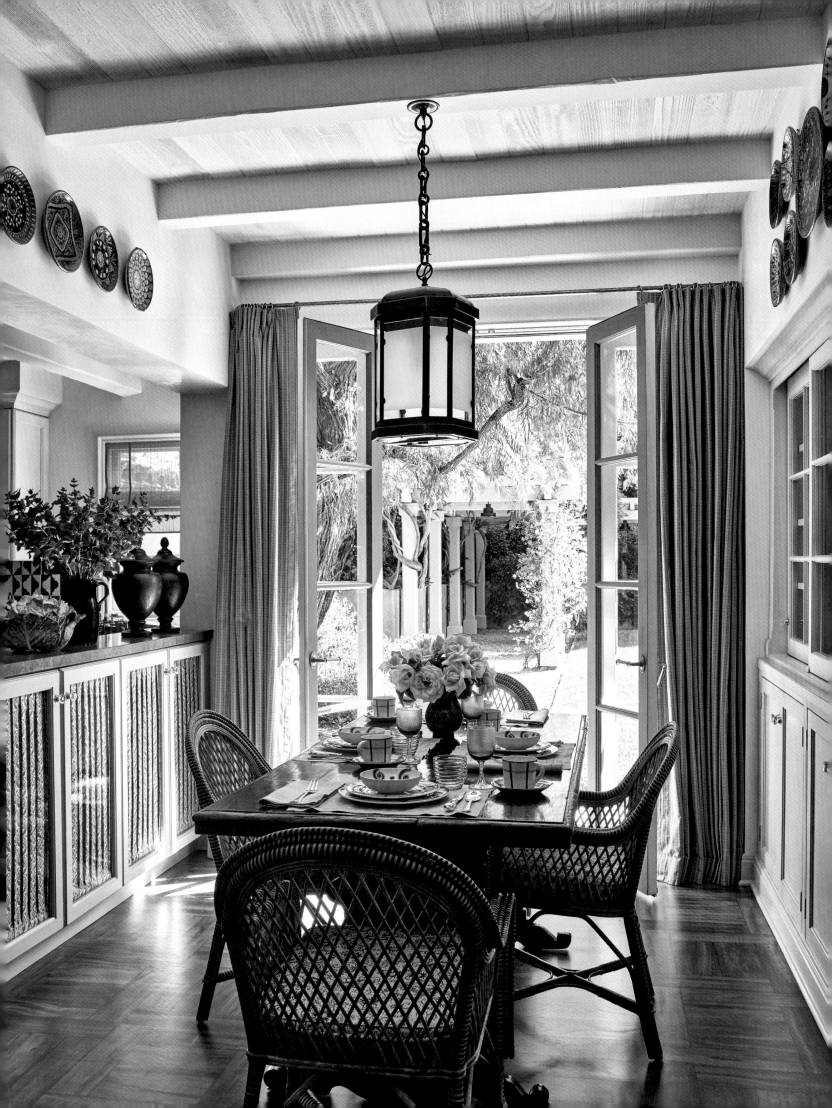

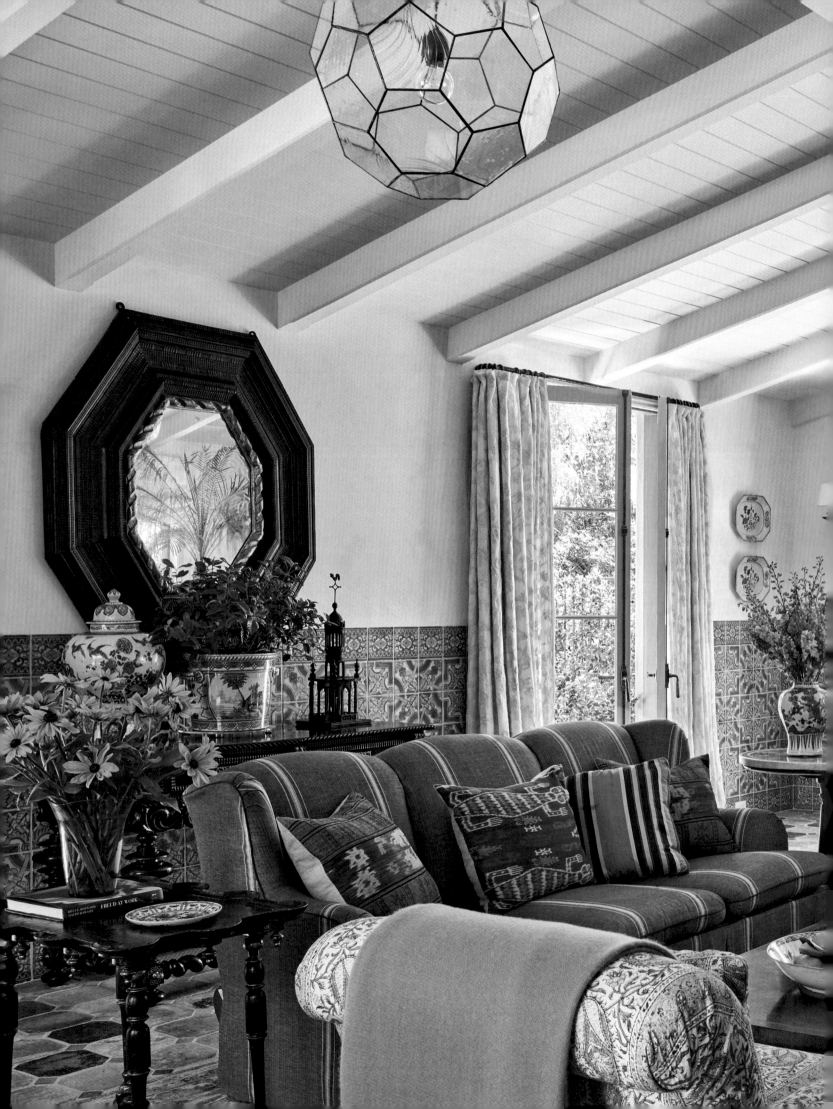

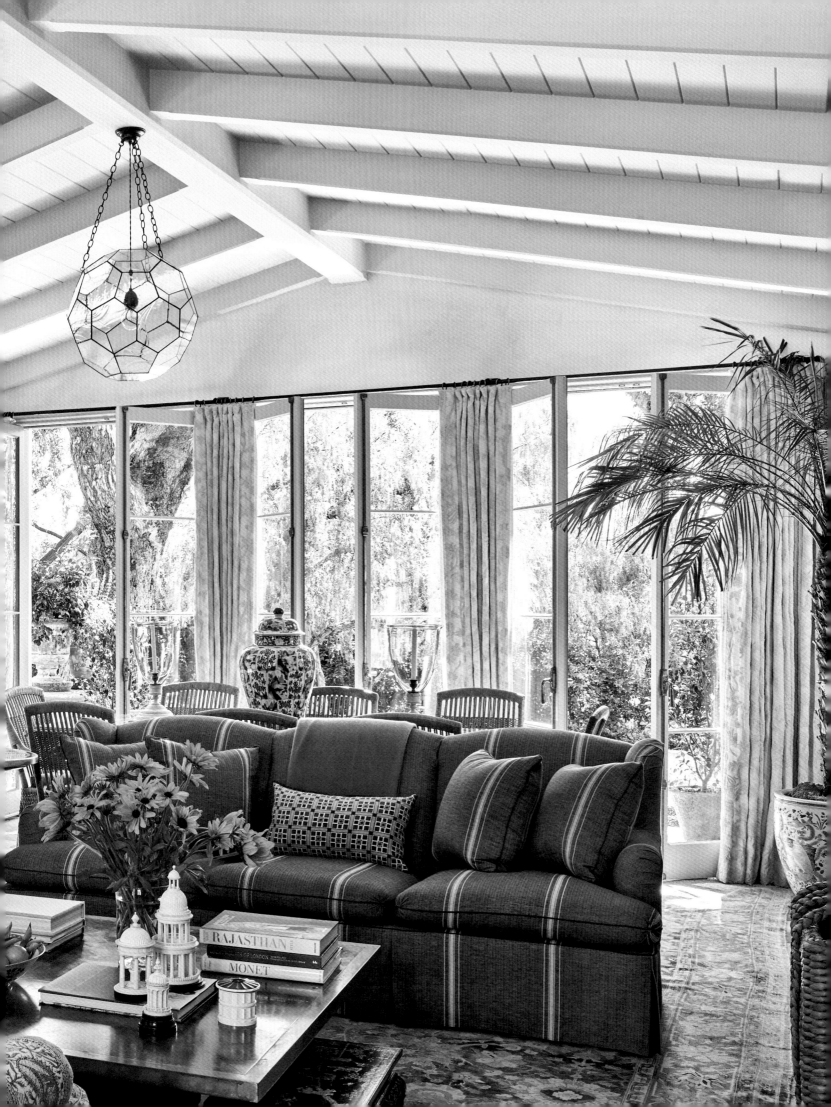

it here, coating the walls with a warm, powder-pink Venetian plaster. He also replaced the original chimney-piece with a delicate pale pink marble Louis XVI–style fireplace surround inset with white marble bas-reliefs. The room is gently infused with a range of pinks, from the subtlest blush to pomegranate, in the nineteenth-century Turkish carpet made for the European market, the sofa upholstered in a bold botanic print from fabled fabric design company Pierre Frey, and the many pillows that populate the seating arrangements.

"This project was an exercise in fabric choices—it's a color, texture, and pattern story," says Smith, adding that the house is in many ways an homage to Pierre Frey. "The clients are huge fans of the French textile firm, and we went with many patterns that they've loved for years, but had them made in customized color combinations and used them in novel ways."

The dining room also has a pink aura, though here the color is mixed with warmer shades of burgundy and mocha. There's enough gilding on the picture frames, sconces, mirrors, and consoles to make the room glow. Above the custom marbleized wainscoting, the walls are clad in intricately painted and embossed leather by Atelier Mériguet-Carrère—another nod to Spain and its traditional crafts. The colorful plates filling the walls of the breakfast room provide yet another touch of Spanish decor, though these plates are actually by French master-ceramist André Metthey, whose work the homeowners collect.

The sunny garden room is also imbued with classic Iberian style, from the beamed ceiling to the warmly toned and beautifully honed antique ceramic floor tiles, which Smith found in Spain. The blue-and-white color scheme extends to the seating, comfy sofas and armchairs upholstered in stripes and paisley, and echoes in stunning examples of Chinese export porcelain displayed throughout the room. Blue-and-white tile wainscoting is another European reference, though one with personal meaning as well. Smith says, "The tiles on the walls are a local, California interpretation of an antique Portuguese tile that I'd used in an earlier home for these clients—a visual heirloom for them from years ago."

On the second floor, the various rooms of the primary suite offered Smith a chance to combine different styles and periods deftly, creating a very sophisticated blend of California casual and French sophistication. In the bedroom, he ran a crisp aqueous blue-and-cream checked wall covering right up onto the gently pitched ceiling to create a soothing backdrop for other fabric choices in blues and pale greens. The bed is Smith's homage to Le Clos Fiorentina, Hubert de Givenchy's beloved home on the French Riviera.

Just off the primary bedroom, the wife's study is compact but flooded with sunlight that pours in through large windows overlooking the lushly verdant garden. The abundance of light visually expands the space, as does—perhaps paradoxically—the flower-strewn wall covering. The designer brought the garden inside by enveloping the small room in a boldly scaled Zuber floral wallpaper; he even hired painter Maria Trimbell to continue the vines and branches onto the ceiling. One might expect all that pattern to shrink the space, but Smith knew it would have the opposite effect.

"It is a classic decorating trick to visually expand a smaller space by using chinoiserie-inspired floral wallpaper," the designer explains. "The interlaced vines and overlapping blooms create an illusion of depth, giving the impression that one can see into the space beyond."

He did something similar in one of the guest rooms, selecting a vivid Cowtan & Tout floral fabric for the walls and ceiling and an equally intricately patterned carpet for the floor. The compact upper-story room feels like a garden bower. In a ground-floor guest room that opens directly onto the garden, Smith used more discreet hand-painted wall paneling, but had a bit of fun by hanging an eighteenth-century life-size portrait of a gentleman who can be spotted between the bed-curtains.

That kind of playful spirit abounds in the house. Indeed, it feels almost like a resort or holiday getaway—something the designer played up with wicker furniture outdoors and lots of comfy nooks inside for reading and unwinding. "The home has a certain wit and lighthearted air about it," Smith says. "It's not for grand entertaining but for their own personal enjoyment."

PREVIOUS PAGES: Grandchildren are welcome to play in the sun-filled garden room with its indestructible tile floor (reclaimed from Spain, as was the floor in the entry) and beautiful blue-and-white azulejo wainscoting. The tile color scheme inspired the upholstery choices, as well as the abundant display of blue-and-white Chinese porcelain. OPPOSITE: A pictorial Bessarabian rug anchors the cozy paneled study with its exquisitely sculptural ceiling. A plumply cushioned sofa is upholstered in yet another Pierre Frey fabric (the homeowners are devoted fans of the fabled French textile house). The sleek cocktail table is by Jasper.

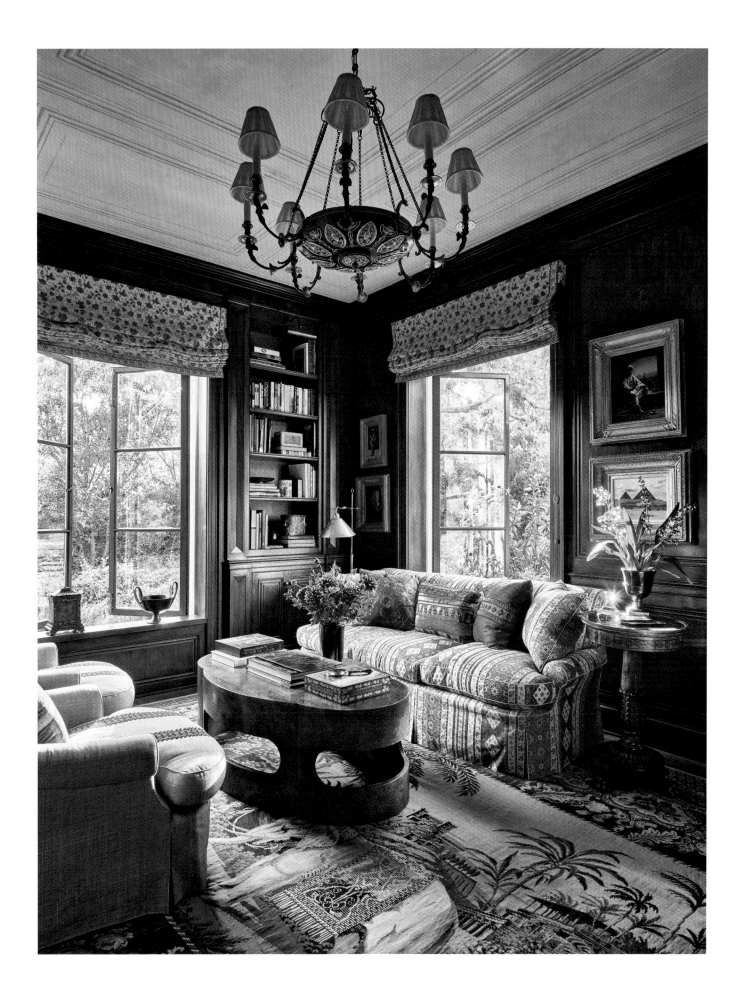

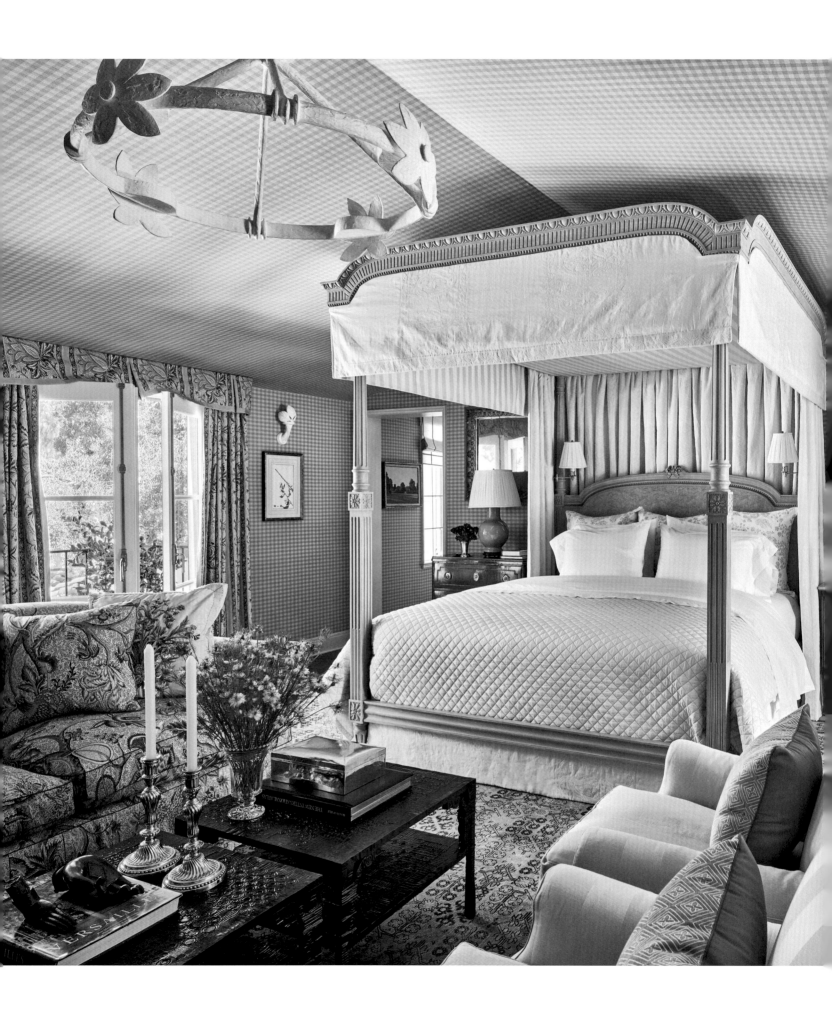

LEFT: The walls and ceiling of the primary bedroom are clad in a fresh, simple blue-and-cream checked fabric as a backdrop to Smith's homage to Hubert de Givenchy's canopy bed at Le Clos Fiorentina, his home on the Riviera. The bronze light fixture with plaster finish is by Philippe Anthonioz and the bronze cocktail tables in the sitting area are by Ingrid Donat. ABOVE: The simple checked cotton walls continue in another upstairs sitting area with a romantic Turkish-style sofa in a Robert Kime woven stripe fabric.

RIGHT: In a smartly paneled guest room painted a chalky, greenish blue, a life-size eighteenth-century portrait of a gentleman peers out from between the bed-curtains.

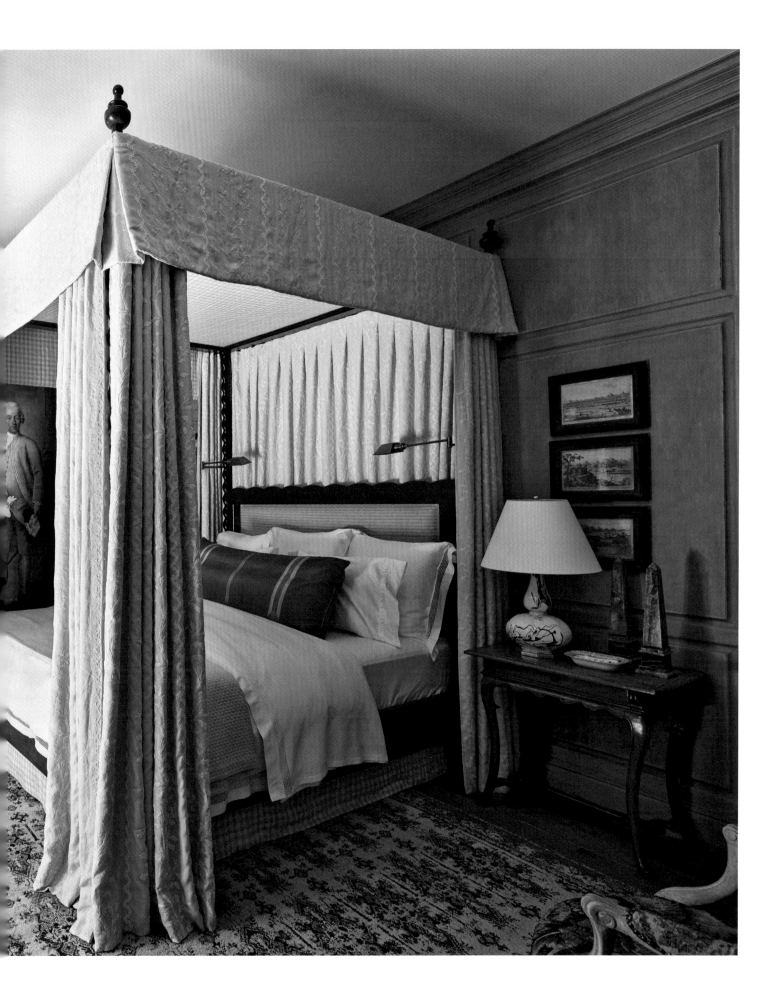

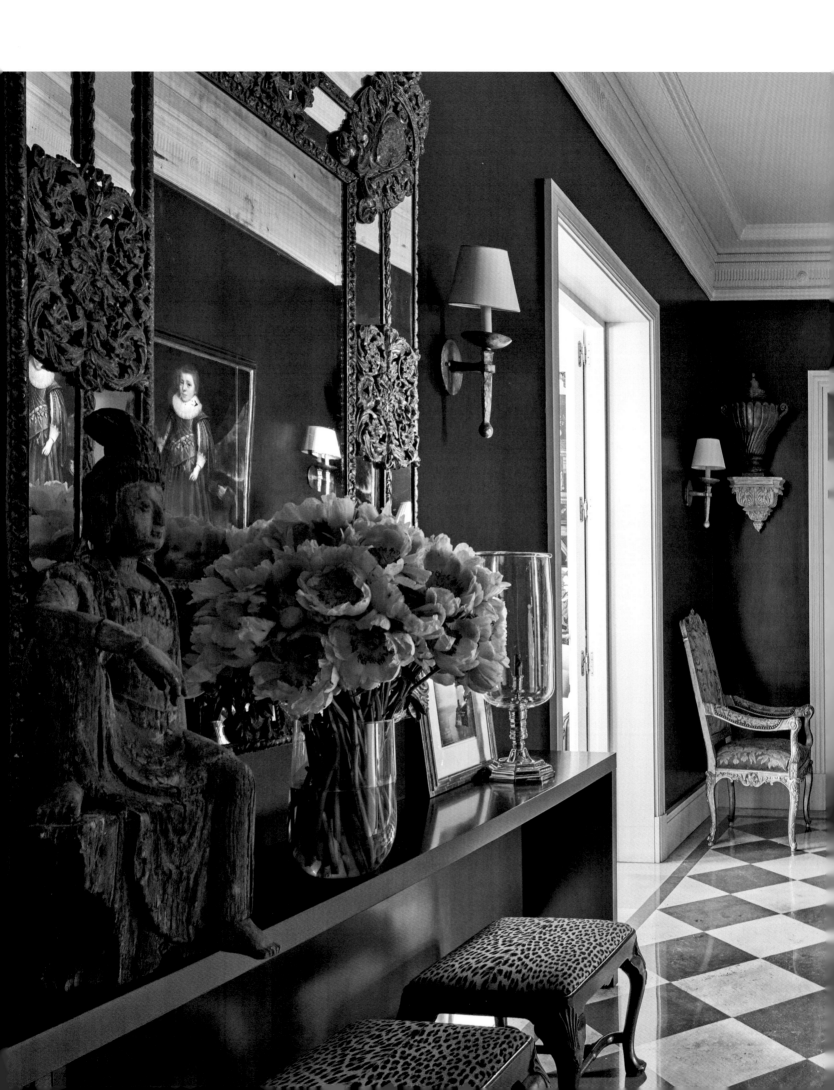

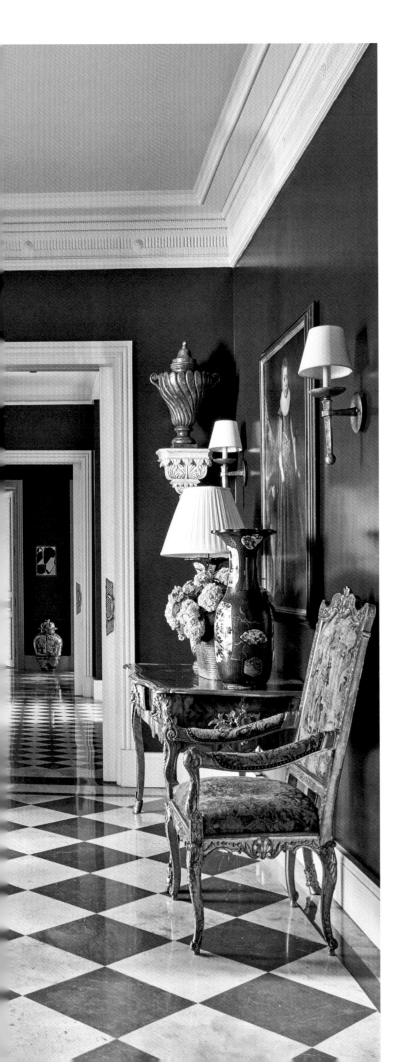

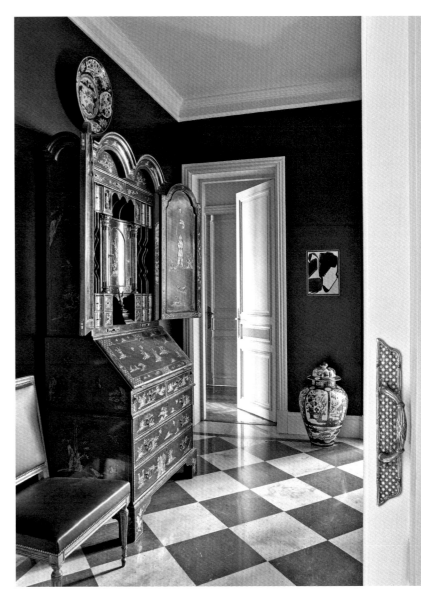

PIED-Á-TERRE
MADRID

IN 2013, WHEN MICHAEL SMITH'S PARTNER, James Costos, was tapped by President Barack Obama to serve as ambassador to Spain and Andorra, the couple began maintaining a home in Madrid. Their first was, naturally enough, the official ambassador's residence on the Paseo de la Castellana, the Spanish capital's grandest throughfare. Smith immediately rejuvenated and redecorated the straitlaced 1950s residence, filling it with stunning furnishings and blue-chip American

and international contemporary art. The couple then flung open the doors to a four-year whirlwind of parties, events, commemorations, intimate movie screenings, and all manner of social gatherings that *madrileños* still speak about nostalgically years later. When Obama's (and thus Ambassador Costos's) term ended in early 2017, the couple said goodbye to the embassy and residence, but not to Madrid.

With a surfeit of stylish furniture and artworks in tow, not to mention a whole new social universe of friends—from the realms of art, commerce, design, entertainment, politics, and, yes, royalty—the couple were committed to maintaining a toehold in the Spanish capital. Well before their diplomatic eviction date arrived, Smith had already organized a soft landing—a rental apartment owned by friends—in the heart of Madrid's postcard-pretty Barrio de Salamanca.

"This was another one of those cases where my job was pure decoration," Smith says. "Because it was a rental, we couldn't move walls or reconfigure the layout in any way." Fortunately, the apartment occupied half the *piano nobile* of a pretty brick building—the palatial former home of a nineteenth-century noble family that had been converted into apartments by the same construction firm that had worked on the embassy residence. "It was such an easy transition," Smith recalls. "The most basic things like the light switches, doorknobs, and closet were all the same as we'd had before, so it immediately felt like home."

Both the entrance foyer's polished black-and-white checkerboard floor and its deep brown wall color were among the features Smith inherited and couldn't alter. "But the floor was beautifully crafted," he says. "And the walls had a waxlike finish on them that gave the color depth and warmth without the hardness and shine of enamel or lacquer."

PREVIOUS PAGES: Located on the *piano nobile* of a former nobleman's family palace, the apartment has a handsome entrance and high ceilings. When downsizing from the United States embassy residence in 2017, Smith had more than enough furniture to fill the space. Among the pieces was an ornate red lacquer chinoiserie secretaire with delicate gilded decoration from Burton-Ching. RIGHT: Seeking a sense of lightness and lack of fuss after years of diplomatic duty and grand entertaining, Smith had the seating furniture in the living room covered in white slipcovers of different weaves and patterns. The eighteenth-century Coromandel screen has followed him from home to home for almost two decades.

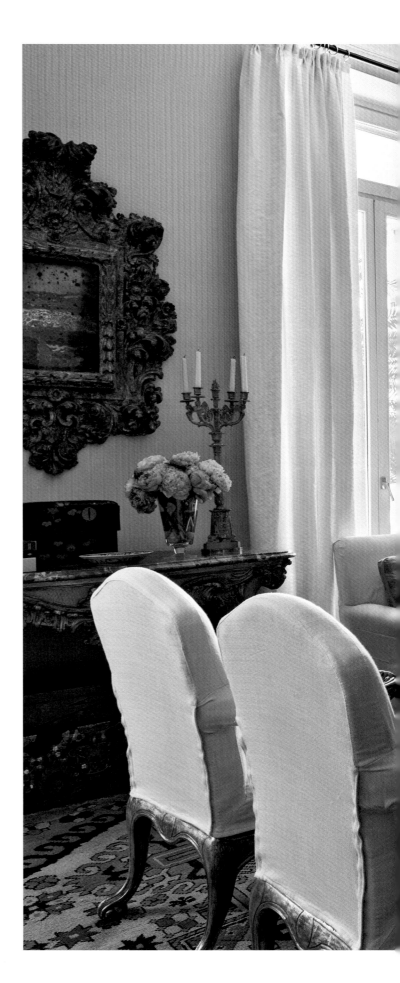

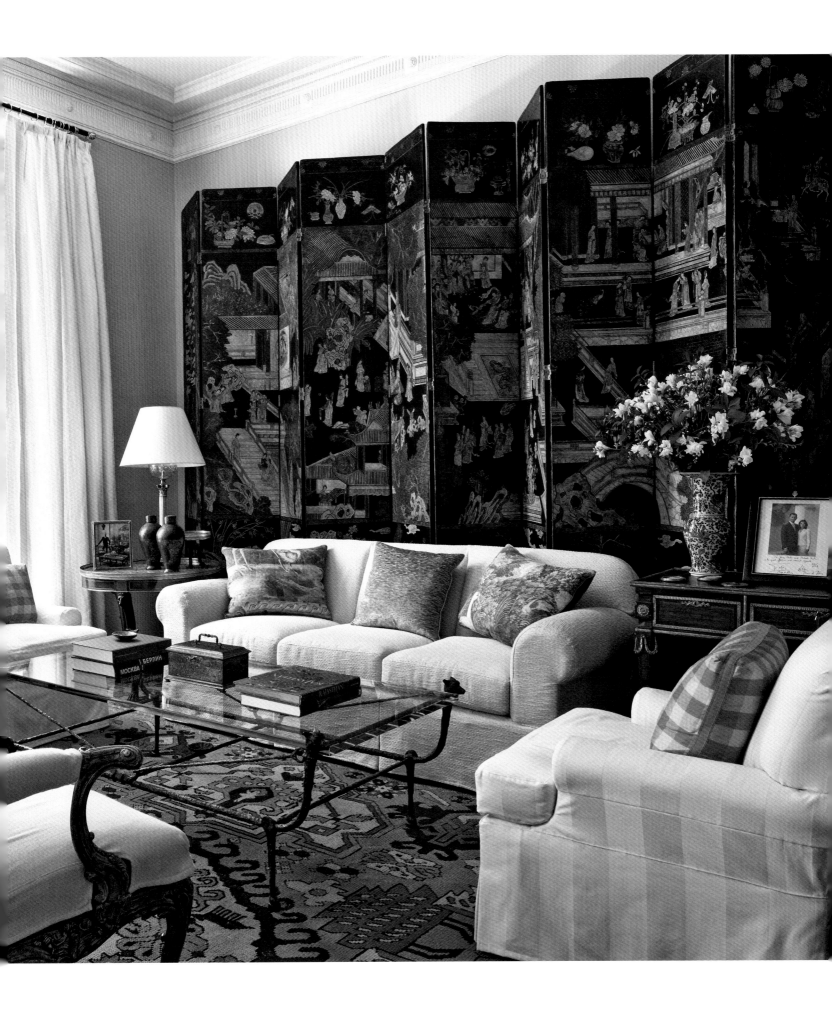

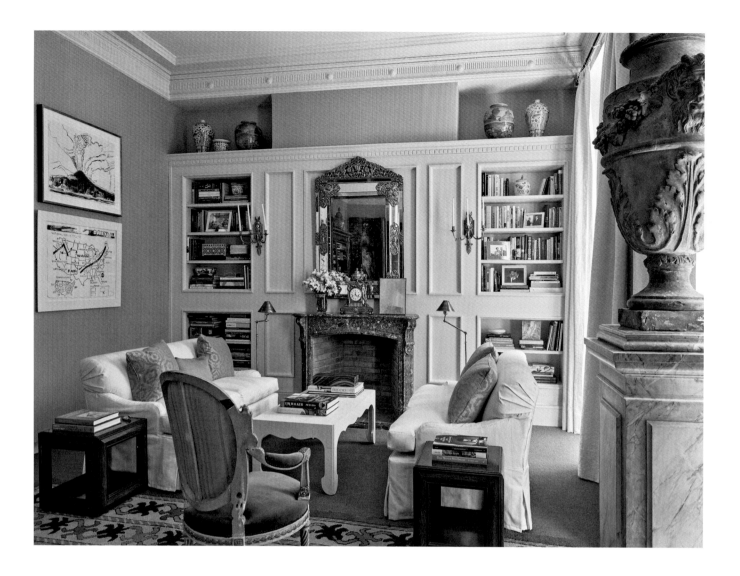

The foyer links all the public rooms through two pairs of pocket doors that create an abbreviated enfilade, heightening the sense of grandeur. Smith took that drama even further at the hall's far end by deftly combining a tall and ornate red lacquer chinoiserie secretary with gilded decoration and a diminutive but powerful abstract painting by Patricia Treib hung above a large polychrome Chinese ginger jar standing on the floor. This unexpected trio guards the passage from the home's public spaces to the private realm of the bedrooms.

After years of formal entertaining, Smith wanted their new Madrid home to have a breeziness that an embassy residence never could, so he draped most of the seating furniture in white slipcovers. These look simple at first glance, but a closer inspection reveals that Smith had had them made from an array of different fabrics, from patterned cotton damask to striped white linen. "I love texture," Smith confesses, "and tend not to love a flat, plain weave on anything, ever."

While the living room is not huge, it has two distinct seating areas, the larger of which is presided over by a splendid eighteenth-century Qing-dynasty Coromandel screen that Smith has owned for years and that is rumored to have belonged to Coco Chanel. At the embassy, it was centered in a far larger room and often served as a backdrop in press photos of visiting dignitaries. Here it nearly covers the entire wall, and its rich oxblood lacquer and delicately painted scenes of palace life create a cozy ambience for conversation. Across the

ABOVE: On the opposite side of the living room, Smith punctuated the pared-down aesthetic with a few choice pieces, like the large urn at right and the Louis XV–style mirror over the fireplace. Artworks on the wall at left are by Andy Warhol. © 2024 The Andy Warhol Foundation for the Visual Arts, Inc./Licensed by Artists Rights Society (ARS), New York. OPPOSITE: A view from the former ambassador's library, with its bronze Jasper chandelier and furniture without slipcovers, looking into the dining room.

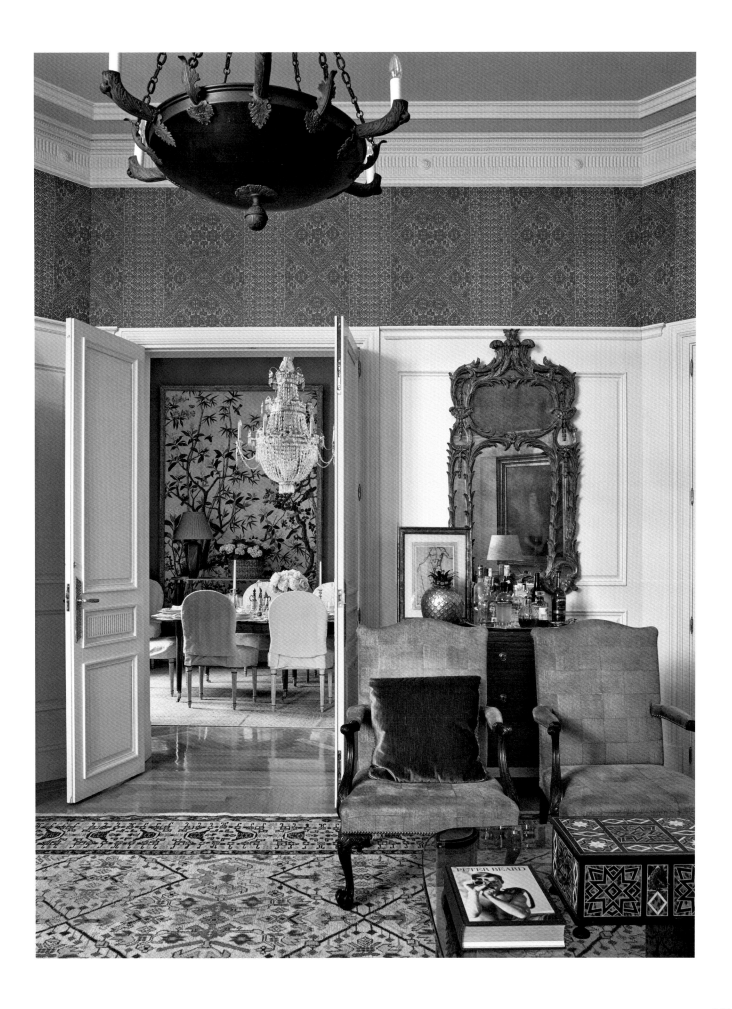

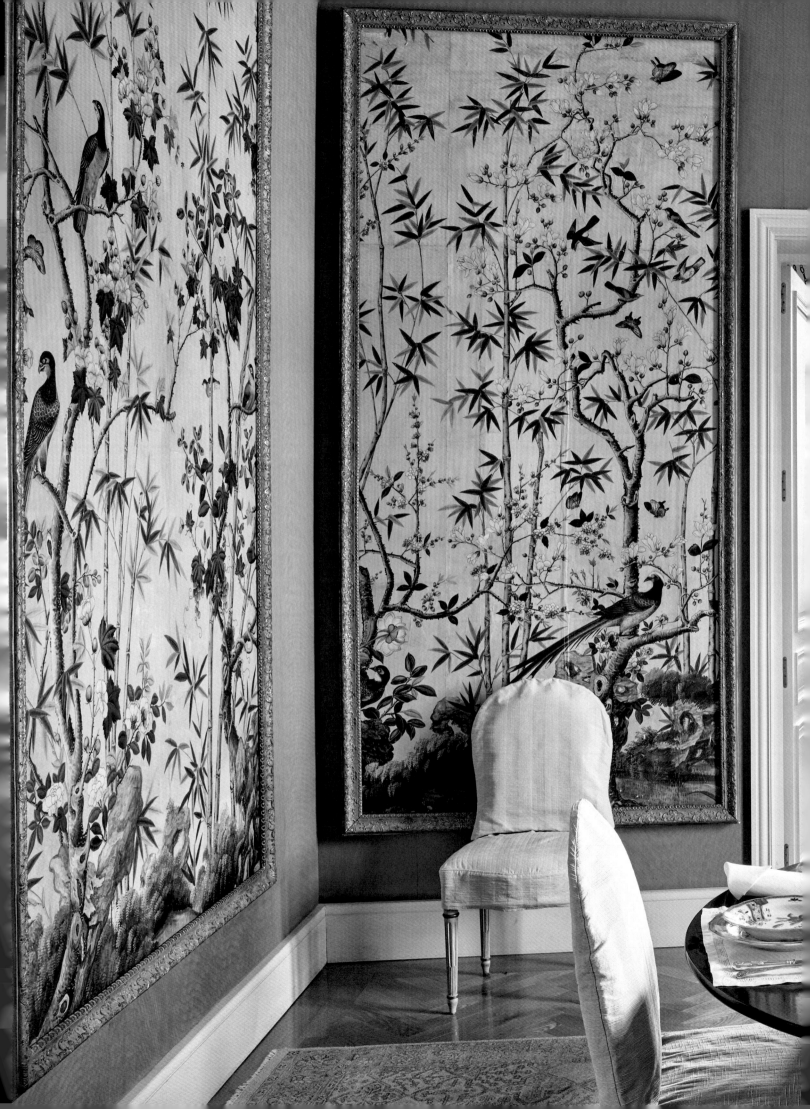

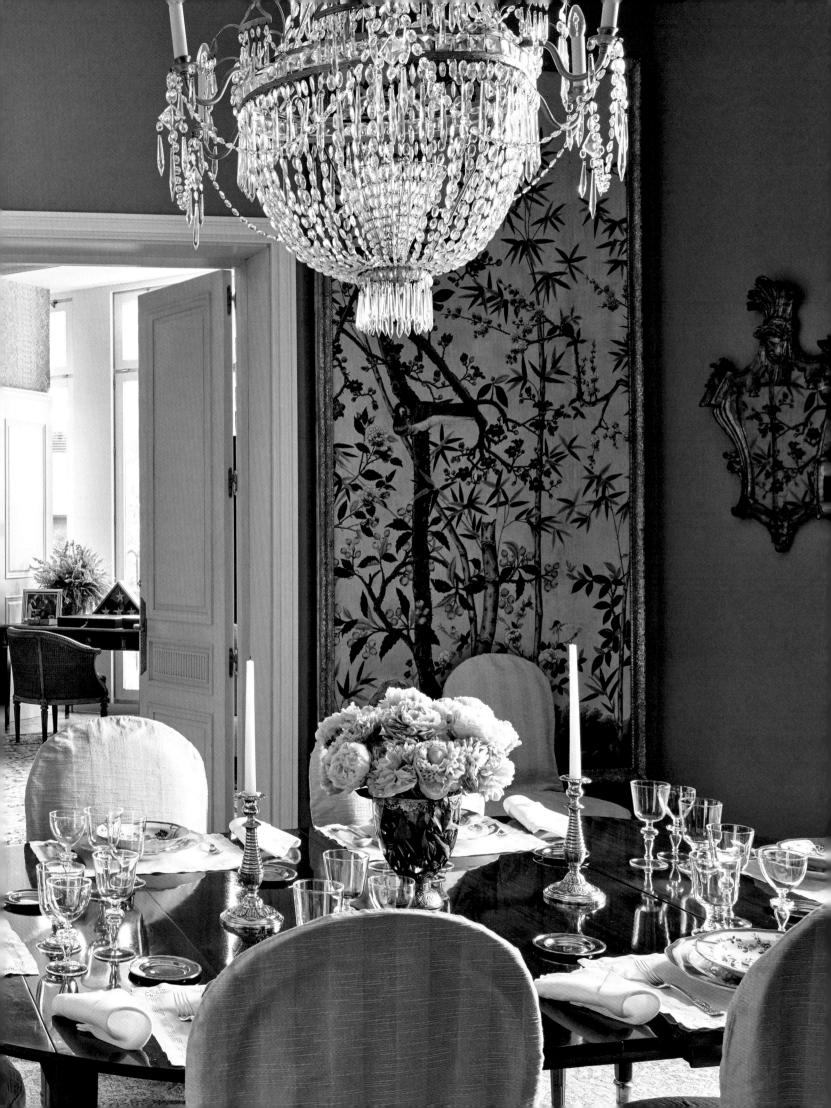

room, Smith arranged a jaunty mix with a shimmering gilded Louis XV–style mirror over the fireplace and a pair of prints by Andy Warhol hung above the sofa.

Another of Smith's beloved treasures—a suite of elegantly framed eighteenth-century Chinese painted wallpaper panels resplendent with exotic plants and fowl—adorns the dining room. "Experts in Chinese art always highlight the quality and exquisite detail of the painting," Smith says. "But I find the refined carving and beautifully aged gilding on the French Régence frames equally appealing."

The panels have followed Smith from home to home for years and adorned the principal guest suite at the embassy where Barack and Michelle Obama stayed. In the new Madrid abode, the panels' vivid emerald-green bamboo leaves stand out against walls covered in a subtler jade-green moiré fabric. The result is a garden-like dining atmosphere in the heart of the city.

Among the designer's more recent acquisitions are a pair of portraits of Spain's King Charles IV and his queen, Maria Luisa of Parma, by one of Goya's most accomplished followers, Agustín Esteve y Marqués. Here the royal couple reign over the library—a cozy, white-paneled room furnished with comfy seating upholstered in a symphony of autumnal shades like gold, brown, and burgundy.

The aesthetic is not so straitlaced in the bedrooms, where the designer mixed bold patterns, furniture, and art from many different periods. The guest room walls are covered in a colorful linen floral upon which hang four trompe-l'oeil bas-reliefs titled *The Atrocities of Napoleon* for guests' bedtime contemplation. In the primary bedroom, a crisp blue-and-white Madeleine Castaing fabric on the walls and curtains is the backdrop to a shimmering silver Jason Martin canvas. That modern work squares off against an old-school heraldic embroidery hanging above the bed that confers a whiff of noble stature to the residents who sleep beneath it.

PREVIOUS PAGES: Starting with the Templeton green cotton moire he put on the walls, Smith essentially conceived of the dining room decor in relation to the display of his prized suite of eighteenth-century hand-painted Chinese wallpaper panels in Régence frames. The mahogany table is Louis XVI and the chandelier is nineteenth-century. LEFT: In the library, Smith used a mix of Jasper fabrics on an O. Henry House sofa and club chairs. The coffee table is a vintage Ron Seff design. Smith purchased the royal portraits of Spain's King Charles IV and his wife, Maria Luisa of Parma, at auction.

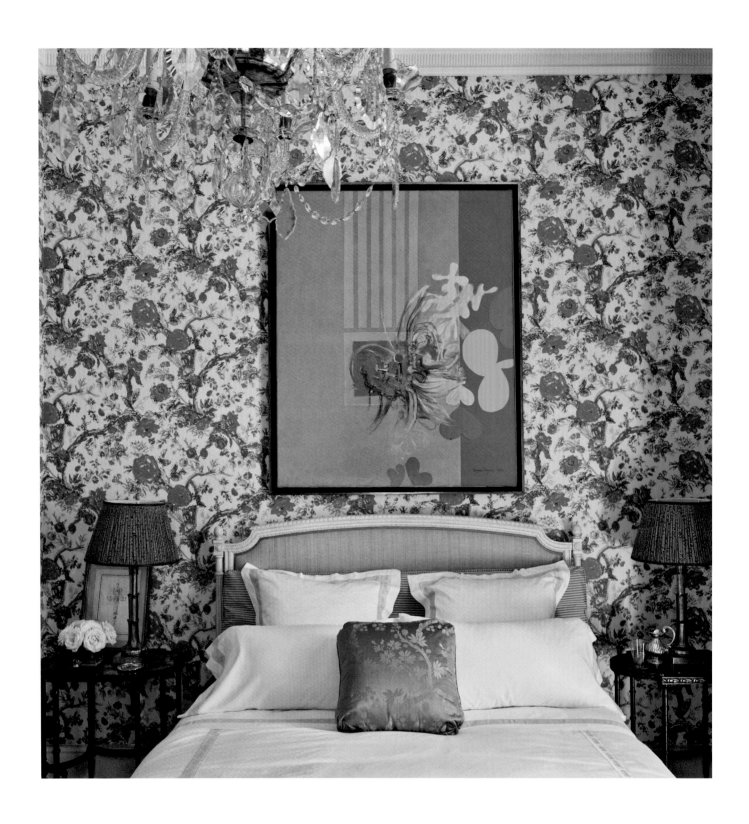

ABOVE: In the guest room, a painting by Bryan Organ
plays off the floral wall covering by Jasper. The lamp on the
night table is by Vaughn with an Irving & Morrison shade.
OPPOSITE: A Louis XVI settee is ironically placed beneath
a series of trompe-l'oeil bas-reliefs depicting *The Atrocities
of Napoleon* by Nicolas-Louis-François Gosse.

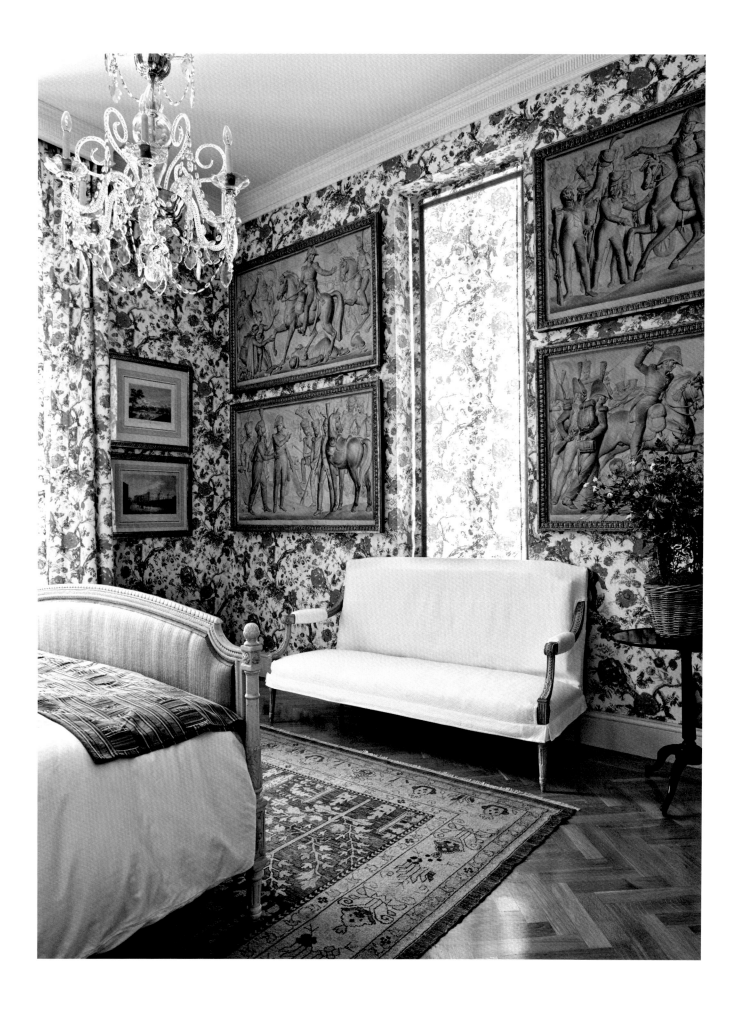

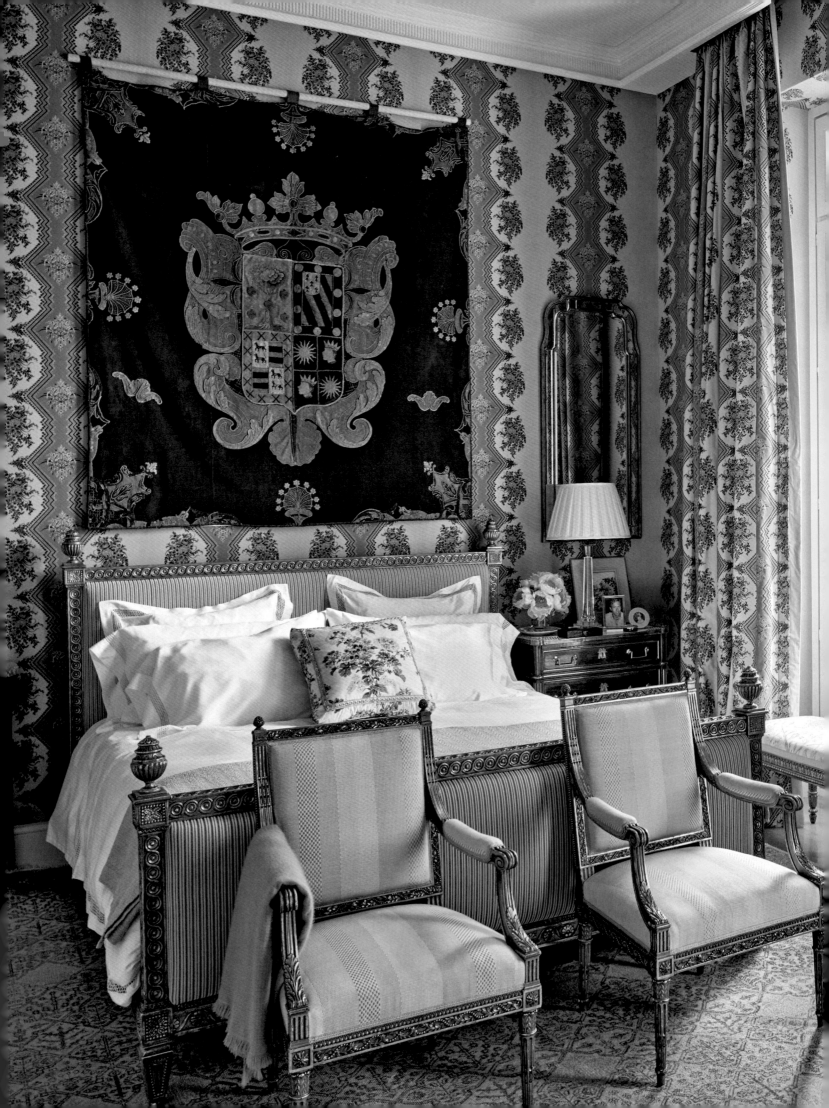

LEFT: In the primary bedroom over the ornate giltwood bed hangs an antique banner with the elaborately embroidered coat of arms of a noble family. ABOVE: Smith used a bold blue-and-white Madeleine Castaing fabric for the walls and curtains. The painting is by Jason Martin.

SALTBOX REIMAGINED
EAST HAMPTON

THIS HOUSE WAS A CUSTOM BUILD FOR a couple of Smith's very dear California clients whose family—their adult children and grandchildren—had been slowly migrating from the West Coast to New York. Wanting to be closer, the couple sold their Malibu beach house and together with Smith set out to create a family compound on a property overlooking the dunes and the Atlantic Ocean in East Hampton, New York.

Originally, the clients were determined to build a big modernist or contemporary house with spacious and flexible gathering rooms. Smith had another idea. With his potent powers of persuasion, he convinced his friends that there is no architectural style more modern than a pared-down classic Colonial American saltbox.

"The previous owner of the property had amassed on the land a considerable number of historic seventeenth- and eighteenth-century vernacular structures—sheds, barns, and small homes—that she had saved from the wrecking ball," Smith recounts. "I've always been inspired by the severity and restraint of those structures, the simplicity of the forms and volumes, the honest and forthright construction, and the weathered silvery cedar siding that clads them."

It's important to note that no historic structures suffered for Smith to give his friends a modern version of that practical and pared-down aesthetic. Before the previous owner sold the property, she donated all the salvaged historic buildings to the town of East Hampton

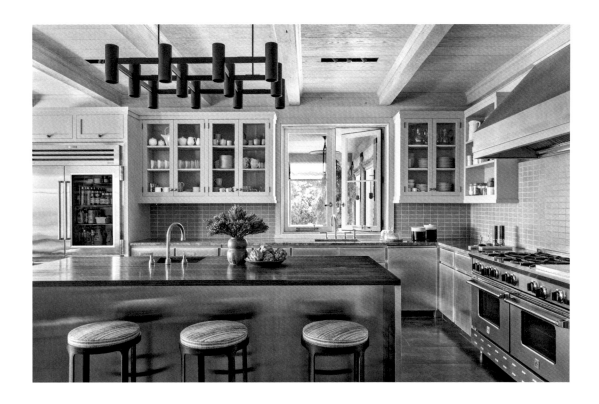

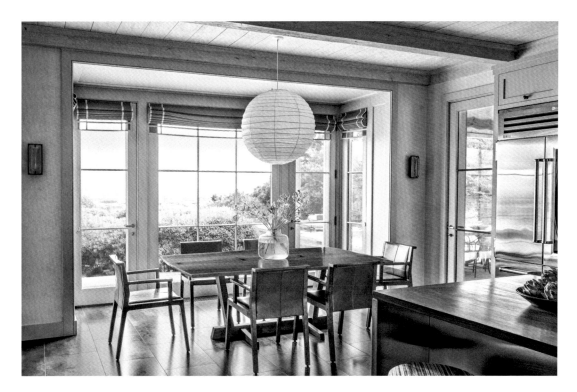

PAGE 198: Designed with architecture firm Ferguson & Shamamian, the home was conceived to look like an early Hamptons farmhouse that had been expanded over successive generations. Landscape architect Arne Maynard aimed to nurture a sense of permanence in the garden. PAGE 199 AND OPPOSITE: The great room was created to appear as if that fictive historic farmhouse had been hollowed out to create a modern loftlike space. While the architecture has a rough-hewn aesthetic, the ambience is decidedly more polished. Smith designed the custom chevron-patterned carpets. The curvy ladderback chairs in the foreground were custom made by Jamb. A small abstract sculpture by Alexander Calder rests on the table at the window. ABOVE TOP AND BOTTOM: Smith designed a timeless update to the stainless-steel kitchen, which has a bright, seaside breakfast area.

RIGHT: A large abstract canvas by
Alfred Leslie hangs in the second-floor
library, which also features bronze
bookshelves by Ingrid Donat and a
sleek coffee table by Karl Springer.

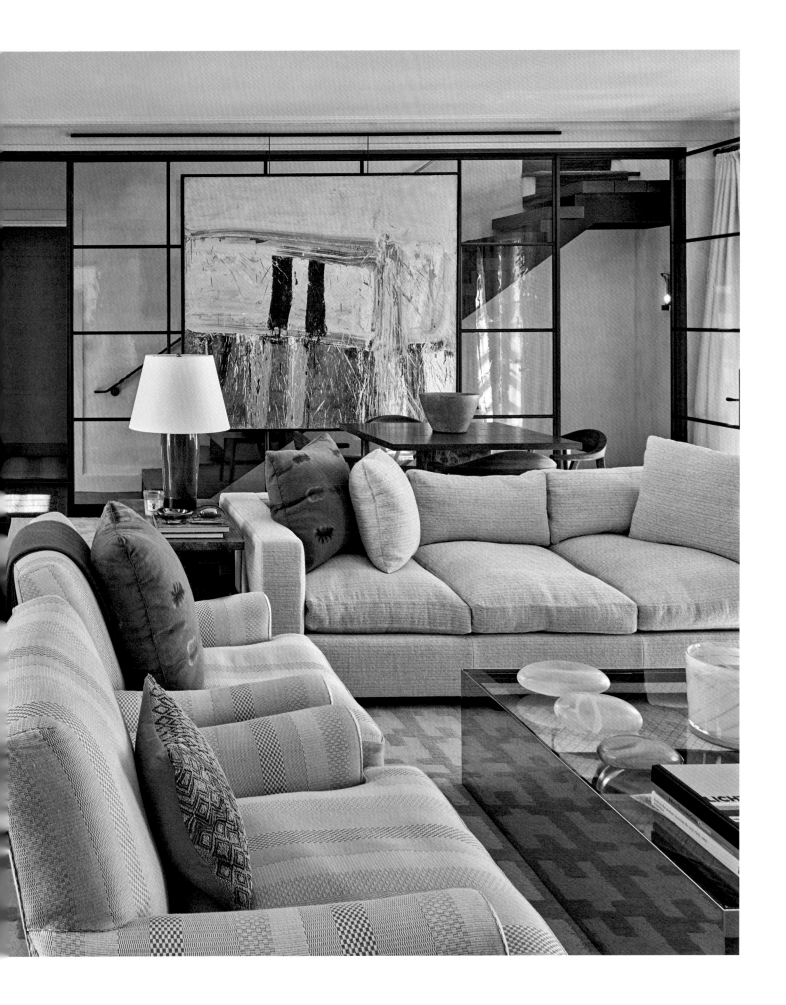

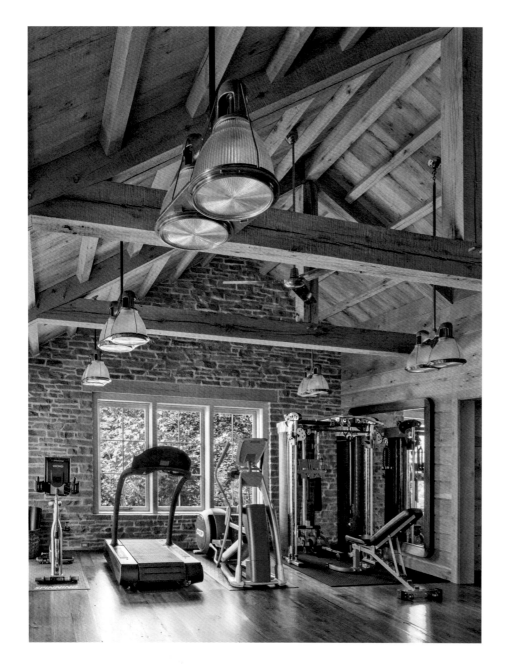

and relocated them so they could be publicly appreciated for their history and beauty.

"But back on the beach, I definitely wanted to recreate that unpretentious and slightly haphazard massing of structures on the property," Smith notes. "Obviously, working with the talents of architect Oscar Shamamian and his team, there'd be nothing haphazard about it. The idea was to wrap the proportions and customization of a 10,000-square-foot modern home—the large rooms, comfort, and livability—into an almost agrarian, Shaker-style shell that appears as if it was built in the eighteenth century and has been added to over the intervening centuries."

Around the finished home, renowned garden designer Arne Maynard used autochthonous plantings and humble materials. For example, brick terraces are linked by pathways of crushed oyster shells to create what Smith calls a "fusion of clean, underdone outdoor spaces that feel as if they've always been there. The property had long had an orchard and much of that was maintained, which adds another layer of history."

Inside the home, however, Smith was not interested in creating a look that could in any way be mistaken for one of the Colonial period rooms at the Metropolitan Museum of Art. There's not a camelback settee or a wing-back chair among the great room's mix of custom-made

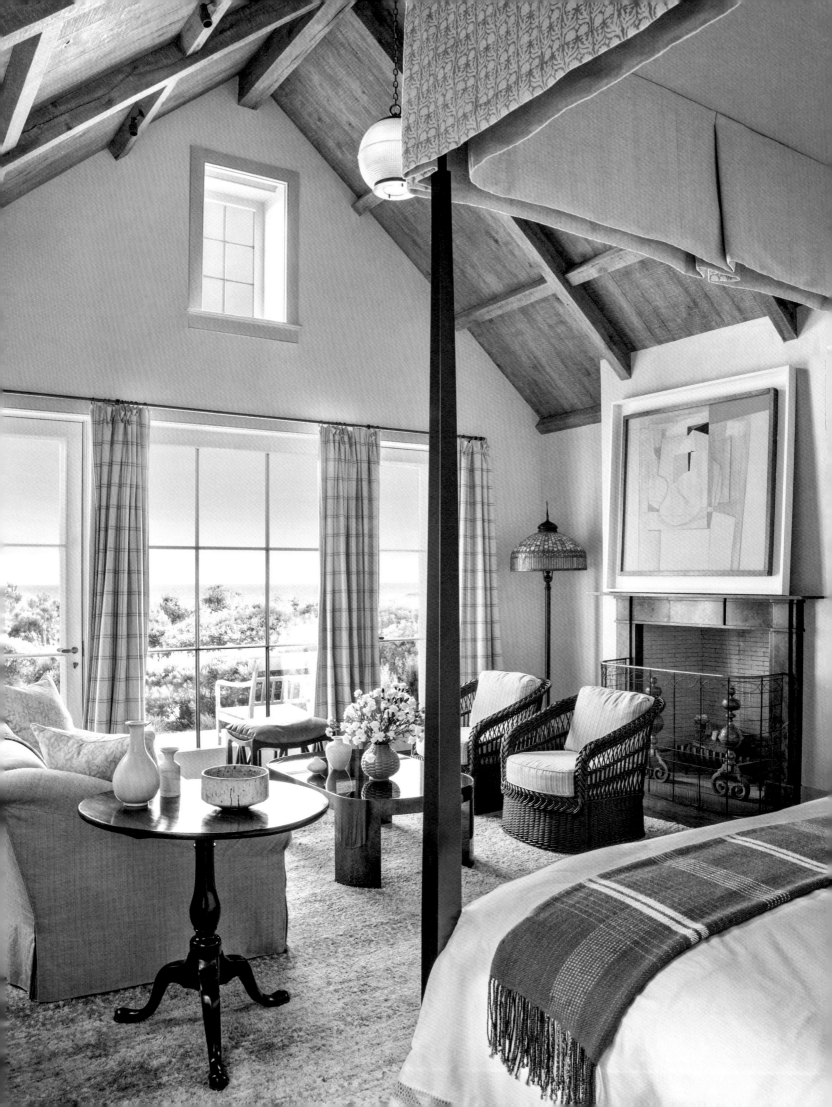

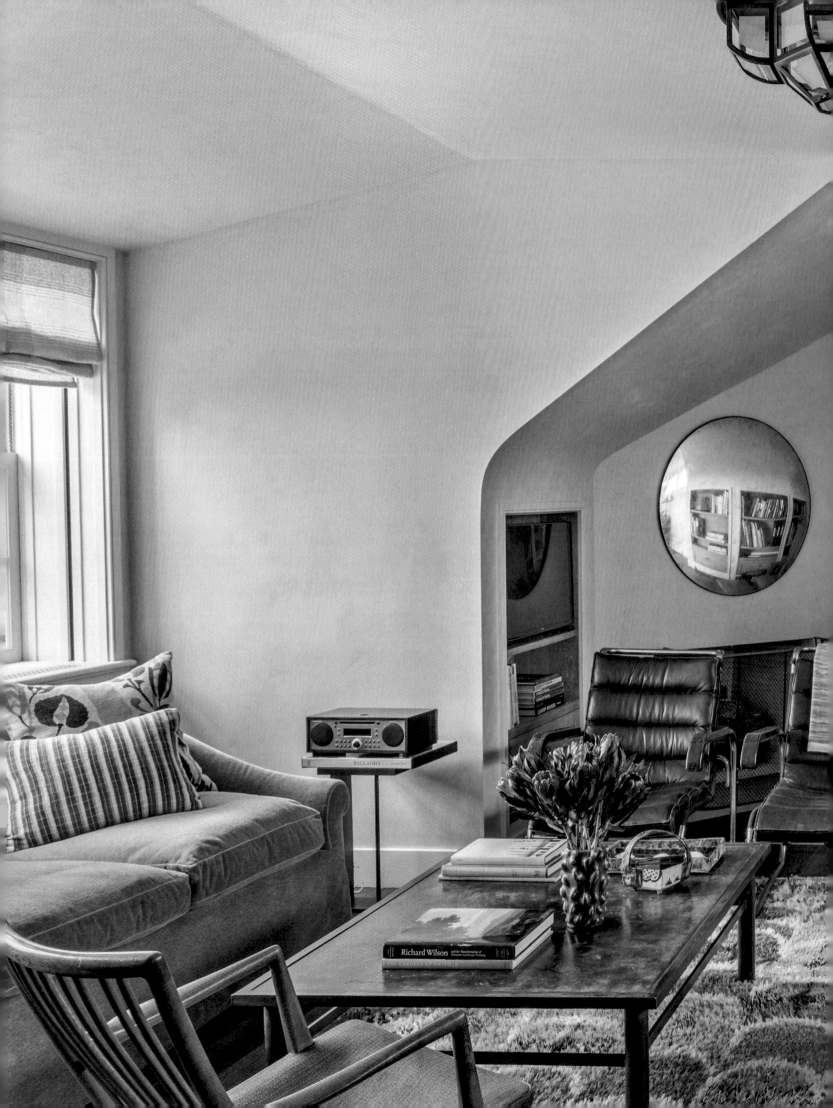

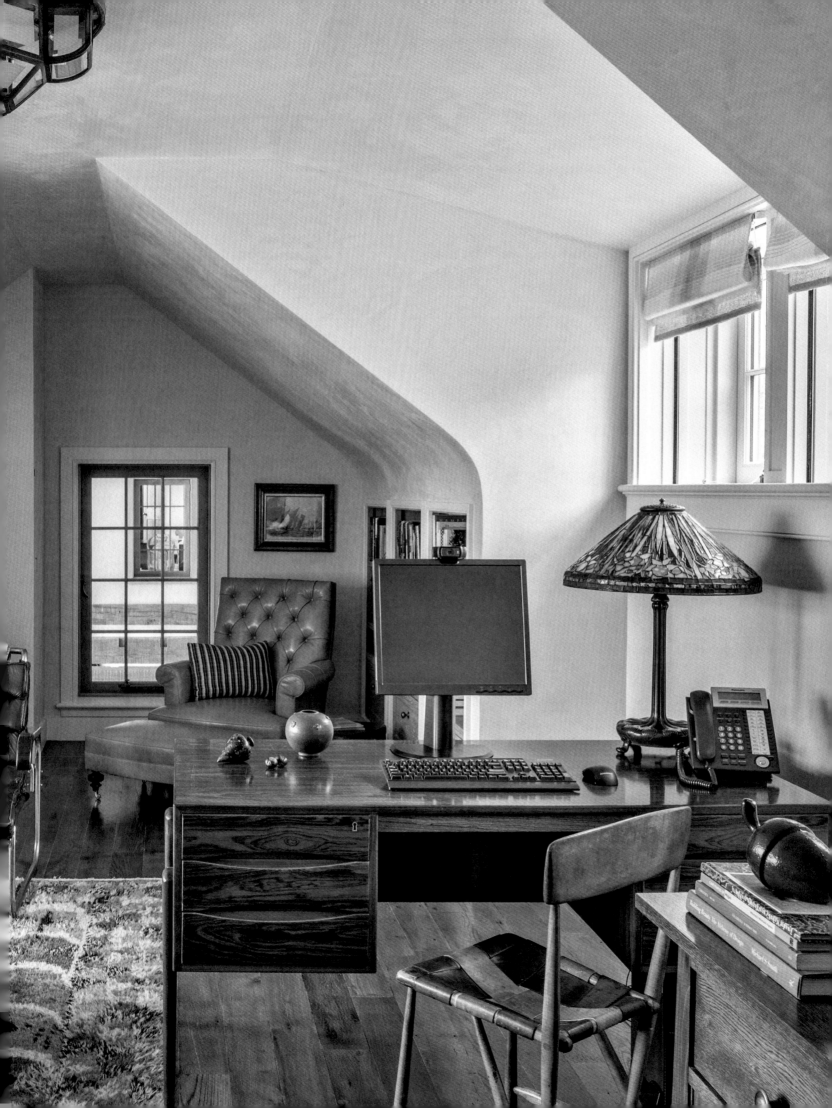

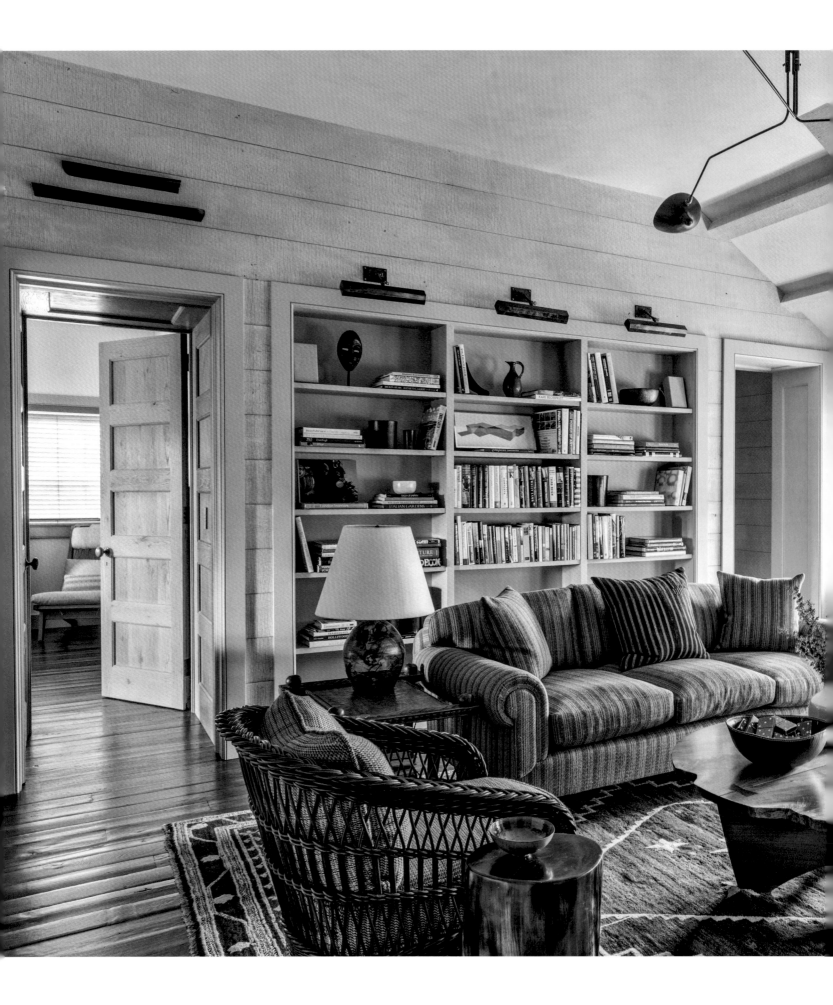

PREVIOUS PAGES: The home's exterior hints at generational evolution, as do the interiors, as in this study with stellar examples of midcentury Scandinavian and French furniture, like the rosewood desk at right. LEFT: An upstairs sitting room in the kids' and grandkids' house on the compound features a carefully curated mix of furniture styles—1900s wicker, a 1920s sofa, and more recent additions like the Nakashima coffee table beneath a Serge Mouille light fixture. FOLLOWING PAGES: Two views of what Smith refers to as the "back hall" of the guesthouse evoke the eighteenth-century incarnation of the Hamptons, when the area was a fishing and farming community. The pale pink wall color at right was achieved by mixing brick dust with Venetian plaster.

ABOVE: The great room and kitchen of the guest house bring the grand chronological sweep of the home's interiors to the present day with white-painted wood beams and a beach-casual blue and green color palette. Painting by John Altoon. OPPOSITE: A guest suite sitting room with an eclectic mix of periods and styles—from the upright wingback chair to the luxe leather and rosewood midcentury Danish armchairs.

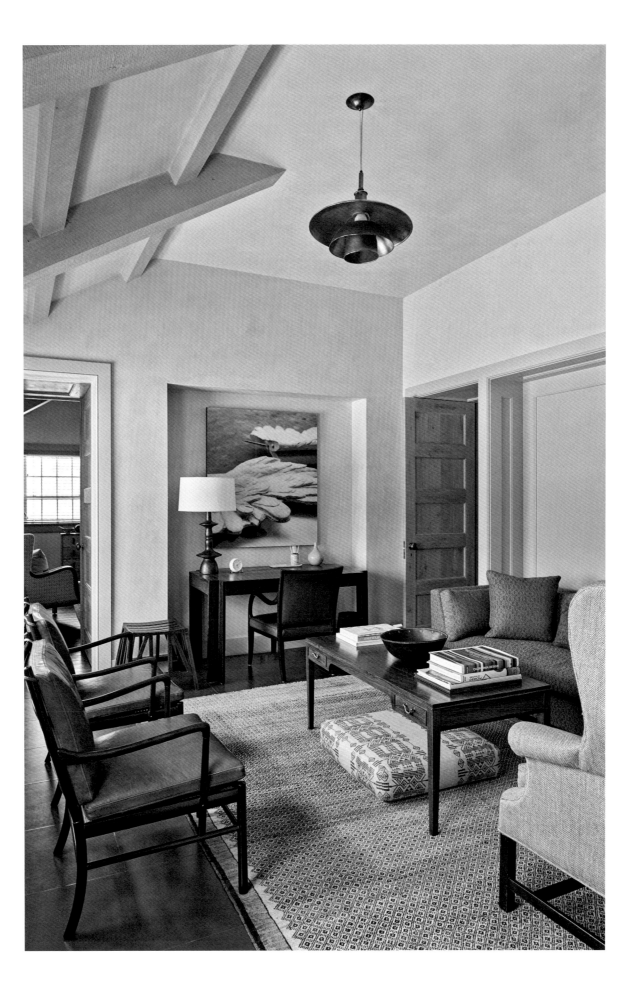

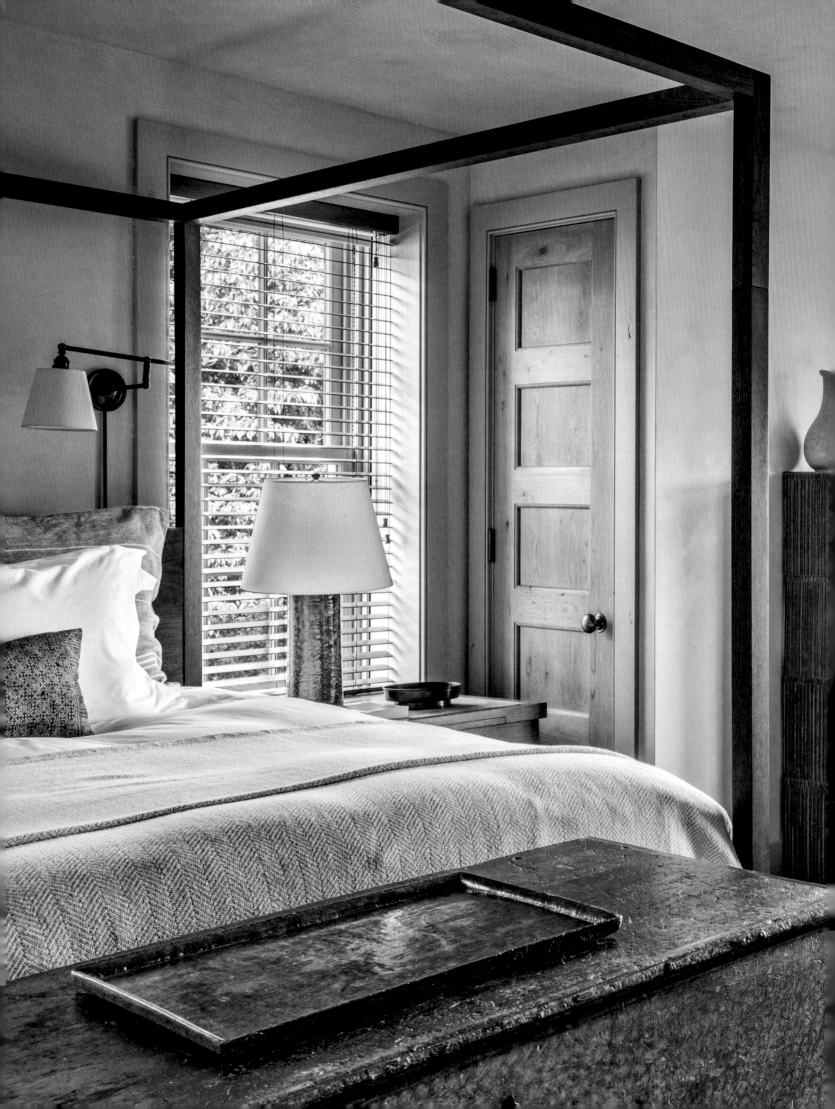

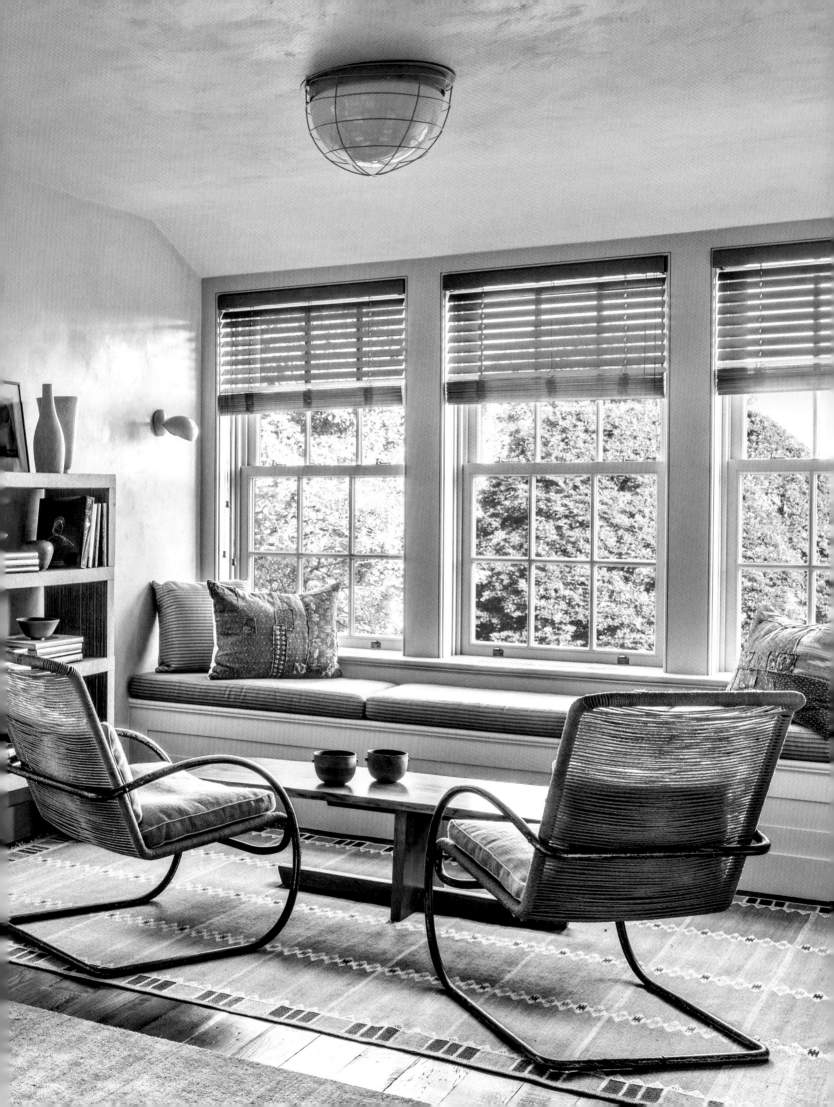

and comfortably overscale upholstered seating furniture. The design is all clean lines, and the shades of blues and ecru on the fabrics were inspired by the landscape of sea and sand. The fireplace surround has a modest Shaker appearance—only up close does one realize it's made of bronze. "Even the few antique pieces, like a square-topped highboy painted matte black and a suite of English eighteenth-century Windsor chairs, have lines that are so crisp and clean they could have been made in the 1750s, 1950s, or today," Smith says.

He explains, "Pretty much everything in the great room had to pass muster with the concept of Shaker or just plain Yankee simplicity and practicality while also being beautiful and engaging. Commissioned from Jamb in London, the dining room chairs are a slightly sexier, curvier, and more commodious interpretation of classic Shaker ladderback chairs. And—in a departure from many of my projects—there are very few objects on tables and surfaces, aside from some hurricane lamps, several art books, a large eighteenth-century iron compass, and a small sculpture by Alexander Calder— an American modernist who was deeply connected to the traditions of craft."

With the room's massive trusses and roof beams all exposed—and largely made of salvaged timbers that were lime-washed and waxed to give them a unified patina—its architecture embodies that old-new mix. It feels like an old farmhouse that's been stripped of all its tiny rooms and converted to a vast contemporary loftlike space. The windows are triple hung to echo the look of early American homes while providing easy flow between the interior and the garden.

A second-story library space is cozier and more contained than the great room, but the look is just as crisp and modern. The room is presided over by a striking abstract expressionist canvas by Alfred Leslie hung on the glass wall that separates the room from the stairway hall. A simple shimmery steel Karl Springer coffee table sits amid comfy custom chairs and sofas. Created by Ingrid Donat, the bronze bookshelves look simple, but Smith explains, "Their metal surfaces have been painstakingly cast and embossed with these amazingly intricate, almost organic patterns and textures. In decorating, metal is often considered a 'cold' material, so it's surprising to see how such artfully handled bronze can add tremendous warmth to the room."

In the primary bedroom, Smith paid homage to various moments in Hamptons history with everything from an eighteenth-century mahogany tilt-top table to stately wicker chairs and a stained-glass floor lamp that reference the area's rise as a fashionable summer resort at the turn of the twentieth century to the early abstract canvas above the fireplace by midcentury master Ben Nicholson. "I intentionally made the curtains in an earnest, buttoned-down windowpane pattern as a reminder of the region's beginnings as a hardscrabble farming and fishing community before it was 'discovered' by artists like William Merritt Chase and everyone who came after them," Smith says.

A small stone structure that includes a guest room and a gym intentionally looks as if it had once been a barn or outbuilding and follows the great room's aesthetic lead in appearing stripped down to the rafters for the ease of contemporary living. Other contiguous buildings include a large guesthouse for the couple's children and grandchildren. Its stunning pale-pink back hall (the walls are coated with Venetian plaster tinted with ground brick) with a well-used eighteenth-century trestle table, scuffed-up captain's chair, and globular blown-glass pendant lamps breathes eighteenth-century America. But elements of the modern world also appear, starting with the Lynn Davis photographs of icebergs that wink at the seafaring past of the Hamptons, a George Nakashima coffee table, and a suite of midcentury Danish rosewood chairs and other icons of twentieth-century design that blend seamlessly into the mix.

The attentive eye will notice a similar progression on the exterior of these alleged architectural accretions to the main house and property, which reveal "newer" nineteenth- and early twentieth-century features like French doors and Venetian blinds, reinforcing the invented narrative that the home has been expanded at different moments. The twenty-first-century compound now nestles perfectly into its site. Smith says, "It seems as if it's always been there and, like the dunes and shrubbery that surround it, has evolved over time."

PREVIOUS PAGES: A top floor guest room that nicely conveys a casual carefree Hamptons charm with the Venetian blinds and window seat and rustic chest combined with modernist pieces like the tubular metal lounge chairs and Nakashima coffee table.
OPPOSITE: The discreetly placed pool and a lounge area in muted tones blend with the home's autochthonous silvery weathered cedar siding and Maynard's natural garden aesthetic.

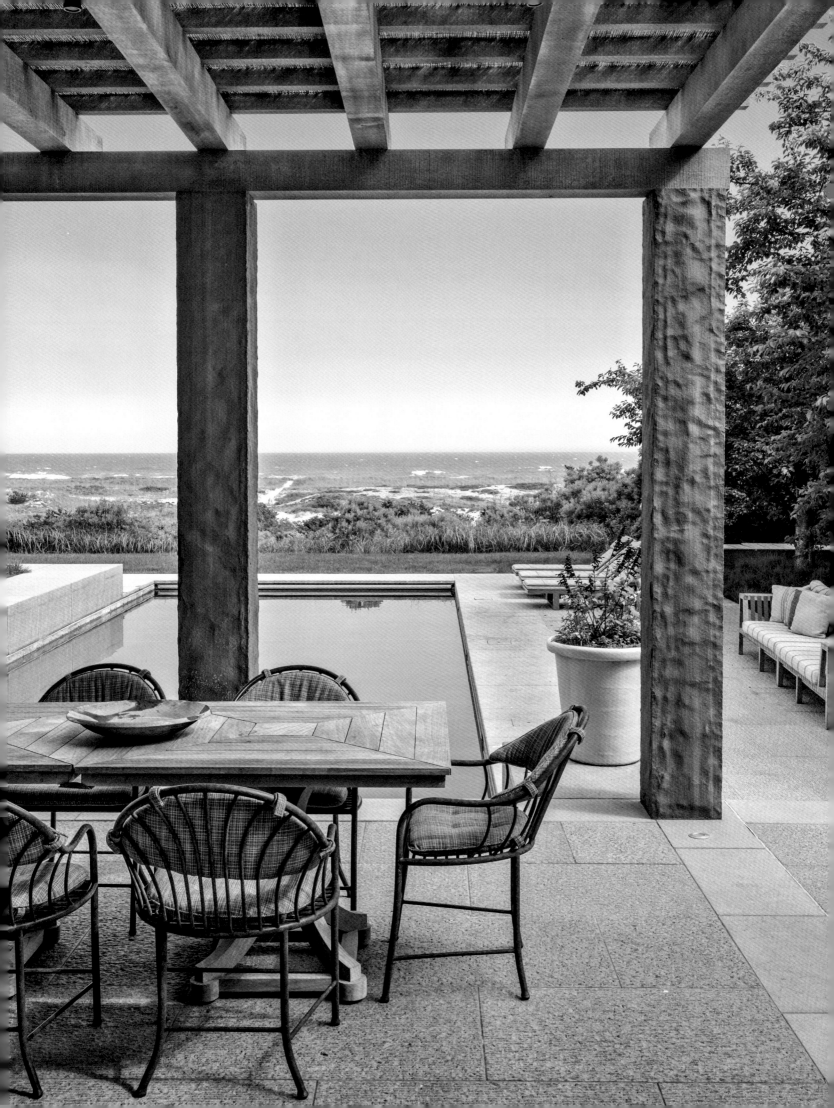

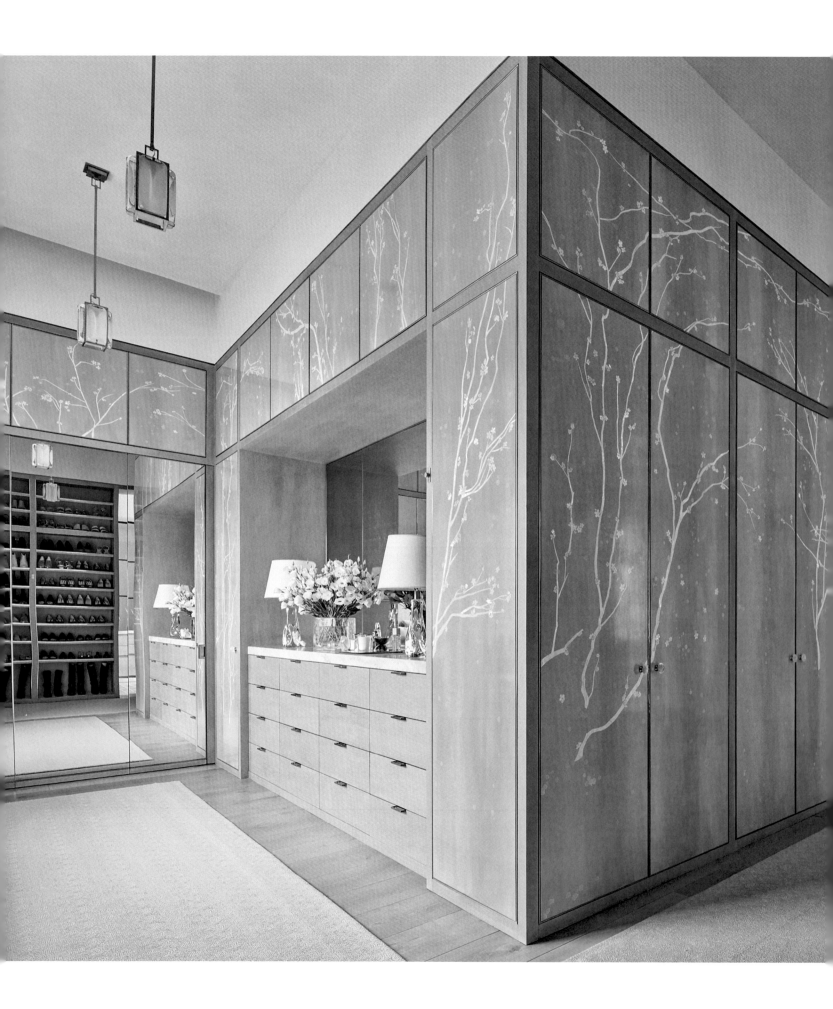

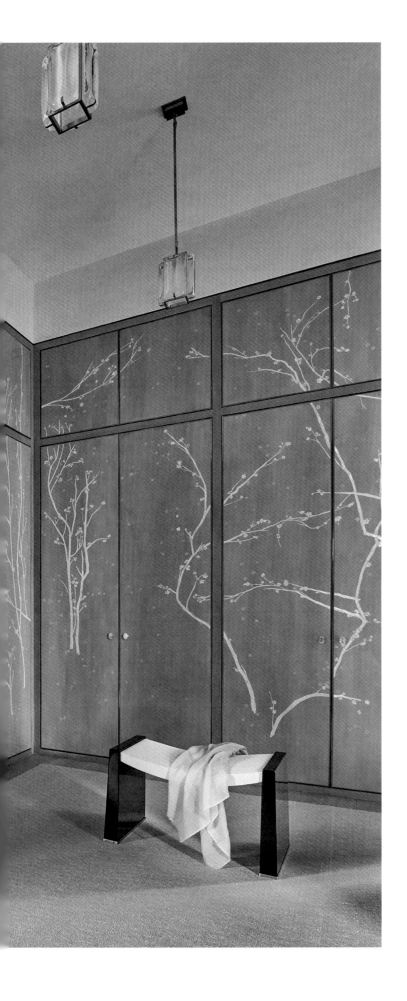

GARDEN HOUSE
LOS ANGELES

THIS SPACIOUS HOLMBY HILLS HOUSE occupies a long-coveted parcel of Los Angeles real estate that, in previous incarnations, had been home to some of the biggest names of Hollywood's gilded age. About a decade ago, a major studio executive charged Napa Valley–based architect Howard Backen, éminence grise of the new American farmhouse aesthetic, to design a sprawling family home on the site. When the house came on the market just a few years later, a couple of Smith's longtime friends and clients purchased the property and set out to make it their own, not only engaging Smith for the interiors, but also hiring landscape designer Christine London to reconfigure the garden and optimize its many points of connection to the house. The new owners brought treasured plantings like white crepe myrtle trees and fifty-year-old boxwoods from their former garden so it would feel truly like home.

"In the years leading up to this project, my friends had drastically increased the scale and scope of their art collecting, especially works by David Hockney, Hurvin Anderson, and other figurative artists," Smith says. That art became an important element in his arsenal for personalizing the look of the rooms. "I wanted to take their collection and point it outward, making it the focus of many of the rooms and spaces."

Whereas historically, in grand European and American homes, collections of this quality and importance would have been hung in a specific gallery-like room or *Kunstkammer*, accessible only for the delight of the owners and a select group of friends, Smith deployed the blue-chip artworks throughout the entire house—kitchen, hallways, and all. The effect is to convey a complete sense of the residents' taste and

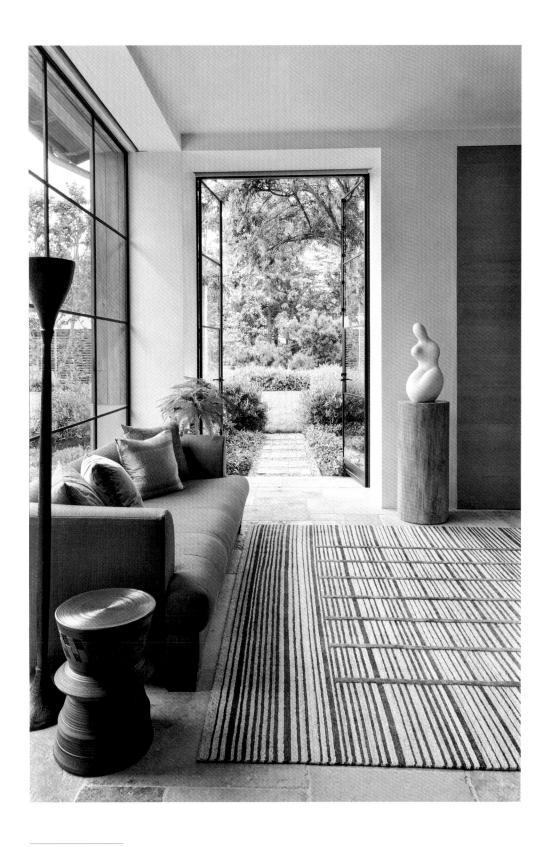

PREVIOUS PAGES: In the wife's dressing room, Smith had artist Nancy Lorenz camouflage the closet doors with a garden's worth of branches in mother-of-pearl and lacquer. OPPOSITE: The owners are major contemporary art collectors. At the end of an all-glass passageway, a small but potent work by Sean Scully awaits. ABOVE: The home, designed by Howard Backen, is astonishingly open to the grounds. Here a sculpture by Jean Arp draws attention to the outdoors, but there's hardly a room in the house that doesn't invite one to step into the garden.

ABOVE: A Lalanne bird fountain graces the entry hall. OPPOSITE: The dining room is among the most glamorous rooms in the house. A suite of klismos chairs from Saridis of Athens surround a contemporary custom table by Hervé Van der Straeten. The white Louise Nevelson sculpture hangs above an art deco cabinet that once belonged to the Maharaja of Indore. The Big Sky light fixture is by Lianne Gold.

personality and enhance the home's already potent connection with the idyllic landscape. To come in from a swim in the pool and be faced with multiple versions of David Hockney's emblematic depictions of L.A. swimming pools, says Smith, is "the ultimate expression of the California lifestyle that people long to have."

Smith embraced the 14,000-square-foot home's luxe rusticity and its spacious and well-conceived layout, which, as he says, was "designed around a central courtyard as a spare, reductive series of boxes or volumes that are all really comfortably proportioned and well edited." Some wings of the house stretch out through the garden, and massive wall-sized windows and doors abound, so the interiors and garden seem to flow into each other. Most rooms are clad in simple but beautifully honed bleached walnut planks.

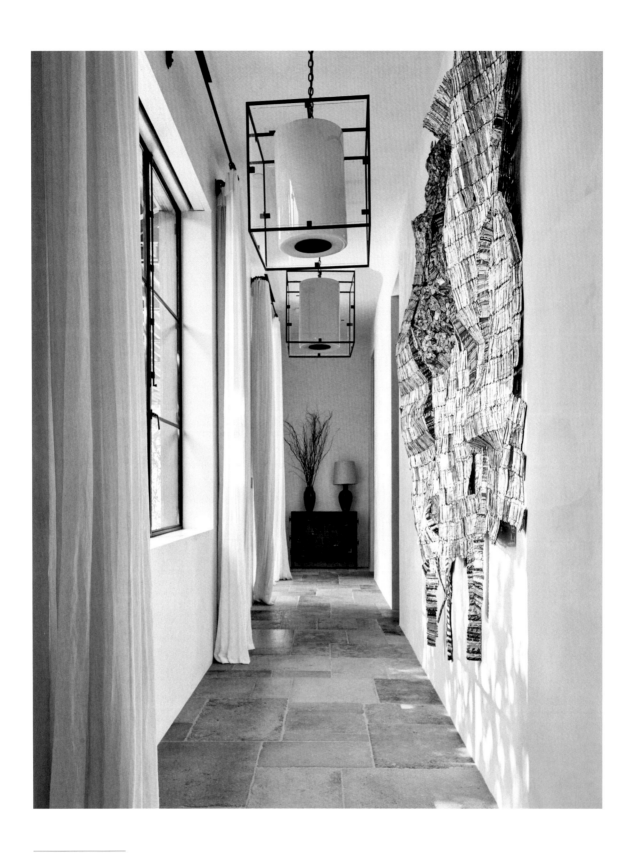

PREVIOUS PAGES: In the living room, painter Hurvin Anderson's *Country Club* functions almost like another window into the garden. The chaise is by Atelier Viollet and the coffee tables by Alexander Lamont. The antique rug is from Mansour. ABOVE: A hallway with beautifully hewn and seemingly ancient stone pavers is brought up to the twenty-first century with a work by the Ghanaian sculptor El Anatsui. RIGHT: A vintage rug by Ingrid Hellman-Knafve sets a cheery tone in the garden room. The table and chairs are by Jasper, the rope sofa by John Himmel and the curtains by Elitis. The tree-trunk table base along with the paw-footed John Dickinson plaster table bring even more nature into the room.

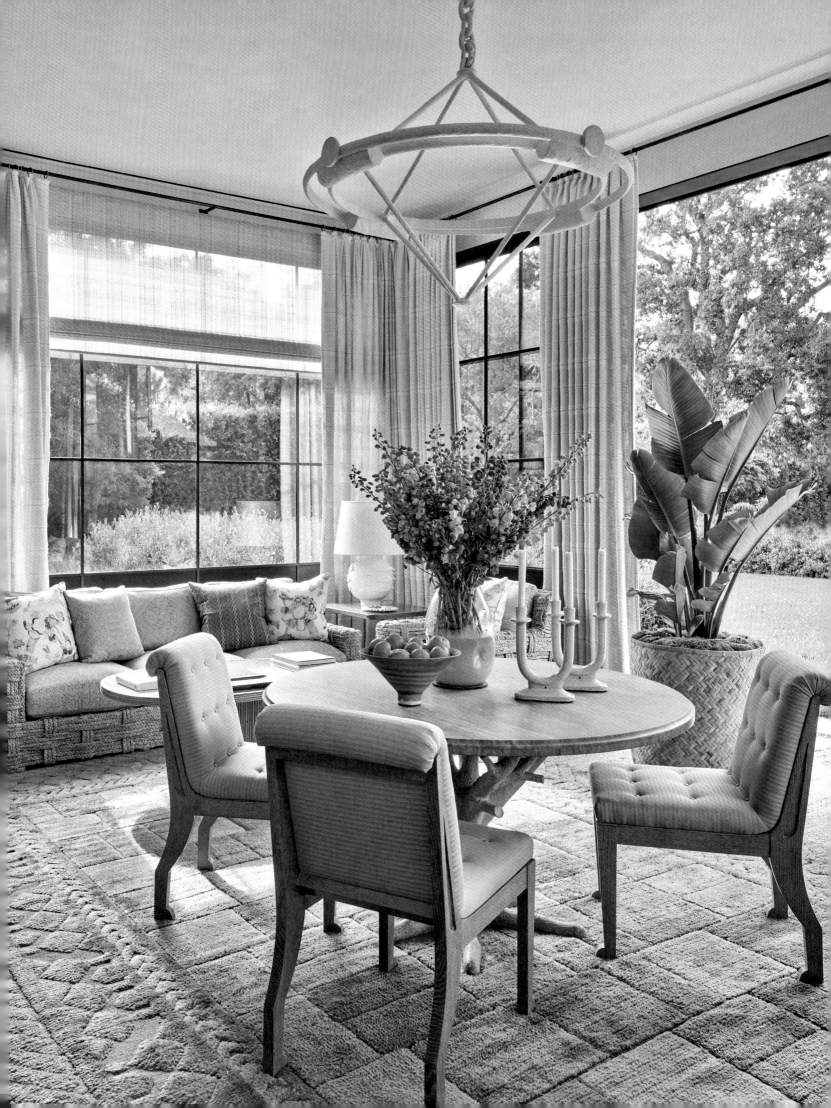

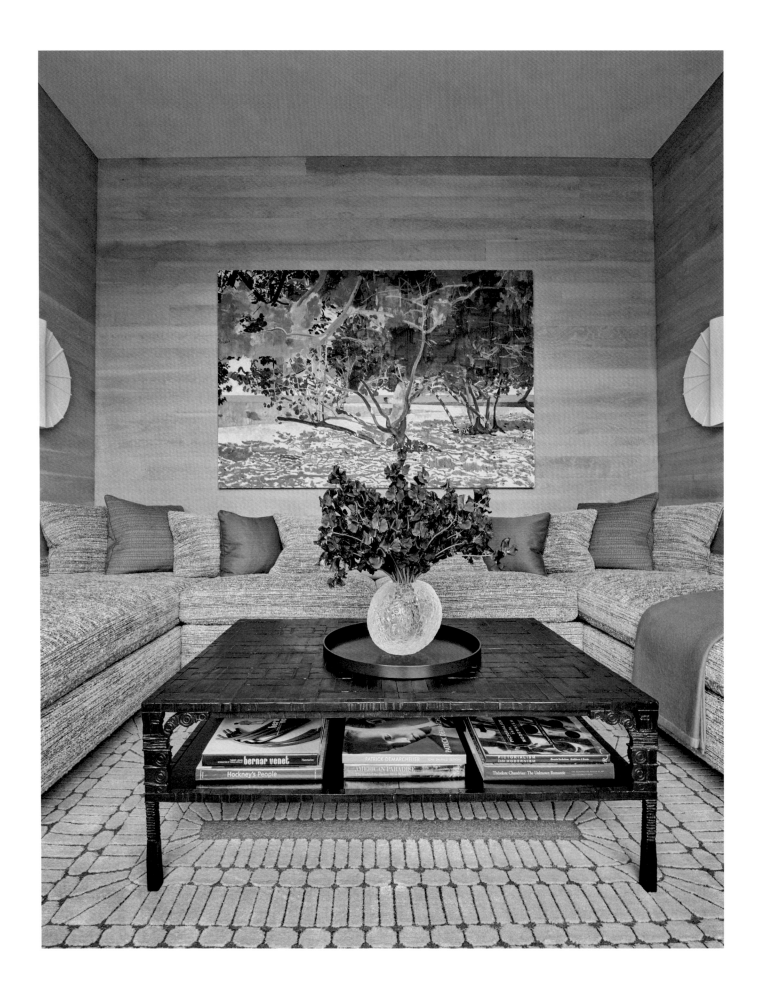

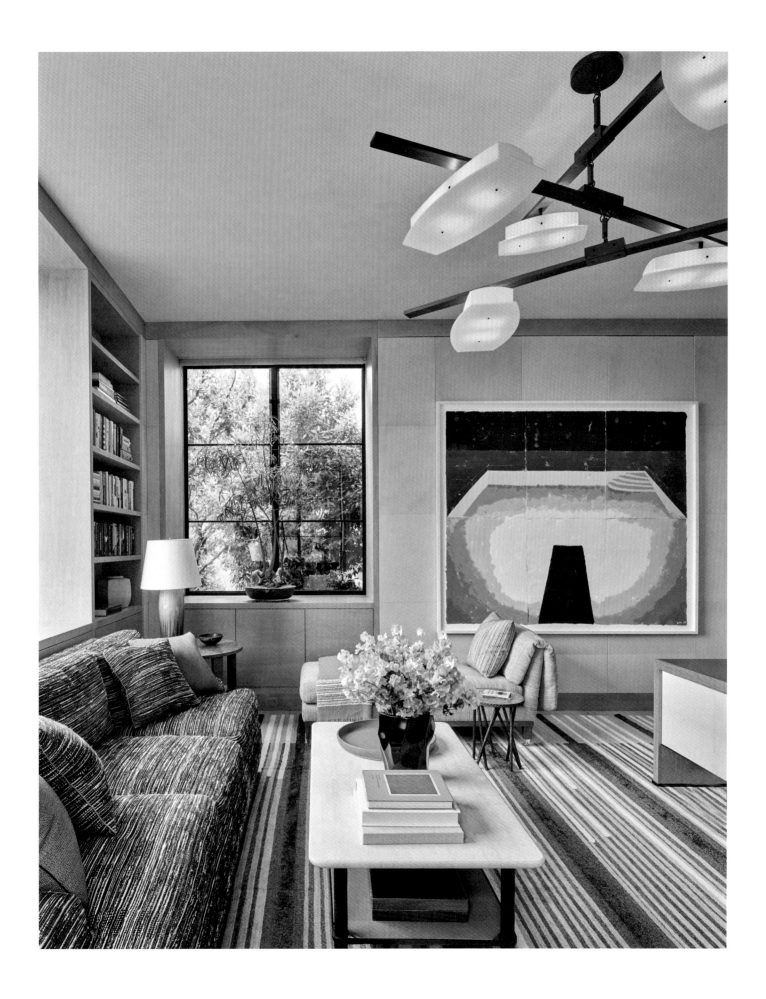

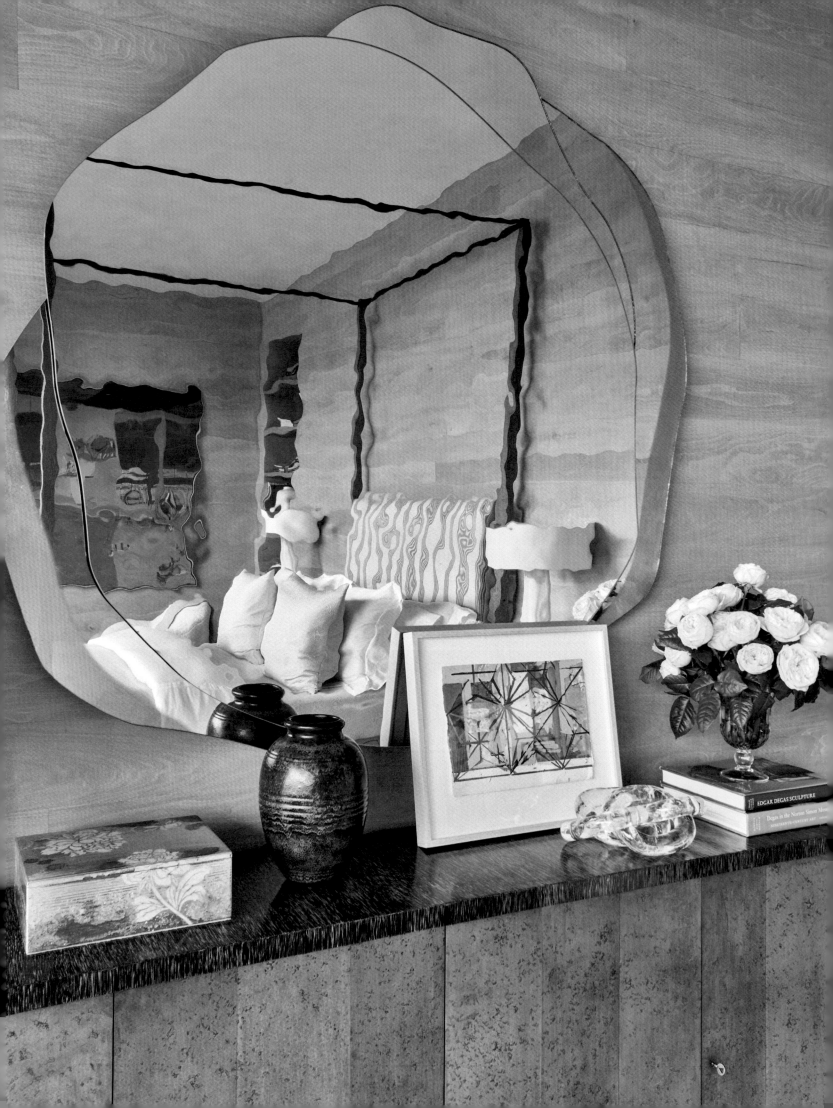

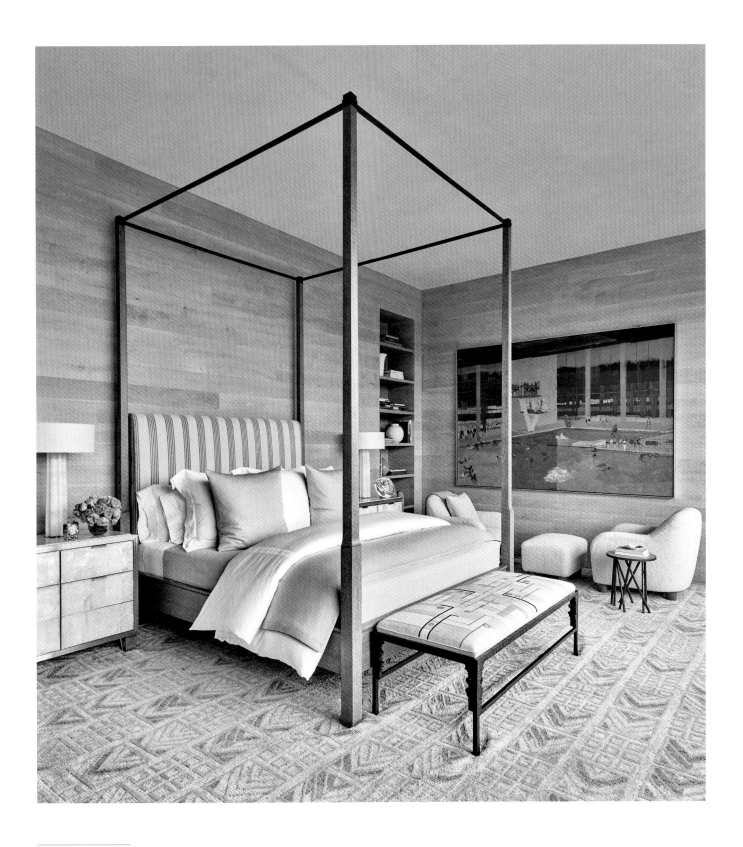

PAGE 230: A seating alcove in the primary suite features an Ingrid Donat coffee table and a vibrant Hurvin Anderson landscape painting. The plaster sconces are by Stephen Antonson. PAGE 231: In the husband's study, all eyes eventually land on David Hockney's *Paper Pool: Diving Board* (created with Tyler Graphics), one of two such works in the home. The vivid range of blues provides a vibrant foil to all the green foliage peering in through the windows. Light fixture by Pagani Studio. OPPOSITE: A mirror by Sébastien Reese in the primary bedroom. ABOVE: The primary suite has a cool Scandinavian vibe with a Swedish-style carpet from Mansour and a pair of fleece upholstered armchairs by Roman Thomas. A Hurvin Anderson painting of an indoor pool adds a jolt of cool blue to the room.

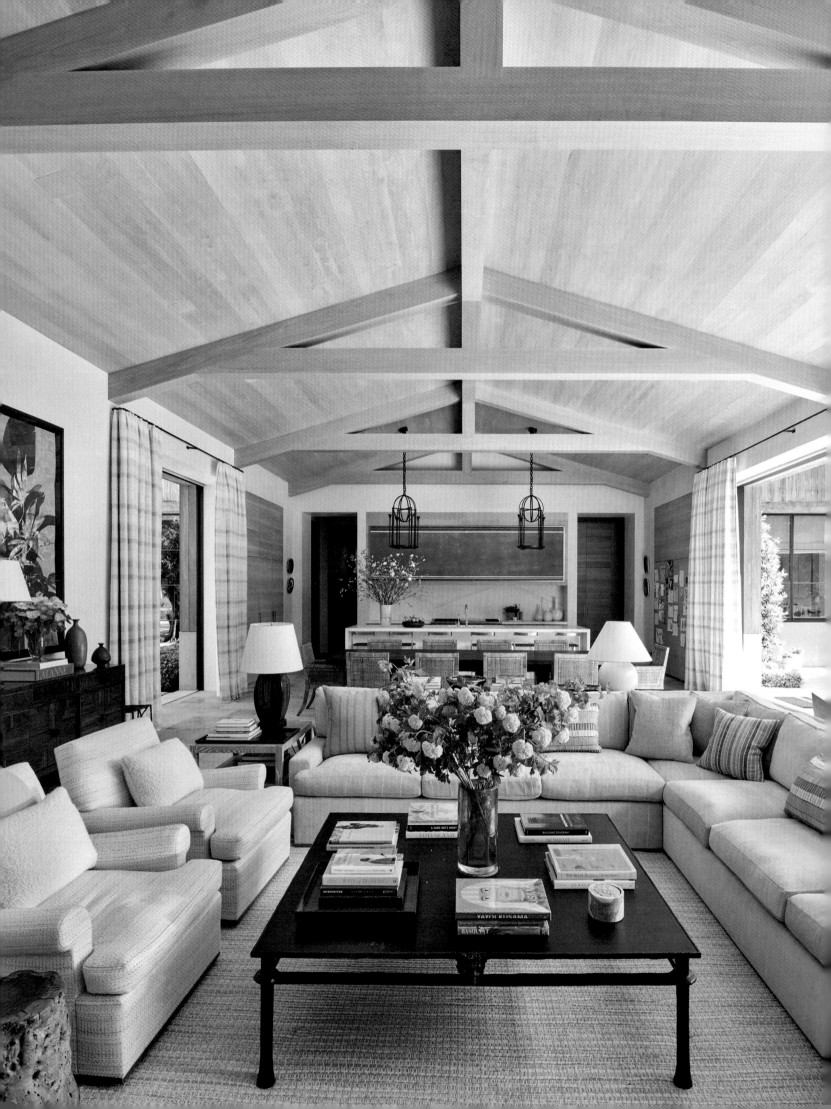

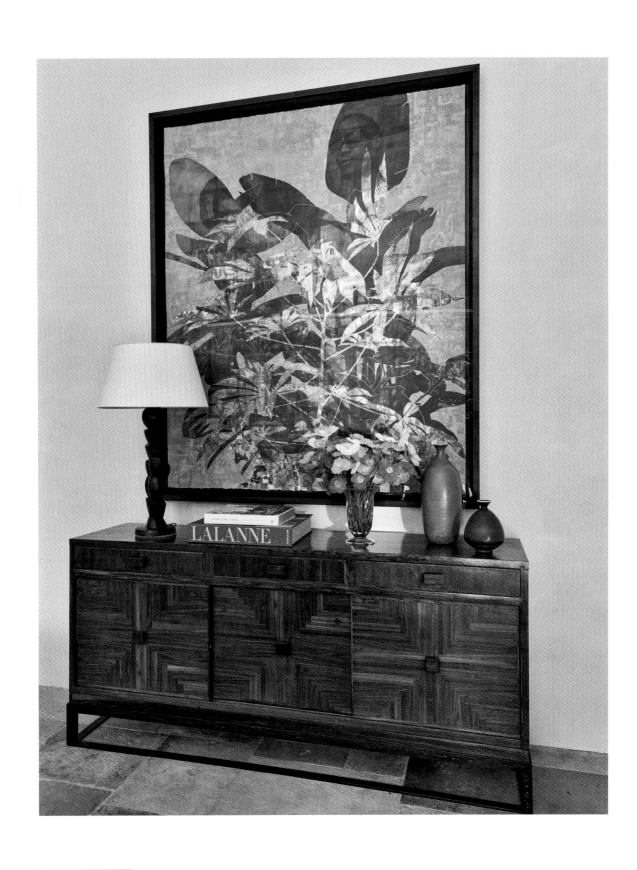

LEFT: At the far end of the great room is the kitchen, where Kenneth Noland's *Mexican Camino* is displayed. The great room itself has walls that almost disappear. The custom sofas and chairs wear Lee Jofa textiles and the curtains are made of a Dedar fabric. ABOVE: A foliate Njideka Akunyili Crosby painting crowns a vintage rosewood cabinet.

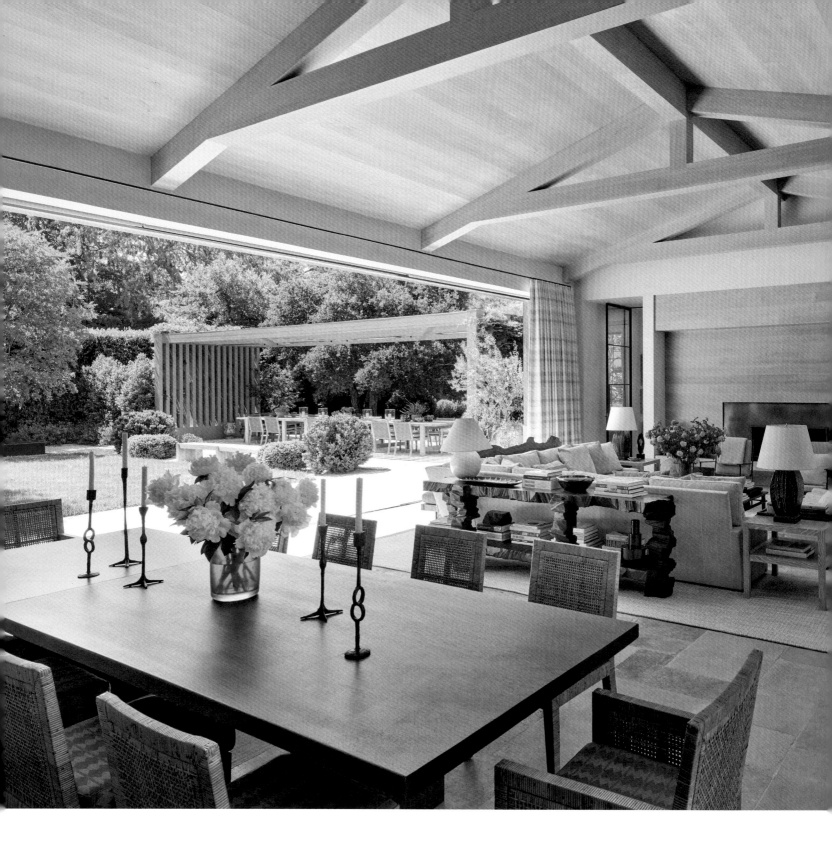

ABOVE: The great room links the kitchen with the greenhouse-like garden room, visible through the doors on either side of the fireplace. To the left, a massive pergola shades an alfresco dining area.
OPPOSITE TOP: A signature Backen house feature is a monumental outdoor fireplace. Sofas from The Wicker Works. OPPOSITE BELOW: In the garden, a Bernar Venet sculpture focuses the view.

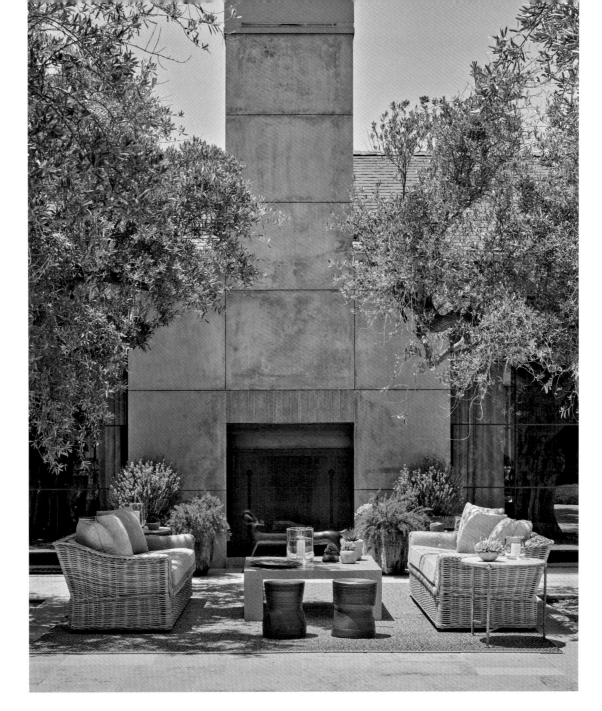

A self-professed lover of hand-painted wallpapers and other colorfully patterned wall coverings, Smith trod lightly on the home's Zen character. He left the walnut walls largely unadorned except for sparingly placed but high impact works of art. In this reductive space, Smith gave individual pieces of art the breathing space and contemplative respect they deserve, such as a diminutive but radiant Sean Scully painting at the end of a long, sunlit hallway or Hurvin Anderson's canvas *Country Club*, which brings a burst of saturated color to the living room.

The result is that the home's country air has been maintained, with classical elements integrated in the same understated way as the art. Smith notes, "Throughout the house, one immediately senses that the owners have tremendously diverse possessions and expansive, highly refined taste. My job was to give them a richer, more classical and layered atmosphere to reflect their eclectic sensibility."

This balance is on full display in the beautifully proportioned dining room, where a large glass wall opens to the garden. Floating in the middle of the commodious room is a custom marble and gilt-bronze dining table by French designer Hervé Van der Straeten that's surrounded by klismos chairs from the famed Saridis of Athens. A stunning white Louise Nevelson wall sculpture hangs above a sleek art deco credenza that once belonged to the Maharaja of Indore. On the opposite wall, a pair of shimmering silver-leaf and gesso panels by Nancy Lorenz appear to be a folding screen but open to reveal a stylish built-in bar.

Lorenz, a frequent Smith collaborator, worked her magic in the wife's dressing room as well. She converted a seemingly endless expanse of closet doors into a tranquil glade of pale-green lacquer adorned with branches inlaid with mother-of-pearl. That's just one example of how Smith has used his clients' art and his own artisan commissions to foster a connection between his interiors and the outdoors.

In the spacious and airy primary bedroom, a moody indoor pool scene by Hurvin Anderson faces the elegantly tall, crisply simple tester bed and cocooning Swedish-inspired armchairs. Throughout the other bedrooms and in virtually any nook in the house with a wall big enough to hang a picture, Smith deftly deployed the couple's collection to bring the outdoors inside with paintings of landscapes, tropical beaches, and swimming pools. One example is a tightly focused composition of dense foliage by Nigerian-born, Los Angeles-based Njideka Akunyili Crosby that hangs in the family room. "Each painting, even the abstract ones, offers a vista—a view into another realm," says the designer.

Despite the impressive, almost extraterrestrial Pagani Studio ceiling lamp overhead in the husband's study, Smith says, "The clear focal point of the room, what catches your eye immediately, are the intense blues of David Hockney's amazing *Paper Pool: Diving Board*, created with Tyler Graphics. Smith echoed those blues in a beautifully glazed table lamp and other accents throughout the room. And in the sunroom, the cheerful blue-and-green vintage Swedish rug Smith chose also evokes a swimming pool.

A beamed and trussed ceiling and informal open design give the impression that the kitchen and family room was originally a shed or outbuilding that was later joined to the house. When the massive doors on two sides are open to the outdoors, it feels like a garden pavilion. Inside, however, a museum-caliber painting by Kenneth Noland, a handsome vintage rosewood cabinet, and a stylish array of Swedish ceramics subtly reinforce the atmosphere of worldly sophistication Smith nurtured throughout the home.

Art has been equally carefully arranged in the garden, home to a Bernar Venet steel sculpture. The owners expanded the garden by moving the pool away from the house to the perimeter of the lot. This created more space for multiple outdoor "rooms," like a sprawling terrace lounge anchored by a monumental concrete fireplace—a signature Backen home feature. Other areas, like the private gardens afforded to the guest rooms, provide a cozy sense of privacy and shelter. With seven fountains gurgling among the lush foliage, Smith says, "The house and the garden blend to provide moments for reflection and appreciation of nature, and perfectly embody the romance of California and indoor-outdoor living that lured artists like Hockney here so many years ago."

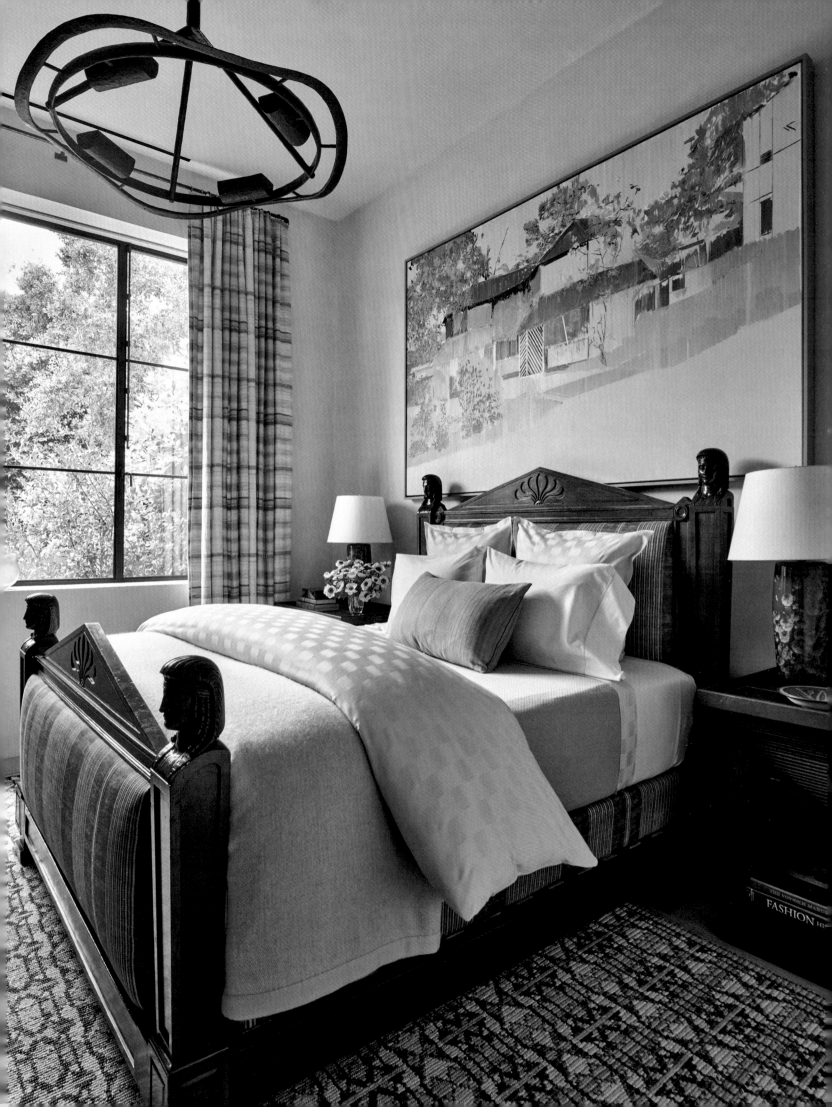

MODERN
BEACHFRONT
MALIBU

ON A PRIME PARCEL OF BROAD BEACH in Malibu, Smith's clients commissioned the late Rafael Viñoly—the celebrated Uruguayan architect responsible for such striking buildings as New York's super-slender skyscraper 432 Park Avenue, widely known as the Needle—to create a weekend getaway for the couple and their children to have a respite from their busy lives in Los Angeles. The clients knew Viñoly's work well from past commercial real estate collaborations, so they made a calculated choice to bring in the architect of what was briefly the world's tallest residential building rising improbably from a tiny Manhattan lot to confront a similar spatial conundrum in seaside Malibu, only without the air rights.

Prime California beachfront houses tend to sit side-by-side on lots longer than they are wide and always, in Smith's parlance, "with the short end of the shoebox facing the beach." Thus, the challenge was to design the best possible shoebox to capture the stunning views and magical light without the owners peering into neighbors' homes or having the neighbors peer into theirs. "You really have to be clever about how you frame the view so that you get the best of the seaside atmosphere but are able to screen yourself as much as possible," says the designer, who has revamped many homes in the coveted enclave over the years.

Viñoly conceived the house as a birdcage by locating the pool and family recreation area in the middle of the property, in an airy open courtyard wrapped in glass and a metal framework patinated a deep red. Sunlight and sea breezes filter into the center of the house with separate (but connected) public and private modules on opposite sides of the pool. Entertaining spaces such as the living and dining rooms, as well as the kitchen, all

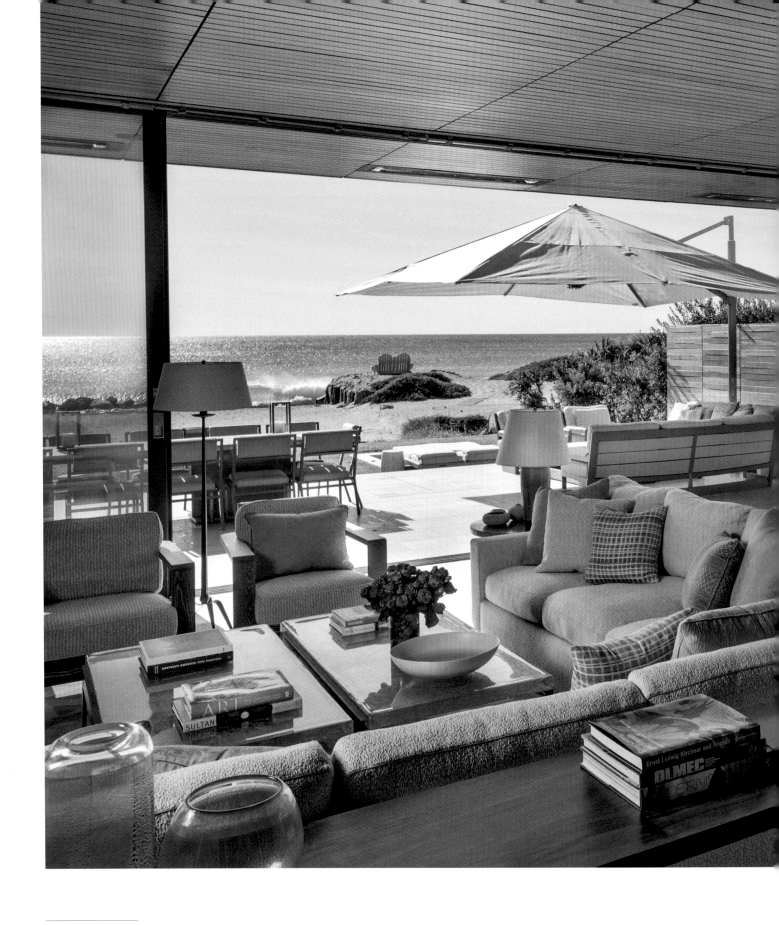

PREVIOUS PAGES: The crisp, modern primary bathroom overlooks the Pacific Ocean. The Empire wall sconce is by Urban Archaeology. ABOVE: The high-functioning, multi-zone living room makes seaside entertaining straightforward and easy. Maintaining the same limestone floor and rift oak ceiling in the living room and on the terrace creates seamless indoor-outdoor Malibu living. Smith kept the palette to neutral naturals—colors that echo the sand, sea, and dune grasses steps away.

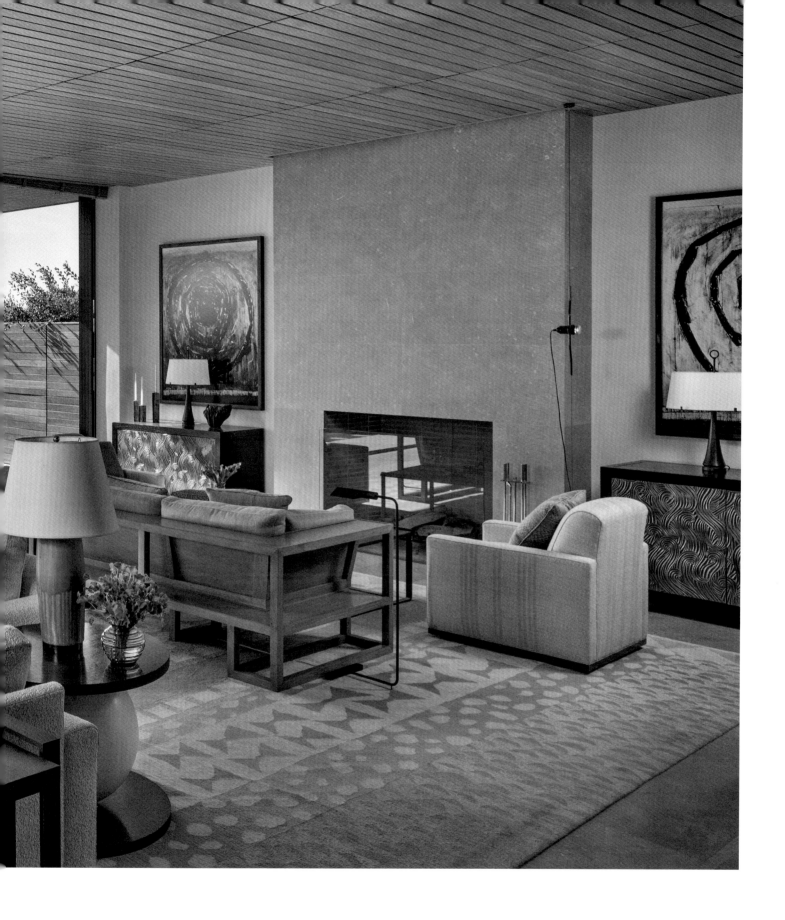

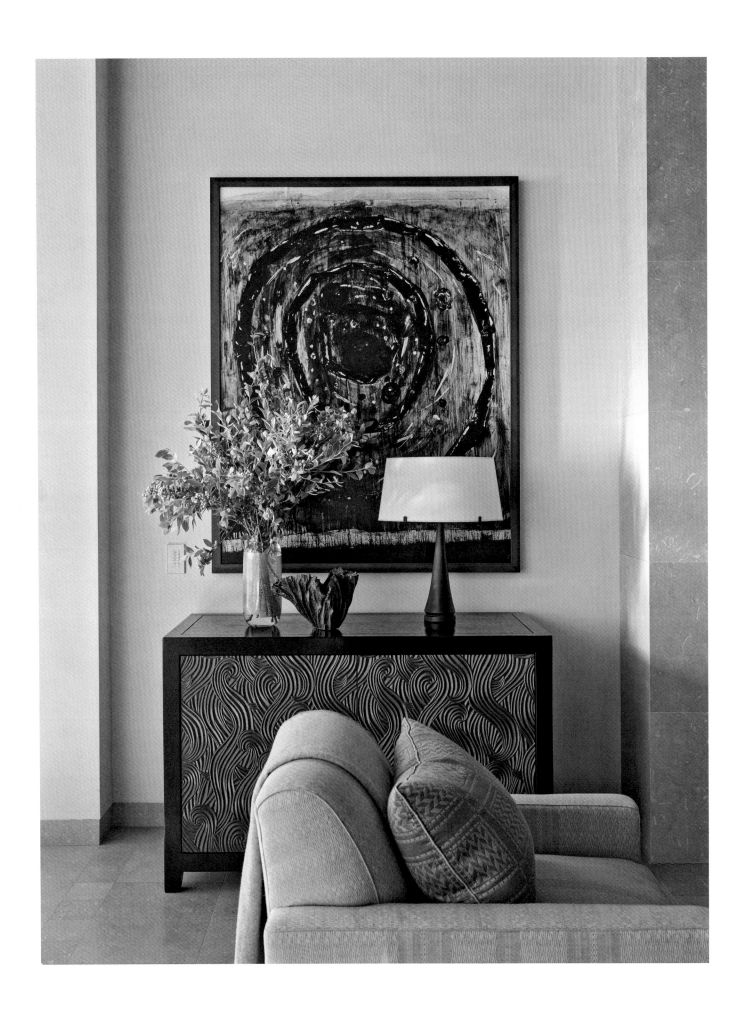

OPPOSITE: A Paul Ferrante table lamp rests upon one of a pair of Dragon Swirl cabinets by Robert Kuo that flank the living room fireplace. ABOVE: Where the dining room meets the foyer and the stairs to the primary suite, Smith showcased a large Cecily Brown canvas, perhaps the home's most sensuously painted and vibrantly colored artwork. FOLLOWING PAGES: In the media room, Smith used a subtle seagrass wall covering to add warmth and texture. The woven rope sectional sofa is by John Himmel and the custom Jasper swivel chairs are upholstered in a natural Lee Jofa linen tweed. The artwork is by Shannon Ebnar.

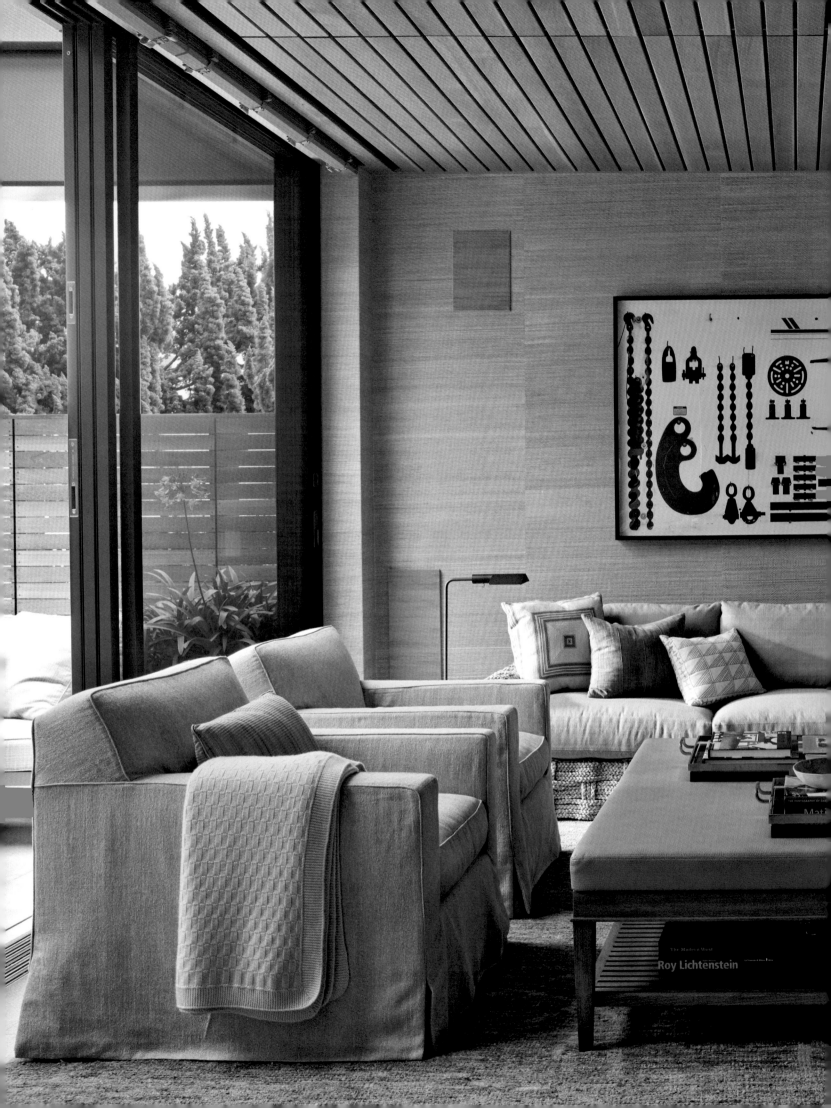

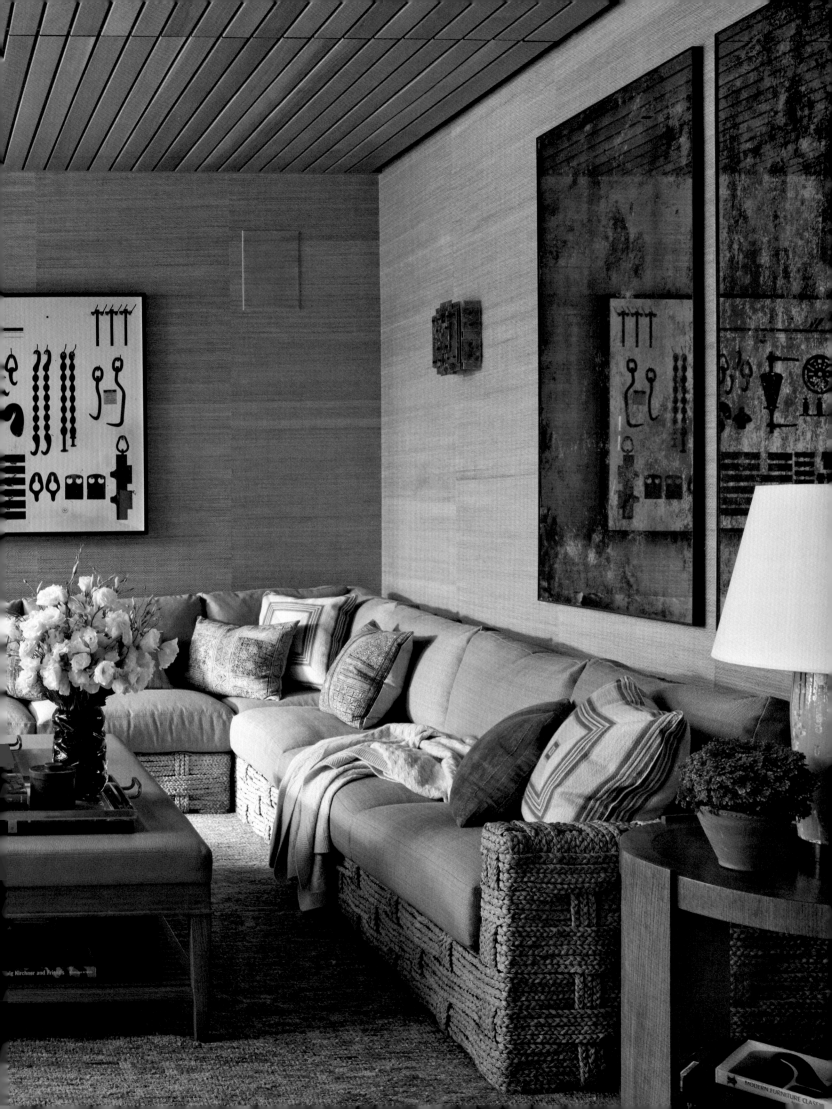

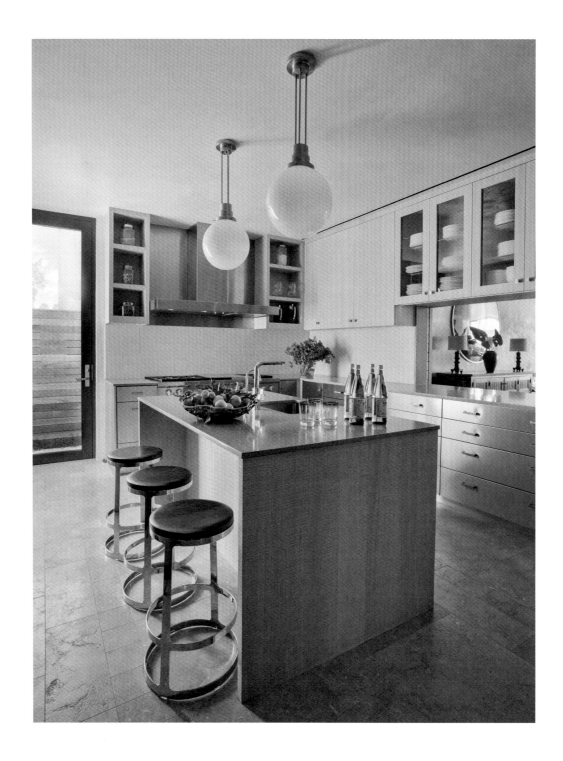

open onto the beach and the blue Pacific beyond—as does the primary bedroom suite one flight up. And, with the pool and all its accoutrements discreetly tucked away, the ocean view is delightfully uncluttered—harking back to the days when Malibu was an idyllic playground for movie stars.

"It's a very successful site-specific adaptation," Smith says of the home's structure and layout. "It's not at all dictatorial or flashy and attracts notice primarily for its beauty and aptness for the amazing setting."

Taking cues from the architecture, the designer wanted to support and accentuate the feeling of this crisp modernist home as a yacht at sea. He says, "To lean into these romantic, nautical, and seaside qualities the house exudes, we used Venetian blinds in all the rooms that face the water. That also reinforced the idea of the brise-soleil employed in Viñoly's birdcage design."

Whatever effect the combination of salt air and sunlight rhythmically filtered through louvered shutters may have—Smith cites references as diverse as 1920s

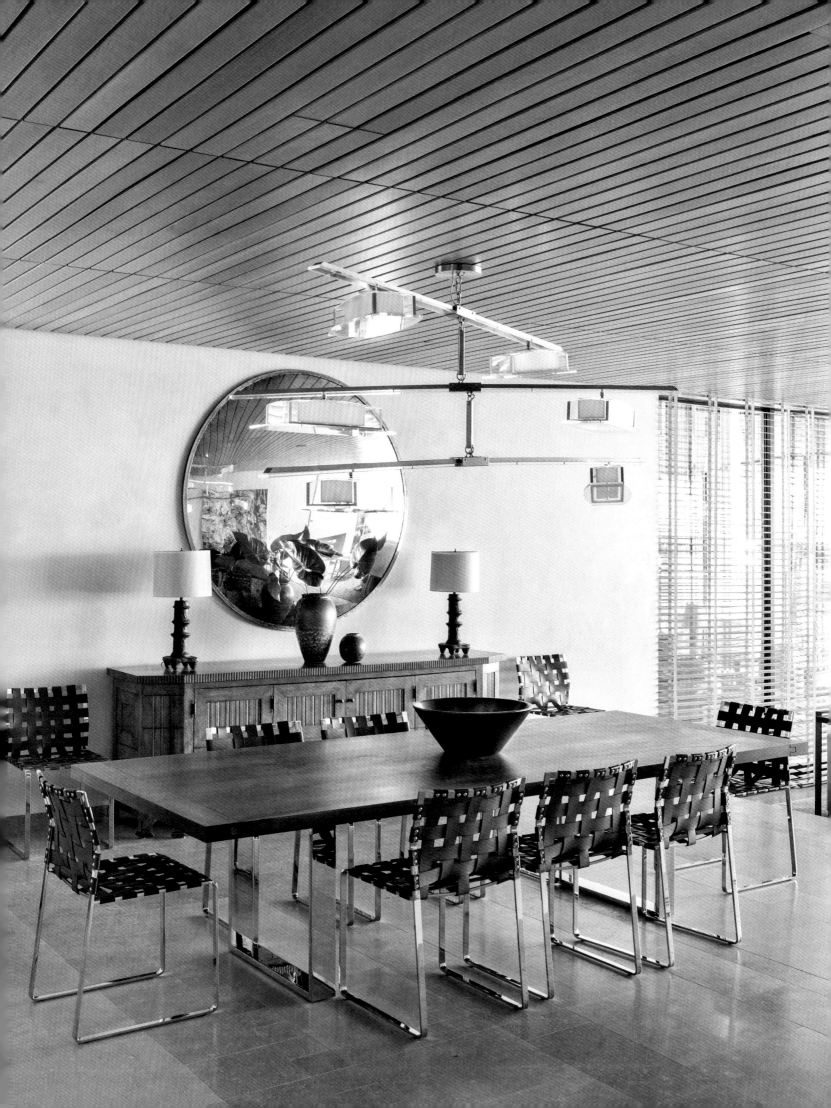

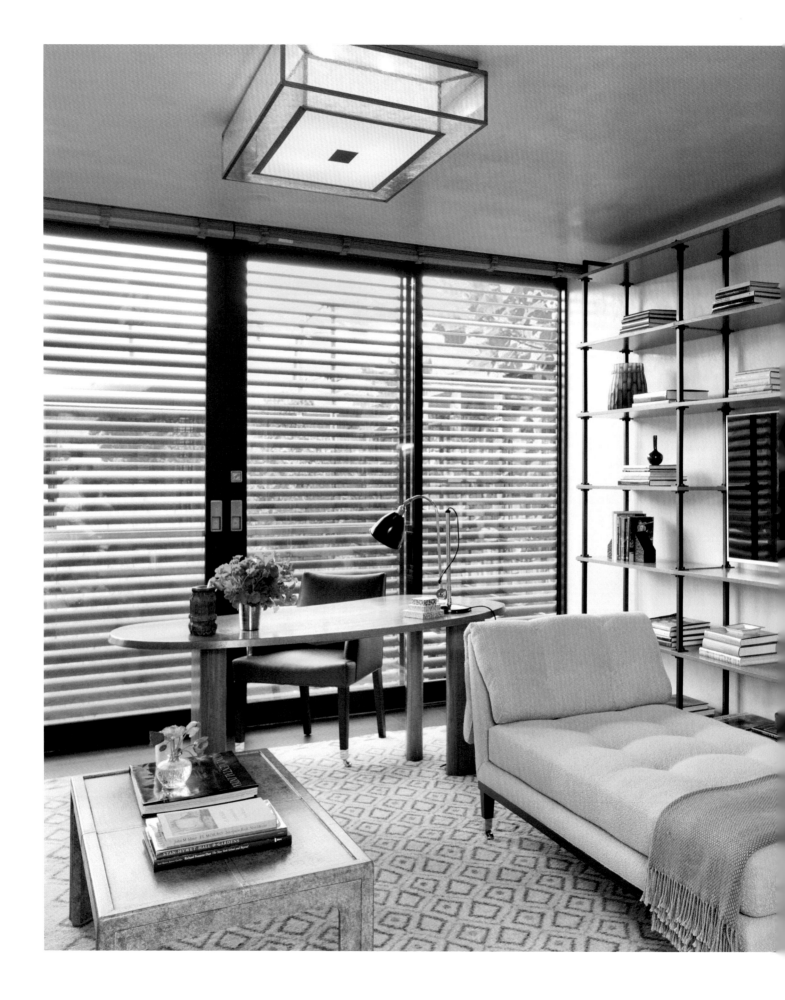

Saint-Tropez, film noir, and Key Largo—the vibe of the home makes clear that visitors are entering a special place, away from workaday cares. "A lot of architects create great spaces but not transitions; this house delivers both from the moment you arrive," he says.

Enhancing the home's out-of-office attitude, the simple oak planks that line the ceilings are major multitaskers that give a clear visual nod to nautical decking and docks while providing welcome sound absorption, and they also impart a sense of warmth for when the sun goes down. In the living room, he designed several key pieces of seating furniture and had them made in the same oak, giving a rich tonal harmony to the space that quietly unifies the various indoor seating areas and links them to the terrace outside. With massive glass doors that open wide, the two spaces naturally run together, so on the pale limestone floors, Smith laid simple Moroccan rugs in a blend of beiges and ecrus to match the sand on the beach. However, a pair of tables made of radiant cast glass backed with gold leaf make clear that per Michael Smith, "Easy-breezy beachy doesn't preclude elements of great beauty, artistry, richness, and sophistication."

In the dining room the designer again kept the lines sharp and modern and the palette mostly neutral to echo the architecture and the sandy hues outdoors. But he brought in a deft play of textures and visual reminders of the hand of the artisan with a lushly painted and vibrantly colored canvas by Cecily Brown on the wall and Mark Albrecht metal chairs with seats of wide woven leather straps.

If the surfside part of the home is geared toward entertaining, Smith says the streetside is more "practical" with family bedrooms where the kids can be on their own, space for exercise, and a home office. Having grown up not too far away in Newport Beach, he knows that even in summer you can have a rainy day, so he ramped up the coziness in the large media room that faces the pool with walls covered in a delicately nubby woven grass and a deep, enveloping sectional sofa. The base is covered

PAGE 248: The open kitchen maintains the home's largely neutral sand-colored palette and spacious, easy flow. PAGE 249: The dining room features a Mark Albrecht table and chairs with woven leather seats. The cabinet, lamps, and mirror at back are all Jasper and the ceiling fixture is by Pagani Studio. LEFT: In the study, a Pagani Studio light fixture floats above a Patrick Naggar chaise from Ralph Pucci and a desk inspired by the work of Charlotte Perriand.

in woven rope for a toothsome texture that conveys visual warmth similar to that of shearling. Underfoot, a plush silk rug supplies another comforting tactile experience, albeit in a cooler shade of deep blue to recall the sea just outside the door.

"This was meant to be a weekend getaway, but, like most of the so-called second homes I've worked on, it's used all the time," Smith says. The family members come whenever they can, filling it with friends and especially the kids' friends. "James and I might be invited for what we expect will be a quiet lunch, and when we turn up there are twenty-five people already there enjoying pretty much the whole house."

ABOVE: The primary suite's dressing area reveals the beauty and adaptability of the short-plank oak paneling used throughout the house. On ceilings and walls in other parts of the house, the planks evoke ship decking or seaside docks. Here, they've been transformed into closet doors that practically disappear in the streamlined space. OPPOSITE: A passage with architect Rafael Viñoly's brise soleil connects the front and rear modules of the house. The outdoor Echo benches are from Thomas Lavin.

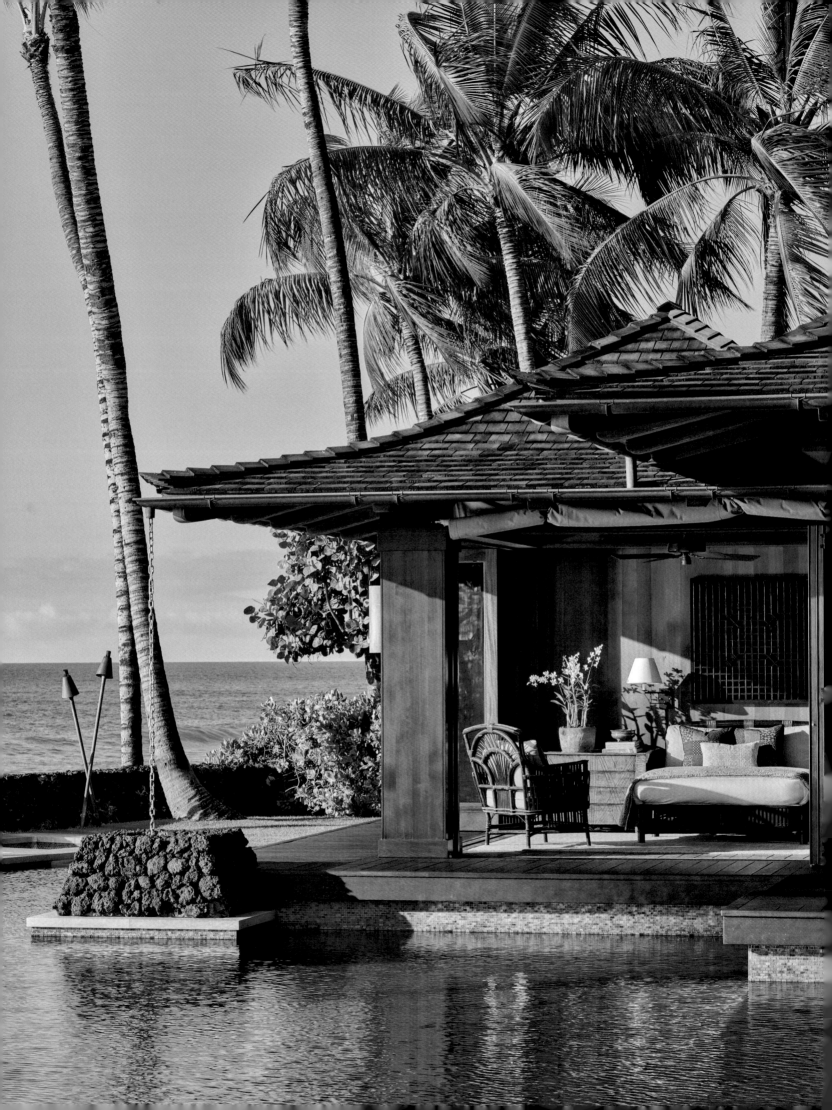

ISLAND COMPOUND
KAILUA-KONA

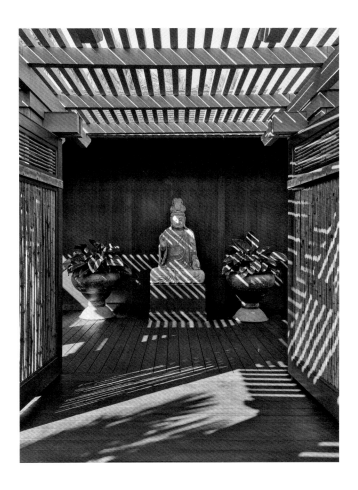

THIS BEAUTIFUL AND STUNNINGLY SITED home on the coast of Hawaii was designed and built by San Francisco architect Sandy Walker around the year 2000. "Eventually my clients saw the house and fell in love with it. They purchased it fully furnished and then immediately began spending long periods on the island enjoying this idyllic property," Smith recalls. "For them, it has never been just a vacation home, but a place where they gather often as a family throughout the year."

Smith and the family had worked on other homes together over the years; here they decided they wanted the interiors to be more personal and reflect their wide-ranging tastes as collectors. "Because they use the house so frequently, it needed to be more complex and have a sense of dimension and layers that would reveal themselves over time," the designer says. "With second homes, people sometimes get really obsessed with one thematic direction and it tends to seem boring after a while. This house has the detailing you'd expect to see in a primary residence."

Built almost entirely of lustrous caramel-colored teak timbers, the home's approximately 7,500 square feet consist of a series of interconnecting pavilions that wind through a spectacular seaside garden. Indeed, it is equal parts indoor and outdoor space, with much of the latter covered by water in what is said to be one of the largest swimming pools in Hawaii. Enhancing the sense of an indoor-outdoor paradise, the pool extends right up to several of the bedrooms' terraces and the lanai-style common areas, such as the family room.

From a home decorating perspective, Smith says that Hawaii often inspires people to think of either Doris Duke's famed Moorish, Middle Eastern, and Mughal fantasy home Shangri La (now a museum of Islamic art) in Honolulu, or tiki bars and 1960s surf culture. "But Hawaii is way more diverse—from its rich Polynesian

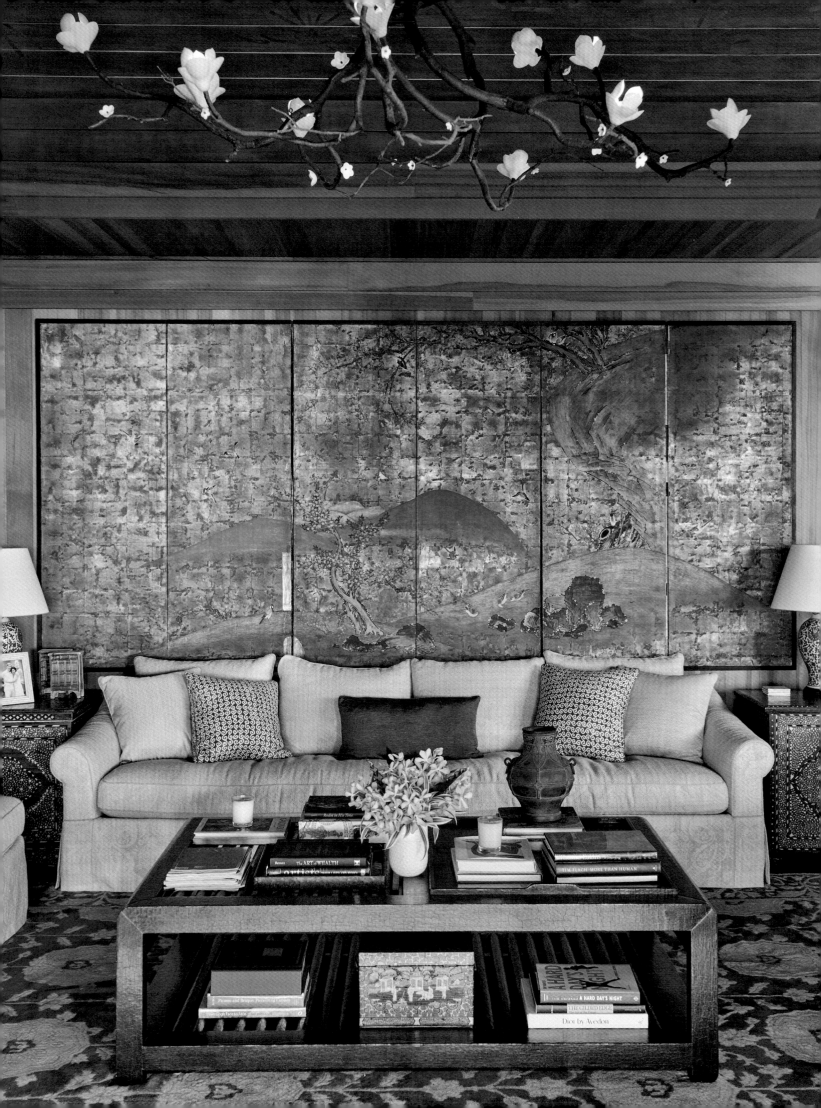

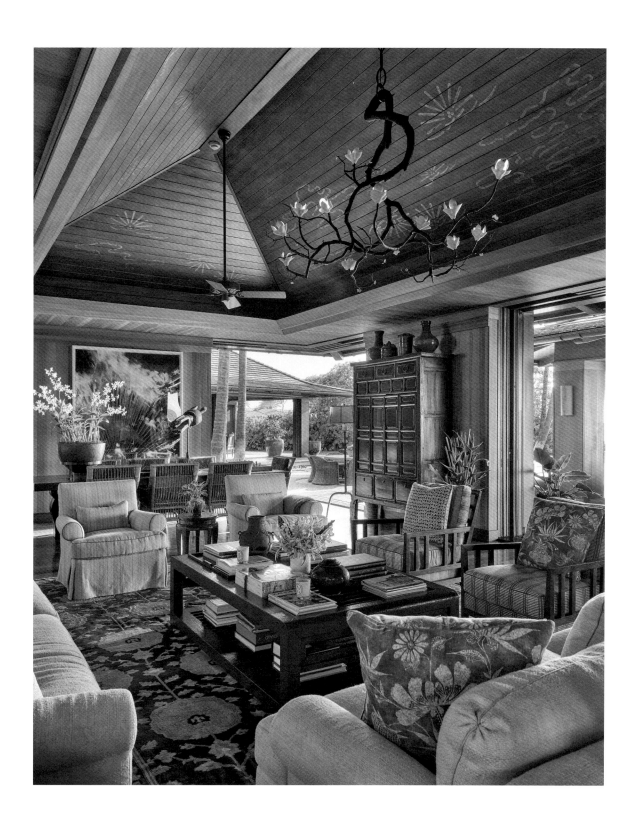

PAGE 254: This idyllic bedroom pavilion enjoys sweeping ocean views and bedside access to the home's pool, among the largest in Hawaii. The rain chain on the left helps draw water off the roof without splashing it on the terrace or into open rooms. PAGE 255: Sun dapples an indoor-outdoor passageway. OPPOSITE: The focal point of the living room is a radiant silver-leafed six-panel Japanese screen. The seating area includes a Ralph Lauren sofa, a Rose Tarlow coffee table, an early twentieth-century Chinese rug, and a pair of striking Syrian marquetry chests that serve as end tables. ABOVE: A custom David Wiseman chandelier spreads its branches—and light—over the living room's main seating area.

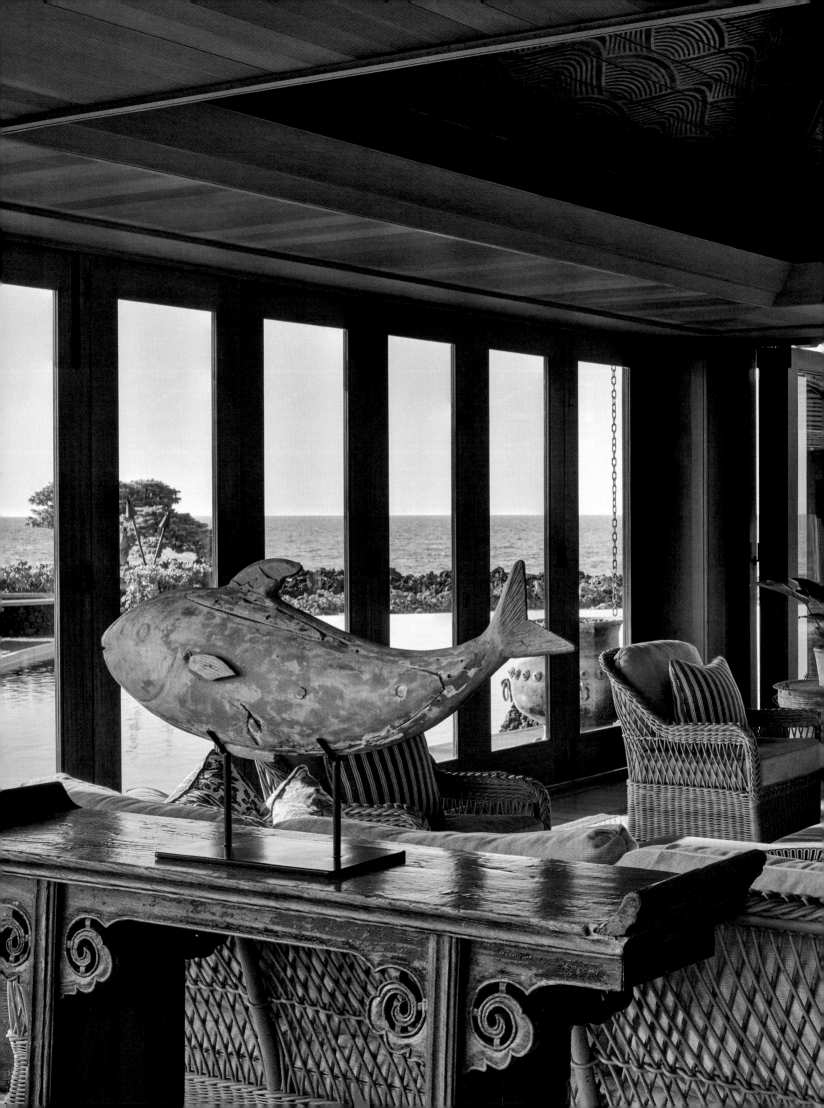

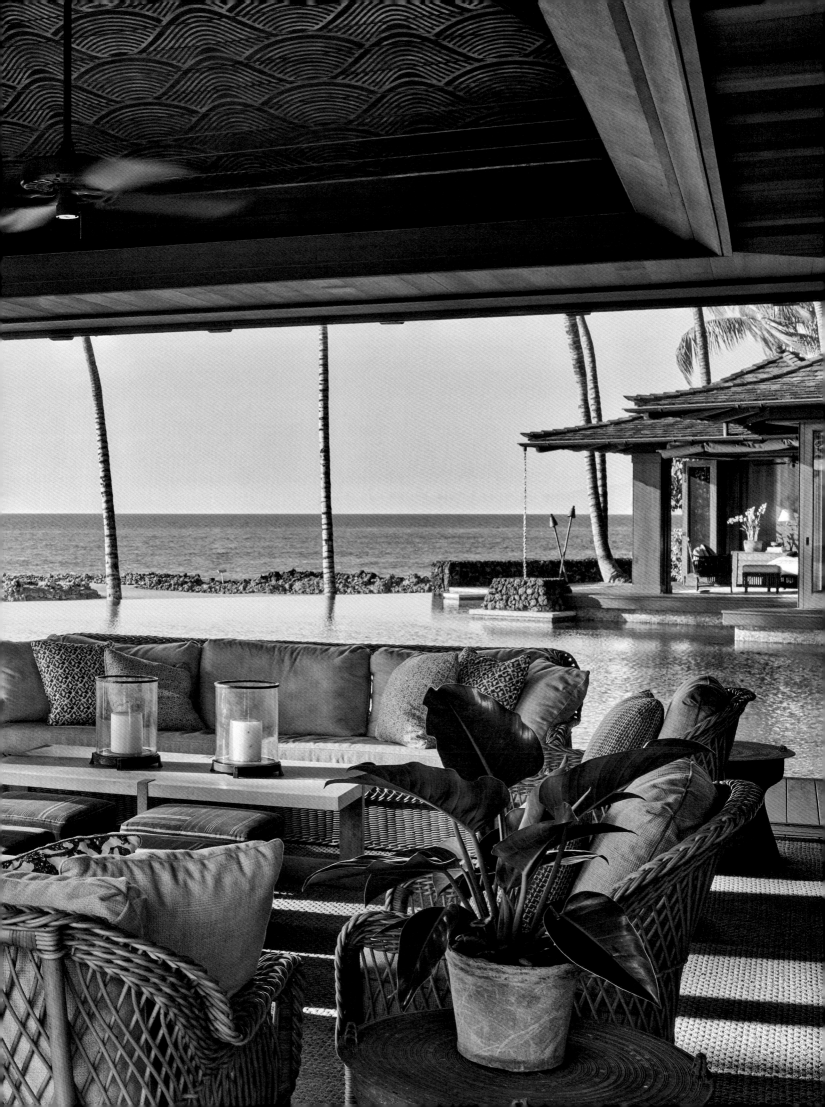

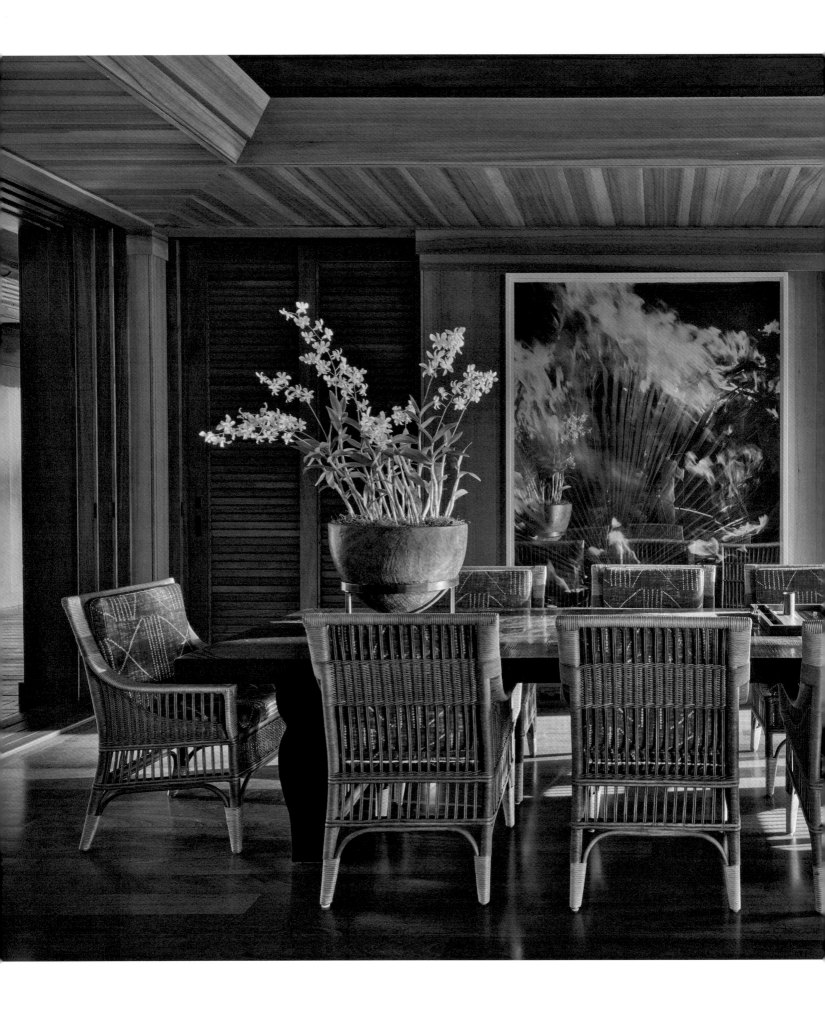

roots to more recent eras when it became a crossroad of cultures from Asia and the Pacific to the U.S. and other western countries, all of which have left their mark."

The designer wanted to reflect that distinctive reality while meeting the needs of his clients and their family. Hence the abundance of Asian antiques, from furniture and ceramics to architectural fragments and fabrics like vintage batiks and Japanese tie-dyed cottons. Smith says all of these were part of the mix in local homes—even after modernist architecture started sweeping the islands in the 1950s and 1960s—and remained signifiers of cultivated taste.

While Smith's clients may be voracious collectors of art, their Hawaiian home has precious few walls on which to display it. "So many rooms have barely any walls, or walls that fold away and disappear, so we used the ceilings to add another layer of interest," says Smith. He commissioned the painter Maria Trimbell to study Japanese screens and Polynesian motifs and then echo those designs on the recessed ceilings of the principal rooms.

With Trimbell's cloudlike painterly touches overhead, the living room reflects the boldest blend of Smith's desired mash-up of cultures—from a Chinese carpet and ceramics to a pair of stunningly sophisticated Syrian inlaid chests to Ralph Lauren sofas, a Rose Tarlow coffee table, and a bespoke David Wiseman branch chandelier with delicate lights.

The most wall-less room in the house is the lanai-style family room that projects into the garden. In it, Smith deployed wicker sofas and chairs by Bielecky Brothers. "They are utterly indestructible," he says. "Some of the designs might be eighty years old but still have the durability and simplicity that you want for Hawaii's incredible weather and indoor-outdoor lifestyle." A set of four George Nakashima stools represent the islands' Asian and American influences in the work of one artisan, and Trimbell's wavy fish-scale design on the ceiling recalls a metalwork motif common on Japanese armor.

PREVIOUS PAGES: The family room or lanai can be almost completely opened, so Smith opted for indoor-outdoor Bielecky Brothers wicker furniture for the space; four diminutive Nakashima stools are centered between two seating areas. Since there are virtually no walls for hanging art, Smith had Maria Trimbell paint the ceiling with a subtle Japanese decorative motif. LEFT: In the dining room, the home's beautifully honed teak architecture glows golden in the early evening sun. Photograph by Jack Pierson.

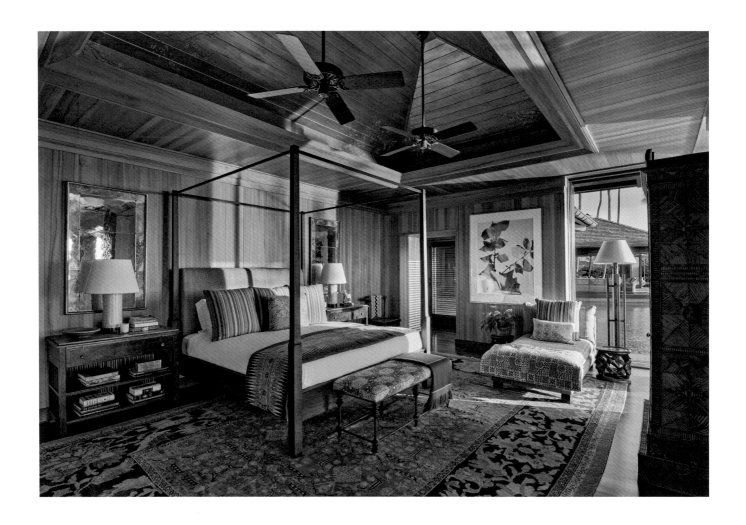

ABOVE: The primary bedroom, which has direct access to the home's vast and sprawling pool, features a Holly Hunt four-poster bed and a comfy daybed for afternoon lounging. The photograph is by James Welling.
OPPOSITE: On the opposite side of the primary bedroom, an eighteenth-century Japanese screen inspired artist Maria Trimbell to paint delicate peach blossoms on the ceiling above the bed. The Chinese chairs are late Qing dynasty, and the marquetry chest dates to Meiji-era Japan.

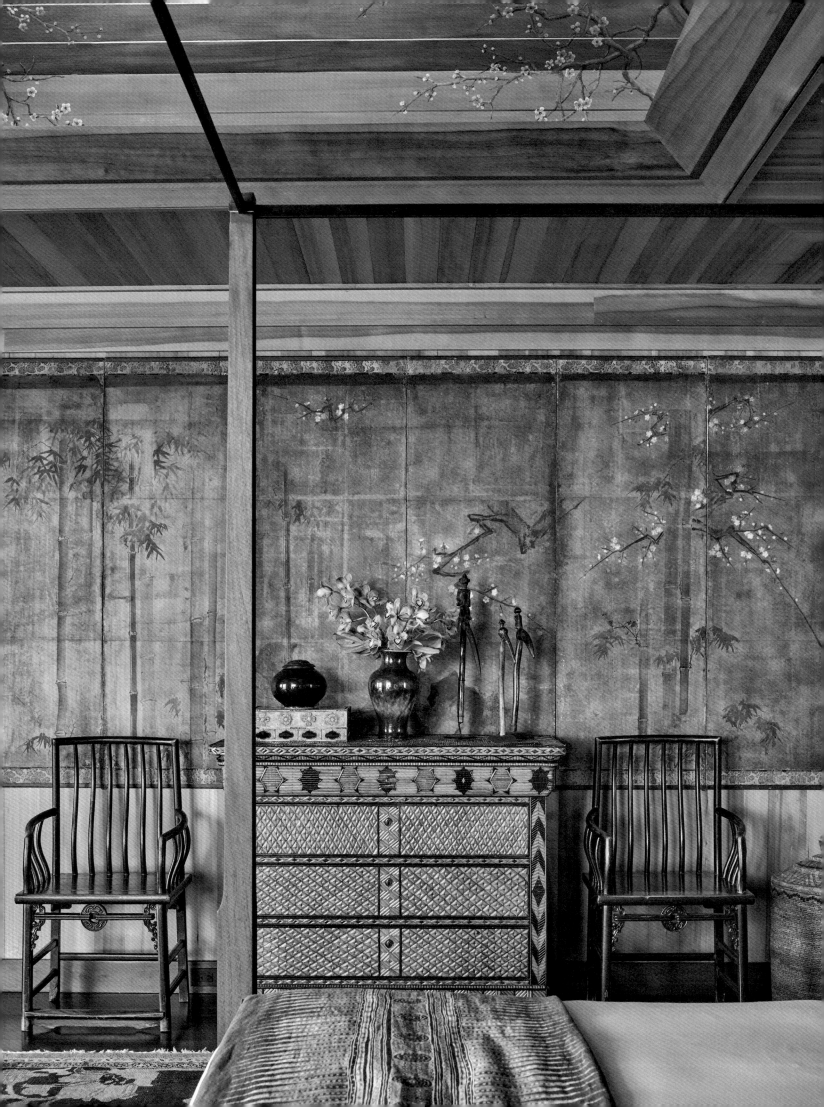

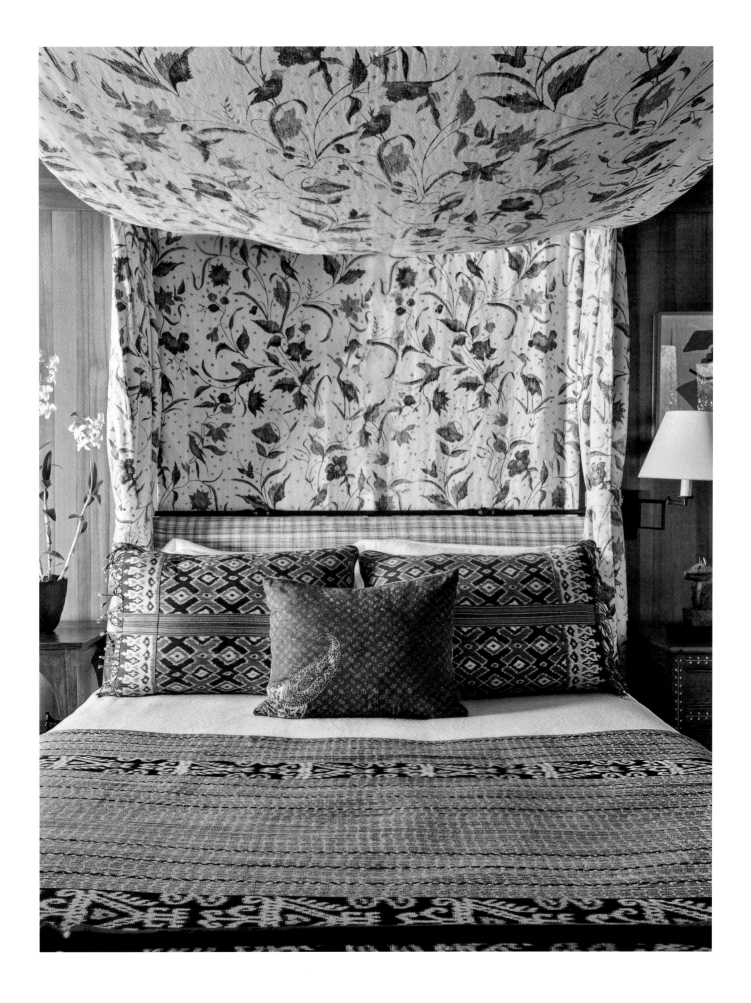

The home has many places to eat either indoors or alfresco, but Smith especially likes the sunny breakfast room, which combines the appeal of both since it opens on multiple sides to the garden. The room is anchored by a hefty Indian table and chairs atop an antique carpet with a delicate pattern of cherry blossoms. The vivid indigo and white fabric on the chair cushions came from Laos. Standing in for a sideboard is a cinnabar-lacquered Southeast Asian cupboard upon which rests a rafter tail from a Japanese temple that looks like a chunky minimalist sculpture. On an adjacent wall, Smith hung some of his clients' Hispano-Moroccan tiles as a wink at Doris Duke's Shangri La, but also, he confesses in a more practical mien, "because tiles are durable and not affected by humidity or sun." With the tiles, the textiles, the lacquer, and the teak—not to mention the lush green foliage that peeks in though the open doors and windows—the room is a symphony of intense tropical color.

Opposite the family room, the bedroom wing stretches off toward the sea, with most rooms open to the pool and the sound of the Pacific waves crashing in the distance. The primary bedroom—as in many a Smith-designed home—serves as a tranquil retreat for his clients. In addition to the grand Holly Hunt tester bed, there's a daybed that's large and comfortable enough to be used for more than laying out clothes. This, too, is a nod to traditional Hawaiian interiors, which have multiple places to lounge, rest, or read. The chaise faces a gorgeous Japanese screen hanging above an impressive Meiji-era marquetry chest and a pair of elegantly simple Chinese armchairs.

"While architecturally this house represents a form and style many people would keep plain, we tried to layer in varied and interesting pieces," says Smith. "Our goal was to infuse it with the diversity and complexity of the cultural mix on the island." Combined with this family retreat's truly idyllic indoor-outdoor lifestyle at the junction of land and sea, it's all about classic Hawaiian details.

PAGE 264: In the bedroom wing, Smith layered Indo-Asian antiques and textiles. A Chinese lacquered console doubles as desk and vanity. PAGE 265: The designer favored handmade textiles, batiks, block prints, and intricate tie-dyed fabrics. LEFT: The breakfast room is among Smith's favorite spaces in the house. The table and chairs are from India and the antique lantern was bought and restored in London.

ACKNOWLEDGMENTS

Many talented minds and hands contributed to the creation of this beautiful and enriching volume. I would like to thank Andrew Ferren, who made this process delightful and truly understood my voice; I admire his clarity and the beauty of his writing. Designer David Byars created a wonderfully clean and compelling framework to showcase projects that were so meaningful for me to document. To Shonda Rhimes, a client and a dear friend, thank you for writing such a personal and heartfelt foreword that brilliantly captures the collaborative spirit I strive to engender on all projects.

I'd also like to express my deep gratitude to everyone at Rizzoli, in particular Charles Miers and my editor Kathleen Jayes for, time and time again, producing beautiful documentation of my work and for being so respectful of my desire to try to capture the magic of the process. Thank you also to Margaret Russell, my lifelong supporter and editor in life and all projects, whose insight and wisdom are always remarkably evident. I'd like to recognize both the many photographers whose gorgeous images appear in this book, as well as the magazine editors who have featured these projects in their pages, for believing in my work, producing it professionally, and presenting it beautifully.

Thank you also to the superb architects who have collaborated with me over the years, including Ferguson & Shamamian Architects, Kovac Design Studio, and the late Rafael Viñoly, in our continuous pursuit of improvement. Without their experience, guidance, and craft, I would never be able to fully achieve my vision for these projects. I must also thank my own team for sharing their talent and dedication every day on every level. My assistant, Christina Dial, deserves special mention for her ample resourcefulness and attention to detail, which proved vital throughout the creation of this book.

From the very bottom of my heart, I want to acknowledge my supportive and extraordinarily courageous clients. It's difficult to express just how much their trust in me—and willingness to often take huge leaps of faith—inspires me to keep trying to deliver ever-more refined, interesting, and diverse homes to reflect their passions.

Most importantly, I wish to thank James, for being full of encouragement at every turn in the road and over every hill. Thank you for always having my back and being at my side.

PHOTOGRAPHY CREDITS

Michael Mundy: Front and back covers, endpapers, pages 3–5, 7, 10–12, 15, 28–29, 52–57, 59–93, 116–117, 119–137, 148–159, 161–167, 170–177, 179–183, 202–203, 212–213, 220–237, 239, 254–267, 271

Roger Davies: Pages 2, 8, 17–21, 23–26, 30–40, 43–51, 240–241, 244, 246–247

Magnus Marding: Pages 6, 94–115

Adrian Gout: Pages 16, 27, 41–42

Miguel Flores-Vianna: Pages 138–147

Dominique Vorillon: Pages 168–169

Ricardo Labougle: Pages 184–197

Lisa Romerein: Pages 198–201, 204–211, 214–217, 219

John Ellis Photo: Pages 242–243, 245, 248–253

ART CREDITS

Front Cover, page 124: Franz Kline, Untitled, 1952 ©
2024 The Franz Kline Estate/Artists Rights Society
(ARS), New York

Front Cover, page 124: Joaquín Torres-García,
Constructivo en Blanco y negro con pez © Estate of
Joaquín Torres-García

Front Cover, page 124: Gabriel Orozco, Untitled,
graphite and gouache on paper, 2006 © Gabriel
Orozco and Marian Goodman Gallery

Back Cover, page 59: Robert Polidori,
Annunciation by Fra Angelico, Cell 3 © Robert
Polidori

Pages 4, 117: Agnes Martin, Untitled #5, 1996 ©
Agnes Martin Foundation, New York/Artists Rights
Society (ARS), New York

Page 7: Kenneth Noland, Mexican Camino, 1970;
© 2024 The Kenneth Noland Foundation/Licensed
by VAGA at Artists Rights Society (ARS), NY

Page 12: Hughie Lee-Smith, End of Act One, 1987
© 2024 Estate of Hughie Lee-Smith/Licensed by
VAGA at ARS, NY

Page 16: Andreas Eriksson, Even Tide © Andreas
Eriksson. Courtesy the artist and Stephen Friedman
Gallery

Page 16: Theaster Gates, Coup Coop, 2013, wood,
asphalt, tar, metal, and fire hose © Theaster Gates.
Courtesy of the artist and the Monastery Foundation

Page 16: Peter Schlesinger, Two Sculptures,
"Untitled", ceramic stoneware, 2010 © Peter
Schlesinger

Page 16: Lowell Nesbitt, Blue Iris, 1966 © 2024
Estate of Lowell Nesbitt/Licensed by VAGA at Artists
Rights Society (ARS), NY

Page 17: Philip Taaffe, Choir, 2014-2015, Mixed
media on canvas 141¼ x 110¾ inches (358.8 x 281.3
cm) © Philip Taaffe. Courtesy of the artist and
Luhring Augustine, New York

Page 18: Gary Simmons, Hurricane, 2013, Oil and
enamel paint on panel, 3 panels. Overall: 96 x 144 1/4
inches, each panel: 96 x 48 inches © Gary Simmons.
Courtesy the artist and Hauser & Wirth.

Page 20: Christine Taber, Untitled

Page 23: Jack Roth, Thesis IV (1981) © The Estate
of Jack Roth, used with permission.

Pages 24-25, 26: Nancy Lorenz, Dining Room,
2021, Moon gold, mica, white gold © Nancy Lorenz

Page 27: Samuel Levi Jones, Flow, 2018 © Samuel
Levi Jones. Courtesy Galerie Lelong & Co.

Page 27: Robert Therrien, "No Title" 1985-86
© 2024 The Robert Therrien Estate/Artists Rights
Society (ARS), New York

Pages 28, 30: Power Boothe, Blue, Green on Red,
1987. Courtesy of the Fred Giampietro Gallery

Page 28: Jack Pierson, (TORSE D'ATHLETE EN
MARBLE), 2010, Folded pigment print, 83 x 62 inches
© Jack Pierson. Courtesy Regen Projects

Page 29: Jack Pierson, (BURNING PALM
FRONDS), 2010, Folded pigment print, 83 x 62 inches
© Jack Pierson, Courtesy Regen Projects

Page 33: Samuel Levi Jones, Action Over Words,
2021 © Samuel Levi Jones. Courtesy Galerie Lelong
& Co.

Page 39: David Montgomery, QUEEN
ELIZABETH WITH CORGIS (HEATER), 1967
(PRINTED 2018)

Page 39: Katy Moran, Mancini Sunday, 2008
© Katy Moran. Courtesy of the artist and Sperone
Westwater, New York

Page 39: Hugo McCloud, Untitled 13, 2016,
Aluminum foil, aluminum coating, oil paint on tar
paper. Stamped

Page 44: Andy Woll, Mt. Wilson (Tiepolo Opponent
Process IV), 2019, oil on linen © Courtesy of the artist
and Night Gallery, Los Angeles

Page 45: Louise Nevelson, Night Mountain
Tapestry, 1977 © 2024 Estate of Louise Nevelson/
Artists Rights Society (ARS), New York

Page 46: Eduardo Chillida, Zedatu I-IV, 1991 ©
Zabalaga-Leku, Artists Rights Society (ARS), New
York 2024

Pages 48-49: Power Boothe, Blue & Black on Red
Drift. Courtesy of the Fred Giampietro Gallery

Page 49: Irving Penn, Nubile Young Beauty
of Diamaré, Cameroon, 1974 © The Irving Penn
Foundation

Page 53: Lorna Simpson, For Beryl Wright, 2021
© Lorna Simpson. Courtesy the artist and Hauser
& Wirth.

Pages 54-55: Walton Ford, Necropolis, 1999
Artwork © Walton Ford. Courtesy of the artist and
Kasmin, New York

Page 60: Santiago Giralda, Brooklyn II. Oil on
linen. 250 x 185 cm. 2018 © 2024 Artists Rights Society
(ARS), New York/VEGAP, Madrid

Page 61: Richard Serra, Spoleto Circle,1972 ©
2024 Richard Serra/Artists Rights Society (ARS),
New York

Pages 68-69: Antonio Corpora, Misura di Spazio
Luce, 1971

Pages 70-71: Joana Choumali, Farewell, 2022 ©
Courtesy the artist and Sperone Westwater, New York

Page 72: Nancy Lorenz, Sky and Falls 2015, moon
gold and palladium, lacquer © Nancy Lorenz

Page 73: Mira Nakashima, Butterfly Screen ©
Nakashima Woodworkers

Page 77: Marina Adams, Roma II, 1993, Oil on
Canvas, 59 x 43 ½ in./149.9 x 110.5 cm © Marina
Adams

Page 81: Clara Graziolino, Fishbone sculpture,
2022 © 2024 Artists Rights Society (ARS), New York/
VEGAP, Madrid

Page 82: Suzanne Caporael, From Where I Sit, 2005
© 2024 Suzanne Caporael/Artists Rights Society
(ARS), New York

Pages 84-85: Jack Pierson, (SOMEWHERE IN
THE MEDITERRANEAN), 2010, Folded pigment
print, 83 x 62 inches © Jack Pierson. Courtesy Regen
Projects

Pages 88-89: Santiago Giralda, Top: Hydra, oil on
linen, 45 x 35 cm, 2015. Bottom: Tempel, oil on linen,
45 x 35 cm, 2015 © 2024 Artists Rights Society (ARS),
New York/VEGAP, Madrid

Page 90: Massimo Vitali, Le Menuires Quartett ©
Massimo Vitali

Pages 92-93: Sten Kauppi, Snowride, 1994/5 ©
2024 Artists Rights Society (ARS), New York

Pages 94, 99: Christopher Le Brun, Wild Vine,
1961 © 2024 Artists Rights Society (ARS), New York/
DACS, London

Page 101: Left: Pablo Picasso, Sable Mouvant: Tête
d'Homme barbu, 1966; Right: Pablo Picasso, Sable
Mouvant: Sculpteur, 1966 © 2024 Estate of Pablo
Picasso/Artists Rights Society (ARS), New York

Pages 102-103,111: Candida Höfer, Casa De
Labrador Aranjuez III, 2000 © 2024 Artists Rights
Society (ARS), New York/VG Bild-Kunst, Bonn

Page 116: Helen Frankenthaler, Portrait
of Margaretha Trip, 1980 © 2024 Helen
Frankenthaler Foundation, Inc./Artists Rights
Society (ARS), New York

Page 119: Josef Albers, Homage to the Square:
White Nimbus, 1964 © The Josef and Anni Albers
Foundation/Artists Rights Society (ARS), New
York, 2024

Pages 120-121: Alexander Calder, Seven White
Dots, Brass Spiral, on Black and Red, 1960 ©
2024 Calder Foundation, New York/Artists Rights
Society (ARS), New York

Pages 120-121: Franz Kline, Untitled, 1957 ©
2024 The Franz Kline Estate/Artists Rights Society
(ARS), New York

Page 122: Richard Diebenkorn, Berkeley
#48, 1955, oil on canvas © Richard Diebenkorn
Foundation

Page 123: Pablo Picasso, Femme Allongee
Lithograph, 1946 © 2024 Estate of Pablo Picasso/
Artists Rights Society (ARS), New York

Page 127: Brice Marden, Glyphs, 1986 © 2024
Estate of Brice Marden/Artists Rights Society
(ARS), New York

Page 129: Nancy Lorenz, Garden Room 2014,
white gold, silver leaf, mother-of-pearl inlay,
lacquer © Nancy Lorenz

Page 130: Peter Lanyon, Cliff Wind, 1961 ©
Sheila Lanyon. All Rights Reserved, DACS,
London/Artists Rights Society (ARS), New York/
DACS, London

Page 131: Frank Stella, Untitled, 1960s © 2024
Frank Stella/Artists Rights Society (ARS), New York

Page 134: Hans (Jean) Arp, Constellation
According to the Laws of Chance, 1930 © 2024
Artists Rights Society (ARS), New York/VG Bild-
Kunst, Bonn

Page 152: (left to right) Walter Henry Williams
Jr, Southern Landscape #2, 1981-82 and Untitled
(Boy on Porch), 1965

Page 158: Thornton Dial, Two Untitled Works
© 2024 Thornton Dial Jr./Artists Rights Society
(ARS), New York

Page 185: Patricia Treib, Cameras (2013), oil
on paper mounted on board © Courtesy of Kate
MacGarry, London.

Page 188: Andy Warhol, Mount Vesuvius, 1985
© 2024 The Andy Warhol Foundation for the Visual
Arts, Inc./Licensed by Artists Rights Society
(ARS), New York

Page 188: Andy Warhol, Untitled (Weather Map)
1984-1986 © 2024 The Andy Warhol Foundation
for the Visual Arts, Inc./Licensed by Artists Rights
Society (ARS), New York

Page 194: BRYAN ORGAN b.1935,
Metamorphosis II, 1966, Oil on canvas, 60" x 50" ©
Bryan Organ and The Redfern Gallery, London

Page 197: Jason Martin, Visionary, 2002, acrylic
on polished stainless steel. 59 ½ x 59 ½ in. (151.1 x
151.cm)

Pages 199, 200: Alexander Calder, Three Legged
Kite, 1956 © 2024 Calder Foundation, New York/
Artists Rights Society (ARS), New York

Page 203: Alfred Leslie, Nix on Nixon, 1927 ©
Estate of Alfred Leslie

Page 205: Ben Nicholson, Sept. 53 (Balearic),
1953 © Angela Verren Taunt. All rights reserved,
DACS, London/ARS, NY 2024

Page 213: Lynn Davis, Iceberg #6, Disko
Bay, 1988 © Courtesy of the artist and
Edwynn Houk Gallery, New York

Page 213: Lynn Davis, Iceberg #8, Disko
Bay, 1988 © Courtesy of the artist and
Edwynn Houk Gallery, New York

Page 214: John Altoon, The Portrait of
a Spanish Poet, 1959 © The Estate of John
Altoon and Michael Kohn Gallery, Los
Angeles

Page 215: Louise Lawler, Grieving
Mothers, 2005

Page 220: Nancy Lorenz, Cherry Blossom
Panels, 2021, Celadon lacquer and mother-of-
pearl inlay © Nancy Lorenz

Page 222: Hans (Jean) Arp, Déméter, 1961
© 2024 Artists Rights Society (ARS), New
York/VG Bild-Kunst, Bonn

Page 223: Sean Scully, Small Chelsea Wall
of Light #6, 2000, oil on canvas, 18 x 24 inches
© Sean Scully. Photo: courtesy the artist

Page 225: Louise Nevelson, Floating Cloud
VII, 1977 © 2024 Estate of Louise Nevelson/
Artists Rights Society (ARS), New York

Pages 226-227: Hurvin Anderson,
Country Club, 2003 © 2024 Artists Rights
Society (ARS), New York/DACS, London

Page 228: El Anatsui, Strained Roots, 2014.
Aluminium and copper wire © El Anatsui

Page 230: Hurvin Anderson, Maracas
Series, 2010 © 2024 Artists Rights Society
(ARS), New York/DACS, London

Page 231: David Hockney's "Piscine de
Medianoche (Paper Pool 30)" 1978. Colored
and pressed paper pulp © David Hockney/
Tyler Graphics Ltd

Page 233: Hurvin Anderson, Audition,
1998 © 2024 Artists Rights Society (ARS),
New York/DACS, London

Page 235: Njideka Akunyili Crosby, Bush
Babies, 2017. Acrylic, transfers, colored pencil
and collage on paper, 72 in.x 60 in. © Njideka
Akunyili

Page 237: Bernar Venet, 223.5° Arc x 5,
2006, Rolled steel, 200 x 200 x 46 cm

Page 239: Hurvin Anderson, House, 2005
© 2024 Artists Rights Society (ARS), New
York/DACS, London

Page 243: John Divola, Rings, 1989 © John
Divola

Pages 243, 244: John Divola, Rock in
Water, 1980 © John Divola

Page 245: Cecily Brown, Haha Fresh!,
2006 © Cecily Brown. Courtesy Paula
Cooper Gallery, New York

Pages 246-247: Shannon Ebner,
Instrumentals, 2013; Archival pigment print
75 x 42 ¼ in, 190.5 x 107.32 cm © Shannon
Ebner. Courtesy of the artist and Altman
Siegel, San Francisco

Pages 257, 260-61: Jack Pierson,
(BURNING PALM FRONDS), 2010, Folded
pigment print, 83 × 62 inches © Jack Pierson.
Courtesy Regen Projects

Page 262: James Welling, 003, 2007,
Chromogenic print, 48 x 37.25 inches ©
James Welling. Courtesy Regen Projects, Los
Angeles.

First published in the United States of America in 2024 by
Rizzoli International Publications, Inc.
300 Park Avenue South
New York, NY 10010
www.rizzoliusa.com

Copyright © 2024 Michael S. Smith
Text: Andrew Ferren
Foreword: Shonda Rhimes

Publisher: Charles Miers
Senior Editor: Kathleen Jayes
Production Manager: Barbara Sadick
Managing Editor: Lynn Scrabis

DESIGN BY DAVID BYARS

Printed in Italy

2024 2025 2026 2027 / 10 9 8 7 6 5 4 3 2 1

ISBN: 978-0-8478-30251

Library of Congress Control Number: 2024934048

Visit us online:
Facebook.com/RizzoliNewYork
X: @Rizzoli_Books
Instagram.com/RizzoliBooks

ENDPAPERS: A detail of a luminous mixed-media (gesso, abalone shell, and silverleaf, among other materials) wall panel by artist Nancy Lorenz. PAGE 2: A gilt-metal candle sconce by Hervé Van der Straeten. PAGE 3: A selection of Iznik and Hispano-Moroccan tiles. PAGE 4: Smith deftly combined disparate textures, materials, and periods, from seventeenth-century Italian baroque furnishings to twentieth-century minimalist art, in a Manhattan duplex. PAGE 5: Some of the patinated bronze panels by Moorland Studios surrounding one of the fireplaces of a home in Montana. PAGE 6: In an idyllic home on Mallorca, Smith layered Mediterranean details like a Moroccan carved ceiling and the Italian wicker chairs designed by Renzo Mongiardino for Bonacina. PAGE 7: A striking Kenneth Noland canvas and a pair of Philippe Anthonioz lanterns adorn the kitchen of a Los Angeles home. PAGE 8: The sinuous staircase of a home in Malibu is paneled in oak planks. PAGES 10–11: With his clients' grandchildren in mind, Smith used Carolina Irving's Indian Flower fabric for the bed canopies and hung the walls with watercolors of exotic animals. PAGE 12: A painting by Hughie Lee-Smith hangs above a late eighteenth-century painted Italian chest in a Manhattan penthouse. PAGE 15: A sumptuously ornamented Chinese Export lacquered cabinet upon a later carved and gilded English stand (detail). PAGE 268: A selection of images from the designer's Instagram feed @michaelsmithinc. PAGE 271: A specimen olive tree, given to Smith by a dear friend, was planted to create a striking view from both inside his living room and garden in Los Angeles.